THE
VICTORIAN
ART WORLD
IN PHOTOGRAPHS

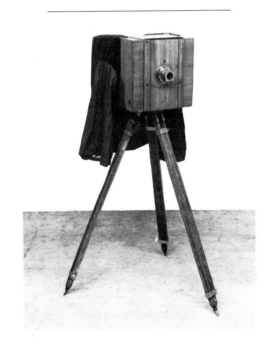

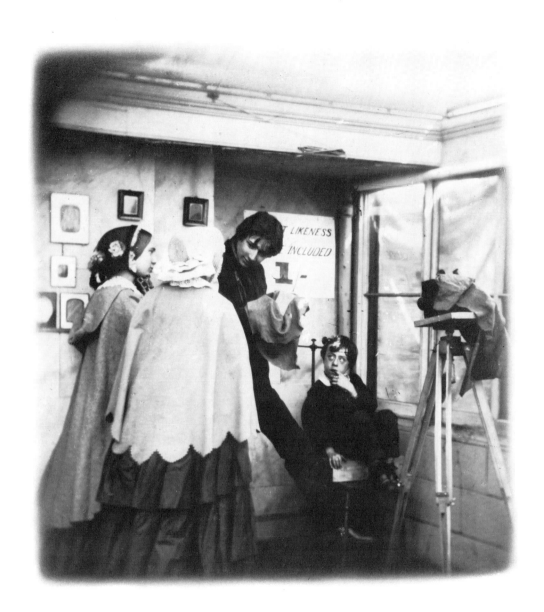

THE
VICTORIAN
ART WORLD
IN PHOTOGRAPHS

JEREMY MAAS

UNIVERSE BOOKS

NEW YORK

Published in the United States of America in 1984
by Universe Books
381 Park Avenue South, New York, N.Y. 10016

83 84 85 86 87/10 9 8 7 6 5 4 3 2 1

Printed in Great Britain

Library of Congress No. 83-40565

ISBN 0-87663-429-3

CONTENTS

ACKNOWLEDGEMENTS

My first debt of gratitude is to Jeannie Chapel, who has been a help at every stage of this book. My thanks are due also to Henry Ford, who has read the text as it came off Joanna Littlejohns's typewriter, and to her as well I owe thanks. Others who kindly read sections of the text are Virginia Surtees, Andrew Wyld and Dr Susan Beattie, and to them I am much indebted. I also acknowledge the help kindly given by Frances Dimond, MVO, Curator of the Photograph Collection in the Royal Archives, the late Mrs Jean Spring, Howard Ricketts, Valerie Lloyd of the Royal Photographic Society, Richard Ormond, Deputy Keeper of the National Portrait Gallery at the time of writing, Philippe Garner of Sotheby's, Terence Pepper of the National Portrait Gallery, and the staff of the London Library. However, I take full responsibility for any errors which may be revealed. Lastly, I reserve my gratitude to those others who have answered queries and helped in many ways, without whom a book such as this could hardly have seen the light of day.

PHOTOGRAPHIC ACKNOWLEDGEMENTS

Plates 123, 136, 168, 270, 308 and 361 are reproduced by gracious permission of Her Majesty The Queen; Plates 2, 5, 11, 16, 18, 22, 33, 36, 48, 50, 52, 61, 63, 67, 68, 80, 84, 87, 92, 98, 110, 116, 125, 130, 131, 132, 162, 169, 193, 237, 238, 247, 274, 276, 285, 286, 375, 386, 388, 391, 393, 399, 401, 403, 415 and 417 by permission of the National Portrait Gallery, London; Plates 12, 79, 135, 175, 177, 182, 244, 334, 339 and 381 by permission of the Royal Photographic Society; Plates 159, 364, 365 and 412 by permission of the Victoria & Albert Museum, London (Crown Copyright); Plates 20, 102, 141, 228, 248, 300, 307, 323, 380, 384 and 421 by permission of Sotheby Parke Bernet; Plate 321 by permission of the Trustees of The Wallace Collection, London; and Plate 278 by permission of the Controller of Her Majesty's Stationery Office and of the Director, Royal Botanical Gardens, Kew (Crown Copyright). Other owners who have kindly given permission to reproduce their photographs are acknowledged in the captions.

Wherever possible, the process and dimensions of photographs are recorded. In some cases, however, where access to original photographs is difficult or impossible to obtain, or whose whereabouts are unknown, illustrations have been reproduced from copy prints, and as a result such details are not known.

INTRODUCTION

*Treasures such as these we shall be able to hand down to our posterity,
for there is little doubt that photographs of the present day will remain perfect,
if carefully preserved, for generations.*
Photographic News, 28 February 1862

THIS book has a dual purpose, first as an entertainment and secondly as documentation. What is offered here is a comprehensive photographic survey of nearly all the celebrated people and numerous lesser-known people who played a part in the busy, lively and richly heterogeneous art world during Queen Victoria's reign. All the various members are represented: the painters, sculptors, engravers, illustrators, patrons, collectors, dealers, print-sellers, models, mistresses, wives, children, writers on art and literary associates. There has been a wealth of choice: for every photograph selected, about five were rejected. A pity, you might say; but to have included them all would have made for prohibitive costs and a prohibitive price for the book. There is, after all, something to be said for the discipline of selection.

That it has been possible to collect together such a large number of photographs of Victorian artists and their friends must to some extent be due to the standing the artists themselves enjoyed in society. The popularity of art and artists in Victorian times was on a scale that is scarcely imaginable to us today: the artists who regularly exhibited could be counted in their tens of thousands, and they were outnumbered by those who painted but never exhibited. Art was considered to be a civilizing influence and, through its schools and patronage (usually misconceived), the Government actively encouraged it, particularly where it could be applied to industry. Art was given wide coverage in the press, not only in the national newspapers but in the local press, the art magazines, notably the *Art-Journal* and *Magazine of Art*, in the *Illustrated London News*, the *Athenaeum*, the *Spectator*, the *Builder* and *Fraser's*

Magazine; in fact, in every newspaper and magazine of the period. Some of these periodicals contained gossip columns, in which art and artists were often given more prominence than any other branch of human endeavour. The Summer Exhibition at the Royal Academy was the focal point of all artistic effort, and was considered the most important event of the season, to which the entire family, from all classes, went not just once but often several times: pictures were closely examined and became the talking point throughout the country.

For the Victorian artist enjoyed a particular benefit that now, alas, is largely a thing of the past: complete rapport with his public. Pictures were painted to give pleasure, even instruction if the subject was moral or historical, but above all they were painted to be understood. The Victorians did not look at pictures in a general way as is now the practice, nor did the artist intend them to. Pictures were painted in such a way as to invite close inspection either by way of felicitous, even virtuoso painting, or by the possession of narrative content.

The seed from which this book has grown took about thirty years to germinate for it fell on highly infertile soil in, I think, the year 1953, when a friend and I rented a dank, dark, rambling basement flat of eleven rooms, at 63 Harrington Gardens, London. It was a big Victorian house heated throughout by an ancient boiler which, in winter, we, in the flat, had to stoke several times daily, a task inherited from the flat's earlier occupants, presumably a large staff of servants disposed about its eleven rooms. The sole surviving relic

from our predecessors, left dusty and discarded on a shelf, lies before me as I write. It is a small leather-bound album with the vestiges of three ornate metal clasps. Inside the cover is the binder's label, Martinet of 172 Rue de Rivoli, and the volume contains forty-two photographs (some ten years later I learnt their true name – *cartes-de-visite*) of English and foreign royalty, statesmen, writers, poets, philosophers, artists and actresses, the last picture in the album being that of the future Kaiser Wilhelm II of Germany, then aged 3. Ruskin, the great critic, was there and the artists included Edwin Landseer, Holman Hunt, Gibson, Millais, Marcus Stone, Rossetti and Whistler.

Although the album survived numerous moves, and never quite seemed to fit anywhere, its vestigial clasps defying insertion into a bookshelf and it being too shabby to be regarded as a conversation piece, it never excited in me anything more vibrant than mild curiosity. I discovered in the course of time that such articles used to be commonplace in many families. (My own family has numerous early photographs, though never in albums, including those of a maternal grandfather and great-uncle who fought for the Union in the American Civil War, and a paternal grandfather who knew, not Lloyd George, but Sir Lawrence Alma-Tadema. An aunt of mine, after expressing some surprise that anyone could be interested, described to me tea-parties she attended at Tadema's house.) This mild curiosity burned with a slow fuse and only began to show real flickers of life when, unimpeded by tutors who would have assuredly deflected me at that time from taking such an aberrant course, I began to take an interest in Victorian art. During this period, in the 1950s, only a handful of people showed any interest in that daunting, denigrated period. It was at this time, too, that part of the ritual for those few was to make a pilgrimage to a little house in Woodstock, Oxfordshire, where Helen Rossetti Angeli lived, the daughter of William Michael Rossetti. Frail yet delightfully articulate, she lay on the sofa which Shelley had bought in Pisa in 1821, the year before he was drowned, and recalled her family, which included her grandfather Ford Madox Brown, and of course Dante Gabriel and Christina Rossetti, and Lizzie Siddal, as though she were talking of yesterday.

In that year, 1960, I started a picture gallery in London, with the idea of specializing in Victorian art, at that time so unfashionable as to be inviting near-certain disaster. The first item in the stock book was a print after Sir Frank Dicksee, a name then shrouded in

oblivion; and in 1961 the gallery held an exhibition of Pre-Raphaelite artists, the first of several, and apparently the first commercial exhibition devoted entirely to that movement (as I learned four years later from that indispensable compendium *Pre-Raphaelitism: a Bibliocritical Survey*, by W. E. Fredeman).

But back to the photographs. Some time in the early 1960s a friend showed me a collection of early calotype photographs of some water-colour artists taken between 1845 and 1850. He kindly let me have duplicates and many of them are reproduced in this volume. Not long afterwards, someone came into the gallery and sold me a bundle of Victorian artists' letters, together with a large collection of photographs. My interest now finally kindled, I placed the photographs under glass on a large print cabinet, and set about building up the collection. In no time I was in book-shops and junk shops, burrowing through shirt-boxes, shoe-boxes and trays for photographs of artists. Rarely, very rarely, did I ever pay more than a shilling for one. No one else seemed to be interested. One kind book-seller, Eric Barton, allowed me to take home his entire collection of miscellaneous photographs, and it was the work of a whole weekend to dig out all the photographs of artists. As the collection grew, so it went under the same glass. Another unexpected source was the descendants of artists who, noticing that their ancestors were missing from my collection, kindly sent me photographs of them to make good the omission, nearly always free of charge, and to them I am much indebted.

As the years went by, what was at first almost an absent-minded interest became an engaging pastime; and an *affordable* one, since for about the first ten years, when there was a price to be paid at all, it nearly always remained constant, at one shilling per photograph. One other factor remained constant: this was my surprise that so many artists from the distant past should have been photographed at all and that such photographs should still exist. Giving the matter some thought, I put a proposition to myself that since photography in its early days was considered a fantastic novelty, it was not a question of who had been photographed and who had not, and I should act on the assumption that every-one alive from about 1845 onwards had stepped in front of a camera, if only once; and that somewhere the photograph lay unseen and unrecognized. This assumption provided a useful incentive.

Heading for nearly unmanageable proportions, the collection grew, with photographs coming in from every conceivable source. I acquired a collection of

books, manuscript letters and photographs that had belonged to the critic F. G. Stephens, an original member of the Pre-Raphaelite Brotherhood, from a retired railway signalman living in Kent. For a long time I had suspected that Holman Hunt, Stephens's one-time friend and later bitter enemy, must have owned a fine collection of artists' photographs. Sure enough, I was able to secure the whole collection, catalogued in just two lots in a London sale-room. Two other, related, finds come to mind: the purchase in a London sale-room of an album of uncut proof photographs (they would now be called contact prints) by Charles Watkins; and about eighteen months later, in a country sale-room, the purchase of an album of autograph letters from artists to John Watkins, his brother and partner, concerning their sittings for photographs.

I have been guided by two rules in building up the collection. First, to go for the straightforward studio photograph by one of the hundreds of commercial photographers, rather than the more 'arty' variety by Julia Margaret Cameron or her teacher David Wilkie Wynfield. The apparently inferior commercial photograph provides truer documentation and, of course, is vastly less expensive than the other kind. Second, I resolved to be content with modern duplicates of early photographs, where possession of originals is not possible. Even the latter approach has its moments. I have always had an affectionate regard for the Royal Academy and particularly for its far from uncontroversial history, a large part of which falls within the Victorian period. I was amazed one day to chance upon the following entry in the 1901 supplement to the catalogue of the Royal Academy Library: 'Leighton, P.R.A. (Frederic, Lord). Lying in state at the Royal Academy of Arts, Feb. 1–3, 1896. 6 *photographs.*' I at once went there and asked to see them. They did not have them, I was told. 'Ah, but you must,' said I. 'It says here. . . .' Repeated requests were met with a polite but firm denial. Months later, however, after a diligent search, they were found, and two of these extraordinary photographs, so heavy with the aura of High Victorian Art and the pomp of high office, are reproduced here (Plates 242 and 243).

It might perhaps be worthwhile remarking on one curious aspect of forming this collection: that is, the strange experience of collecting in a market which, to all intents and purposes, did not exist. The most common and mundane procedure was to enter a second-hand bookshop which had a section for ephemera, and leaf through, often for many hours at a time, photo-

graphs and postcards which, if I were lucky, had a section entitled 'portraits'. It was simply not possible to walk into any kind of establishment and ask to see its collection of photographs of artists. Nor, for all I know, is it possible to do so even now. And yet although I have never counted the number of photographs of Victorian artists, sculptors, engravers *et al* that I have assembled, I would put the number at well over 2000.

Of all the inventions of the nineteenth century, photography was by far the most original and far-reaching in its consequences. It was at once appreciated that whereas the likenesses of previous generations were subject to the skill of a portrait painter and the conventions of portraiture prevailing at that time, the photograph conveyed directly 'the very lines that Nature has engraven on our faces'. The comparative cheapness, too, allowed the possibility of everyone having not just one, but forty or fifty exact portraits of themselves. It is hardly surprising, therefore, that photography soon achieved widespread popularity of nearly epidemic proportions, which continued unabated for generations to come. As an art form it instantly attracted practitioners who quickly proceeded to raise it to a high level of achievement, sometimes equalled but rarely bettered by subsequent photographers.

However, it was to the main subjects of this book, the artists, that it posed the greatest threat. A modern equivalent would be the invention and manufacture of a robot which appeared capable of instantly wiping out an entire profession. Photography, in fact, did just that to the art of miniature painting, although the art underwent a few subsequent temporary resurrections. Sir William Ross, miniature painter to the Queen, simply retired; another miniaturist, H. T. Wells, went to the other extreme and took up portraiture in oils; and many miniaturists became photographers. Throughout the second half of the nineteenth century there existed a love-hate relationship between artists and photographers. While some artists derided the achievements of photography, others became full- or part-time photographers, or, like Frith and Millais, made full use of the new processes as an aid in painting. There is little doubt, too, that it was in some measure a contributory factor in the realization of one of the aims of Pre-Raphaelitism, the rendering of fine detail, closely observed 'truth to Nature'.

This is no place for a full history of early photography; there are many excellent books on the subject. The processes which concern us here are mainly the

daguerrotype, the calotype and the wet plate or collodion process resulting in the ambrotype on glass, or the albumen print on paper. The daguerrotype was the invention of the Frenchman Louis Jacques Daguerre in 1839. Although photographs taken by this method could be very beautiful, it had several disadvantages, particularly in its early days, when a sitting of fifteen to thirty minutes was required. If a clock was in the background the hour hand would be allowed to show, but the minute hand would not. Owing to the mirror-like surface of a daguerrotype it had to be viewed at a certain angle. It not only looks like a mirror but gives a mirror image of the sitter, and when I discovered this it immediately cleared up a mystery. The blemish which seems like a birthmark, which appears to be on the left cheek in the daguerrotype portrait of P. F. Poole (Plate 79), does not appear on later albumen prints where he has presented his left cheek to the camera. Until this peculiarity of the daguerrotype became known to me, I had had to assume, for want of proper evidence, that the fault was in the photograph not the sitter.

The daguerrotype was in general use from 1839 to about 1857. The calotype or Talbotype, so named after its inventor William Henry Fox Talbot, was introduced in 1841 and was in relatively common use until 1857. It represented the first application of the negative/positive principle of photography and the image was printed on paper. The best-known photographers using this process were David Octavius Hill and Robert Adamson, several of whose photographs are reproduced in these pages. The development of the wet plate or collodion process, made by Frederick Scott Archer in 1851, resulted in the ambrotype, similar to the daguerrotype and with some of its disadvantages. The collodion process also produced the albumen print on paper and these comprise the majority of the photographs shown in this book. The albumen print gave way to other vehicles for the photographic image in about 1895.

The wet plate process prepared the way for an unlimited number of copies and, with its brief exposure period – of varying lengths of time, from half a minute – for cheap, popular photography. The most dramatic development was the invention of the *carte-de-visite*, usually a portrait 90 × 52 mm mounted on a card 101 × 63 mm. The idea originated in France with, as usual, any number of photographers ready to claim the credit, and was introduced into Britain in 1857 by the French firm A. Marion & Co. The idea only really took

root when J. J. E. Mayall published in August 1860 a *Royal Album*, containing fourteen *carte* portraits of the royal family. Many hundreds of thousands of these photographs were sold (including some 70,000 of Prince Albert within a week of his death in 1861) and the craze for buying *cartes-de-visite* was on. As its name implies, the *carte-de-visite* was originally intended as a novel substitute for the ordinary printed visiting card, the photograph replacing the name of the person represented. The idea never really caught on, which is hardly surprising since the only name and address printed on the card was that of the photographer. The format, however, endured, as did its name.

One of the first and most subtle of the *carte-de-visite* photographers was Camille Silvy, a French aristocrat who was so successful and made so much money that he was able to retire to his ancestral château in 1869. The *Photographic News* of 28 February 1862 paid a visit to his august establishment and reported on the visit:

Monsieur Silvy appears to have made the *carte-de-visite* his special study, and has brought to his task all the resources of an artistic mind. . . . A visit of inspection to his studio in Porchester Terrace is full of interest. In walking through the different rooms, you are puzzled to know whether you are in a studio, or a house of business. His photographic rooms are full of choice works of art in endless number [including one which contained a silver equestrian statue of Queen Victoria by Marochetti]; for it is his aim to give as much variety as possible to the accessories in each picture, in order to accomplish which he is continually changing even his large assortment. Sometimes when a Royal portrait has to be taken the background is carefully composed beforehand, so as to give a local habitation, as it were, to the figure. The well-informed person, without a knowledge even of the originals, may make a shrewd guess at many of the personages in his book of Royal Portraits by the nature of the accessories about them. Thus, all the surroundings of the Duc de Montpensier's daughter are Spanish, whilst his son's African sojourn is indicated by the tropical scenery. The portraits of members of our own Royal Family are surrounded with fitting accessories which stamp their rank. As M. Silvy takes every negative with his own hand, the humblest as well as the most exalted sitter is sure of the best artistic effect that his establishment can produce. This we feel certain is the great secret of M. Silvy's success, as the skill required in taking a good photograph cannot be deputed to a subordinate. But, as we have said, his house is at the same time a counting-house, a laboratory, and a printing establishment. One room is found to be full of clerks keeping the books, for at the West End credit must be given; in another a score of employees are printing from

the negatives. A large building has been erected for this purpose in the back garden. In a third room are all the chemicals for preparing the plates; and again in another we see a heap of crucibles glittering with silver. All the clippings of the photographs are here reduced by fire, and the silver upon them is thus recovered. One large apartment is appropriated to baths in which the *cartes-de-visite* are immersed, and a feminine clatter of tongues directs us to the room in which the portraits are finally corded and packed up. Every portrait taken is pasted in a book, and numbered consecutively. This portrait index contains upwards of 7,000 *cartes-de-visite*, and a reference to any one of them gives the clue to the whereabouts of the negative. Packed as these negatives are, closely in boxes of fifties, they fill a pretty large room. It is M. Silvy's custom to print fifty of each portrait, forty going to the possessor, and ten remaining in stock, as a supply for friends. Sometimes individuals will have a couple of hundred impressions, the number varying, of course, according to the extent of the circle. The tact and aptitude of M. Silvy for portrait taking may be estimated when we inform our readers that he has taken from forty to fifty a day with his own hand. The printing is, of course, purely mechanical, and is performed by subordinates, who have set afloat the world 700,000 portraits from this studio alone.

By 1861 'cartomania' (or 'cardomania') had grown apace, with *carte-de-visite* photographers cropping up everywhere. In 1862 Regent Street alone could boast of thirty-five photographers while every suburban road swarmed with them. Several million *cartes* were made annually in Britain, and the craze resulted in the wholesale collecting of *cartes* of celebrities (usually prominent men in England, famous actresses and dancers in France), with friends and acquaintances swapping cards. Some *cartes* had a perpetual sale, others ran like wild-fire for only a few days. The death of a celebrity always caused a flurry of sales. Soon no drawing-room was complete without one or more albums, often in elaborately tooled leather bindings with ornate clasps. The contents usually started with royalty (always a best-seller), followed by men and women of public eminence – bishops, scientists, philosophers, writers, artists – petering out, finally, into photographs of the family that owned the albums. Hero worship and a quest for status were thus united, while the apparently large and varied range of acquaintances drew admiration from casual browsers.

Prospective sitters were ushered into the studio, their heads clamped into a head-rest, and many an ordinary soul was made to pose against a Corinthian column, walking-stick and top hat in hand, when most likely he had never entered a house that boasted a column, Corinthian or otherwise. Back-drops of every description were used, often with little imagination and even less subtlety. Usually the sitter felt ill at ease and apprehensive, as though he were visiting the dentist. Even the average thirty seconds' exposure time seemed to pass like an eternity. All around him, out of view of the camera lens, were the props: a pair of globes for the geographer, a nautical compass for the mariner, a pair of compasses for the civil engineer, a palette and easel – on which was laid an often entirely inappropriate picture – for the artist, a bust of Apollo for the sculptor, a curtain painted with library shelves heavy with books for the clergy, who were supplied with additional real books, as was the philosopher with an hour-glass, and the author with an ink stand impaled by a gigantic feather.

Public figures, known in the trade as 'sure cards', were constantly pestered for sittings and few could resist the allure of the studio. Some proved elusive, like Disraeli, but others like Lord Brougham could rarely resist going into the photographer's from time to time to inquire as to how they were selling; and to judge from the huge number of *cartes* of Thomas Carlyle, he seems to have formed an addiction, spending most of his daylight hours in front of the camera. As soon as any artist became an A R A, pressing invitations from the *carte* photographers flew through the letter box, to be repeated when he became an R A. Any artistic success was crowned by a nimbus of frantic tripod-rattling photographers. For example, a bewildered Elizabeth Thompson (later Lady Butler), reeling under the sensational success of her picture *The Roll Call* at the 1874 Royal Academy exhibition, was whisked into the studio of the first-comer and photographed, looking distinctly ill at ease. The photographer, however, knew he was on to a sure thing.

There is little doubt that some artists were not slow to exploit the publicity value of photographic portraits. It is no coincidence that those painters whose names most frequently occur in the art gossip columns of the periodicals are amongst the most photographed of all artists. These include Frith and Holman Hunt, both superb publicists and astute businessmen, and both not a little vain. While engaged on important pictures, both these artists encouraged press reports on work in progress, to heighten anticipation and to encourage the acquisitive instincts of patrons. Favourite outlets for 'stories' were magazines like the *Art-Journal*, the *Athenaeum* and the *Illustrated London News*, the last of which frequently carried portraits of artists engraved

from photographs. Hunt was well served by his friend F. G. Stephens, art critic on the *Athenaeum*, while Frith evidently had good contacts on the *Illustrated London News*. Like most celebrated painters of the period, both were plagued by the pesterings of autograph hunters. Both readily complied and Frith hit upon the device of affixing a photograph of himself to the letter heading for good measure. There is one such letter in my collection from a lady who had merely requested his autograph. The letter is dated 19 February 1858, when he was putting the finishing touches on his *Derby Day*, as yet unseen by the public but already famous through advance publicity. 'Madam,' he wrote, 'though I cannot flatter myself that my name is worthy of a place in your list of celebrities, I have still much pleasure in acceding to your request for my autograph. I remain, Madam, faithfully yours, W. P. Frith.' Stuck at the top of the page is a tiny version of the photograph by Maull & Polyblank reproduced as Plate 30. Of course, there was more than a touch of vulgarity in such self-publicity, and Frith was never short of this commodity, a characteristic he shared with his friend Charles Dickens. Other artists from a less humble background, like Augustus Egg (a friend of Frith, Hunt and Dickens), were strongly averse to such indiscriminate dissemination of their features, and doubtless paid the penalty in terms of worldly success.

Although there is plenty of evidence that artists were quick to use photography as an aid in painting (Frith had used photographs, unsuccessfully, for *Ramsgate Sands*, but successfully for *The Derby Day* and *The Railway Station*), it is not quite so easy to find examples of the use of *cartes-de-visite* for this purpose. They served the best use as an aid in painting multiple portraits, where the image on the canvas could be scaled down nearer to the size of the *carte* image. This was done on a colossal scale by Frith while painting *The Marriage of the Prince and Princess of Wales* (R A, 1865) when he used no less than sixty-two *cartes*. Indeed, Frith averted almost certain disaster by their use, since he had the greatest difficulty in persuading many of those who had attended the service to sit. Jerry Barrett used a *carte-de-visite* of the famous heroine of the Crimea in his painting *Florence Nightingale at Scutari* (now at the National Portrait Gallery, London); Holman Hunt used a *carte* of his first wife Fanny (Plate 358) for his portrait of her – as the picture was not finished until two years after her death, he had good reason. The dealer Gambart, a tireless taskmaster, once sent the painter William Linnell a *carte-de-visite* of

himself to instil a sense of urgency in completing a picture under contract to him.

Cartes-de-visite had the field all to themselves until 1867 when the cabinet portrait (so called for no very good reason) began to attain popularity. This, the second most common format in this book, had the same overall appearance as the *carte*, but was larger, 140 × 102 mm mounted on a board 165 × 108 mm. During the 1870s even larger sizes became popular – the Promenade, the Boudoir, the Imperial, and the largest of all, the Panel, its mount measuring 330 × 203 mm. All these innovations kept the collecting of photographs in fashion, while albums were continually adapted to suit them.

Although, as we have seen, the earlier efforts of the *carte-de-visite* photographers showed little imagination in the way of props, composition or varieties of pose, we are nevertheless still left with a valuable photographic record of an artist's features which, before the adoption of sophisticated methods of retouching, are even more authentic than later examples. (The practice of retouching was introduced at the same time that portrait photography became popular – in the mid-1850s – but these earlier attempts were often crude and are now, after the passage of time, easily distinguished.) The main problems were lighting and cumbersome photographic apparatus. It was not until 1884 that J. P. Mayall systematically photographed artists and sculptors in their studios. Many of his photographs are reproduced here, and very telling they are. This first series was followed by another, published in 1892, of Royal Academicians, by Ralph Winwood Robinson, the son of the more celebrated photographic pioneer, H. P. Robinson. Towards the end of the century photographs of artists in their studios reproduced by mechanical processes on postcards began to achieve popularity. Although valuable as documents, they do have a contrived appearance, even a touch of naïvety, in the placing of heavily framed pictures on the easel, in front of which sits the artist, brushes and palette at the ready, dressed in his Sunday best.

The reader might well be struck by the clean, well-cut, even fashionable clothes worn by most of the artists in their photographs. On looking through nineteenth-century photograph albums of public figures one notices little difference in dress, deportment or hair-style as one progresses from one section to another, and artists look scarcely any different from clerics, philanthropists and generals. Indeed, at the time that photographic portraiture began to attain

popularity, in the 1850s, the financial position of artists began to improve on a truly extraordinary scale. Earnings by averagely successful artists might be anything from £5000 to £15,000 a year. Outstandingly successful artists like Millais and Landseer could command earnings of £30,000 to £40,000 a year. As can be judged from some of the later photographs of artists in their studios, many of them lived, like their counterparts in Paris, in palatial style. Leighton, Alma-Tadema, Birket Foster, Holman Hunt, Millais and many others lived a life of considerable luxury, even grandeur. Tadema once observed to a fellow artist, 'My good fellow, you must wake up; your expenses are too small. You need a better studio and a bigger house.' Thomas Carlyle, stunned by the grandeur of the white marble columns, imposing staircase and the fine pictures hanging on the walls of Millais's house in Palace Gate, said, turning to the artist, 'And does all this – er – [indicating the surroundings with a wave of the hand] come from a pot of paint?' Millais himself disdained the company of the more 'arty' artists. As his son wrote, 'He hated the affectation of the long-haired and velvet-coated tribe, whose exterior is commonly more noticeable than their Art, and just dressed like other men according to circumstances of time and place.' Millais himself said, 'I can see no reason that, because a man happens to get his living by using palette and brushes, he need make himself look like a Guy Fawkes.' As can be seen, most of his contemporaries echoed these sentiments.

In August 1969 my book *Victorian Painters* was published. Sir Michael Levey, Director of the National Gallery, began his review in *The Observer* with these words:

Open this book, and there they are. In a clever and slightly frightening assemblage of sepia photographs, like so many *cartes-de-visite* the massed faces of Victorian painters are found gazing from its endpapers.

Even apart from their vastly varied ages and often opposed opinions, they do not appear a reassuring lot, indeed, by those Victorian standards of physiognomy in which you look like your nature, these men must be largely mountebanks or criminals. Watts is got up to look like Titian, which is certainly a fraud; John Herring is ready to sing Gilbert and Sullivan; Millais is an octaroon with vicious propensities. Lady Butler (Elizabeth Thompson), the sole woman, seems faintly sympathetic – only somebody's accomplice. The

most truly tragic face is Landseer's: a ghostly, petulant ruin of a handsome man, apt indication of real talent ruined.

In many cases the criminal appearance may well not be the fault of early photography. Some of these men were, to borrow Blake's words about a leading English painter of an earlier generation, 'hired to depress art'. They were hired for high sums of money, lived well and were accounted successful.

To be fair, not all the rest of the review was in this vein, but it does provide a provocative basis for considering the photographs themselves. Of those mentioned in the review only the one of Lady Butler is shown here (Plate 128), and in a slightly different pose at the same sitting. At least she did not have, could not have a beard. Victorian whiskers may well have covered many a weak chin or even a trait of character. Imposing as many of them are they do tend to impede the view. They conceal rather than reveal. John Brett (Plates 171 and 172) looks like a bottle-brush with eyes and nose; Walter Crane's imposing imperial disguises, if Graham Robertson is to be believed, a shy man without self-confidence (Plate 184); Holman Hunt and, in his later years, Madox Brown present us with veritable beard-scapes (Plates 199 and 176) and one would venture to suggest that Hunt would have been not at all averse to have been likened to an Old Testament prophet. Ruskin's beard suggests, rather, a tragic dislocation from a former brilliance, a querulous capitulation to increasing mental aberration, only just apparent in the touching photograph of his last meeting with Hunt (Plate 198). If you do adopt the Victorian view, as Levey suggests, namely that your physiognomy betrays your nature, then another feature of this book may, by adding a further dimension, help to interpret those physiognomies.

Many a countenance will, I believe, spring to life and invite a closer look in the light of the descriptions of the sitters by their contemporaries, which I have assembled anthologically with the photographs. These are nearly all taken from published works, mainly biographical and mostly contemporary or nearly so, and they have yielded a rich and entertaining harvest. However strongly they illuminate the sitters, I fully realize that this device can be grossly unfair to the subject. A barbed, unfair but witty comment, *in print*, can leave its mark for eternity. Totally opposed perceptions of the same person by various individuals remind us of the diversity of a single personality. These quotations vary from descriptions of the subjects' appearance to

summaries of character, to an anecdote or observation which gives us a perception of character. Some are long, some are short. Some of the short ones are the most telling of all. Suddenly we have a marvellous perception of Holman Hunt as a young man from G. P. Boyce's diary entry: 'From an omnibus top saw Holman Hunt with nose high in air'; or Aubrey Beardsley seen by Oscar Wilde: '... a face like a hatchet, with grass-green hair'. How vivid is Vernon Lee's perception of John Singer Sargent in just one sentence of a slightly longer description: 'He was very shy, having I suppose a vague sense that there were poets about'; while Whistler demolished the same artist in six words: 'A sepulchre of dullness and propriety.' I must confess to having collected these gems, both large and small, with what might be considered as rather unseemly relish. My disappointment was all the more acute, therefore, when, on finding the following description, I could find no matching photograph either in this country or in his native Germany. I refer to the redoubtable Herr Professor Doktor Gustave Waagen (1794–1868), renowned Director of the Royal Gallery of Pictures, Berlin, and author of the monumental *Treasures of Art in Great Britain* and *Galleries and Cabinets of Art in Great Britain* in four volumes, 1854–7. These volumes were the result of thirteen months of 'unremitting exertions' spent in touring England and Scotland, peering into the murky recesses of hitherto unrecorded collections, conversing with their owners and curators in English which, according to his hostess, Lady Eastlake, was very imperfect, although he was 'full of mimicry and drollery'. Sir Joseph Crowe, journalist, art critic, commercial attaché and brother of the painters Eyre Crowe, RA, visited the learned doctor at his museum. 'I was introduced to Dr Waagen, its director,' he wrote, 'who asked me to tea and regaled me with a sight of a collection of old engravings.' He contined:

I was struck with the aspect of this venerable authority in the domain of art. His face was beyond measure plain. He was near-sighted to such a degree that he could not judge of a picture unless he almost touched it with his nose, and yet he had a wide repute as an art critic, had written many works on painting, and quite recently completed his well-known volumes on the Art Treasures of Great Britain. I had observed that some physical defect must often have prevented Dr Waagen from seeing things as other people saw them. The Catalogue of the Berlin Museum registered inscriptions on exhibited pictures without accuracy, and frequently attributed wrong names to panels and canvases. But

Dr Waagen was, nevertheless, acknowledged as an authority, and he probably deserved that epithet, not because his organs of vision were good, but because he possessed great general erudition, was indefatigable in his application, and widely experienced in travel.

Oh, for a photograph of Dr Waagen!

Amongst the verbal portraits, William Michael Rossetti emerges as far the best describer of people. He made it a point of duty to describe, with scrupulous fairness, almost everyone he mentions in his reminiscences. Ruskin, on the rare occasions when he painted verbal vignettes, left some indelibly deft little portraits; while Julian Hawthorne, son of Nathaniel, was the master of the full-length portrait, the Sargent of the pen, with something of the same scorpionic touch. Solomon Alexander Hart, Professor of Painting at the Royal Academy, left some deliciously quirky and slightly malicious descriptions of his colleagues; and as for the civil servant diarist, Arthur Munby, the thickest armour could not escape the penetrating darts of his perception. Just three of our subjects left verbal self-portraits which could scarcely be bettered by other observers: W. M. Rossetti – again – Edward Lear and Henry Stacy Marks.

As for the subjects of the photographs, various patterns began to emerge. Certain figures make appearances in almost every account by their contemporaries but, for various reasons, some only to be guessed at, are rarely described. These include the painters Augustus Egg, Burne-Jones, Edward Poynter and the dealer Ernest Gambart. Sculptors, apparently a race apart, are rarely described, and only a few of the better-known engravers. There is, too, a long list of artists, many of them household names at the time, who are hardly ever mentioned in contemporary accounts, let alone described. These include Alfred Elmore, Briton Riviere, Francis Danby, H. T. Wells, W. E. Frost, Sir Frank Dicksee (in spite of being President of the Royal Academy), B. W. Leader, William Dyce, James Archer, J. W. Waterhouse, Sir William Boxall, Frederick Goodall and Albert Durer Lucas. Others like Richard Redgrave and Lady Butler are often mentioned, but rarely described. (This is true of women artists generally.) The longest list of all comprises those artists who are most often mentioned and most frequently described and, one may add, photographed: E. M. Ward, Sir John Everett Millais, D. G. Rossetti, Holman Hunt, Whistler, Ruskin, Sir Lawrence Alma-Tadema, Lord Leighton, Frith, Sir Edwin Landseer,

Fred Walker, John Linnell and Daniel Maclise. While there are those who projected an image which became subject to inconsistent interpretation by their contemporaries, others elicited descriptions which scarcely ever varied. These include Charles Keene, J. R. Herbert, John Leech, the Landseer brothers Edwin, Charles and Tom (the engraver), and Marcus Stone. Some artist memorialists left excellent descriptions of their fellows. William Bell Scott was one, Graham Robertson another. Holman Hunt in his massive two-volume memoirs only occasionally describes people. Does this tell us anything? Is it self-absorption? Is it perhaps because he has already described through the medium of paint?

If the observations contained, or implied, in these lists strike one as somewhat trivial, my defence is that in any investigation, whether historical, scientific or criminal, nothing is trivial – indeed, trivia are the parts of which the sum makes up the whole. Clearly some artists were much esteemed by their colleagues, others greatly liked or disliked, others scarcely noticed (like Samuel Palmer, whose reputation in the twentieth century stands high) or ignored, while yet others (like G. F. Watts) were held almost in awe by their contemporaries, suffering in subsequent years a seemingly irrecoverable decline in reputation. But how they stood in relation to each other is surely worth noting.

Known biographical information and single, sharp, passing *aperçus* can help us to interpret these photographs. The discrepancy between the appearance of Walter Crane and his apparently true character has been noted; who could have guessed from his appearance in his later photographs that Millais was regarded by all as an Adonis in his youth? The photograph does not reveal all. The illustrators Du Maurier and Sir John Tenniel were blind in one eye, and it was the cruel fate of the painters Richard Redgrave, W. F. Yeames, Holman Hunt and Thomas Faed to pass the last years of their lives in blindness; in Plates 83 and 200 Redgrave and Holman Hunt are already afflicted. The celebrated painter of nudes, William Frost, became deaf, as did Henry le Jeune and William Mulready; and most of the Landseer family were also deaf – John and his son Tom completely so, while Charles, another son, was partly deaf. Fred Walker bit his fingernails – no wonder he kept his hands out of camera range. The painters Thomas Webster, Henry O'Neil and Ford Madox Brown all suffered from gout, the latter two in the hands – the last-named took pains to conceal one or both hands in gloves or pockets while in front

of a camera. William Mulready, who appears as a distinguished old gentleman, was more probably a dirty old man. George Cruikshank looked like a gigantic grasshopper when he walked. The poet Swinburne, the sculptor Woolner and the painter Poynter all had red hair, and Annie Miller, who looks like a school prefect at Roedean, had dubious morals. The big and burly painter E. J. Gregory had blond hair and was crippled by the most appalling stammer. Solomon J. Solomon lived to become a camouflage expert during the Great War. The staid, sober-looking painter H. T. Wells was remembered by a student of the Royal Academy Schools to have uttered the strange exhortation, 'Fload-id-od, by dear boy – fload-id-od! A bere filb – a gossaber!'

On the other hand, one can play the Victorians at their own game and read the nature revealed in the physiognomy: the doleful irritability of Sir Edward Poynter, the sweet nature of Arthur Hughes, the coarseness of Thomas Creswick, the shyness of J. W. Waterhouse, the poseur in Whistler, the not-so-accidental resemblance to Titian in G. F. Watts, the pride of George Jones in his resemblance to the 1st Duke of Wellington, the near-certainty that Thomas Heatherley would have drawing-pins to spare for his students stuck in the soles of his shoes, the lurking spite of William Bell Scott, the mental derangement of Richard Dadd, the hard-grained indomitability of John Linnell and T. S. Cooper.

It is tempting to speculate as to the rarity or otherwise of the photographs shown in this book. It is a question to which there is no final answer. Photographs were not numbered like limited editions of books or engravings. It can only be stated that these photographs must now be considered rare, and that some of them – perhaps 20 to 30 per cent – may well be unique. In all, something in the region of 70 per cent of these photographs have never before been published, and those that have were in relatively obscure or not generally accessible publications.

It was my original intention to publish only photographs from my collection. But this book is now enriched with photographs from many diverse sources, and where a photograph from another source improved on an existing one in my collection, I have not hesitated in favouring the outsider. Nor have I disdained photographs already reproduced in half-tone, if the original has not been obtained.

The most difficult problem was to sort into appropriate chapters certain artists who, for various reasons,

defy classification. It is the photographs themselves which proved the stumbling block. A photograph is indivisible, with the result that an all-round artist, or one that seems to fit uneasily into any single category, has had to be finally and irrevocably placed in a particular section, for better or for worse. G. F. Watts and J. W. Waterhouse, for instance, were neither Pre-Raphaelite nor neo-classical painters, but clearly not primarily landscape or narrative painters either. Watts, therefore, is allocated to 'Portrait painters', of which he was a notable exponent, and Waterhouse to 'Neo-classical painters', which is far from satisfactory. What of Sir Coutts Lindsay, founder of the Grosvenor Gallery? He probably never regarded himself as a dealer, but effectively he was, so, although he was also an amateur artist, he has been placed among the dealers. And what is one to make of Henry Warren, the obliquity of whose peregrinations and one significant non-peregrination, makes him a prospective candidate for nearly six chapters. He began life as a sculptor under Joseph Nollekens, but progressed to illustrative work, wrote humorous poetry, published a book on water-colour painting, painted landscapes, firstly in oils and secondly in water-colours, and became President of the New Water-Colour Society, until he resigned on account of his blindness. His principal pictures represented Eastern scenes and incidents, although he never went to the East. He has been placed in 'British artists in foreign lands'.

To refer to the epigraph at the head of this introduction, culled from the *Photographic News* of over a century ago, we, the posterity thus addressed, have every reason to be grateful for these treasures handed down. Other, smaller collections of photographs I have formed (of European royalty and composers – one, of Rossini wearing a waistcoat bearing evident signs of a plate of spaghetti having been consumed with relish if not care, being a special favourite) suggest that particular interests can be further indulged while at the same time contributing to our knowledge of history.

— I —
LANDSCAPE & NARRATIVE PAINTERS

ALTHOUGH the more earnest Victorian critics insisted that narrative painting occupied a low position in the hierarchy of subject matter, coming a long way down after 'High Art' (which means history painting, either sacred or secular), poetic and imaginative subjects, and portraiture, it was not rated as low as sea and landscape painting which came at the bottom of the scale, below even animal, fruit and flower painting. Significantly, no narrative painter like Frith, Cope or Horsley was ever elected as President of the Royal Academy. Candidates for this august post came from the ranks of historical and ideal painters, and portraitists.

Nevertheless, the majority of Victorian artists fell into the category of narrative and landscape painters, with the result that this chapter contains more photographs than any other. Arbitrary classification does pose problems, because many artists displayed equal skill in several departments of painting and drawing. Edwin Landseer, for instance, a painter of some virtuosity, could paint straight narrative subjects, animal pictures, portraits and landscapes, and sometimes, even, a combination of all four in one picture. He was, in addition, a fine draughtsman, etcher and sculptor. Luke Fildes began his career as an illustrator, went on to paint narrative pictures of social realism, and spent the latter part of his career as a portraitist. John Gilbert divided his career between painting elaborate historical narrative pictures and doing book and magazine illustrations. Fred Walker is remembered primarily as an illustrator, yet he was an excellent painter of narrative pictures in oils. Charles West Cope is known chiefly as a narrative painter, yet he also painted many portraits, as did Frith, Herkomer, Orchardson and others. Some landscape painters, too – notably John Linnell – best remembered for their works in that department, painted excellent portraits. Specialists in one field often combined talents with another artist in a single picture. Such combinations include animals by Richard Ansdell and figures by John Phillip; landscape by Thomas Creswick and cattle by T. S. Cooper; while Frith sensibly employed J. F. Herring to paint the horses in his *Derby Day*.

The aim of both the landscape and narrative painters was really very simple: to paint pleasing pictures which would find a ready acceptance with a public that had been conditioned to buy and enjoy works by living painters. Landscapists, finding it perhaps too daunting to follow the high standard set by Turner and Constable, or even quite unnecessary when the public was content to settle for less, painted, in the main, attractive undemanding views of a rural scenery which seemed all too likely to vanish for ever under an advancing tide of urban and industrial encroachment. Only Francis Danby and John Martin maintained the idea of romantic sublimity in landscape painting, while John Linnell and his son-in-law Samuel Palmer carried on in an earlier traditional style, sometimes verging on the same romantic scale, well into the second half of the nineteenth century. Minor artists like James Smetham formed a link between the early pastoral school of the Shoreham period and the Pre-Raphaelite landscapists. The popular landscape artists of the early and middle years, such as Thomas Creswick and F. R. Lee, while painting many excellent views, did little to enhance the landscape tradition. In the second half of the century, however, B. W. Leader did add a new dimension to landscape painting. The main contribution of the Victorian landscapists, as exemplified by Leader, was to introduce mood into the painting. If Constable's main concern was to reveal landscape through the interplay of light and shade, the Victorian landscape painter, as one might have expected, sought to appeal to the

emotions, even the senses. In a typical autumnal evening view by Leader or Atkinson Grimshaw one can almost smell the rotting leaves and catch the whiff of a distant bonfire. In a painting by Constable one never does. Much of the best work in landscape painting was done by the water-colourists like Cox, de Wint and Callow, all working with masterly ease in the tradition of Constable and Bonington, while Alfred Hunt and Albert Goodwin painted superbly and comfortably following the example set by Turner. The influence of Pre-Raphaelitism and the teachings of Ruskin had a beneficial if temporary effect on the work of many landscape artists working after 1850 – indeed, these influences were hard for a young artist to escape. Some of the Pre-Raphaelites themselves, like Madox Brown, produced masterpieces of landscape painting.

Most of the better-known painters of narrative or genre belonged to associations formed by themselves. Unlike the Pre-Raphaelites, none of them was united by revolutionary ardour, although the first of such associations, called The Clique, formed in the first year of the Queen's reign, was motivated by a desire to revitalize what its members regarded as the stuffy traditionalism of the Royal Academy. If their individual aims were divergent, they at least reflected the diversity of painting at that date. Members of The Clique were W. P. Frith, who declared that he wanted to paint scenes from ordinary life; Richard Dadd, works of imagination; Augustus Egg, illustrations of celebrated literary works; John Phillip, incidents in the lives of the famous; and H. N. O'Neil, pictures which appealed to the feelings. Frith, in his memoirs, included Alfred Elmore, E. M. Ward and 'some others'. They met together 'constantly, formed a sketching club, criticized and abused each other's works whenever we thought they deserved chastisement'. Most of them were as good as their word, especially Dadd who, from 1844, could do little else within the confines of a lunatic asylum. Frith lived to regret straying from painting scenes of everyday life, for which he became celebrated, to painting scenes from history and literature. He was the only member of this group to hit upon the lucrative policy of stunning the public by exhibiting every few years with great set pieces like *Ramsgate Sands*, *The Derby Day* and *The Railway Station*, all of which caused a sensation. Phillip became best known for his Spanish subjects, and Egg enhanced his reputation by deviating from his original intention and painting several pictures of contemporary life, which have endured best.

Another group was the Cranbrook Colony, members of which lived in the village of that name in Kent. They declared no strongly avowed aims. Thomas Webster, the painter of bucolic genre, was its leader. Other members were J. C. Horsley who, after abandoning a grandiose early career in fresco painting, devoted himself to painting scenes of rural and domestic life, F. D. Hardy, G. B. O'Neill and A. E. Mulready.

A third group was by far the most lively and coherent. It was really a fraternity of artists but wholly devoid of aims and manifestos. This was the St John's Wood Clique, whose members were P. H. Calderon, its leader, J. E. Hodgson, G. D. Leslie, H. Stacy Marks, G. A. Storey, Fred Walker, W. F. Yeames and D. W. Wynfield, its founder, whose pioneering work in photography ensured a legacy of photographs of this group, often taken on their many excursions. All these artists, with the exception of Walker, who seems to have been somewhat loosely affiliated, lived, at least in the early years, in what the Victorians called 'The Grove of the Evangelist'. Some of the few unifying factors of the members were a fondness for picnics, puns and practical jokes, although they did meet on Saturdays at each other's houses to draw a given subject. The results were thoroughly 'grilled', hence the Clique's badge – a miniature grid-iron, with the motto 'Ever on Thee'. In an article written nearly twenty years ago Bevis Hillier amusingly and accurately described the subject matter of their pictures: 'A past peopled with wimpled shrews, jesters with toothache, the Princes in the Tower, Henry VIII's wives and Lady Jane Grey . . . their tender treatment of pre-execution farewells, their genial ghosts, their sly medieval humour.' This was set against a background of 'oriels, lattices, drawbridges, portcullises and gingerbread booths'. For all their archness and rather tiresome humour, at least four of the members were excellent artists – Calderon, Walker, Marks and particularly G. D. Leslie, the son of the earlier genre painter, C. R. Leslie – while one of their number, Yeames, painted one of the most famous of all Victorian pictures, *And when did you last see your father?*, its very title something of a catch-phrase.

To hit upon such a felicitous title as late as 1878 was no mean feat when the supply may have seemed near exhaustion point. Subjects for pictures and their titles were relentlessly sought and jealously guarded by narrative painters, who, it was said, crossed to the other side of the street to avoid meeting a rival artist to whom they might have accidentally divulged the subject of

their next picture. Titles, it was soon discovered, could make or break a picture. Landseer once exhibited at the British Institution a picture of a bloodhound called Grafton and a Scotch terrier called Scratch entitled merely *Dogs*, and no one paid much attention. Renamed *Dignity and Impudence*, and helped by an engraving, the picture leaped into international fame.

How and where did these artists sell their pictures? Until the proliferation of the dealers' galleries began in the 1850s, led by Gambart, artists had to rely almost entirely on the exhibiting institutions. Of these, the Royal Academy, in spite of later challenges by the Grosvenor and New Galleries, remained paramount. It was the constant aim of most artists to attain full membership and thus respectability. It was the painter William Collins, RA, who said, 'If it were not for the Academy, depend upon it, artists would be treated like carpenters.' The annual Summer Exhibition was the great showcase of paintings, and an artist's livelihood could be seriously affected according to whether his pictures were accepted or rejected and, if accepted, were 'hung on the line' or 'skyed'. From 1837 to 1868 the Royal Academy was inadequately housed in part of what is now the National Gallery in Trafalgar Square. Only in 1869 did it move to Burlington House. Very much second-best was the British Institution at 50 Pall Mall. This had been established in 1805 for the annual exhibition of pictures with a distinct bias towards 'High Art'. However, its standards slipped lower and lower until it came to be regarded as a useful outlet for pot-boilers, its last exhibition being held in 1867. For some reason that no one could remember it was guarded by two grenadiers with fixed bayonets.

Landscape painters were particularly welcome at the Society of British Artists in Suffolk Street, London, founded in 1823. Much bad blood was caused by the habit practised by the directors of hanging outsiders' pictures badly, in order, it was believed, to encourage new membership. The Old and New Water-Colour Societies, membership of one or the other being a *sine qua non* to any professional, were essential exhibiting arenas for the water-colourists. The National Institution, another exhibiting venue, led a rather inglorious existence after a brave stand in 1847 until it closed its doors in 1861. The founding of the Grosvenor Gallery in 1877 by Sir Coutts Lindsay was due, although he insisted otherwise, to the growing discontent among certain artists, particularly of the romantic idealist school, with the Royal Academy. Although immensely fashionable for over a decade, growing dissatisfaction with its policies and the separation between its founder and his wife led in turn to its closure in 1890. Two years previously the New Gallery had been inaugurated by two disaffected directors of the Grosvenor Gallery, resulting in much the same kind of exhibition for which the Grosvenor Gallery had been noted. Further dissatisfaction and a spirit of youthful rebelliousness against academic officialdom, the mainspring of most nineteenth-century art movements, led to the founding in 1885 of the New English Art Club. Every single one of its rebellious founders, including Wilson Steer, Stanhope Forbes and W. R. Sickert, eventually became Royal Academicians, only to be dismissed as dismal old fuddy-duddies by the succeeding generation. After all this never-ending evolutionary process one is left pondering not only the French saying 'plus ça change, plus c'est la même chose', but also the careers of some of the more distinguished artists who successfully worked outside the pale of the Royal Academy: Rossetti, Burne-Jones (with one momentary lapse), Frederick Sandys, Holman Hunt and Ford Madox Brown.

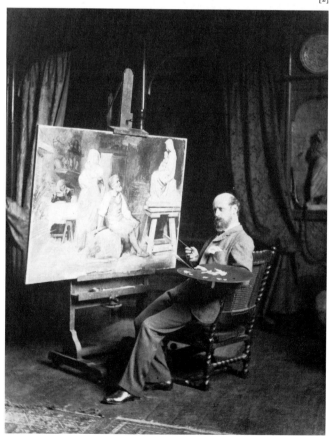

[1]

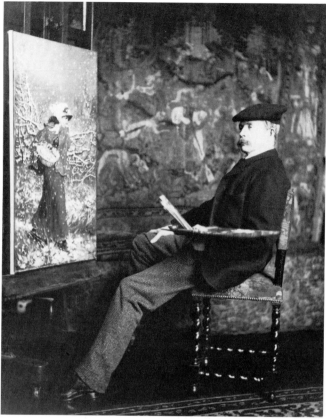

[2]

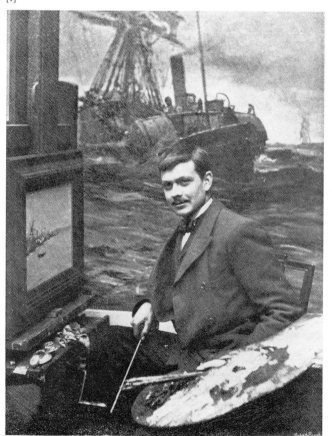

[3]

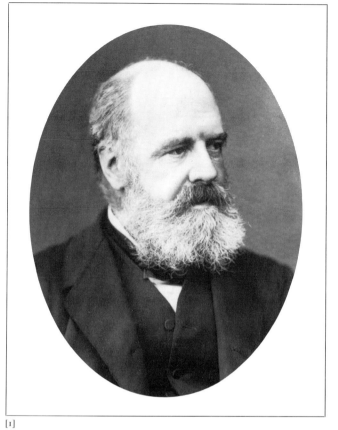

[4]

EDWARD ARMITAGE, RA (1817–96)

Historical painter and pupil of Paul Delaroche in Paris. He was Professor of and lecturer in painting to the Royal Academy in 1875.

1 Woodburytype by Lock and Whitfield, London, oval, 113 × 90 mm.
Author's collection

'Having no children, his wife brought two or three very quaint lonely old ladies to live with them, who were subsequently called "Armitage's mothers"; and it was said that whenever visitors called at his house a tiny little old lady seemed to run out of every corner of the room, seize the guest's hands in both of hers and make the tenderest enquiries respecting the health of the visitors and their whole family

circle. Time eventually removed each of the little old mothers; and with the death of each, Armitage received a substantial addition to his income, so that what was originally a disinterested act of generosity on his part, rebounded greatly to his advantage.'
A. M. W. Stirling, *Victorian Sidelights* (1954), p. 77

GEORGE HENRY BOUGHTON, RA (1833–1905)

Painter and illustrator. Born in England, but taken by his parents to America a year later. He settled in England in 1862.

2 Photograph by Ralph W. Robinson, 195 × 145 mm, published in *Members and*

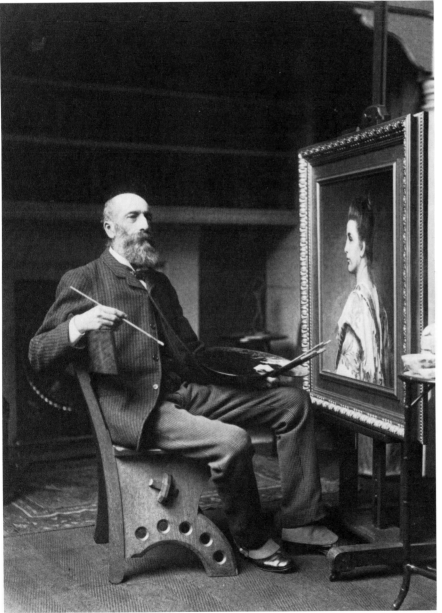

[5]

Associates of the Royal Academy of Arts, 1891, photographed in their Studios (1892). *National Portrait Gallery, London*

'He was of good height, but slouched; inclined to laziness, but never succumbing to it; good natured, dry, quiet, droll; with a wife startlingly incongruous, smart, hard, keen, loquacious, whose assaults he amiably deprecated, and generally got his own way by inertia.'
Julian Hawthorne, *Shapes that Pass* (1928), pp. 253–4

SIR FRANK BRANGWYN, RA (1867–1956)

A versatile artist who excelled in many media, notably etching, lithography and painting, usually of marine interest.

3 Photograph by J. F. Farrar, reproduced from the *Magazine of Art* (1894)

JOHN BAGNOLD BURGESS, RA (1830–97)

Painter of genre subjects, mainly either domestic or Spanish. A friend of Edwin Long (q.v.), who accompanied him on visits to Spain.

4 Photograph by Ralph W. Robinson, 204 × 153 mm, published in *Members and Associates of the Royal Academy of Arts, 1891, photographed in their Studios* (1892). The unfinished picture on the easel is *The Sculptor* (RA, 1890). *National Portrait Gallery, London*

PHILIP HERMOGENES CALDERON, RA (1833–98)

Son of a Spanish priest who left Spain to join the Protestant Church. Painter of genre subjects and leader of the St John's Wood Clique which comprised G. D. Leslie, W. F. Yeames, H. S. Marks, D. W. Wynfield, G. A. Storey and J. E. Hodgson (all q.v.). In 1887 he was elected Keeper of the Royal Academy.

5 Photograph by Ralph W. Robinson, 193 × 148 mm, published in *Members and Associates of the Royal Academy of Arts, 1891, photographed in their Studios* (1892). The chair dates from after 1858–9. *National Portrait Gallery, London*

'He was a man of splendid stature and physique, with the appearance of a Spanish hidalgo. When questioned as to his nationality he was wont to reply: "My father was a Spaniard, my mother was French, therefore I am naturally an Englishman." He was a brilliant man with a somewhat caustic sense of humour and great dramatic ability.'
M. H. Stephen Smith, *Art and Anecdote* (n.d.), p. 137

JOHN MULCASTER CARRICK (*fl.* 1854–78)

Painter of detailed and usually small landscapes.

6 *Carte-de-visite* size, albumen print, photographer unidentified. From the collection of J. Hamilton Trist, a wine merchant from Brighton and patron of artists, in particular Rossetti. *Author's collection*

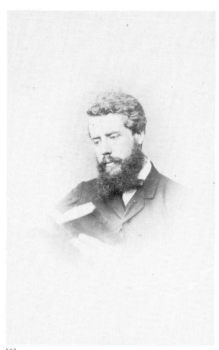

[6]

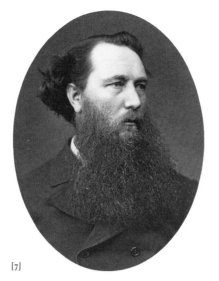

[7]

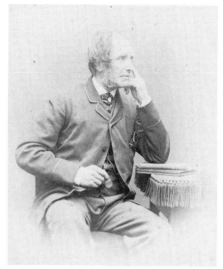

[8]

GEORGE VICAT COLE, RA (1833–93)

Landscape painter who achieved great popularity, on a par with B. W. Leader (q.v.).

7 Woodburytype by Lock and Whitfield, London, oval, 112 × 90 mm.
Author's collection

'A fine head, with handsome, clearly-marked features, was set on a wellknit form of about 5 feet 7 inches in height. His eyes were of a bluish-grey tint, large and clear. The expression of his face was a singular mixture of strength and sweetness. To the latter quality photographs rarely do justice, and none that are preserved of him bring out the lovable nature or bright glances of humour which were so characteristic of the man. In his case, the outward expression represented accurately the inner qualities. . . . With calm eyes he looked you straight in the face, and you could never for a moment doubt his perfect honesty. His was a steadfast nature, with a force of will which at times amounted to obstinacy.'
Robert Chignell, *The Life and Paintings of Vicat Cole, RA* (1898), p. 3

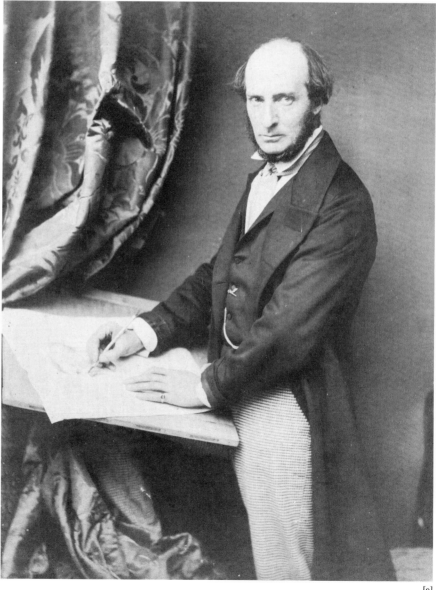

[9]

EDWARD WILLIAM COOKE, RA, FRS, FSA, FLS, FZS (1811–80)

Painter of coastal and river scenes, mostly in oils. He was a man of considerable learning and culture, as is testified by the learned societies of which he was a Fellow, uniquely among Royal Academicians.

8 *Carte-de-visite*, albumen print by John and Charles Watkins, London. In a cordial (undated) letter to the photographers Cooke places an order for several photographs including this print: 'I shall be glad to have a lot of *my knob* with the *hand up to the face*, that is undoubtedly the best. . . .' *Photograph and letter: Author's collection*

CHARLES WEST COPE, RA (1811–90)

Narrative painter who is best remembered for his subjects from contemporary life, especially mothers and children.

9 Albumen print by William Lake Price, 253 × 94 mm, probably taken in 1857 and published by Lloyd Brothers of Gracechurch Street, London, in 1859, as one of a series of twelve portraits of Royal Academicians. Price (*c.* 1810–96) was a water-colourist turned photographer, who was patronized by Prince Albert. *Author's collection*

'Cope, a tall young man of quiet, thoughtful look.'
Lady Eastlake, *Journals and Correspondence* (1895), Vol. 1, p. 266

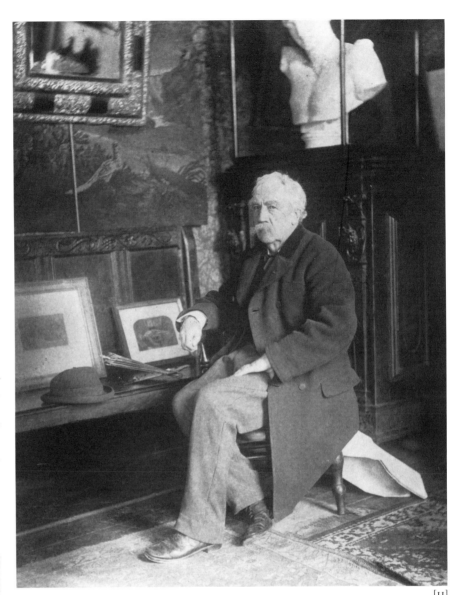

[11]

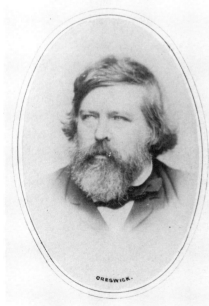

[10]

THOMAS CRESWICK, RA (1811–69)

Prolific painter of landscapes, especially with streams, first in Wales, then Ireland and later in the north of England.

10 Albumen print by an unidentified photographer, oval, 89 × 59 mm, *c.* 1860. *Author's collection*

'He was dirty in his habits, and I do not believe that soap and water often came in contact with his skin . . . [Creswick] was ignorant, vindictive and unsociable.'
T. Sidney Cooper, *My Life* (1890), Vol. 1, p. 93

'Mr Creswick was most festive, rollicking and amusing, albeit he used more "swear words" than would be considered orthodox nowadays and was too fond of both food and drink to be always in the best of health.'
Mrs Panton, *Leaves from a Life* (1908), p. 90

EYRE CROWE, ARA (1824–1910)

A pupil of Delaroche and lifelong friend of Gérôme (q.v.), he specialized mainly in historical subjects. In the 1850s he became secretary to his cousin Thackeray, accompanying him on his visit to America.

11 Photograph by Ralph W. Robinson, 199 × 148 mm, published in *Members and Associates of the Royal Academy of Arts, 1891, photographed in their Studios* (1892). On the bench is a small print or photograph of *Chatterton* by Henry Wallis (Tate Gallery). *National Portrait Gallery, London*

'Beloved by all of us for his extreme good nature, his hearty laugh, and the unaffected simplicity of his manner.'
George Dunlop Leslie, RA, *The Inner Life of the Royal Academy* (1914), p. 194

RICHARD DADD (1817–86)

Painted figure subjects, portraits and landscapes in oils and water-colours. In 1842–3 he became insane, murdered his father, fled to France with the intention of killing the Emperor of Austria, attacked a fellow-passenger near Fontainebleau and was arrested. He spent the remainder of his life at Bethlem Hospital and Broadmoor, where he continued to paint.

12 Daguerrotype by an unidentified photographer, 54 × 42 mm, *c.* 1842. Scratched on the reverse: 'R. C. Dadd Artist'. *Royal Photographic Society*

13 Photograph by Hugh Welch Diamond, *c.* 1850, taken at Bethlem Hospital, where Dadd was confined after the murder of his father. On the easel is *Contradiction – Titania and Oberon* (1854–8). *Bethlem Royal Hospital*

Of Dadd, prior to the onset of insanity in 1843: '"His personal appearance was in his favour," recalled S. C. Hall many years later.

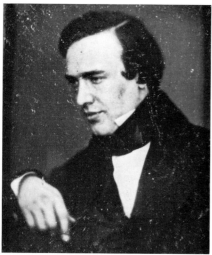

[12]

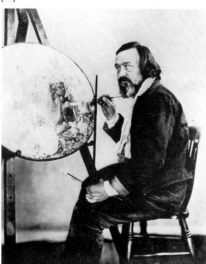

[13]

"He was somewhat tall, with good and expressive features, and gentlemanly demeanour. His career afforded sure promise of a great future." He was about 5 ft 8 inches tall, with dark brown hair, thick dark eyebrows and a sallow complexion. His eyes were blue, variously described as "light" and "fine and dark"; "at one moment almost wild with the varied lights of mirth and fancy, and then so deep and solemn in their thoughtfulness".'
Patricia Allderidge, *The Late Richard Dadd, 1817–1886* (1974), p. 15

Of Dadd, after becoming insane: 'His aspect was in no way impressive or peculiar; he seemed perfectly composed, but with an under-current of sullenness.'
William Michael Rossetti, *Some Reminiscences* (1906), Vol. 1, p. 270

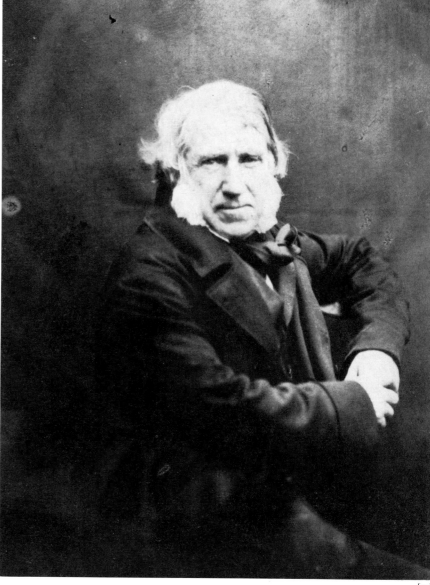

[14]

FRANCIS DANBY, ARA (1793–1861)

Landscape painter, born in Ireland, who lived at Bristol. His subjects are mostly highly poetic and imaginative, and often biblical in subject.

14 Albumen print by an unidentified photographer, 100 × 78 mm. *Author's collection*

'The excellent photographic portrait of Danby, probably taken about 1850, shows a rugged, independent-looking figure, resembling a skipper more than a gentleman-artist; the face is soft in its outline, but strong in its masses, with a stubborn set about the mouth and chin; the eyes, although withdrawn under their brows, are honest and searching.'
Eric Adams, *Francis Danby: Varieties of Poetic Landscape* (1973), pp. 118–19

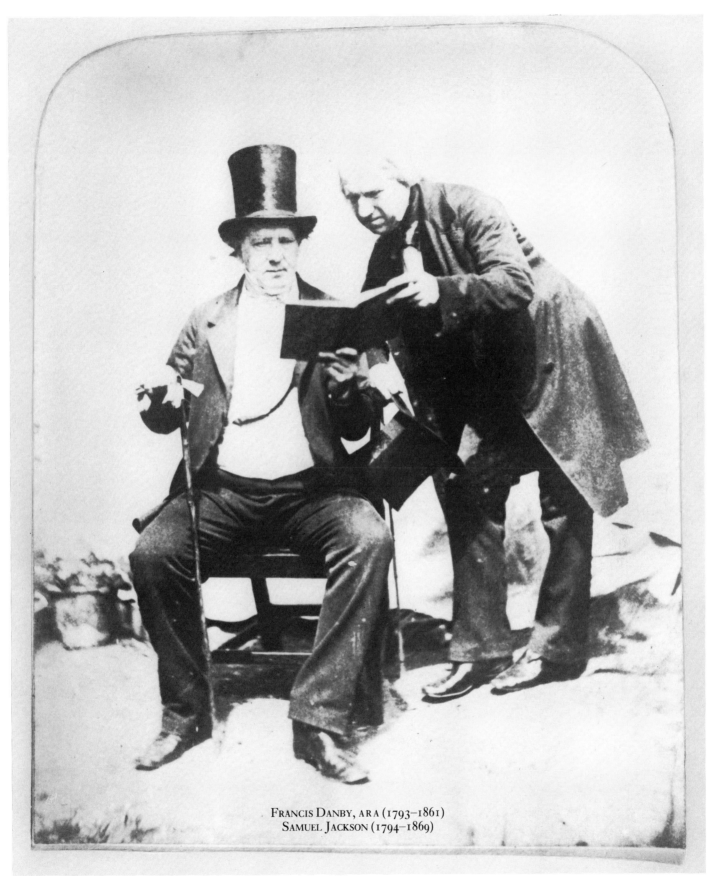

FRANCIS DANBY, ARA (1793–1861)
SAMUEL JACKSON (1794–1869)

FRANCIS DANBY, ARA (1793–1861)
SAMUEL JACKSON (1794–1869)

Samuel Jackson was a painter of landscapes in oils and water-colours.

15 Danby and Jackson, photographed by Samuel Phillip Jackson (son of the latter), *c.* 1855. From the *Ada Villiers album on loan to the City of Bristol Museum and Art Gallery.*

HENRY WILLIAM BANKS DAVIS, RA
(1833–1914)

Landscape and animal painter. His early land-scapes were much inspired by the Pre-Raphaelites. His later work is broader, the canvases large and closer to the manner of Landseer (q.v.) and Rosa Bonheur (q.v.).

16 Photograph by Ralph W. Robinson, 201 × 154 mm, published in *Members and Associates of the Royal Academy of Arts, 1891, photographed in their Studios* (1892). Although he is carrying a picture of a mountain stream, the artist is probably posing in the garden of his studio. *National Portrait Gallery, London*

NELSON DAWSON, RBA (1859–1941)

Marine painter who, in 1895, together with his artist wife, turned to metal and enamel work.

17 Photograph by an unidentified photographer, taken in 1893. *Warren Dailey, Esq.*

LOUIS WILLIAM DESANGES
(b. 1822, *fl.* 1846–87)

Born in London of French origin. His earliest pictures were historical, before he turned to domestic scenes and later to military subjects.

18 *Carte-de-visite*, albumen print by Negretti & Zambra, London. *National Portrait Gallery, London*

WILLIAM CHARLES THOMAS DOBSON,
RA, RWS (1817–98)

Painter of genre, mostly religious and histori-cal, and portraits.

19 *Carte-de-visite*, albumen print by John Watkins, London. The artist wrote the follow-ing letter to the photographer on 4 March, probably 1860, the year in which he was elected ARA, thereby encouraging the atten-tion of the *carte* photographers: 'I am very sorry your letter should have remained so long unanswered but I have been out of town, so please excuse it. I shall be happy to give you a sitting at the first opportunity.' *Photograph and letter: Author's collection*

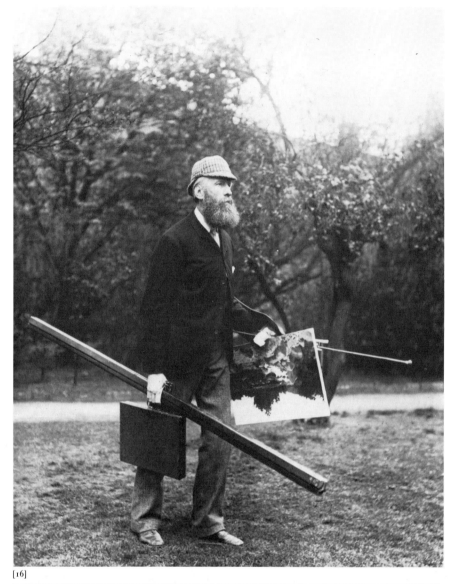

[16]

[17]

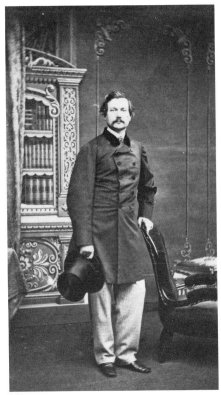

[18]

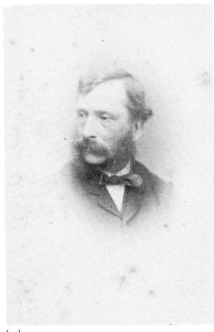

[19]

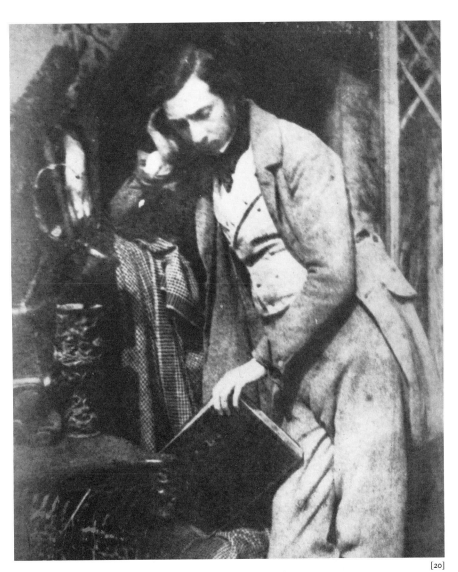

[20]

JAMES DRUMMOND, RSA (1816–77)

Scottish painter of scenes from later Scottish history. Curator of the National Gallery of Scotland from 1868.

20 Calotype by David Octavius Hill (q.v.) and Robert Adamson, 208 × 157 mm. *Sotheby's*

SIR CHARLES LOCK EASTLAKE, PRA (1793–1865)

A much-travelled and learned artist who painted genre subjects and portraits. He was appointed Librarian to the Royal Academy in 1842, President in 1850, Keeper of the National Gallery in 1843 and Director in 1855.

21 *Carte-de-visite*, albumen print by an unidentified photographer. *Royal Academy of Arts*

'He was a thorough gentleman, of calm and refined manners; so over-cautious that he would risk nothing to work out a purpose. . . . His person was much in his favour; he had fine though not expressive features, tinged – tainted, I might say – by what, I think, was constitutional timidity.'
Samuel Carter Hall, *Retrospect of a Long Life from 1815 to 1883* (1883), Vol. 2, pp. 210–11

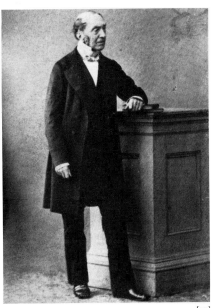

[21]

AUGUSTUS LEOPOLD EGG, RA (1816–63)

Painter of historical and contemporary genre. Egg was one of the few Academicians who sympathized with the Pre-Raphaelites, to whom he gave help and encouragement. His delicate health led to an early death.

22 Albumen print attributed to William Lake Price, 164 × 131 mm, c. 1855. *National Portrait Gallery, London*

'Egg was a valuable man in a way, but without power of any kind whatever.'

William Bell Scott, *Autobiographical Notes* (1892), Vol. 2, p. 28

'He was a mild and gentlemanly man, of pleasant exterior, and full of information.'

Samuel Carter Hall, *A Book of Memories of Great Men and Women of the Age* (1877), p. 492

ALFRED ELMORE, RA (1815–81)

Painter in oils of historical genre. His exhibited work comprises almost entirely illustrations to the history and literature of England, France and Italy, and Shakespeare. He was also an accomplished water-colourist.

23 Calotype by an unidentified photographer, 224 × 162 mm, c. 1845. *Private collection*

24 Albumen print, by an unidentified photographer, 216 × 161 mm, 1852. The unfinished picture on the easel is *A Subject from Pepys's Diary*, subsequently exhibited at the Royal Academy in 1852 (No. 248).
Author's collection

25 'The Four Pilgrims': (clockwise) T. H. Hills (q.v.), Charles Landseer (q.v.), Sir Henry Thompson (q.v.), Elmore. *Carte-de-visite*, albumen print by Clarkington & Co.
Author's collection

'Mr Elmore suffered fearfully from neuralgia and must have endured tortures. I have seen the perspiration pouring down his face while he worked, and he has had to go away and come back again, doubtless to take some anodyne or rest; but the pain grew so awful that it drew up one leg and made him lame, and finally caused his death. It was an acute form of rheumatic neuralgia, caught by sleeping on the roof of one of the Dutch canal-boats, and I do not believe any one ever suffered as he did.'

Mrs Panton, *Leaves from a Life* (1908), p. 107

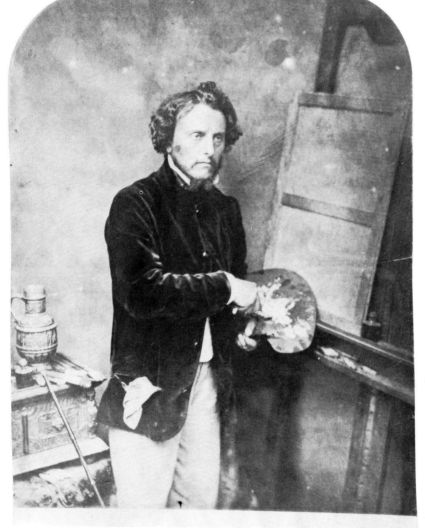

[22]

[23]

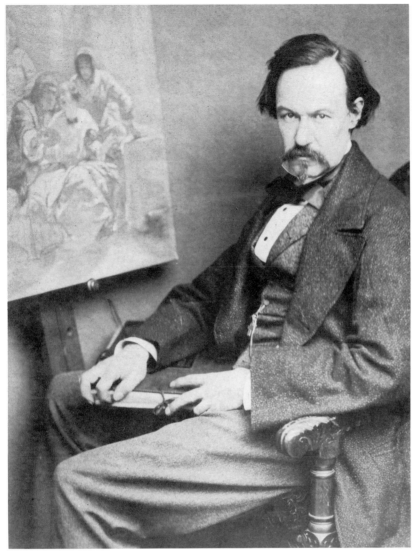

[24]

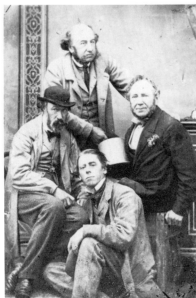

[25]

[26]

THOMAS FAED, RA (1826–1900)

Son of a millwright and brother of John Faed (1819–1902). He painted mainly Scottish peasant life. Due to failing sight he was compelled, in 1892, to cease painting, and he was blind for the last seven years of his life.

26 *Carte-de-visite*, albumen print by an unidentified photographer. *Author's collection*

'A man who in his day was more popular and almost as celebrated as Landseer, was handsome, joyous Tom Faed. Now his fame lingers only in the pages of biographical dictionaries, but once it was on everyone's lips. In his prime, few could rival him in attraction; he seemed universally feted and courted; he was invited everywhere, he dined out nightly and commanded fabulous prices for his pictures.'
A. M. W. Stirling, *Victorian Sidelights* (1954), p. 97

JOSEPH FARQUHARSON, RA (1846–1935)

Scottish landscape painter of winter scenes, often with sheep. His works are poetic if repetitive. For some unfathomable reason he is not included in the *Dictionary of National Biography*.

27 Cabinet portrait, mechanical process on postcard. The picture on the easel is unidentified. *Author's collection*

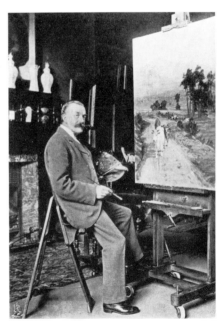

[27]

SIR (SAMUEL) LUKE FILDES, RA
(1843–1927)

Painter of genre and portraits, who began his career as an illustrator of magazines. He also illustrated Dickens's *Edwin Drood*. Two of his genre pictures, *Applicants for Admission to a Casual Ward* and *The Doctor*, are powerful social documents. He was knighted in 1906.

28 Mechanical process on postcard. The large portrait is of Mrs Luke Fildes by the artist (RA, 1887) and is now at the Walker Art Gallery, Liverpool. The portrait on the easel is unidentified. *Author's collection*

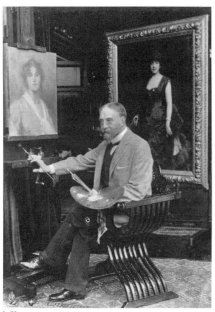

[28]

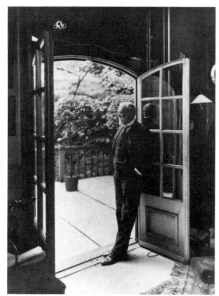

[29]

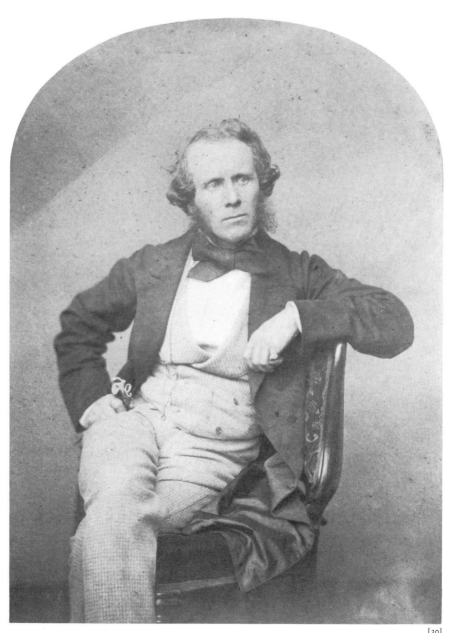

[30]

29 Modern photograph taken from the original glass negative, showing the artist standing at the French windows of his studio at 11 Melbury Road, London. *Author's collection*

'A manly man, and, at the same time, a genial friend and a generous opponent.'
David Croal Thompson, *Luke Fildes, RA* (1895), p. 31

WILLIAM POWELL FRITH, RA
(1819–1909)

One of the most celebrated of the Victorian narrative painters, *Ramsgate Sands*, *The Derby Day* and *The Railway Station* being amongst his most popular works. He was one of the first painters to use photography as an aid in painting, and occasionally to admit to it. He was one of the most photographed of all Victorian artists, and his shrewd commercial instinct would have noted the value of portrait photographs for publicity purposes.

30 Albumen print by Maull & Polyblank, London, 204 × 157 mm, taken in 1857. *Author's collection*

31 *Carte-de-visite*, albumen print by Maull & Polyblank, *c.* 1863. *Author's collection*

32 Photograph by an unidentified photographer, *c.* 1895. *Private collection*

'W. P. Frith, RA, was one of the best-hearted men that ever lived.'
Mrs E. M. Ward's Reminiscences (1911), ed. by Elliott O'Donnell, p. 219

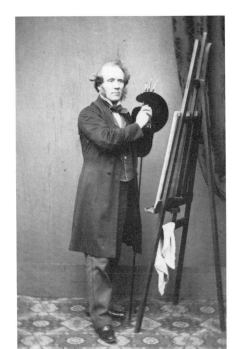

[31]

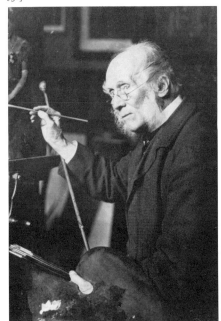

[32]

'With all his popularity he was ever genial and amusing, and kind to those young artists who sought his advice.'
G. A. Storey, *Sketches from Memory* (1899), p. 382

'As everyone knows, the painter of the *Derby Day* was an accomplished realist in his art and the cheeriest companion in his life. I recollect him when he was nigh a nonagenarian, full of *verve* and gaiety and kindliness.'
Walter Sichel, *The Sands of Time* (1923), p. 237

PETER GRAHAM, RA (1836–1921)

Scottish painter of coastal scenery and landscapes.

33 Photograph by Ralph W. Robinson, 202 × 153 mm, published in *Members and Associates of the Royal Academy of Arts, 1891, photographed in their Studios* (1892). *National Portrait Gallery, London*

'With the regularity of the clock, alike in London or St Andrews, Mr Graham is in his studio at 9 a.m.; and, when there, he is one of the most hard-working of artists. A smart walk every day is the only physical exercise Mr Graham cares for and wet or dry he may be seen taking it, attired generally in a light tweed suit, with a soft cap upon his head.'
W. M. Gilbert, *The Life and Work of Peter Graham*, RA (1899), p. 31

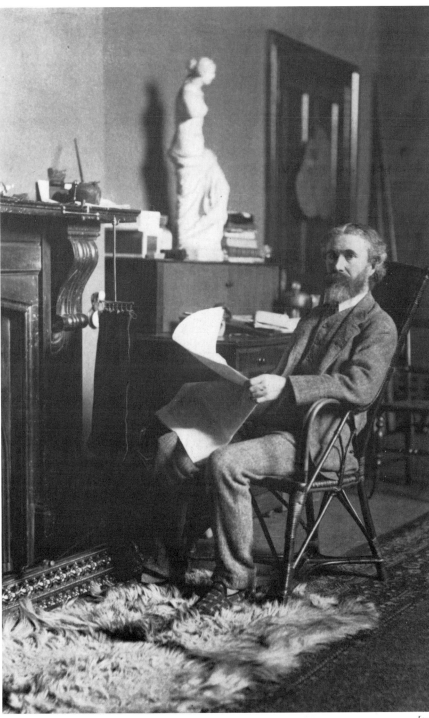

[33]

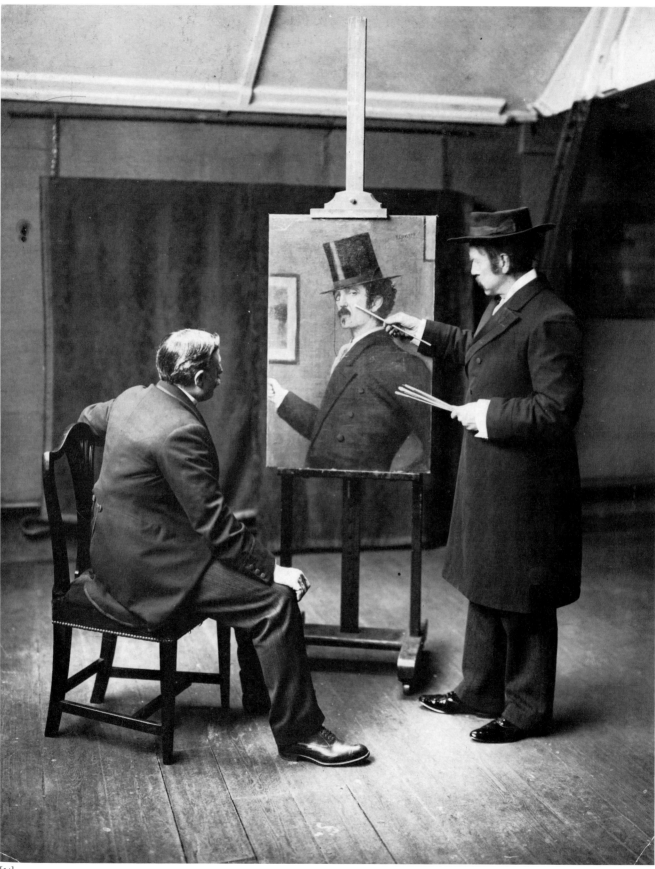

WALTER GREAVES (1846–1930)

Painter of London street and river scenes. Son of a Chelsea boat-builder who used to ferry Turner across the Thames. Walter and his brother Harry did the same for Whistler (q.v.), whom they imitated in dress, manner and style of painting. Except for a few brief periods of recognition Greaves died in obscurity and poverty.

34 Silver bromide by the London Stereoscopic & Photographic Company, 291 × 240 mm. The artist, whose portrait of Whistler is on the easel, is seen with the dealer William S. Marchant. After Whistler's death Greaves went into decline and neglect. Most of his oils passed into the hands of Walter T. Spencer, a second-hand book dealer. Some of them found their way to the picture dealer Walter Dowdeswell, who thought the unsigned canvases might have been by Whistler. W. S. Marchant bought from Spencer for £200 all the oils and twenty-five etchings which Dowdeswell had turned down. He restored the pictures, made contact with Greaves and put on an exhibition with a private view on 4 May 1911 at the Goupil Gallery. The exhibition was an outstanding success and made the artist a temporary celebrity. Greaves dreaded ageing and dyed his whitening hair with blacklead. *Tom Pocock, Esq.*

'The first person we saw in the [Chelsea Arts] Club – though I don't think he ever became a member – was Walter Greaves. He was seated in the Clubroom upstairs, wearing a flat-brimmed top hat and a flowing French tie, waiting possibly for Whistler, for whom we at first mistook him. Our impression was that he was very shabby and dirty-looking for such a celebrity, whom we had never seen up to that time. A lonely figure, he sat in silence, while we in truth were too shy to speak to him, imagining ourselves in the presence of a famous man. The fact was that Walter Greaves imitated Whistler to the extent of dressing as nearly like him as he could.'
A. S. Hartrick *A Painter's Pilgrimage* (1939), p. 132

EDWARD JOHN GREGORY, RA (1850–1909)

Highly talented painter of genre in oils and water-colours. His most famous picture is *Boulter's Lock – Sunday Afternoon* (1898), now in the Lady Lever Art Gallery, Port Sunlight.

35 Bromide print by an unidentified photographer, 250 × 165 mm. *Author's collection*

'This good-natured, and thoughtful, capable, great burly *blond* had the most hopelessly disconcerting and amusing stutter that it was ever given to me to hear. . . . The spirit of compromise was not in Gregory : he made no terms with any word with which he was in difficulty. There was no getting *round* it ; Gregory was *intransigent* ; the word had to be produced – that and no other – though you waited for three mortal minutes, respectfully, considerately, as if you did not notice his travail. It was a relief when the explosion came. I remember Fulleylove, who knew Gregory intimately, telling me that, asked at lunch, on one occasion, what he was going to drink, there began in Gregory the evidences of a struggle, and they waxed greater. Fulleylove knew quite well what Gregory wanted. It was ale. "Won't *Beer* do, Gregory ?" – his friend in desperation suggested. Useless. They had to wait till "Ale" was duly pronounced – and the unconquered Gregory was again at ease.'
Frederick Wedmore, *Memories* (1912), pp. 106–7

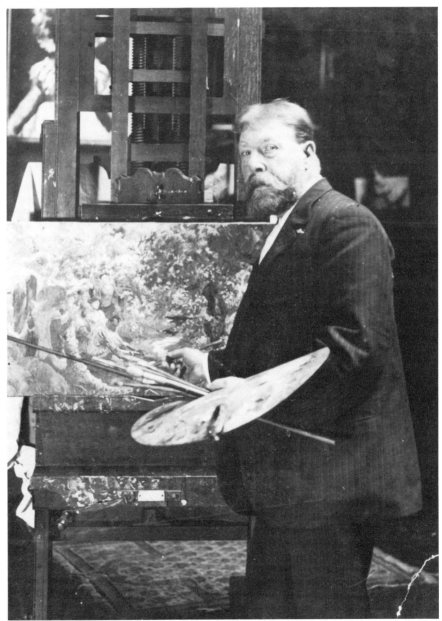

[36]

FREDERICK DANIEL HARDY (1826–1911)

Member of the Cranbrook Colony in Kent, with G. B. O'Neill (q.v.), Webster (q.v.), A. E. Mulready and J. C. Horsley (q.v.). Specialized in humorous genre scenes with children.

36 *Carte-de-visite*, albumen print by L. Caldesi & Co., London. *National Portrait Gallery, London*

SOLOMON ALEXANDER HART, R A (1806–81)

Son of a teacher of Hebrew. Painted historical pictures. From 1854 to 1863 he was Professor of Painting at the Royal Academy, from 1864 Librarian, and for a period Curator of the Painted Hall at Greenwich.

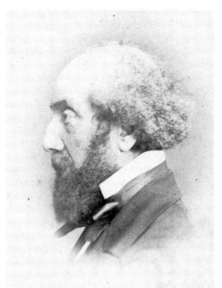

[37]

37 *Carte-de-visite*, albumen print by John and Charles Watkins, London. *Author's collection*

'I have found a place for dear old Solomon Hart here [in his *Autobiographical Notes*], in spite of his continual habit of punning, even scheming to introduce a pun for half an hour, and after all our having politely to laugh at it for the twentieth time.'
William Bell Scott, *Autobiographical Notes* (1892), Vol. 2, p. 276

'Solomon Hart (how ever he came to be an RA no one knew) also occasionally shuffled in on his fat Semitic feet. Pompous to a degree that was highly comical, he would discourse on the biceps muscle, as Charles Landseer had just done on the knee-joint. He was Professor of Painting, and under his gloomy pedantry we had to sit listening to platitudes culled from books on Art, delivered in a mumble as if his mouth had been full of pudding. He was a terrible lecturer – quite terrible – and had it not been for his ridiculous pomposity, his lectures would have been unspeakable tragedies. We caricatured him all the time, applauded the more he mumbled, and thanked God when he closed his manuscript and shuffled out of the lecture room. . . . Good Heavens! They feathered their nests with odd birds indeed!'
Sir William Blake Richmond in *The Richmond Papers* (1926), by A. M. W. Stirling, pp. 162–3

THOMAS J. HEATHERLEY (1824–1914)

Principal of the Heatherley School of Art, 79 Newman Street, London, from 1860 to 1887 without a break.

38 Photograph, probably taken by his son Frank Heatherley, *c.* 1887. The principal is seen in the Antique Room at Heatherley's School, shortly before he retired to the Lake District. *Miss Louise Band*

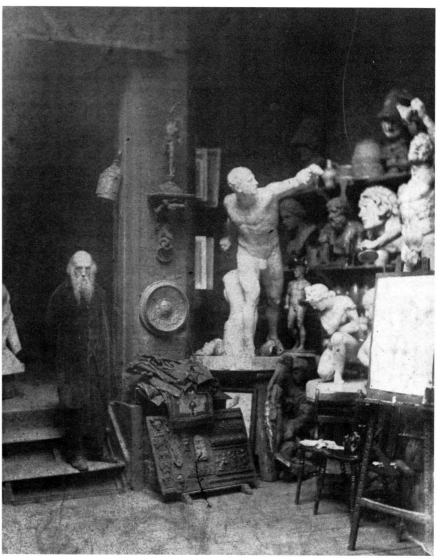

[38]

'T. J. Heatherley, grave of aspect but quietly humorous. . . .'
Henry Stacy Marks, *Pen and Pencil Sketches* (1894), Vol. 1, p. 27

'A rather typical Bohemian-artist-looking man, with long hair and beard, who glided about in a ghostly way through the classrooms in slippers and wearing a sort of long gabardine [*sic*]. He must have worn boots sometimes, however, for it is related that when a student asked him for a drawing-pin he would look at the sole of his boot, where usually he would find one sticking – the tendency towards collecting on boot-soles being a well-known characteristic of drawing-pins in studios. He did not attempt much teaching, at least in the life class, and would only offer a gentle criticism or suggestion in an undertone now and then as he glanced at one's work and passed on.'
Walter Crane, *An Artist's Reminiscences* (1927), p. 81

'He was a solitary man, who relieved his lonely hours by playing the flute for long stretches at a time. His wife was reported to be a terrifying suffragette. From time to time Heatherley would make his appearance amongst the students and call out in stentorian tones: "Would you gentlemen kindly desist from braying."'
Olga Somech Phillips, *Solomon J. Solomon, A Memoir of Peace and War* (n.d.), p. 31

HEATHERLEY'S

This famous art school began its existence in 1845 when a group of rebellious students, headed by J. R. Herbert, was expelled from the Government School of Design in Somerset House because they had reacted so strongly against the academic restrictions imposed upon them. These rebels regrouped themselves at Dickenson's Drawing Gallery at 18 Maddox Street, London. Three years later they absorbed Dickenson's and, after moving to new quarters in Newman Street, became known as Leigh's after its principal James Matthew Leigh, who had been the only pupil of Etty. Leigh had lived abroad for some time, absorbing continental methods of teaching, and he established his school in accordance with these methods. 'Dagger' Leigh, as he was called on account of his trenchant criticism, was a great character and teacher. Leigh's and Sass's (afterwards Carey's) were the only two private art schools at that time in London. Thackeray had been a pupil at Leigh's, and the school was the original of 'Gandishes' in his novel *The Newcomes*, published serially in 1853–5.

On Leigh's death he was succeeded, in 1860, by his pupil and assistant Thomas J.

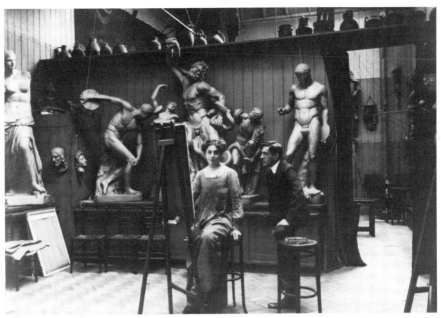

[39]

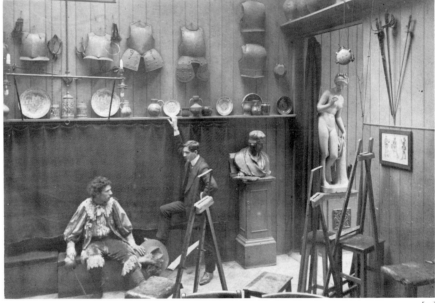

[40]

Heatherley, another notable character. He ran the school, now called Heatherley's, for twenty-seven years without once taking a holiday or a break. He glided about the school with long white hair and flowing beard, robed in a crimson velvet dressing-gown, looking like a medieval alchemist. Heatherley's quickly became the most popular of the private art schools of the nineteenth century and, after various moves, it still exists today. Many of its pupils went on to become famous artists and sculptors, among them Rossetti, Burne-Jones, Henry and Albert Moore, Arthur Hughes, Edward Poynter, H. Stacy Marks, Calderon, Kate Greenaway, Walter Crane,

Joseph Boehm and Alfred Gilbert. For many years it was the only art school in London where men or women artists could study from the nude without any formality.

39 Silver bromide print by Clarke & Hyde, 111 × 151 mm, *c*. 1900. Taken in the Antique School, the Costume Studio visible through the door. Herbert Granville Fell is seen talking to a pupil. *Private collection*

40 Silver bromide print by Clarke & Hyde, 107 × 154 mm, *c*. 1900. A model dressed as a cavalier resting as he talks to Herbert Granville Fell in the Costume Studio. *Author's collection*

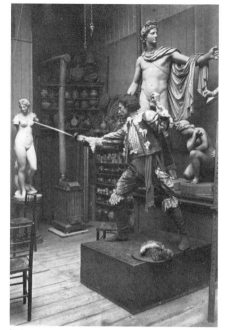

[41]

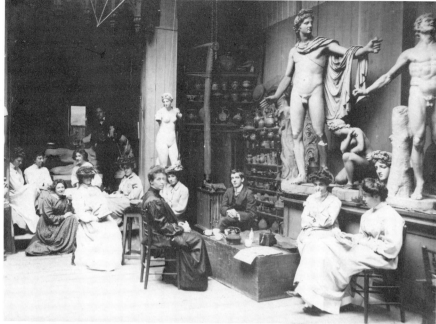

[42]

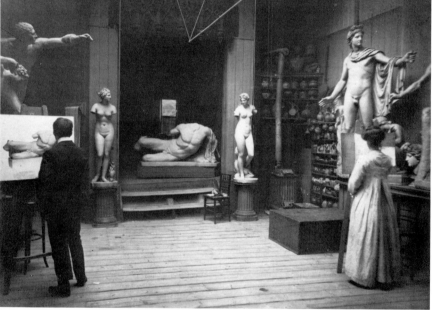

[43]

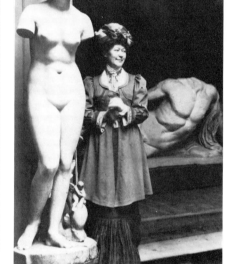

[44]

Heatherley was an enthusiastic collector of antiques of every description, filling the school with a magnificent collection of old armour, pottery and costumes. Much of this was housed in the Antique Room, to which was added a large collection of casts of classical statuary acquired from the sculptor E. H. Bailey, RA, who lived at 17 Newman Street. When Heatherley retired in 1887 he was succeeded by his nephew and pupil John Crompton (1855–1927), who was assisted by his wife Mary and, in the early years, by the artist and journalist Herbert Granville Fell

(1872–1951), who in 1935 became editor of *The Connoisseur*. Fell married May, the second daughter of Sir James Dromgole Linton, PRI (q.v.) The photographs here offer a unique insight into the interior of a celebrated Victorian art school.

41 Silver bromide print by Clarke & Hyde, 154 × 111 mm, *c*. 1900. A model posing as a cavalier in the Antique School. *Private collection*

42 Silver bromide print by Clarke & Hyde, 112 × 152 mm, *c*. 1900. Tea break in the

Antique School, with Herbert Granville Fell seated centre. *Author's collection*

43 Silver bromide print by Clarke & Hyde, 110 × 155 mm, *c*. 1900. Sketching in the Antique School, Herbert Granville Fell (left). The doorway in which Thomas Heatherley posed for his photograph can be clearly seen. A Venus has been added (right) and some of the statuary has been replaced by pots, pans and a stove, probably an improvement installed by Crompton. The illustrator E. H. Shepard was a pupil at Heatherley's; in *Drawn from Life*

(1961) he describes how one passed through the house and descended three steps, which are easily discernible in the photograph, to the Antique School. Beyond this was the Costume Studio. *Author's collection*

44 Silver bromide print by Clarke & Hyde, 155 × 110 mm, *c.* 1900. John Crompton's wife Mary (d. 1949) is by the steps leading into the Antique School. She and her daughter Dorothea (d. 1964) assisted at the school. Mrs Crompton was very popular and earned the nickname 'Little Mummy'. *Private collection*

CHARLES NAPIER HEMY, RA (1841–1917)

Newcastle painter. In his early years he painted coastal scenery much in the Pre-Raphaelite manner. Later, under the influence of Baron Leys of Antwerp, he painted historical scenes. In about 1880 he returned to the sea for his subject matter.

45 Photograph by an unidentified photographer, reproduced in the *Magazine of Art* (1900). The artist is shown in his sea-going studio – the *Vandermeer*.

SIR HUBERT VON HERKOMER, RA (1849–1914)

A man of many talents: he was a painter of social realism, history, landscape and portraits; he composed music, including operas; and he acted and designed stage scenery and even sets for the cinema. He also founded and directed the School of Art at Bushey. He was born in Bavaria, and knighted in 1907.

46 *Carte-de-visite*, albumen print by Elliott & Fry, taken in *c.* 1875. Reversing a trend in the Victorian age, Herkomer wore a beard early in life, until about 1890, after which time he appears clean-shaven. *Author's collection*

47 Bromide print by an unidentified photographer, 140 × 96 mm. *Author's collection*

'He could paint, etch, engrave, work in metals, enamel, play the zither and the piano, compose music, write plays and act them.'
Dictionary of National Biography

'He seemed to have an exceptional faculty for rousing resentments and enmities. . . . "My art is English," he used to say, "my blood is German." His ways and qualities were foreign, especially in his earlier years, for in his later his character gradually matured and became more English in type.'
J. Saxon Mills, *The Life and Letters of Sir Hubert Herkomer* (1923), pp. 311–12

'Herkomer possessed a strong mesmeric power, which he once exercised successfully on his wife, as a substitute for gas, in a difficult extraction of a tooth.'
Gladys Story, *All Sorts of People* (1929), p. 47

[45]

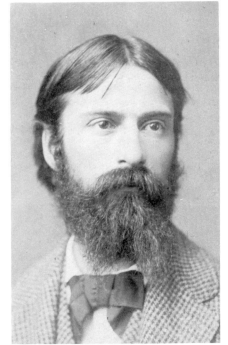

[46]

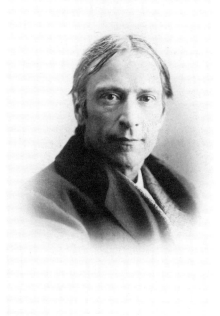

[47]

JOHN EVAN HODGSON, RA (1831–95)

Member of the St John's Wood Clique. Painted landscape, genre, historical and Eastern subjects. Published lectures and other writings. Librarian and Professor of Painting at the Royal Academy from 1882 until his death.

48 Photograph by Ralph W. Robinson, 199 × 153 mm, published in *Members and Associates of the Royal Academy of Arts, 1891, photographed in their Studios* (1892). The picture is unidentified. The screen once adorned the exterior of a barber's shop in Tunis. The figures in the niches are *The Sailor on Duty* and *The Sailor off Duty. National Portrait Gallery, London*

'In personal appearance . . . [Hodgson was] thin, wiry, pale and delicate-looking, with straight, fine brown hair . . . [He] was, of all members of the Clique, both the sweetest tempered and the widest minded. He was quaint and original in all he said or did; he was for ever experimenting in his art, planning and scheming in his brain for new ideas and novel effects. . . . He was much addicted to trying various methods, vehicles, and pigments in the technique of his paintings, though, as is generally the case with those artists who have such proclivities, the results of his experiments were, on the completion of the picture, imperceptible to any but himself. It was for these characteristic habits of his that he obtained amongst his comrades the sobriquet of "The Dodger".'
George Dunlop Leslie, RA, *The Inner Life of the Royal Academy* (1914), pp. 191–3

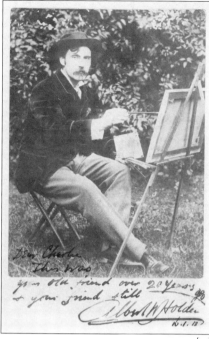

[49]

ALBERT WILLIAM HOLDEN (1848–1932)

Painter of religious and historical subjects and at one time art teacher at King's College.

49 Cabinet portrait, albumen photograph by an unidentified photographer. *Author's collection*

JAMES CLARKE HOOK, RA (1819–1907)

Painter of many rustic anecdotal pictures until 1854, when he turned to painting the coastal scenery for which he became famous.

50 Photograph by Ralph W. Robinson, 204 × 153 mm, published in *Members and Associates of the Royal Academy of Arts, 1891, photographed in their Studios* (1892). *National Portrait Gallery, London*

'It is incumbent on me to say how my host and friend looked at home when clad loosely in the warm, half-grey, half-brown, thick and soft homespun jacket and knickerbockers to match. Stout shoes and stockings completed the costume, with an open collar which revealed a sinewy neck bearing a well-poised head, still covered with locks partly dashed with grey, and clustering compactly about a ruddy visage, which tells of a healthy life, and almost constant exposure to air and sunlight. A little above the middle height, his spare and wiry figure is thin-flanked, broad-shouldered, and muscular. . . .'
F. G. Stephens, *James Clarke Hook, RA* (1888), p. 32

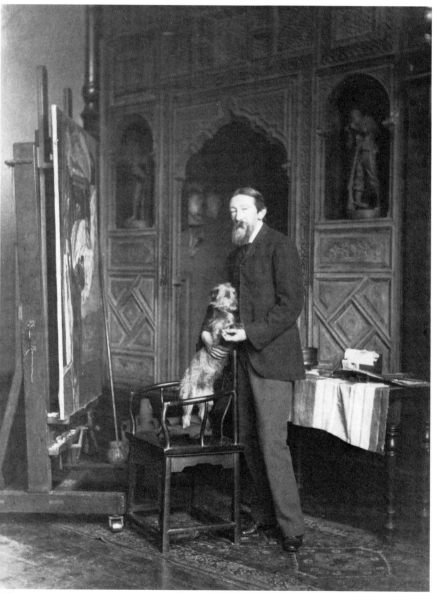

[48]

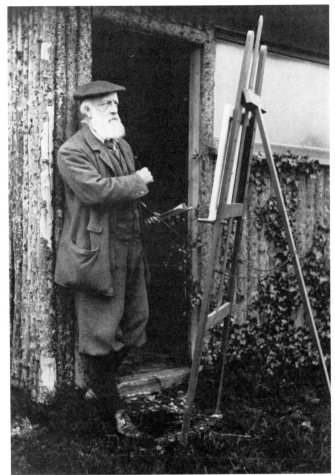

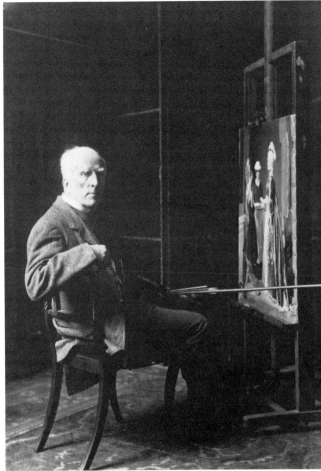

[50]

[52]

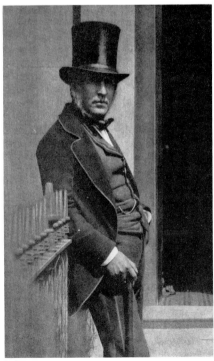

[51]

JOHN CALLCOTT HORSLEY, RA
(1817–1903)

Painter of historical and sometimes contemporary genre. His objection to nude painting earned him the nickname of 'Clothes Horsley' and the jibe from Whistler, 'Horsley soit qui mal y pense'.

51 Photogravure by an unidentified photographer, 140 × 87 mm, reproduced in *Recollections of a Royal Academician* (1903), by J. C. Horsley, facing p. 310. *Author's collection*

52 Photograph by Ralph W. Robinson, 199 × 154 mm, published in *Members and Associates of the Royal Academy of Arts, 1891, photographed in their Studios* (1892). The picture on the easel is *Finishing Touches* (RA, 1890). *National Portrait Gallery, London*

'J. C. Horsley, RA, . . . was one of the best talkers I have ever heard. . . . Up to comparatively recent times [he] was a regular visitor at my studio in Gerald Road, where his clever conversation created quite a panic of delight amongst my pupils.'
Mrs E. M. Ward's Reminiscences (1911), ed. by Elliott O'Donnell, p. 175

CHARLES LANDSEER, RA (1799–1879)

Historical and genre painter, elder brother of Sir Edwin Landseer (q.v.) and son of John Landseer (q.v.). Keeper of the Royal Academy from 1851 to 1873. (See 'The Four Pilgrims', Plate 25)

'[28 July 1860] Charles Landseer is quiet, smug, middle-aged: cross-grained probably, but in talk sensible and rather amusing.'
Munby, Man of Two Worlds; The Life and Diaries of Arthur J. Munby 1828–1910 (1972), ed. by Derek Hudson, p. 68

'Through the exertions of his brother, Sir Edwin, rather than by Charles's own merit, the Keepership was obtained. His knowledge of anatomy was considerable and well adapted to promote its attainment amongst the students. Nevertheless in his practice, C. Landseer has given no proof of his superior acquaintance with the human form.'
Solomon Alexander Hart, RA, *Reminiscences* (1882), p. 46

'[At the Royal Academy Schools] we were taught nothing. . . . The "Keeper", Charles Landseer, brother of Sir Edwin, was supposed

to "come round" once a day and examine the accuracy, or the reverse, of our drawings. He fulfilled the letter of the law. In list slippers, which shuffled over the boards in a most uninspiring fashion, he slipped in and slipped out, having perhaps criticized one portion of our drawing, *usually the knee-joint*, which may, or may not, have been the only portion of the human frame of which he had obtained some knowledge. The patella, he announced invariably, was too high or too low, too much, or not enough, defined. This became a standing joke amongst the students, and they were all ready to enquire with assumed anxiety, "Mr Keeper, I hope the patella is better to-day?" Whereupon a scrutiny would follow, and then the solemn pronouncement, "Still a little too low" or "Still a little too high" in accents of profound wisdom. That was all his teaching! Charles Landseer was a punster, an accomplishment happily not now in fashion.'
Sir William Blake Richmond in *The Richmond Papers* (1926), by A. M. W. Stirling, p. 162

BENJAMIN WILLIAMS LEADER (born Williams), RA (1831–1923)

Landscape painter who adopted the name Leader to distinguish himself from the large family of painters named Williams, to whom he was unrelated. His most famous picture is *February Fill-Dyke* (1881).

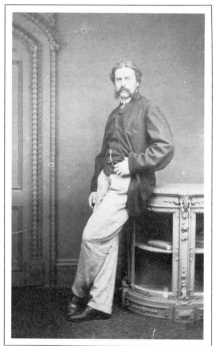

[53]

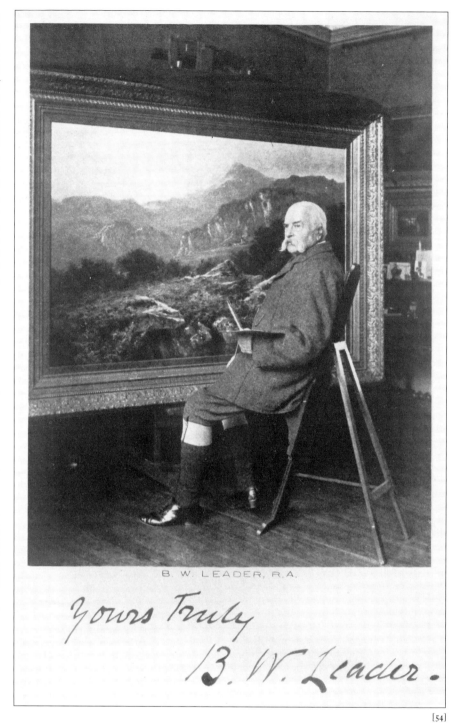

B. W. LEADER, R.A.

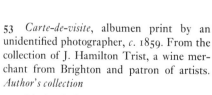

[54]

53 *Carte-de-visite*, albumen print by an unidentified photographer, *c.* 1859. From the collection of J. Hamilton Trist, a wine merchant from Brighton and patron of artists. *Author's collection*

54 Mechanical process on postcard, *c.* 1898. The landscape is entitled *Moel Siabod. Author's collection*

HENRY LE JEUNE, ARA (1819–1904)

Genre painter, noted for his child subjects.

55 *Carte-de-visite*, albumen print by John and Charles Watkins, London. Le Jeune had written to John Watkins on 7 March 1863: 'I will endeavour to be with you between ½ past 9 and 10 Monday morning if not inconvenient to you.' *Photograph and letter: Author's collection*

'Le Jeune always lived in London, and resided for over forty years at Hampstead. In his last years deafness largely withdrew him from society. He was keenly interested in chess problems.'
Dictionary of National Biography

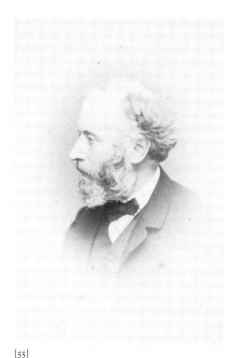

[55]

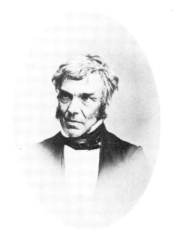

[56]

CHARLES ROBERT LESLIE, RA (1794–1859)

Born in London, the son of American parents. Taken to Philadelphia in 1799 and educated at Pennsylvania University. Taught drawing at West Point Military Academy in 1833. Settled in England. Genre painter, mainly of literary subjects. Father of the marine painter Robert Leslie and G. D. Leslie (q.v.).

56 Albumen print by an unidentified photographer, oval, 58 × 43 mm, *c*. 1855. *Author's collection*

'In person he was of the middle size, slight and gentlemanly, without being graceful. His features were not animated; they seemed rather overburdened with repose; there was neither in the expression of his countenance, nor in his manner generally, any indication of the genius he undoubtedly possessed.'
Samuel Carter Hall, *A Book of Memories of Great Men and Women of the Age* (1877), p. 484

'I was charmed with him from the first, and retain to this day the liveliest recollection of his exquisitely urbane manners, and even of the tones of his voice. . . . On first meeting with him I took him for a clergyman, and told him of it later. He felt rather flattered than otherwise by the mistake, and I have no doubt that his modest nature would at once refer to points on which the average clergyman would probably be his superior. Some artists are lost in admiration of their own works, so that the way to please them is to praise what they have done themselves, but the way to please Leslie was to praise what Constable had done. His admiration for Constable was quite as strong a passion as Mr Ruskin's admiration of Turner, though it did not express itself in such perfervid language.'
P. G. Hamerton, *Autobiography* (1896), pp. 147–8

GEORGE DUNLOP LESLIE, RA (1835–1921)

Son of C. R. Leslie (q.v.). Like his father, he was an extremely able painter of genre subjects. A member of the St John's Wood Clique.

57 Woodburytype by Lock and Whitfield, London, oval, 104 × 91 mm.
Author's collection

'He was a clever talker, and he had the advantage – often precious to a taciturn companion like me – of never allowing the conversation to flag for a single instant. I think I never knew any one of the male sex, with the exception of Francis Palgrave, who could keep up such an abundant stream of talk as George Leslie. This led some of his friends to think that he would never have any practical success in art

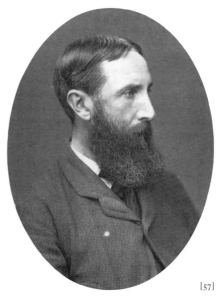

[57]

but he afterwards proved them to be in the wrong. He had a frank, straightforward, boyish nature, with a fund of humour, and a healthy disposition to be easily pleased.'
P. G. Hamerton, *Autobiography* (1896), pp. 155–6

JAMES THOMAS LINNELL (1823–1905)

Landscape painter, son of John (q.v.) and brother of William Linnell (q.v.).

58 *Carte-de-visite*, albumen print by Maull & Polyblank, London, *c*. 1860.
Royal Academy of Arts

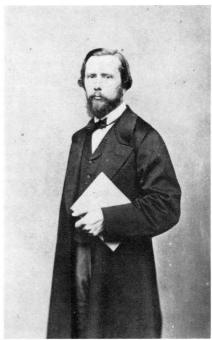

[58]

JOHN LINNELL (1792–1882)

Landscape painter in oils, who also painted portraits and water-colours. Very prolific and industrious. Friend and patron of William Blake and father-in-law of Samuel Palmer (q.v.). Three of his sons were painters; they regarded their profession almost as a family business.

59 *Carte-de-visite*, albumen print by Elliott & Fry, London, taken in 1866. Inscribed on the reverse in Linnell's hand: 'For Miss Frederica Somes'. *Private collection*

'Linnell was a little man, rather Semitic in appearance, brisk in his manner, very alert and evidently endowed with extraordinary energy. He was in his way a patriarch, his sons and his sons' wives living upon his estate, paying rent, of course, for Linnell did not willingly give! He exacted entire obedience from his children long after they had passed into man's estate.'

Sir William Blake Richmond in *The Richmond Papers* (1926), by A. M. W. Stirling, p. 134

'Clever painter as the old man was he was not popular with the Academicians, the reason being that he generally travelled third class, which only the very poor did in those days, and he usually arrived at the Academy with very dirty country boots and a red cotton pocket handkerchief.'

Jeannie Adams-Acton in *Victorian Sidelights* (1954), by A. M. W. Stirling, p. 157

'A strange, dry, withered old man was the painter, quaint in speech, with strange utterance of strange opinions.'

W. J. Linton, *Threescore and Ten Years* (1894), p. 182

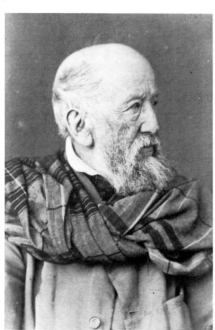

[59]

WILLIAM LINNELL (1826–1906)

Landscape painter, the eldest son of John (q.v.) and brother of James Thomas Linnell (q.v.).

60 *Carte-de-visite*, albumen print by Maull & Polyblank, London, c. 1860. *Author's collection*

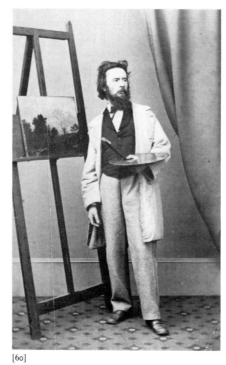

[60]

EDWIN LONG, RA (1829–91)

Painter of oriental and historical genre, and portraits. The sale of his large picture *The Babylonian Marriage Market* at Christie's on 13 May 1882 to Thomas Holloway for 6300 guineas was a record price for a work by a living artist.

61 Photograph by Ralph W. Robinson, 197 × 153 mm, published in *Members and Associates of the Royal Academy of Arts, 1891, photographed in their Studios* (1892). *National Portrait Gallery, London*

'One afternoon, a little before Academy Day, Long asked some of us to his big studio to see his picture for that year – "The Babylonian Slave-Market." Long was a thin, unobtrusive man, with a brown beard, gentle of speech, with an occasional kindling of ideality in his modest eyes. I should have expected him to paint little cabinet pieces, refined, but in the minute Dutch style, correct values, unobtrusive in tone. But he brought us up against an enormous canvas, quite twenty-five feet in length, I should think, and nearly half as high.

The drawing of the figures was unexceptionable, the design of the whole clever, but the archaeology stood out. One thought of studious hours spent over learned folios; an almost painful effort to reproduce the atmosphere of 3,000 years ago. Those draperies! that architecture and furnishings; those dozen or twenty types of exotic girl-beauty! Here was a lingering procession of forms of loveliness in varying postures, passing up broad, low steps to the summit of a sort of marble dais, and down on the other side: on the summit, at the moment, stands the loveliest of them all. On the left sit those whose turn is yet to come; on the right are grouped those ready to depart. It was a situation which seemed to demand the Altogether; but nakedness was less allowable 1879 years after Christ than it may have been 3,000 years before; none of the young women disclosed anything which could have brought the blush of shame to the cheek of modesty: even the one in the centre, just about to be knocked down to the highest bidder, was hardly explicit enough for the occasion. As a work of art, it seemed to me rather long-drawn-out; you had to regard it serially. And the colouring hadn't enough glow and sparkle in it; the air of Mesopotamia burns like fire. I was standing at Fred Leighton's elbow, and I whispered to him: "You should have painted that!" He shook his hyacinthine curls; but it was a safe thing to say, and my technical ignorance wouldn't allow me to venture further.

'And there stood little Long, not actually blushing, but with a blushing expression. "Great oaks from little acorns grow," says the proverb.'

Julian Hawthorne, *Shapes that Pass* (1928), pp. 251–2

JOHN SEYMOUR LUCAS, RA (1849–1923)

Historical genre painter, and occasional portraitist. Nephew of John Lucas (q.v.).

62 Silver bromide on postcard, c. 1895. *Author's collection*

'One's first impression of Lucas was a well-groomed, somewhat horsey-looking little man, clean-shaven, with dark, penetrating eyes, which kindled with lively enthusiasm when discussing things that interested him. But when unsympathetic subjects cropped up in the course of conversation it was easy to see his mind had wandered off to seek amusement elsewhere. . . . In such moments his mind was busy in his studio solving some problem in the picture then on hand; and if suddenly appealed to for his say in the discussion, he would be rapidly brought to the alert with: "What's that? What's that? – I'm sorry, I wasn't paying attention." Then he would

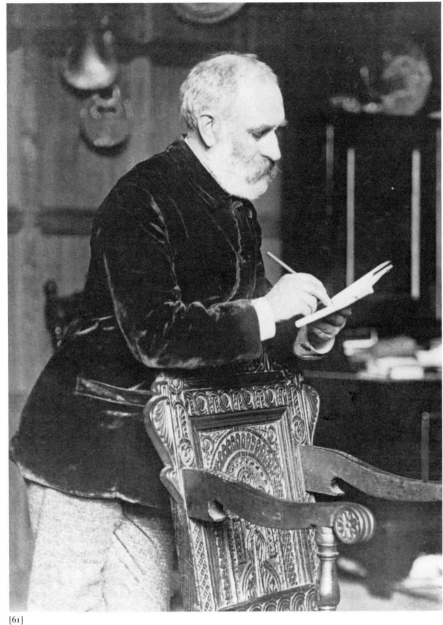

[61]

[62]

[63]

Charles Lucy

follow the thread, and, if his interest had been riveted, so intently that, unknowingly, he silently framed the very words of the speaker with his own lips.'

Allan Fea, *Recollections of Sixty Years* (1927), p. 179

CHARLES LUCY (1814–73)

Pupil of Paul Delaroche. Painter of historical pictures.

63 *Carte-de-visite*, albumen print by Rolfe's, London. If this *carte* was posed in the photographer's own studio, then the props are rather more convincing than usual. *National Portrait Gallery, London*

'He was a short man, of very ordinary appearance and address, more like a country estate-agent than an artist. He was married, friendly and accommodating in disposition. Madox Brown, when I first knew him, was on very intimate terms with Mr and Mrs Lucy; but after a while he seemed to have dropped them entirely, owing (if I am not mistaken) to their taking less kindly than he would have wished to the second Mrs Brown. On any point of this sort, and indeed of some other sorts as well, Brown was tenacious and even peppery, and any one who wanted to stand well in his regard needed to walk circumspectly.'

William Michael Rossetti, *Some Reminiscences* (1906), Vol. 1, p. 139

ROBERT WALKER MACBETH, R A (1848–1910)

Painter of rustic genre, rather in the manner of Fred Walker (q.v.) and G. H. Mason (q.v.). Also an accomplished water-colourist and etcher.

64 Photogravure after J. P. Mayall, 166 × 216 mm, reproduced in *Artists at Home* (1884) by F. G. Stephens, facing p. 88. The painting on the easel is *Far from the Madding Crowd*, exhibited at the Grosvenor Gallery in 1884. *Author's collection*

'It was pleasant to have Macbeth as a neighbour, and he was a fine figure of a man – a broad, thick-set Scotsman, with fine eyes, a flowing moustache, and pointed beard.'
G. P. Jacomb-Hood, *With Brush and Pencil* (1925), p. 121

DANIEL MACLISE, R A (1806–70)

Historical painter and occasional portraitist and illustrator. Painted two frescoes in the Royal Gallery in the House of Lords – *Wellington and Blücher at Waterloo* and *The Death of Nelson* (1857–66) – which are without doubt the greatest historical paintings of the English School. Great friend of Dickens (q.v.), who delivered the funeral oration at his death.

65 *Carte-de-visite*, albumen print by Maull & Polyblank, London, *c*. 1859. *Author's collection*

'Among the innumerable artists I knew during my later school-days, Maclise stands out a massive figure and a strong personality. He reminded me in a certain grand way of a great bull; his chin was especially bovine; it was not exactly a dewlap or a double chin, but a heavy gradation of flesh going down into his collar.'
Leslie Ward, *Forty Years of 'Spy'* (1915), p. 50

At a dinner on 10 December 1868 to mark the centenary of the Royal Academy, Maclise rose to propose the health of the Secretary, J. P. Knight, R A: '"Mac" is a great favourite with all owing to his *bonhomie*, his Irish racy humour, and his fun. . . . I wish I could give an idea of him as he stood there, tall, somewhat more than portly, almost bald and very rosy; blushing as it were all over his head.'
F. M. Redgrave, *Richard Redgrave, C B, R A : A Memoir Compiled from his Diary* (1891), pp. 302–3

'I found him to be a large, phlegmatic, sad-voiced man, to whom success in life seemed to have brought no pleasure, nor had the possession of artistic genius adorned him with any social nimbus.'
William Bell Scott, *Autobiographical Notes* (1892), Vol. 2, p. 84

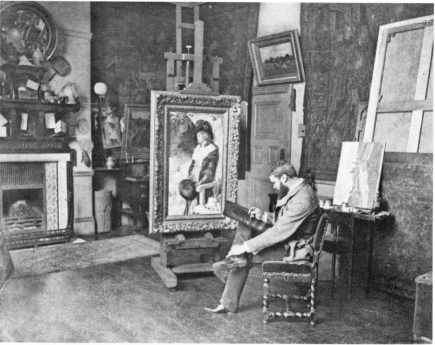

[64]

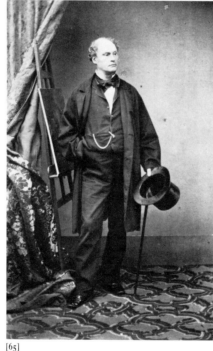

[65]

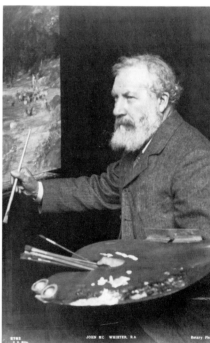

[66]

JOHN MACWHIRTER, R A (1839–1911)

Scottish landscape painter, whose once best-known work *June in the Austrian Tyrol* is in the Tate Gallery.

66 Silver bromide on postcard, *c*. 1898. *Author's collection*

'Rugged and vigorous, a fine, handsome, large-hearted Scotchman, with the gentlest of manners, so strangely at variance with his big, rather rough exterior.'

A. M. Reynolds, *The Life and Work of Frank Holl* (1912), p. 117

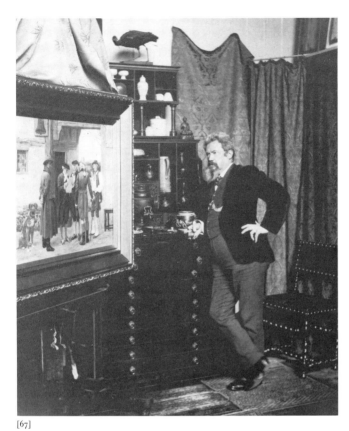

[67]

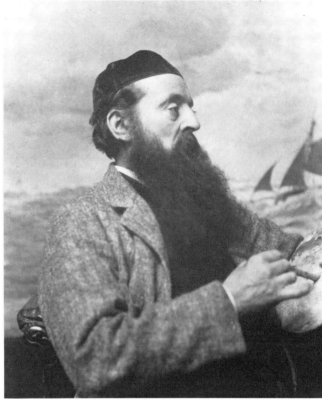

[68]

HENRY STACY MARKS, RA (1829–98)

Humorous anecdotal painter, often of Shake-spearian subjects. Later in life he specialized in natural history subjects, particularly birds. A member of the St John's Wood Clique.

67 Photograph by Ralph W. Robinson, 196 × 153 mm, published in *Members and Associates of the Royal Academy of Arts, 1891, photographed in their Studios* (1892). The picture on the easel is *News in the Village* (RA, 1889). *National Portrait Gallery, London*

'I am told that from my ruddy complexion, and a form described politely as portly, it might be thought I am a seafaring man.'
Henry Stacy Marks, *Pen and Pencil Sketches* (1894), Vol. 2, p. 81

'As an evidence of the truth of my assertion that gravity was the prevailing tone of Marco's character, I would also point out that in no portrait of him that remains – not even in the caricatures and little drawings of him by his friends – can the slightest approach to a smile be traced. . . . Marco was a most delightful companion . . . no one could be more gay and playful on a holiday. . . .'
George Dunlop Leslie, RA, in the *Magazine of Art* (1898)

HENRY MOORE, RA, RWS (1831–95)

Marine painter and brother of Albert (q.v.).

68 Photograph by Ralph W. Robinson, 196 × 153 mm, published in *Members and Associates of the Royal Academy of Arts, 1891, photographed in their Studios* (1892). The picture in the background is *The First Boats Away: Morning After a Gale* (RA, 1887). *National Portrait Gallery, London*

'Mr R. N. [*sic*] Robinson's photograph will give an excellent notion of his personal appearance in later life. . . . It shows us a face, full-bearded, with high intellectual forehead, crowned by thick, dark hair – the latter remained black as coal to the last – keen eyes, and aquiline nose. In stature Moore stood about the middle height, and was big and broad-shouldered in proportion: a massive frame his, with the massiveness in the body rather than in the limbs. His hands and feet, indeed, were small and shapely; his fingers, the long, slender fingers so often found along with the artistic temperament, ended in filbert nails, which he always kept trimmed to a point.'
Frank Maclean, *Henry Moore, RA* (1905), pp. 124–5

'As a man he was not attractive, and he failed to make himself popular; his manners and speech were also against him.'
Bryan, *Dictionary of Painters*

WILLIAM MULREADY, RA (1786–1863)

Irish-born painter of landscape, portraits and genre. He was a highly talented draughtsman and an original colourist.

69 *Carte-de-visite*, albumen print by Cundall, Downes & Co., London, *c*. 1860. Full face and same sitting as Plate 70. *Author's collection*

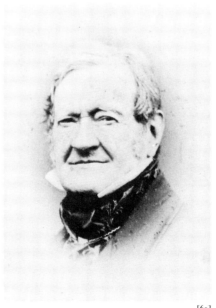

[69]

70 *Carte-de-visite*, albumen print by Cundall, Downes & Co., London, *c.* 1860. Profile and same sitting as Plate 69. *Author's collection*

'In person, Mulready was tall, manly in form, and even in his old age presented an appearance scarcely less vigorous and handsome than it had been in his prime of manhood. His features were finely cut, his eye bright and clear to the last, his mouth severe but by no means sensual; his face had, when circumstances called it forth, a sarcastic expression, and his frown, as I have sometimes seen it, was positively terrible.'
Samuel Carter Hall, *Retrospect of a Long Life from 1815 to 1883* (1883), Vol. 2, p. 218

'I remember Mulready as a small, very neat man, very deaf, and very kind. . . .'
Mrs Panton, *Leaves from a Life* (1908), p. 88

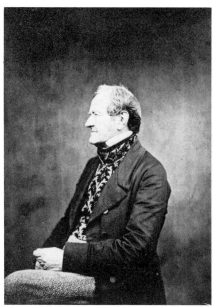

[70]

SIR DAVID MURRAY, RA (1849–1933)

Scottish landscape painter.

71 Mechanical process on postcard. *Author's collection*

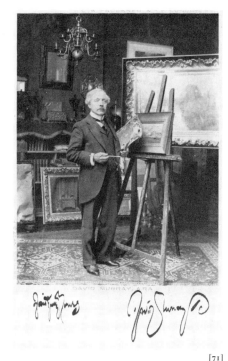

[71]

THE NEWLYN SCHOOL

This was a colony of artists who came to Newlyn, Cornwall, because it offered them the opportunity to paint in congenial surroundings all the year round. The group evolved its distinctive style in the early 1880s, based largely on French influences, most particularly the importance of painting in the open air. Throughout the 1890s the term 'Newlyn School' was regularly and familiarly used.

72 Photograph by Arthur Tanner, 112 × 143 mm, probably taken in the autumn of 1884. Standing, left to right: Frank Bodilly (exhib. 1885–6), Frank Bramley, RA (1857–1915), William Tuelon Blandford Fletcher (1858–1936), William Breakspeare (1855/6–1914), Ralph Todd (1856–1932), Henry Scott Tuke, RA (1858–1929). Seated left to right: William John Wainwright (1855–1931), Edwin Harris (1855–1906), Stanhope Alexander Forbes, RA (1857–1947). *Private collection*

ERSKINE NICOL, ARA (1825–1904)

Painter in oils and water-colours, mainly of Irish peasant life.

73 *Carte-de-visite*, albumen print by Elliott & Fry, London, *c.* 1860. *Author's collection*

'The jovial element in Nicol's canvases had no place in his life. His disposition was grave, shy and reserved.'
Dictionary of National Biography

HENRY NELSON O'NEIL, ARA (1817–80)

Painter of historical genre. He was a member of The Clique and he declared his intention to paint incidents to strike the feelings. A contemporary subject, *Eastward Ho!* (1857), and its sequel, *Home Again* (1858), were his most popular pictures.

74 *Carte-de-visite*, albumen print by Ernest Edwards, published in *Portraits of Men of Eminence* (1866), by A. W. Bennett, Vol. 5. *Author's collection*

'Mr. O'Neil never married . . . [he] lived silently and alone until he died. . . .'
Mrs Panton, *Leaves from a Life* (1908), p. 105

'He was a martyr to gout and somewhat choleric, but withal a most kind-hearted man. A philanthropist, too, in his way – one of the Old Club type – and not without some pretension as a poet. Indeed, much of his leisure time must have been spent in the writing of verses; for he was constantly sending them to Millais or his wife with a quaint little note, such as this: "I send you my latest song – I hope not the worst."'
J. G. Millais, *The Life and Letters of Sir John Everett Millais* (1899), Vol. 1, p. 433

SIR WILLIAM QUILLER ORCHARDSON, RA (1832–1910)

One of the greatest Scottish artists of his generation. Progressing from historical genre, he turned his hand to the psychologically dramatic scenes from upper-class life, the *Mariage de Convenance* series (1884 and 1886) and *The First Cloud* (1887). He painted several fine portraits. Knighted in 1907.

75 Print, 164 × 110 mm, taken from a glass negative by an unidentified photographer when the artist was staying at Achnacloich on the south bank of Loch Etive in 1881 in order to paint the portrait of Alexander Shannon Stevenson (RA, 1882). *Hew S. Stevenson, Esq., great-great-nephew of the sitter*

'Orchardson was not only a most delightful painter, but a man of fascinating personality. He was very much like his own work, delicate, artistic and technically much on the surface. There was nothing deep about Orchardson either in his manner of work or in himself.'
Harry Furniss, *Some Victorian Women* (1923), p. 166

'Sir Quiller Orchardson, the RA, had a most picturesque personality. I don't know what part of Scotland he came from, but, I remember, the first time I heard him speak I thought he was a foreigner.'
Louise Jopling, *Twenty Years of My Life, 1867 to 1887* (1925), p. 217

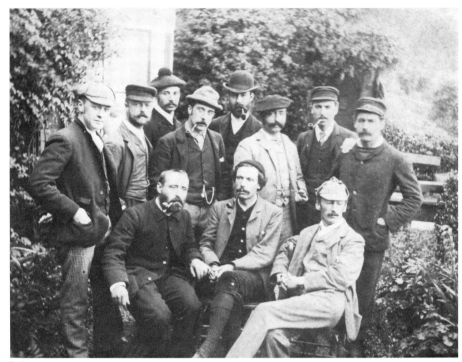

[72]

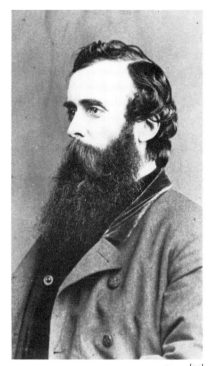

[73]

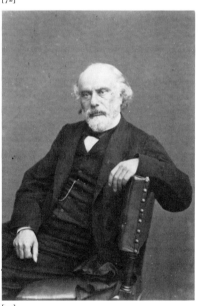

[74]

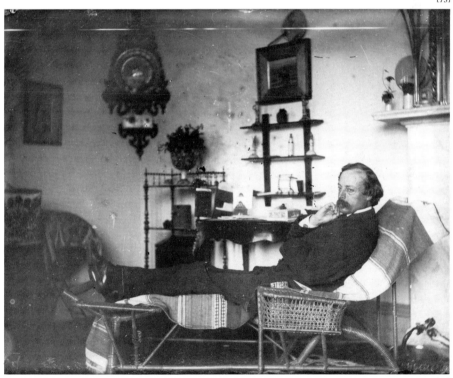

[75]

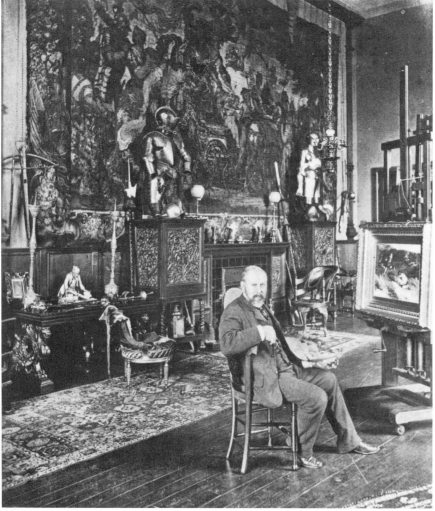

[76]

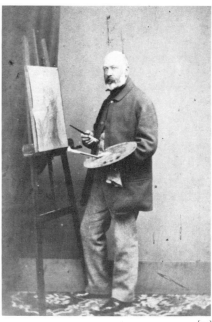

[77]

JOHN PETTIE, RA (1839–93)

Scottish historical painter. His works are vigorous in technique, and dramatic in conception.

76 Photogravure after J. P. Mayall, 213 × 165 mm, reproduced in *Artists at Home* (1884), by F. G. Stephens, facing p. 42. The suits of armour and crossbow are fitting studio accessories for a painter of historical genre. The picture on the easel has not been identified. *Author's collection*

'He died, I believe, under an operation for an abscess on the brain. He had for long suffered from a peculiar hallucination; he used to see an apparition of himself walking before him, dressed in whatever clothes he was then wearing. He would walk along the street watching this figure preceding him, and see it stop at his house and go in before him. Indoors, he would see it go up the stairs and into his studio, then sit down before his easel and look at his picture. He never saw the face, always the back. One can realise how a continuance

of such a disease would work on the nerves and eventually shatter a man.'
A. M. W. Stirling, *Victorian Sidelights* (1954), p. 267

JOHN PHILLIP, RA (1817–67)

Scottish-born painter who settled in London. In 1840 he went to Spain, and thereafter his subjects were mostly Spanish. Worked in oils and occasionally in water-colours. Earned the sobriquet 'Spanish Phillip'.

77 *Carte-de-visite*, albumen print by Maull & Polyblank, London, *c.* 1860. The picture on the easel is probably a studio prop; in any case, being almost certainly a drawing, the brushes and palette would be inappropriate. *Royal Academy of Arts*

'We liked John Phillip: "Phillip of Spain" as he was always called: but at the same time I, for one, was afraid of him. He could never tolerate the least amount of movement, and I can see now how he turned round on his wife

with a snap and a snarl which nearly frightened her into fits because she would sit just behind him while he was painting, drawing her needle in and out of some very stiff material which creaked in the most horrible manner possible. I hated the noise, too, but I would rather have put up with it than been as alarmed as I was at his sudden rage. Poor lady! she was even then on the borderland, and she soon vanished out of our lives, though I think she is still alive, being "taken care of" in some remote district of Scotland.'
Mrs Panton, *Leaves from a Life* (1908), p. 105

FREDERICK RICHARD PICKERSGILL, RA (1820–1900)

Nephew of H. W. Pickersgill (q.v.) and son-in-law of the photographer Roger Fenton. Painter of literary genre, and illustrator of

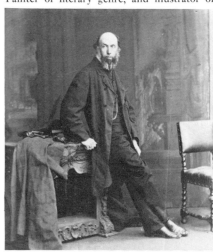

[78]

Shakespeare, Spenser and others; also a photographer. He was Keeper and Trustee of the Royal Academy from 1873 to 1887.

78 Albumen print by Ernest Edwards, 88 × 57 mm, published in *Portraits of Men of Eminence* (1866), by A. W. Bennett, Vol. 4. *Author's collection*

'It was fortunate, I think, for the Academy to have had a Keeper of so much tact and ability just at the time when the female element began to take root in the Schools, for the ladies made under his amiable and careful management a very propitious start. Pickersgill almost entirely gave up painting after he became Keeper, devoting nearly all his time and energy to the welfare of the Schools. He retired from the Keepership in 1887, living for the last thirteen years of his life at Yarmouth in the Isle of Wight.'
George Dunlop Leslie, R A, *The Inner Life of the Royal Academy* (1914), p. 51

PAUL FALCONER POOLE, R A (1807–79)

Bristol-born painter of imaginative historical genre and, by turns, simple pastoral subjects. A scandal involving Francis Danby (q.v.) played a part in his career: it seems that Danby's wife lived with Poole. Danby eloped to Geneva with his current mistress, his own seven children and three of hers. He remained abroad for eight years, which contributed to his failure to be elected as a full Academician. On his death in 1861, Poole married his widow, and secured the R A which had been denied to Danby.

79 Daguerrotype, oval, 55 × 44 mm. Scratched on the glass: 'Mr. Poole R.A.'; scratched on the reverse: 'Mr. Poole R.A., the artist 1842'. There appears to be a blemish, seeming to be not unlike a birth-mark, on his left cheek. This mark does not appear, however, on later photographs by Maull & Polyblank and John and Charles Watkins, for the reason that the daguerrotype presented a mirror image of the sitter. In a later *carte-de-visite* by John Watkins, not published here, the mark which is

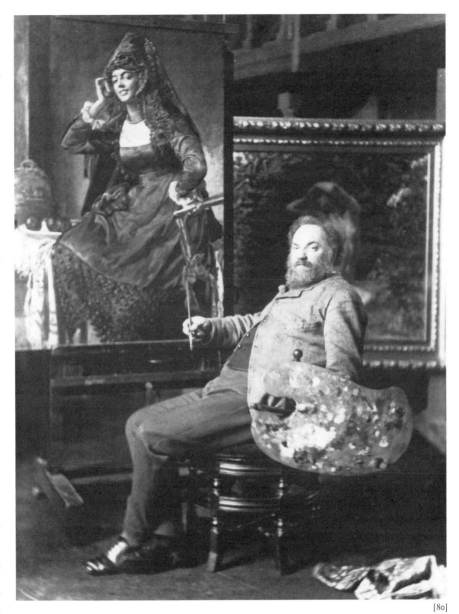

[80]

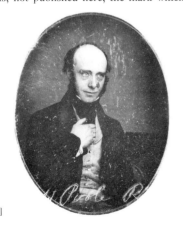

[79]

clearly on his right cheek has been crudely covered with retouching ink. There is a letter to John Watkins, dated 7 July 1856, making an appointment for 10.30 on the next morning. *Daguerrotype: Royal Photographic Society; letter: Author's collection*

'Besides those . . . Poole . . . was possessed of a strong individuality, a man of peculiar powers of mind and vivid perceptions, entering into everything with as much interest as into his own affairs. He was a man with a strain of the savage in his blood, however, and a good hater, with other qualities allied to genius.'
William Bell Scott, *Autobiographical Notes* (1892), p. 111

'All the places where he went to seemed to begin with H. He told us how he had lived in 'Ampstead, 'Ornsey, 'Endon, 'Ammer-smith, 'Ackney, and 'Anwell.

'He also said whatever entered his head. One day when he was dining with us my mother remarked, "I wonder what has become of that old hen who used to lay so many eggs for us?" "Madam," he answered, "the 'en is dead. Do you suppose a 'en has nothing else to do but to lay eggs for your voracious maw?"'
Estella Canziani, *Round About Three Palace Green* (1939), p. 317

VALENTINE CAMERON PRINSEP, R A (1838–1904) *Plate 80*

Painter of portraits and genre. A versatile, socially gifted man, whose paintings are curiously uneven for an artist who had a high contemporary reputation. He was Professor of

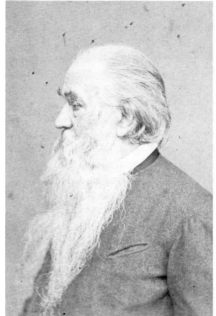

[81]

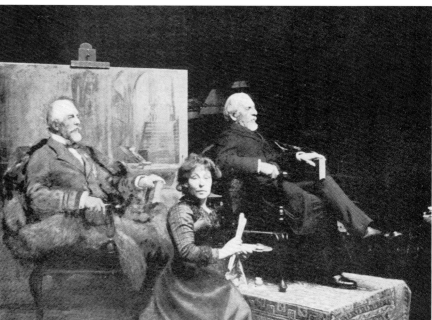

[82]

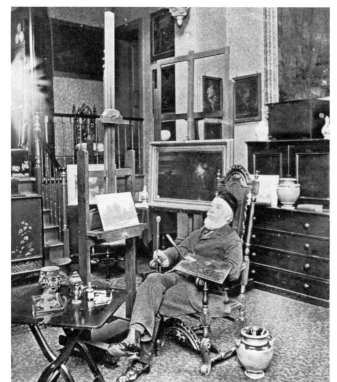

[83]

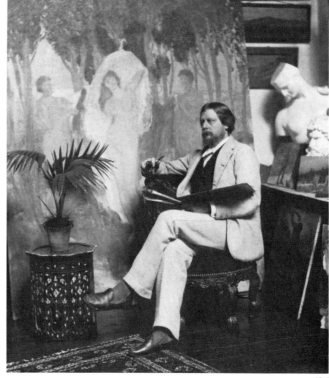

[84]

Painting at the Royal Academy from 1901. He also wrote two novels and two plays. He was married to Florence, daughter of the patron F. R. Leyland (q.v.).

80 Photograph by Ralph W. Robinson, 201 × 150 mm, published in *Members and Associates of the Royal Academy of Arts, 1891, photographed in their Studios* (1892). On the easel is a variant of *Carmen* (RA, 1889); to the right, *The First Awakening of Eve* (RA, 1889). *National Portrait Gallery, London*

'He is 23; 6 foot 2; hasn't an ounce of fat on his body, being as hard as I am, and yet weighs the fabulous weight of 16 stone 6; 14 inches around the arm like Heenan [the Benicia Boy, a pugilist]. All that is manly, honest, clever and jolly, a painter, Watts' pupil; fair woolly hair, and an eastern face of a splendid ugliness which women love better than Ciabati's beauty. In short Thackeray's Philip with 20 times the brain, and none of the beastly egotism and bullying. N'est-il pas soigné, ce gaillard.'
George Du Maurier in *The Young George Du Maurier* (1951), ed. by Daphne Du Maurier, p. 112

JAMES BAKER PYNE, RBA (1800–70)

Landscape painter in oils and water-colours, and an admirer of Turner, whose influence may be seen in his paintings.

81 *Carte-de-visite*, albumen print by John Watkins, London, *c.* 1860. *Author's collection*

'Pyne was one of the best talkers on art I ever knew, and a critic of very great authority.'
W. J. Stillman, *Autobiography of a Journalist* (1901), Vol. 1, p. 103

HENRIETTA RAE (Mrs Ernest Normand) (1859–1928)

Painter of literary and classical genre and portraits. In 1884 she married Ernest Normand who painted similar subjects.

82 Photograph reproduced in *Henrietta Rae* (1905), by Arthur Fish, facing p. 102.

RICHARD REDGRAVE, CB, RA (1804–88)

Genre and landscape painter of great charm. Official duties restricted his painting activities, for he was the first Keeper of Paintings at the South Kensington Museums, Surveyor of the Queen's pictures, and co-author with his brother Samuel of *A Century of Painting* (1866). For the last six years of his life he was almost completely blind.

83 Photogravure after J. P. Mayall, 215 × 165 mm, reproduced in *Artists at Home* (1884), by F. G. Stephens, facing p. 38. The quotation below lends a certain poignancy to Mayall's photograph. *Author's collection*

'In the latter years of his life . . . my father became more and more blind, and at the last was almost entirely sightless, though he could distinguish the figures of his family, when they came against the light, so as to know one from the other, till within a year of his death. After the operation, he rejoiced in his liberty, and was able to get about again, and his friends were always most kind in coming to see him.'
F. M. Redgrave, *Richard Redgrave, CB, RA: A Memoir Compiled from his Diary* (1891), p. 351

SIR WILLIAM BLAKE RICHMOND, RA (1842–1921)

Son of George Richmond (q.v.). Painter, sculptor, medallist and mural decorator. Although he painted numerous imaginative subjects, he was sustained by his portrait practice. He designed mosaic decorations for St Paul's Cathedral.

84 Photograph by Ralph W. Robinson, 200 × 153 mm, published in *Members and Associates of the Royal Academy of Arts, 1891,*

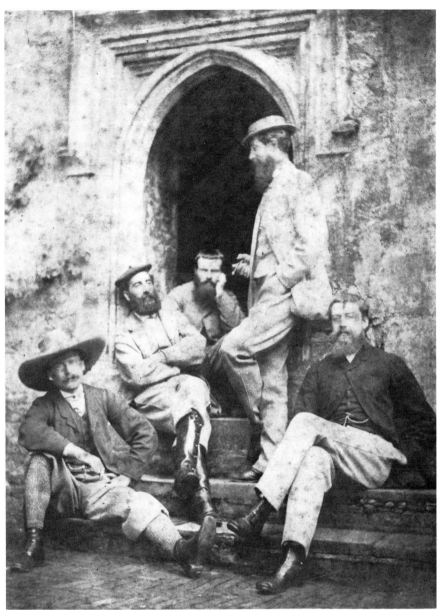

[85]

photographed in their Studios (1892). The large unfinished painting is *The Bath of Venus*, which was not eventually exhibited. *National Portrait Gallery, London*

'One trait in Richmond's character which I liked, but which was not popular, apparently, with everyone, was that he took a boyish delight, half unconscious, in playing a part – sometimes the devout ascetic, spending weeks in a mountain monastery with holy friars and religious exercises, or as the devil-may-care swashbuckler and braggart, at other times the humble and devoted student of Art, or the purely pagan Platonist, rejoicing in all the pleasures of the world.'
G. P. Jacomb-Hood, *With Brush and Pencil* (1925), pp. 54–5

'Richmond very handsome with a pellucid skin like porcelain.'
Manuscript annotation by a next-door-neighbour, Sir William Ball, MP, on the fly-leaf of his copy of *The Richmond Papers* (1926), by A. M. W. Stirling. *Author's collection*

ST JOHN'S WOOD CLIQUE

85 Group photograph taken at Hever Castle by David Wilkie Wynfield (q.v.). From left to right: G. A. Storey (q.v.), P. H. Calderon (q.v.), W. F. Yeames (q.v.), G. D. Leslie (q.v.) and D. W. Wynfield. *Mrs Tower*

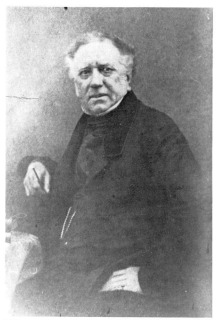

[86]

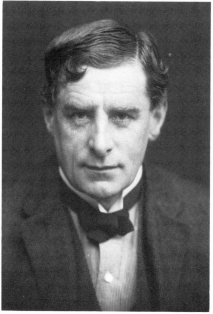

[87]

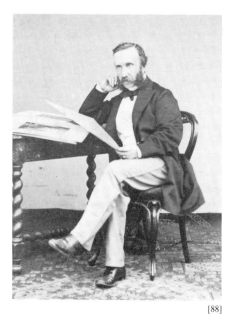

[88]

WILLIAM SHAYER, RBA (1787–1879)

Prolific landscape and animal painter of pastoral scenes with rustic figures and shore scenes with fisherfolk. His son, William J. Shayer, continued painting in the same vein.

86 Photograph by an unidentified photographer, *c.* 1850. *M. J. Cutten, Esq.*

WALTER RICHARD SICKERT, RA (1860–1942)

Born in Munich, the son of a Danish painter and illustrator. Painted mainly impressionistic street scenes, interiors and portraits. A very able lecturer and writer on art.

87 Photograph taken from a half-plate glass negative, *c.* 1910. *National Portrait Gallery, London*

'He had a small room where he worked, at the end – the shabby end – of the Chelsea Embankment west of Beaufort Street. Needless to say, this room was in one of the few ugly houses to be found along Cheyne Walk. His taste for the dingy lodging-house atmosphere was as new to me as was Ricketts' and Shannon's Florentine aura. I had known many poor studios in Paris, but Walter Sickert's genius for discovering the dreariest house and most forbidding rooms in which to work was a source of wonder and amusement to me. He himself was so fastidious in his person, in his manners, in the choice of his clothes; was he affecting a kind of dandyism *à rebours*? For Sickert was a finished man of the world. He was a famous wit; he spoke perfect French and German, very good Italian, and was deeply

read in the literature of each. He knew his classical authors, and could himself use a pen in a masterly manner. As a talker he could hold his own with either Whistler or Wilde. Further, he seemed to be on easy and familiar terms with the chief social, intellectual and political figures of the time; yet he preferred the exhausted air of the music-hall, the sanded floor of the public house, and the ways and talk of cockney girls who sat to him, to the comfort of the clubs, or the sparkling conversation (or so I imagined it) of the drawing-rooms of Mayfair and Park Lane. An aristocrat by nature, he had cultivated a strange taste for life below stairs. High lights below Steers, I used to say, in reference to this predilection, and to his habit of painting in low tones. Every man to his taste, I thought; but had I a tittle of your charm, your finished manners, your wit and good looks, I should not be painting in a dusty room in the squalidest corner of Chelsea. Nor, for that matter, should I be laboriously matching the dingy tones of women lying on unwashed sheets, upon cast-iron bedsteads.'
Sir William Rothenstein, *Men and Memories* (1931), Vol. 1, pp. 167–8

ABRAHAM SOLOMON, ARA (1824–62)

Elder brother of the painters Rebecca and Simeon Solomon (q.v.). Painter of historical and contemporary genre. His two most famous paintings were *1st Class – The Meeting* and *3rd Class – The Parting*. He died in Biarritz on the day that the Royal Academy elected him ARA.

88 *Carte-de-visite*, albumen print by an unidentified photographer, *c.* 1860. *Author's collection*

SOLOMON JOSEPH SOLOMON, RA (1860–1927)

Painter of genre and portraits. No relation to the family of painters of the same name. He lived to become a camouflage artist in the First World War.

89 Cabinet portrait, albumen print by Elliott & Fry, London, *c.* 1880. *Author's collection*

'Joseph Solomon had a great deal of the squire in his presence, being a powerfully built and robust man with a ruddy countenance.'
Olga Somech Phillips, *Solomon J. Solomon, A Memoir of Peace and War* (n.d.), p. 19

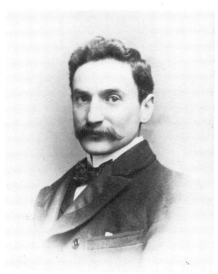

[89]

WILLIAM CLARKSON STANFIELD, RA
(1793–1867)

Marine painter in oils and water-colours. Worked at first as a scenery painter in London and Edinburgh, where he met his lifelong friend David Roberts (q.v.). Some of his sea-pieces rivalled those of Turner.

90 *Carte-de-visite*, albumen print by Maull & Polyblank, London, *c.* 1860, reduced from a larger photograph. *Author's collection*

'When I knew him first, he was a tall and handsome young man, of agreeable, yet not of polished, manners, liking and seeking society of an intellectual character. When I saw him last – it was at the private view of the Royal Academy in 1866 – he was dropping gradually into the grave; and as he leaned on my arm down the staircase in Trafalgar Square, there was certainty that his toil on earth was nearly done. . . .'
Samuel Carter Hall, *A Book of Memories of Great Men and Women of the Age* (1877), p. 477

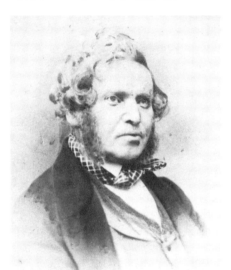

[90]

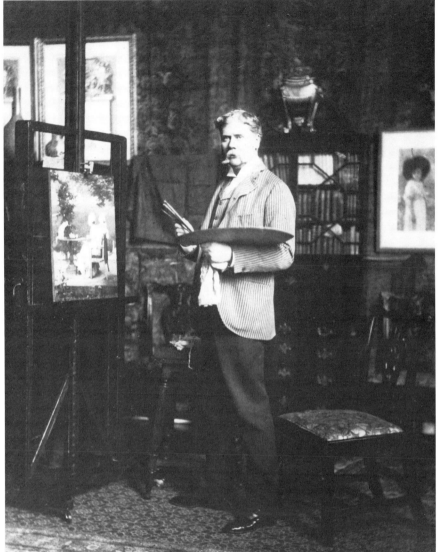

[92]

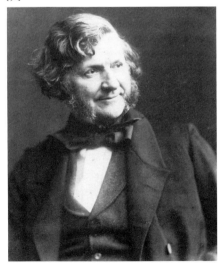

[91]

FRANK STONE, ARA (1800–59)

Painter of genre and portraits, and an illustrator. He specialized in the 'Keepsake' type of beauty, so reviled by the Pre-Raphaelites. Father of Marcus Stone (q.v.) and, like his son, a friend of Dickens (q.v.).

91 Albumen print by Herbert Watkins, *c.* 1858–9, from an album presented to Mrs Stanton by the photographer in March 1859. Probably the only known photograph of this artist. *Christie's, South Kensington*

'No fair-weather friend was he, but true as steel when friendly countenance might be sorely needed. Still, I confess there were drawbacks to the enjoyment of Stone's society. It was enough for anyone to advance an opinion, for Stone to differ from it.'
W. P. Frith, RA, *My Autobiography and Further Reminiscences* (1887), in 3 vols, Vol. 1, p. 159

MARCUS STONE, RA (1840–1921)

Son of Frank Stone, ARA (q.v.). Painter of historical genre and an illustrator. A deservedly highly esteemed painter in his day, he had the misfortune to die long after his kind of picture had fallen into disrepute. This illustrious painter is not listed in the *Dictionary of National Biography*.

92 Photograph by Ralph W. Robinson, 194 × 151 mm, published in *Members and Associates of the Royal Academy of Arts, 1891, photographed in their Studios* (1892). The picture on the easel is *Good Friends*, his diploma picture of 1888, or a version of it. To the right is *The Lost Bird* (1883). *National Portrait Gallery, London*

'The name of Marcus Stone is not in the *Dictionary of National Biography*, though whether he has been omitted from ignorance

or prejudice it is hard to say. He outlived his fame and when he died *The Times*, though kindly, summed him up as "a lover of arts and cats, a devotee of fashionable attire and of his own elegance and refinement". In his heyday this Dorothy artist had been a splendid, slightly truculent figure, one who had been called Marcus Apollo Belvedere Stone. "A man of distinguished and pleasing presence and manner, a good talker, a clever phrase maker and an omnivorous reader. His memory was prodigious. . . . He was a militant radical both in politics and religion" and he often inveighed against God, the Royal Family and the Victorian prudery which caused him to paint such sentimental nonsense. "One sells one's birthright," he used to say.'
Mary Clive, *The Day of Reckoning* (1964), p. 47

EDWARD MATTHEW WARD, RA (1816–79)

One of the most popular of all the Victorian painters of historical genre. His subjects were taken from English and French history and from literature. He married the historical painter Henrietta Ward (q.v.) in 1848.

93 Albumen print by Maull & Polyblank, London, 199 × 145 mm, taken in January 1857. E. M. Ward was one of the most photographed of Victorian artists. Like his contemporaries Frith (q.v.) and Goodall (q.v.) he evidently saw the publicity value of *cartes-de-visite*. *Author's collection*

94 Uncut proof *carte-de-visite*, albumen print by John and Charles Watkins, London, *c.* 1860. An undated letter to John offers him a sitting on his return from France. *Photograph and letter: Author's collection*

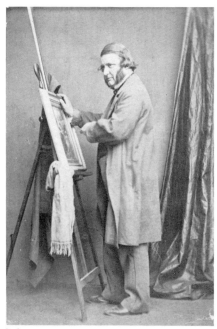

[94]

[93]

'The impression I received of him at our first rencontre is still vividly stamped on my mind. He was then twenty-seven years old, and appeared to me to be singularly handsome, with a very pale complexion, straight dark hair which he wore rather long and parted on one side, and a slightly aquiline nose. He was so much like an Italian, both with regard to features and colouring, that he was often mistaken for one, the illusion being intensified by the circumstance that he could speak Italian most fluently. Being close on six feet (with a proportionate width of chest), he was comparatively tall, but a certain droop of the head and slight stoop, a habit he had doubtless acquired from criticising his own and other people's work, considerably detracted from his height. . . . He was such an admirable talker that wherever he was conversation never flagged, and in corroboration of this statement I will quote a remark the late Lord Lytton once made to me. "Although," he said, "I have enjoyed the companionship of endless great men, I have never met one who was so grand a conversationalist as your husband."'
Mrs E. M. Ward's Reminiscences (1911), ed. by Elliott O'Donnell, p. 32

'[28 July 1860] Ward is a big gross man, kindly and weakwilled, one would say, but a loud incessant talker: and his conversation not cultivated or brilliant.'
Munby, Man of Two Worlds: The Life and Diaries of Arthur J. Munby 1828–1910 (1972), ed. by Derek Hudson, p. 68

MRS EDWARD MATTHEW WARD (née Henrietta Ward) (1832–1924)

Painter of historical genre, similar in subject and treatment to that of her husband E. M. Ward (q.v.), whom she married in 1848. She published her reminiscences twice (*Mrs E. M. Ward's Reminiscences*, 1911, ed. by Elliott O'Donnell, and *Memories of Ninety Years, c.* 1922, ed. by Isabel G. McAllister) and, judging from the second book, with all the appearance of her having forgotten the first one.

[95]

95 Albumen print by Ernest Edwards, published in *Portraits of Men of Eminence* (1866), by A. W. Bennett, Vol. 4. There is a long helpful letter to A. W. Bennett, the publisher, dated 17 May 1865, concerning biographies of herself and her husband. *Photograph and letter: Author's collection*

96 Photograph reproduced in *Memories of Ninety Years* (*c.* 1922), by Mrs E. M. Ward, facing p. 198. She is shown giving lessons to Princess Alice, Countess of Athlone (1883–1982). Mrs Ward painted several members of Queen Victoria's family at Windsor Castle, and her portrait of Princess Alice's father, Prince Leopold, Duke of Albany, was the last portrait she painted there.

[96]

THOMAS WEBSTER, RA (1800–86)

Painter of rustic genre, and a senior member of the Cranbrook Colony of artists.

97 Photogravure after J. P. Mayall, 166 × 216 mm, reproduced in *Artists at Home* (1884), by F. G. Stephens, facing p. 9. The artist sits in the door of his house in Cranbrook where he had lived since 1857. A figure can be seen reading a newspaper in the window to the left. *Author's collection*

'Mr Webster was very lively and full of fun, and devoted to children, like many people who have none of their own. . . . During a severe attack of gout, he went one winter's day, wrapped up in blankets in a bath-chair, to the Round Pond in Kensington Gardens, in order to note some ice and snow effects for his picture of "Boys at a Slide", his reason being that he feared a thaw might set in and lose him the opportunity for observation. In his later years he suffered terribly from the same affection, and would constantly declare that it was only with the greatest difficulty he could put an eye to a small figure or a curl of hair in its proper place, as his poor fingers and trembling hands caused him to paint details, and even features, in quite wrong positions.'
Leaves from the Note-Books of Lady Dorothy Nevill (1907), ed. by Ralph Nevill, pp. 192–3

WILLIAM LIONEL WYLLIE, RA (1851–1931)

Marine painter in oils and water-colours, and an etcher.

98 Photograph by Ralph W. Robinson, 202 × 153 mm, published in *Members and Associates of the Royal Academy of Arts, 1891, photographed in their Studios* (1892). The painting on the easel is *Birth of a Titan* (RA, 1890). *National Portrait Gallery, London*

'He had a tanned face, very keen, dark eyes, and a very black beard and hair; with white, gleaming teeth that showed when he spoke. There was a certain likeness between him and his great dog, with her black muzzle and fierce eyes, that looked up at the same time as he did. That dog terrified me at first.'
M. A. Wyllie, *We Were One: A Life of W. L. Wyllie* (1935), p. 15

[97]

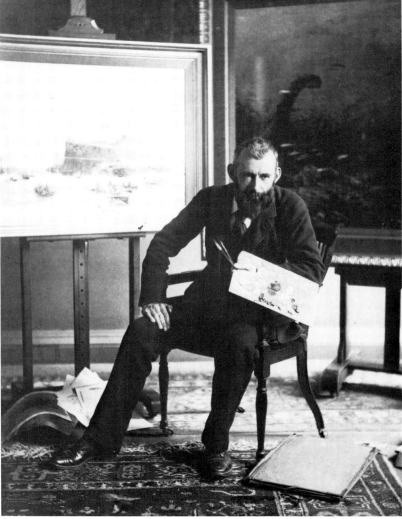

[98]

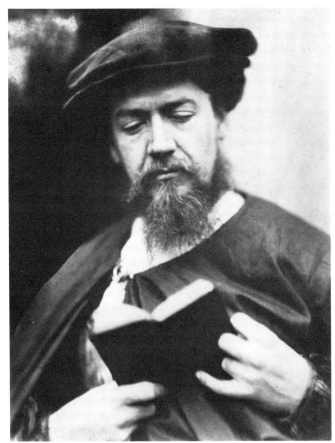

[99]

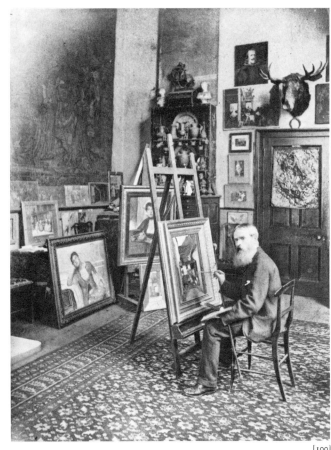

[100]

DAVID WILKIE WYNFIELD (1837–87)

Great-nephew of Sir David Wilkie. Painter of historical genre and a member of the St John's Wood Clique. He was also a pioneer photographer, who taught Julia Margaret Cameron.

99 Albumen print, self-portrait. *Royal Academy of Arts*

'With his camera David Wynfield filled the same rôle for the Clique as Fred Walker had done with his pencil. So accustomed are we to the beautiful photography of to-day that we can hardly realize what an able pioneer he was in the photographic work of his time. The camera was practically in its infancy, and its productions consisted chiefly of cartes-de-visite of ladies in stiff crinolines holding long-handled baskets of artificial flowers, and gentlemen with side-whiskers, standing by marble pillars, one peg-top leg twined elegantly round the other, and a thunderstorm venting its fury from behind a heavily tasselled curtain in the background. . . .

'He photographed all the Clique in turn, and left hundreds of beautiful studies behind.

'His method was to adjust the camera slightly out of focus, which softened and did away with the stereotyped hard look of the professional photographs of the day. He also gave his plates a special preparation.

'He taught his friend Mrs. Cameron, of the Isle of Wight, how to take photographs in the same way, and her beautiful and well-known portraits of Lord Tennyson and others, were the result of his instruction.

'A collection of these photographs of Wynfield's was presented by my uncle to the Academy library.'

M. H. Stephen Smith, *Art and Anecdote* (n.d.), pp. 152–3

WILLIAM FREDERICK YEAMES, RA (1835–1918)

Painter of historical genre and member of the St John's Wood Clique. Painted one of the most celebrated of all Victorian pictures, *And when did you last see your father?*

100 Photogravure after J. P. Mayall, 214 × 167 mm, reproduced in *Artists at Home* (1884), by F. G. Stephens, facing p. 53. Resting against the table behind the easel is a version of *Tender Thoughts* (1882); the picture on the easel is *Welcome as the Flowers in May* (1882). *Author's collection*

PORTRAIT PAINTERS

IT is often maintained that by the time Queen Victoria came to the throne, the great age of portrait painting had come to an inglorious end. This is only superficially true. Although the death of Sir Thomas Lawrence saw the end of an era in that there were no successors of comparable talent, many remarkable portraitists flourished in Victoria's time and after, and portraiture continues to be practised up to the present day. It was not so much that a great era of portrait painting had come to a close, but that the society it reflected had changed. Gainsborough, Reynolds, Romney, Raeburn and Lawrence had painted mainly the aristocracy and landed gentry. With the rapidly changing social structure, brought about by the emergence of the new middle class and an expanding materialistic society, so the demand for portraiture and the nature of the portraits changed.

Two main factors affected Victorian portraiture. The first was the invention of photography and its almost immediate leap into near perfection. The second was that in an age when almost everybody seemed to paint, many professional painters who specialized in other subjects pursued a separate career as portraitists, often attaining equal distinction in this and their specialist area.

The rapid advancement of photography and the speed with which it gained popularity had an immediate effect. In the 1851 census fifty-one photographers were recorded; ten years later there were 2879. In Paris in the same year, 1861, there were no less than 33,000 people making a living from photography and allied trades. In 1851 there were about a dozen portrait studios in London and by 1861 there were over two hundred, thirty-five of which were in Regent Street. The earliest effect was an instant syphoning off of members of the painting fraternity. Holman Hunt

noted that 'many turned their steps towards photography and business connected therewith, and thus found a much more tranquil career and oft-times ample fortune'. Madox Brown, for instance, found a lucrative addition to his small income early in his career by working with Lowes Dickinson in retouching enlargements.

The first major casualty, which had in any case been ailing for some time, was the miniature portrait. The art sustained a blow from which it has never fully recovered, except for a brief revival during Edwardian times. Sir William Ross, too advanced in years, simply gave up, lamenting on his death-bed that 'it was all up with future miniature painting'. On the death of the miniaturist Robert Thorburn, *The Times* noted that his 'admirers, as they stand beside his grave, feel that it is not opened now for the first time. His favourite art went down to the tomb before him. Thirty years ago, photography murdered it.' H. T. Wells took up oil painting immediately with a vengeance, depositing at the Royal Academy, as his diploma work, a group portrait nearly 6 feet high by over 10 feet long.

However, the mainstream of portraiture managed to survive and, in the hands of some practitioners, with surprising new vigour. Civic pride and the need to document and commemorate eminent public figures for posterity ensured a proliferation of busts and statues in public parks, squares, and down the corridors of central and local government. Town halls, boardrooms, council chambers, schools, universities, charity commissions, hospitals, barracks and embassies all needed their luminaries to be appropriately enshrined. The National Portrait Gallery itself, the first of its kind in the world, met this mood. It was created in 1856 under the directorship of George Scharf, who wrote extensively on the subject of portraiture. That the

majority of artists, including portrait painters, did not feel threatened by photography but actually welcomed it and even used it extensively as an aid to painting is borne out by the comments made in a letter to John Watkins by H. W. Pickersgill, a veteran portraitist (he exhibited portraits at the Royal Academy from 1806 to 1872): 'When any member of a Community raises any Art or Science to the highest degree,' he wrote, 'it is only an act of justice to him to acknowledge it – The pre-eminence you have attained in Photography I hope you will long live to enjoy the result of.'

An entirely novel dimension was added to the art of portraiture by the Pre-Raphaelites, nearly all of whom were accomplished portrait painters. This was the inclusion of each other's and their own likenesses in many of their pictures. Millais's *Lorenzo and Isabella* is said to have contained likenesses of the Rossetti brothers, W. B. Scott, F. G. Stephens, Millais's father and his sister-in-law. Stephens modelled again for the figure in *Ferdinand Lured by Ariel*, by the same artist, and again in *Jesus Washing Peter's Feet* by Ford Madox Brown. Lizzie Siddal appears in several paintings, including Millais's *Ophelia*. Ever short of 'tin', Madox Brown economized by using himself and his wife as models for the two emigrants in *The Last of England*. Rossetti's women became a kind of leitmotif to Pre-Raphaelite painting, while the later female heads of Burne-Jones established an internationally recognized type of beauty.

As for the portraitists themselves, there are almost too many to enumerate. G. F. Watts's career as a distinguished portraitist encompassed the whole of Victoria's reign. Millais, Herkomer, Sant, Buckner, Grant, Leighton, Cope, Ouless and Holl were amongst the most successful portrait painters, while towards the end of the century what Sickert called the 'Wriggle-and-Chiffon School' became the fashion, with Sargent as its most celebrated exemplar.

SIR WILLIAM BOXALL, RA (1800–79)

Portrait painter and Director of the National Gallery from 1865 to 1874.

101 Uncut proof *carte-de-visite*, albumen print probably by Charles Watkins, London, *c.* 1860. *Author's collection*

'His loss is too recent . . . for any judicial estimate of him to be possible. No doubt he had faults of temper, no doubt to some men he was difficult and irritable. His health was never strong, he lived much alone; and those only who have experienced the terrible suffering of nervous weakness, and have risen superior to its depressing effects, are entitled to condemn a fellow-creature who has, it may be, allowed such suffering sometimes to overpower his self-control. But he had rare and noble qualities. I do not speak only of his intellectual gifts and his great acquirements. Few men, indeed, had more of both. His feeling for what was beautiful in nature and noble in any form of art, in poetry, in painting, in sculpture, in

[101] [102]

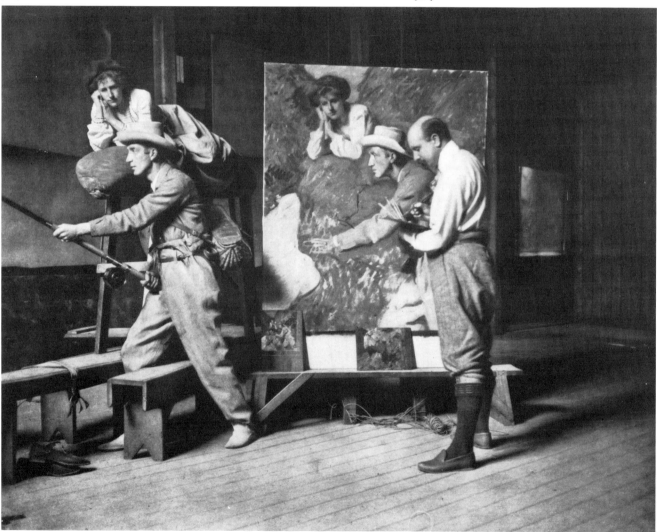

[103]

architecture, was delicate and keen, and yet was as wide as nature herself, and was limited to no particular form or school of art or literature. . . . A friendship of thirty years may justify me in adding that to some men he was never difficult, but always affectionate and forbearing; and that there are those who feel that they have lost in him the most delightful and instructive of companions, the warmest, the most steadfast, the most generous of friends.'
Lord Coleridge, *Sir William Boxall, R A* (1880), pp. 188–9

'A very aesthetic Man. (I always thought him an Ass). . . .'
Letter from Edward FitzGerald to George Crabbe, March 1867, in *The Letters of Edward FitzGerald* (1980), ed. by A. M. and A. B. Terhune, Vol. 3, p. 16

THOMAS DUNCAN, ARA, RSA (1807–45)

Scottish painter of portraits, genre and scenes from Scottish history. Professor of Drawing at the Royal Scottish Academy.

102 Calotype by David Octavius Hill (q.v.) and Robert Adamson, 146 × 110 mm. *Sotheby's*

CHARLES WELLINGTON FURSE, ARA (1868–1904)

Painter of portraits and figure subjects, lecturer and writer on art. His manner was free and original and he was particularly adept at painting horses.

103 Photogravure by an unidentified photographer, 280 × 680 mm, enlarged from a Kodak print. The artist is shown painting Mr and Mrs Oliver fishing the River Laerdel in Norway. He used the village gymnasium at Laerdel for a studio in August 1903. *Author's collection*

'Heavily built and square-shouldered, he looked so robust, in his knickerbockers and tweeds, with big biceps and full calves. There was a suggestion of Rembrandt in his massive head, with its small, humorous eyes; and he wore a short moustache and tuft under his lip. Pugnacious, argumentative, ever trailing a coat, he was the joy of his friends, of whom no man had more.'
Sir William Rothenstein, *Men and Memories* (1931), Vol. 1, p. 173

SIR JOHN WATSON GORDON, RA, PRSA (1788–1864)

Leading Scottish portrait painter after the death of Raeburn in 1823. President of the Royal Scottish Academy in 1850. Knighted in 1851.

104 Albumen print by J. G. Tunny, 150 × 120 mm, *c.* 1854. *Author's collection*

'[1855] Sir W. Gordon is affable and entertaining, with a grave and dignified carriage. An active man, too, for his years.'
David Cox, Jr, in *Memoir of the Life of David Cox* (1875), by N. Neal Solly, p. 238

SIR FRANCIS GRANT, PRA (1803–78)

Painter of portraits and sporting scenes, much patronized by fashionable society. Became President of the Royal Academy in 1866. Knighted in the same year.

105 Calotype by David Octavius Hill (q.v.) and Robert Adamson, 208 × 157 mm, *c.* 1845. *Private collection*

[104]

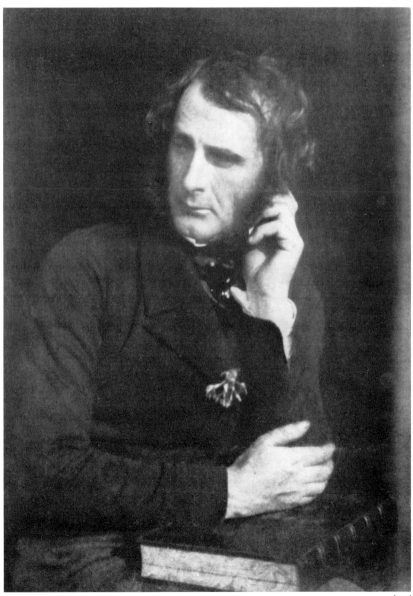

[105]

Queen Victoria to Earl Russell

'OSBORNE [undated: ? 19 February 1866]. The Queen will knight Mr Grant when she is at Windsor. She cannot say she thinks his selection a good one for Art. He boasts of *never* having been in Italy or studied the old Masters. He has decidedly much talent, but it is the talent of an amateur.'

The Letters and Journal of Queen Victoria (1926), 2nd series, Vol. 2, p. 301

'The mutual antipathy which existed between Sir Francis Grant, when he was president of the Academy, and Leighton occasioned [Sir John] Gilbert great concern, and he did much to alleviate it. He was on the best of terms with both men, but there was no disputing the superiority in many ways of one man over the other. He was wont to recall, at a meeting once at Marlborough House with King Edward (then Prince of Wales) presiding, when Leighton so outshone the president in practical sense and influence that Sir Francis excused himself to the Prince and abruptly left the meeting with a display of irritation which was observed and remarked upon by the Prince. Sir John, seeing that something was wrong, hurried after him and found him at the Royal Academy, seated in the hall with Eaton the secretary, and raging furiously. Asking what was the matter, the answer came, "That Leighton, I can't stand him." Should Sir John speak to him? "No, no, let him alone, d— him," said Grant.'

A. G. Temple, *Guildhall Memories* (1918), p. 119

FRANK HOLL, RA (1845–88)

Illustrator, painter of social-realism pictures and portraits. Considered one of the best portraitists of his age. Son of Francis Holl (q.v.).

106 *Carte-de-visite*, albumen print by Elliott & Fry, London. *Author's collection*

'Sun. 10th. Feb. [1884] when papa [Rupert Potter] went to Mr Millais, he had to be sharp because Mr Holl was coming at 11 to paint Mr Millais' portrait for *The Hours*. Mr Millais said he was a nice man, but dreadfully nervous, and put on too much paint. I don't wonder his being nervous in that studio.'

The Journal of Beatrix Potter from 1881 to 1897 (1966), ed. by Leslie Linder, p. 65

MRS J. M. JOPLING, formerly MRS FRANK ROMER (née Louise Goode), RBA (1843–1933)

Painter of portraits, landscape and genre. Her second husband, J. M. Jopling, was a watercolourist. Her third husband was G. W. Rowe, a lawyer.

107 Photograph by R. W. Thomas, reproduced in the *Windsor Magazine* (Vol. 24), June–November 1906.

'Mrs Jopling [after 1884] a very beautiful and attractive young widow. . . .'

C. C. Hoyer Millar, *George Du Maurier and Others* (1937), p. 3

JOHN PRESCOTT KNIGHT, RA (1803–81)

Portrait painter. Professor of Perspective at the Royal Academy from 1839, two years after

Turner had vacated the chair, until 1860; Secretary 1847–73.

108 *Carte-de-visite*, albumen print by Charles Watkins, London. Knight wrote to Watkins on 27 May 1862, making an appointment for 'Monday morning next [2 June 1862] at ten o'clock for my visit to your *atelier*'. *Photograph and letter: Author's collection*

'Knight was a good-natured and indulgent master; his knowledge of perspective was very thorough, and he had the art of explaining things in a lucid manner; but he was not a good disciplinarian, and I am sorry to say we

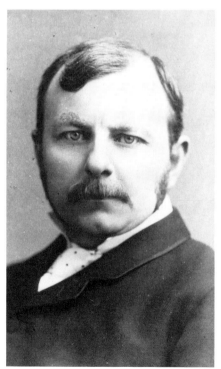

frequently took advantage of his amiability by indulging in all sorts of noise and practical jokes. His drawing board was in the North Room, and when he wished the class to assemble round it, he gave a tapping on it, with his ruler; this weapon he called his bell, and occasionally when he was away attending to the students in the West Room, some student would tap with his ruler exactly in Knight's manner, upon which the whole class, including those in the West Room with Mr Knight himself, would come rushing up to the Professor's empty chair. On occasions of this sort we generally received a mild reproof, as, of course, it would have been quite impossible to attempt to discover the culprit.'

George Dunlop Leslie, RA, *The Inner Life of the Royal Academy* (1914), pp. 17–18

SIR JOHN LAVERY, RA (1856–1941)

Painter of portraits, landscape and genre. Knighted in 1918.

109 Mechanical process print by an unidentified photographer, 120 × 78 mm. *Author's collection*

'Little man looking like anything but an artist.'

Sir Edmund Walker in *The Walker Journals*, article by Katharine A. Lochnan in *Racar*, ix/1–2/1982

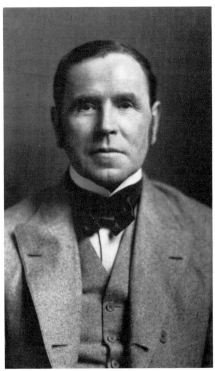

[109]

JOHN LUCAS (1807–74)

Portrait painter. Much patronized by the royal family and the aristocracy; he painted four portraits of Prince Albert. Uncle of John Seymour Lucas (q.v.).

110 *Carte-de-visite*, albumen print by Messrs Lucas, London. These photographers describe themselves as 'Artists & Photographers' on the reverse of this *carte* and give their address as 3 St John's Wood Road. John Lucas gives the same address in the *London Post Office Directory* from 1865 to 1872. Presumably, in addition to his lucrative portrait painting practice, he or members of his family,

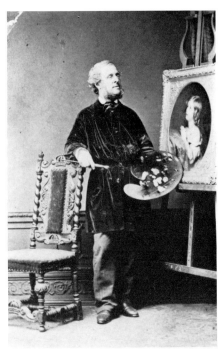

[110]

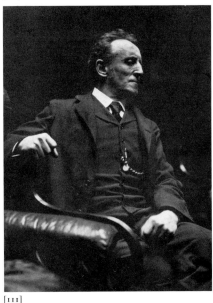

[111]

or both, ran a photography business. *National Portrait Gallery, London*

WALTER WILLIAM OULESS, RA (1848–1933)

Portrait painter who acquired a remarkable practice in fashionable society.

111 Albumen print by an unidentified photographer. The photograph was used by Sir H. von Herkomer (q.v.) as an aid in painting his *Council of the Royal Academy* (1907). *Miss B. Pomeroy*

'Walter Ouless, who had brought with him from his native Channel Island a love of the sea, would be taken for a sailor rather than a painter; a straightforward simplicity and hatred of affectation and of cant were qualities which helped to endear him to me, added to a kindly cheeriness and good-nature.'

G. P. Jacomb-Hood, *With Brush and Pencil* (1925), p. 313

HENRY WILLIAM PICKERSGILL, RA (1782–1875)

Portrait painter and uncle of F. R. Pickersgill (q.v.). Immensely prolific, exhibiting at the Royal Academy from 1806 to 1872.

112 *Carte-de-visite*, albumen print by Maull & Polyblank, London, *c.* 1860. For once, an artist is probably holding a portrait painted by himself, although, perhaps, an easel would have been more appropriate than a pillar. Pickersgill was also photographed by, among others, John and Charles Watkins, whom he

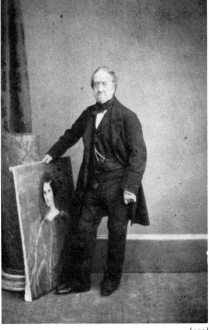

[112]

evidently held in high esteem (ironically, since as a painter of portraits he was in a rival profession), as is borne out in his letter to John Watkins, dated 7 May 1868: 'When any Member of a Community raises any Art or Science to the highest degree, it is only an act of justice to him to acknowledge it – The pre-eminence you have attained in Photography I hope you will live long to enjoy the result of.' *Photograph: Royal Academy of Arts; letter: Author's collection*

'Pickersgill's fastidiousness concerning his backgrounds [of his portraits] was painful in the extreme. Often have I gone to his studio, 15, Soho Square, to advise with him on proposed changes in the arrangement of some parts of the picture. He would have also the opinion of Mr. Witherington. Afterwards he would alter the whole scheme for one of his own, which he thought a great improvement. Sometimes he kept me waiting until his return from the City, where he had gone to consult his lawyer about some mortgage. The height of his ambition was to be a delineator of female beauty. It was generally considered, that he had not any good idea of feminine beauty. He would often turn round towards a spectator when showing his work, and with a look of satisfaction, assert that he had produced a work as good as Titian's. Frequently, in language so extravagant, did he compare his works with those of his contemporaries, as to be quite absurd.

'Pickersgill was not without some culture. He had a good memory, also some power of mimicry, and sufficient material for conversation to keep awake his male sitters.'
Solomon Alexander Hart, RA, *Reminiscences* (1882), pp. 80–1

'[31 December 1861] Pickersgill, who says he is 79, also said he was quite uncertain when his birthday was. "What, were you never baptised or registered?" said Landseer. "Oh, yes, I was baptised when my eldest child was; and therefore it had nothing to do with my birth." There were many jokes about his being able to boast of his age, since no one can dispute it.'
F. M. Redgrave, *Richard Redgrave, CB, RA: A Memoir Compiled from his Diary* (1891), p. 262

GEORGE RICHMOND, RA (1809–96)

Water-colourist and portrait painter, one of the finest of his age. He painted miniatures and pictures in chalks and oils. He belonged to the group of followers of Blake known as 'The Ancients'. He was a lifelong friend of Samuel Palmer (q.v.) and father of Sir William Blake Richmond (q.v.).

113 Photograph, reproduced from *The Richmond Papers* (1926), by A. M. W. Stirling, facing p. 72. Richmond was probably at some time photographed by John and Charles Watkins, of London. He wrote them a letter, dated 15 May 1866, postponing a sitting on that day on grounds of health. *Author's collection*

'My father used to tell me how he and his brothers all rose when their father entered the room, and remained standing till he left. He did not countenance anyone in the house having a latch-key, and he expected implicit obedience and deference from all. As grandchildren were added to the large home-circle, the position of George Richmond became patriarchal, while he continued to inculcate in all alike the fear of God and the love of man. One day in his presence a member of that younger generation made a facetious remark

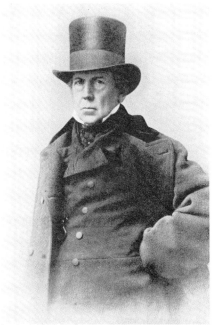

[113]

about Abraham. "I do not consider," reprimanded Mr. Richmond severely, "that it is right to speak with levity of the Friend of God." It was partly due to this gravity of outlook, as well as to his resemblance to a Bishop, that he was nicknamed "the Parson of the Academy".'
'One of his grandchildren', quoted in *The Richmond Papers* (1926), by A. M. W. Stirling, p. 72

WALFORD GRAHAM ROBERTSON, RBA (1867–1948)

Painter of portraits and landscape, illustrator and designer. He was the subject of one of Sargent's most attractive portraits. His book of reminiscences, *Time Was* (1931), contains many felicitous accounts of fellow artists, and has been widely used in the writing of this book.

114 Silver bromide by an unidentified photographer, 154 × 110 mm, *c.* 1905. Graham Robertson loved the company of dogs – grey bobtailed sheep dogs in particular. *Author's collection*

'In the eighteen-nineties he reached his prime, in which the picture of him by Sargent has perpetuated his slim and graceful figure surmounted by the perceptive, vital face – kindly, alert, intelligent. . . . The famous Sargent portrait, now in the Tate, shows one aspect of his attractiveness as a sensitive young artist. He was tall and well proportioned and the thinness stressed by Sargent was not conspicuous after early middle age, if indeed it ever was.'
Letters from Graham Robertson (1953), ed. by Kerison Preston, p. xiv

SIR WILLIAM CHARLES ROSS, RA
(1794–1860)

Painter of miniatures, particularly of royalty and aristocracy, although his earlier exhibits at the Royal Academy were historical paintings in oils. Knighted in 1842. He was struck by paralysis in 1857, but continued to exhibit at the Royal Academy until 1859.

115 *Carte-de-visite*, albumen print by John and Charles Watkins, London. A letter dated 24 May 1852 from the artist to John Watkins sets out his movements with a view to complying with a request for a sitting: 'Sir W. C. Ross presents his compliments to Mr. Watkins, and apologizing for having so long deferred replying to his note, begs leave to say that he is in town for a day – tomorrow – and that he will be happy to be at 34, Parliament St. on that day at 9 o'c[lock] – which he hopes may be convenient to Mr. Watkins. After that he will be out of town until after the 1st of June.' As the year, 1852, anticipates the *carte-de-visite* era by seven years or so, it is possible that a photograph taken then may later have been adapted to the *carte* format. *Photograph and letter: Author's collection*

'There were one or two members [of the Royal Academy] at that time of whom I can recall little save their bald heads and the tone of their voices. Sir William Ross, the miniature painter, was one of these; he had a very clean bald head fringed with pure white hair, his voice was extremely bland and sweet, and his manners were innocent as those of a child.'
George Dunlop Leslie, RA, *The Inner Life of the Royal Academy* (1914), p. 153

'Sir William Ross, RA, miniature painter to Queen Victoria, lived at No. 38 Fitzroy Square. We knew him very well, a kind little man, who looked more like a doctor than a famous painter. . . . Sir William once stayed with us at Worthing, and my aunt having lent us her donkey for the children to ride, Sir William took a fancy to go for a ride one morning. We tried to dissuade him, knowing that the celebrated painter was no equestrian, and that the animal had a mind of its own. We saw him mount and ride away in high spirits, but alas! the donkey preferred the town to the country, and conveyed Sir William into the main street, where he backed into a shop, and refused to leave. Sir William finally had to lead him home in disgrace.'
Mrs E. M. Ward, *Memories of Ninety Years* (c. 1922), ed. by Isabel G. McAllister, p. 244

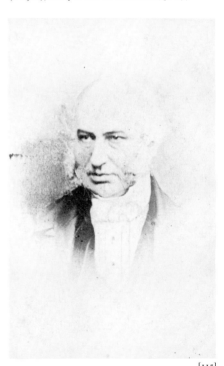

[115]

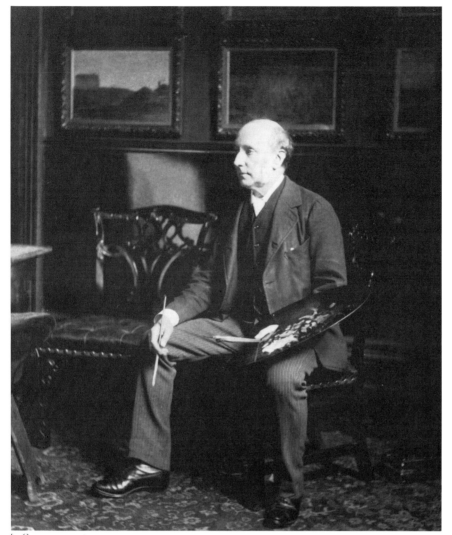

[116]

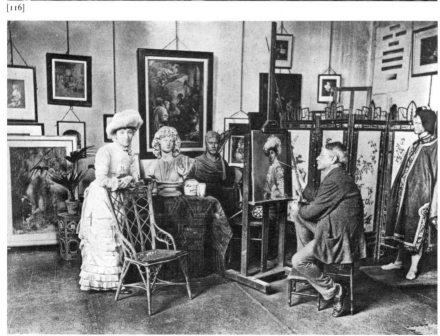

[117]

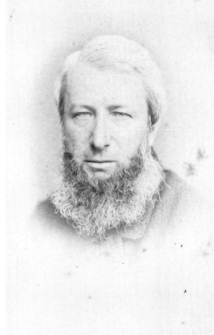

[118]

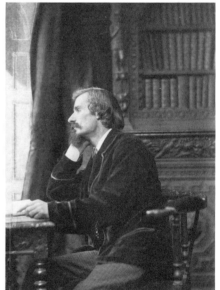

[119]

JAMES SANT, RA (1820–1916)

Portrait and subject painter. As a portrait artist he enjoyed the patronage of the aristocracy. He was appointed Painter-in-Ordinary to Queen Victoria in 1871.

116 Photograph by Ralph W. Robinson, 198 × 153 mm, published in *Members and Associates of the Royal Academy of Arts, 1891, photographed in their Studios* (1892). *National Portrait Gallery, London*

'His art reflected his own character fully, being invested with a refinement, spirituality, and beauty that was very marked. Dear James Sant! . . . My daughter Flora was very shy by disposition, and as Mr. Sant said he was the same, they used to hobnob together and were good friends over their mutual misfortune. But a story told of James Sant receiving in his studio a lady, who wanted him to paint her portrait, hardly bears out his testimony to shyness. When the day came the lady arrived, thickly covered with powder and rouge. "I see we both paint," was his only remark.'
Mrs E. M. Ward, *Memories of Ninety Years* (c. 1922), ed. by Isabel G. McAllister, pp. 283, 298

GEORGE ADOLPHUS STOREY, RA (1834–1919)

Portrait and genre painter and member of the St John's Wood Clique.

117 Photogravure after J. P. Mayall, 166 × 218 mm, reproduced in *Artists at Home* (1884), by F. G. Stephens, facing p. 92. The artist's wife is posing for her portrait. At the centre is a bust of the artist. *Author's collection*

'Storey, the perspective lecturer [at the Royal Academy Schools], was a good-hearted little man, and we were up to jokes with him and called him "Augustus Fib". At Christmas we wound up a toy lamb and set it trotting about the architectural room during our lecture; he didn't even report us when his wet blackboard sponge went flying about.'
Estella Canziani, *Round About Three Palace Green* (1939), p. 153

ROBERT THORBURN, ARA (1818–85)

Painter of miniatures. A portrait of Queen Victoria painted in 1848 assured the patronage of fashionable society thereafter. Father of Archibald Thorburn, the animal painter (q.v.).

118 *Carte-de-visite*, albumen print by John Watkins, London. The artist wrote to the photographer from Edinburgh on 13 June 1867: 'Mr Thorburn presents his compliments to Mr Watkins and begs to say that he will be very happy to sit to him the first time he returns to town.' *Photograph and letter: Author's collection*

'Mr. Robert Thorburn, ARA, the famous miniature-painter, is dead; and last Saturday *The Times* devoted to his memory a ponderous monody in the form of a leading article. One passage, however, is quite animating. "His [Mr Thorburn's] admirers, as they stand beside his grave, feel that it is not opened now for the first time. His favourite art went down to the tomb before him. Thirty years ago, photography murdered it." Sensation! The rest of the article is dull. Of course photography drove miniature-painting out of the market. It was a very beautiful, but perhaps the most flattering art in the world. And it was frightfully expensive.'
Amateur Photographer, 13 November 1885

ALEXANDER HAMILTON WARDLOW (exhib. 1870–99)

Painter of miniatures, whose three daughters also painted miniatures. They all lived at the same London address, first in York Road, Acton, then from 1890 at Enmore Park, South Norwood. They all, with the exception of Eleanor (q.v.), exhibited, at various dates, at the Royal Academy from 1884 to 1889. Mary (q.v.) continued to exhibit until 1914.

119 Platinum print by an unidentified photographer, 145 × 150 mm, c. 1890. *Author's collection*

ANNE WARDLOW (exhib. 1887–92)

120 Cabinet portrait, albumen print by an unidentified photographer, c. 1890. *Author's collection*

[121]

ELEANOR FRANCIS WARDLOW (exhib. 1893–99)

121 *Carte-de-visite*, albumen print by an unidentified photographer, c. 1890. *Author's collection*

MARY ALEXANDRA WARDLOW (exhib. 1885–1914)

122 *Carte-de-visite*, albumen print by an unidentified photographer, c. 1890. *Author's collection*

[120]

[122]

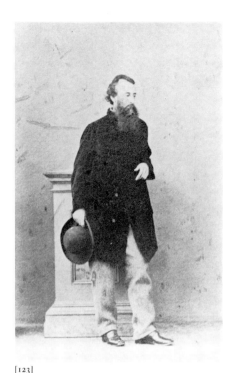

GEORGE FREDERIC WATTS, OM, RA
(1817–1904)

One of the great figures of his age, whose reputation has suffered more than those of most of his contemporaries in subsequent years. Painter in oils of portraits, and historical and allegorical subjects. He also sculpted. Always an isolated and a rather Olympian character, he twice refused a baronetcy. He was married firstly to Ellen Terry, the actress (q.v.), in 1864, but this was foredoomed to failure and they were divorced in 1877; and secondly to Mary Fraser Tytler in 1886.

123 *Carte-de-visite*, albumen print by Jabez Hughes, Royal Photographic Studio, Regina House, Ryde, Isle of Wight. From an album compiled by Prince Albert in 1860.
Her Majesty The Queen

124 Photogravure after J. P. Mayall, 166 × 220 mm, reproduced in *Artists at Home* (1884), by F. G. Stephens, facing p. 45. Pictures in the upper part of the photograph, from left to right, include: *Britomart and her Nurse* (1878), a version of *The Creation of Eve*, *The Meeting of Jacob and Esau* (1868), *The Rider on the White Horse* (c. 1868); in the lower part, from left to right: *The Spirit of Christianity*, *Cardinal Manning* (1882), *Lady Lindsay of Balcarres*, *The Duke of Devonshire* and *Paolo and Francesca* (1872–80). F. G. Stephens wrote: 'The chamber containing these pictures was built by the painter to contain his works, including those of the Little Holland House Gallery.' *Author's collection*

125 Photograph by Ralph W. Robinson, 201 × 153 mm, published in *Members and Associates of the Royal Academy of Arts, 1891, photographed in their Studios* (1892). The artist is under a full-size model of *Physical Energy* on which he had worked for many years. It was cast in bronze for South Africa as a memorial to Cecil Rhodes's achievements as a pioneer of empire. After his death another cast was placed in Lancaster Walk, Kensington Gardens. *National Portrait Gallery, London*

'[6 April 1859] Watts is very pale & [Ruskin's deletion] thin – long faced – rather bony and

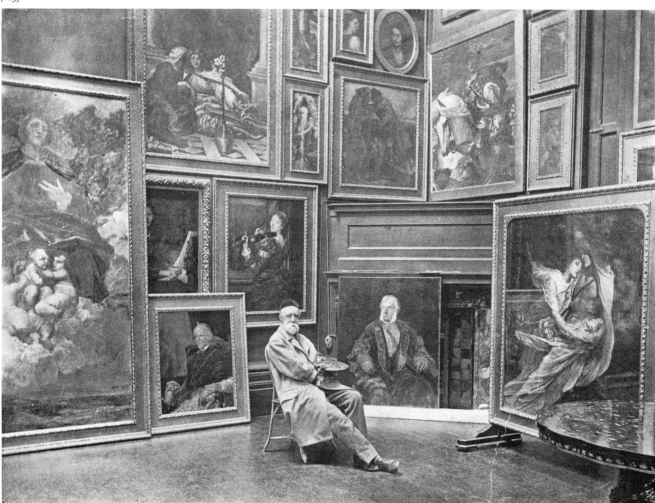

skinny in structure of face features – otherwise
sensitive in the same manner as Tennyson, of
course in less degree the thinness being evi-
dently caused by suffering both of mind and
body: but not involving any permanent harm
to health – no [*illegible*] – Dark hair – Eyes
bright [Ruskin's deletion] clear & keen, but
not in any way noticeably brilliant or beautiful
– and rather small. His smile very sweet: but
firm – not going far.'

John Ruskin to Margaret Bell in *The Winnington
Letters* (1969), ed. by Van Akin Burd, pp. 156–7

'[When] I first met Watts . . . he was . . . a
very old man, very gentle, obviously delicate
in health, but of serene and dignified aspect.
He wore a black velvet skull-cap and a fine
cambric shirt, with delicate wristbands setting
off beautiful, old, veined hands.'

Sir William Rothenstein, *Men and Memories*
(1931), Vol. 1, p. 207

HENRY TANWORTH WELLS, RA
(1828–1903)

Painter of miniatures who gave up his practice
in about 1860 when the encroachment of pho-
tography obliged him to take up portraiture
in oils. In 1857 he married Joanna, the sister
of G. P. Boyce (q.v.).

126 *Carte-de-visite*, albumen print by H.
Lenthall, *c.* 1866. *Author's collection*

'Mr Wells, RA, had a pleasant house and gar-
den on Campden Hill. As he told me, he had
begun as a miniature painter, and took to por-
trait painting on a life-size scale later.

'As far as I remember him, side-whiskers
and the general appearance of a successful
business man in a frock-coat and top-hat is
my impression. He had a kindly and gracious
manner, his accurate pronunciation interfered
with by – I suppose – adenoids. As Visitor

in the Royal Academy Schools, he is reported
to have said to a student, "Fload-id-od, by
dear boy – fload-id-od! A bere filb – a
gossaber!"'

G.P. Jacomb-Hood, *With Brush and Pencil* (1925),
p. 316

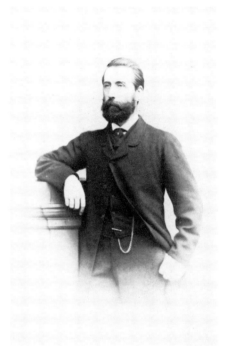

[126]

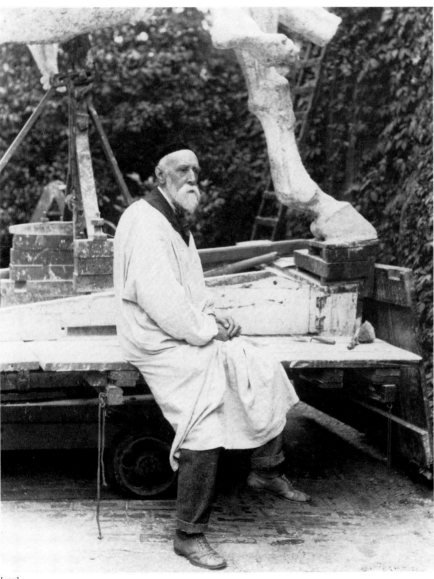

ANIMAL, SPORTING & BATTLE PAINTERS

IN spite of the ever-increasing growth of towns and cities, animals were far more a feature of everyday life in Victorian times than now – as a means of locomotion in both peace and war, in sport, in their original wild state and as domestic pets. If the legend still persists that the British are the greatest animal-loving nation on earth, it was even more true in the nineteenth century, from royalty downwards. Wild and exotic animals were kept as pets, and not only by the rich and educated. The keeping of menageries was not only the prerogative of the aristocracy (the 13th Earl of Derby's was sufficiently well stocked to keep Edward Lear occupied for four years as a painter) but was widely indulged in. Rossetti's visitors were amused to see tortoises creeping about his garden in Chelsea in the company of armadillos, wombats, moles and dormice. Janey Morris would recline on a chaise-longue watching children playing hide and seek, while keeping a wary eye on two kangaroos, mother and daughter, which might suddenly tire from fighting each other and turn on the little ones. There were strict instructions not to lift a heavy stone off a packing case containing a racoon. Indoors, a parrot of uncertain temperament would lunge at a stroking finger. Gentlemen returning from their travels abroad would bring back cheetahs, monkeys, parrots, wild boars, bears and snakes, and some of these would find their way into London's Zoological Gardens, which had been opened in 1826.

Farm animals were often to be seen being driven along the streets in London and, in the City, it was not at all uncommon for an entire flock of sheep to be seen, bound for the slaughter house, disrupting the horse-drawn traffic. The horse, in particular, was everywhere in evidence. Apart from the railways, the horse was still, until the invention of the bicycle and the internal combustion engine, the only means of propulsion on land. It was not possible to set foot in the street without encountering large numbers of horses; indeed, the invention of the motor-car was seen by some as a timely deliverance, before London all but sank under a mountain of droppings. In 1851 the Board of Health estimated that some 200,000 tons of horse dung clogged up the streets of London in one year. It has been estimated, too, that in Victorian times one horse was required for every man, woman and child to keep society on the move. By 1902 there were something like $3\frac{1}{2}$ million horses in Britain, and about 30 million in the USA.

There was intense devotion, particularly among the aristocracy and gentry, to field sports, racing, coursing, hunting, shooting and fishing. Shooting parties frequently lasted for several days, resulting in the slaughter of hundreds, sometimes thousands of birds. Fishing was a favourite sport with many artists such as G. D. Leslie, C. W. Cope and Millais, the latter taking three months off every year to indulge his pastime. In Cope's memoirs there are more than twice as many references to fly-fishing as to fresco-painting, which had occupied so much of his time in the new Palace of Westminster. Fox-hunting was an obsession with many: Thomas Assheton Smith, the squire of Tedworth, Hampshire, when not sleeping spent most of his life in the saddle. He hunted for seventy years and was MFH for nearly fifty. In 1856, in his eightieth year, he still hunted four days a week, and regretted the other three. To condition himself to the rigours of the hunting-field he would plunge his head into a bucket of cold water in the morning and hold it there for as long as he could. To other artists, wars and battles, and especially cavalry charges, were merely an extension of field sports and outdoor leisure activities. Most of the officers who charged at Waterloo and Balaclava owed

their experience to the hunting-field.

Small wonder, then, that Ben Marshall was able to remark in 1812 that he could 'discover many a man who will give me fifty guineas for painting his horse who thinks ten guineas too much for painting his wife'. The whole approach to animal painting was one of extreme specialization and required as profound a knowledge of anatomy and the ways of animals, as of ships and rigging for a marine painter. Any departure from the normal, any anomaly, was sure to be spotted and the slightest discrepancy in military apparel in a battle painting was seized on. Painters of these subjects went to almost any length to achieve authenticity. When painting *The Roll Call*, Lady Butler interviewed elderly survivors from the Crimean War because she 'feared making the least mistake in these technical matters'. The Prince of Wales himself, who could be relied upon to spot an incorrectly worn ribbon at thirty paces, marvelled at the precision of military detail and asked her how she did it, after inquiring whether he could buy the picture.

In 1891 E. Landseer Grundy (a name to inspire confidence) wrote in the *Magazine of Art*:

Animal painting is a branch of art that requires the most profound study and the most assiduous and painstaking application – a fact, however, which seldom deters even those who have failed as painters in other branches of art from embarking on it with the utmost assurance. Many of these do not know the animals they paint; that is to say that they are alive to their pictorial value, but have no deeper sense of their character or of their qualities as subjects for artistic interpretation. In this country, animals, especially dogs and horses, are always appreciated, and if well drawn and painted, with a little story attached to them, are generally sure of purchasers at most of the exhibitions.

Every one of the great animal and battle painters of the last century had this to heart, from Edwin Landseer, the most celebrated of all, to T. S. Cooper, who for sixty-seven years, without a break, exhibited animal pictures at the Royal Academy, once contributing seven pictures, several times five, and rarely less than four. He could draw a cow with perfect accuracy, he claimed, with his eyes shut. He also offered 'a challenge to any artist who will take it up, and will bet £1,000 to £500 that I will draw a thousand sheep in a thousand hours without any copy; each one to be in a different position, done from memory (to ensure which they might be removed, as soon as they were finished, out of my sight); and every sheep to be not less than the length of my fore-finger in size.' The challenge, issued by a painter who further claimed that he painted two pictures before breakfast every morning of his life, was not taken up. Perhaps Landseer was not around at the time: he could certainly have offered the same challenge with dogs, which, could also possibly have been met later by Briton Riviere, his successor in that field. In an anonymous letter written to *Punch* Frith, who attended the Landseer memorial exhibition at the Royal Academy in 1874 and was overwhelmed by the preponderance of canine features, commented that it was not a catalogue that was needed, but a dogalogue.

Briton Riviere, with his Oxford degree and classical learning, was the first British animal painter to introduce classical themes to his paintings. Like Landseer he was something of a child prodigy. When only 11 years old he exhibited two pictures at the British Institution. One bore the title *Love at First Sight*, suggesting a touch of precociousness in one of such tender years were it not that it depicted a kitten being introduced to its first mouse.

Battle painting demanded special talents: historical and military knowledge, the ability to compose a unified picture out of the chaos of battle, and a high degree of skill in painting horses and figures. Obtaining the necessary accoutrements and getting people or horses to pose in awkward and unnatural positions was always a problem. French painters, like Meissonier and Detaille, were generally more resourceful at this kind of work than their British counterparts, and would go to incredible extremes to establish authentic detail. Meissonier, in painting a picture of the retreat from Moscow, waited until it snowed, ordered his servants to trample on the snow and then roll a cart over it to make ruts. When the scene was set he sat down and painted, regardless of the cold. On another occasion he dressed a model in hussar's uniform, made him stand rigidly for several hours, and then only painted the carbine hanging from his belt. He is said, too, to have arranged a troop of cavalry to charge across his park; but when the horses disappeared out of sight, he found that he could not catch their movements. Undeterred, he had a railway track built so that he could follow in a truck as the horses thundered by.

English war painters – pre-eminently Thomas Jones Barker and Abraham Cooper earlier in the century, and Lady Butler, Caton Woodville and Ernest Crofts later – were less drastic in their methods. Of all those just mentioned it is Lady Butler who engages the attention most – to a large extent, of course, on account of her

gender. Women painting muscular equine subjects were not so uncommon: Rosa Bonheur had already had great experience in that capacity, as, later and on a less ambitious scale, had Lucy Kemp-Welch. Lady Butler's short steps to bursting 'into fame', as Tom Taylor put it, were quite remarkable. The first picture she submitted to the Royal Academy was rejected and returned with a large hole in it; the second was rejected without a hole; the third offering was accepted but 'skyed'. Her fourth picture, *The Roll Call*, was one of the three most sensationally successful pictures of the nineteenth century, taking its place alongside Wilkie's *Chelsea Pensioners Reading the Gazette of the Battle of Waterloo* and Frith's *Derby Day*. Her large sombre painting depicted a line of proud but exhausted Grenadier Guards, after an engagement in the Crimea, about to have the roll called. What particularly struck the spectator was the tone of sang-froid which had been so well caught by the artist. Elizabeth Thompson, as she then was, became a celebrity overnight. The picture, which had been bought by Charles Galloway, a manufacturer of boilers and heavy engineering equipment, was ceded to Queen Victoria. It was taken briefly from the Summer Exhibition of 1874 by the Queen to show Tsar Alexander II at Windsor; after the exhibition it was taken to the bedside of the invalided Florence Nightingale. Within hours of the opening of the exhibition Elizabeth Thompson had been besieged by the *carte-de-visite* photographers, much to her disgust. However, her grandfather marched her into the shop of the first photographer to ask her, in Regent Street. Duly photographed, a quarter of a million of the *cartes-de-visite* (Plate 128) were sold within weeks, and an aunt of hers, passing a costermonger's barrow, was astonished to see one of these photographs amongst some bananas.

RICHARD ANSDELL, RA (1815–85)

A popular animal and sporting painter, often in the manner of Landseer (q.v.). He painted genre and historical scenes, sometimes in collaboration with John Phillip (q.v.) and others.

127 Uncut albumen print by Ernest Edwards, 95 × 71 mm, 1865, published in *Portraits of Men of Eminence* (1866), by A. W. Bennett, Vol. 4. *Author's collection*

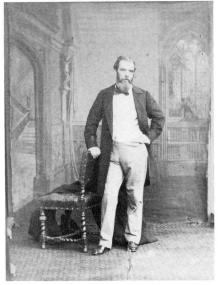

[127]

'In appearance he was tall and inclined to stoutness, with an attractive manner, which brought him patrons among the county families at an early age.'
H. C. Marillier, *Memoirs of the Liverpool Artists* (1904), p. 54

'As a companion he was most genial, most unaffectedly kindly and good-natured, but there was a proud spirit in the man; any slights or undue familiarities he resented vehemently, and did not easily forgive.'
J. E. Hodgson, RA, in the *Magazine of Art* (1889)

LADY BUTLER (née Elizabeth Thompson) (1846–1933)

Celebrated battle painter. *The Roll Call* (RA, 1874), which was bought by Queen Victoria, made Lady Butler's reputation instantly. Her sister was Alice Meynell, the writer.

128 *Carte-de-visite*, albumen print by Fradelle & Marshall, 230 and 246 Regent Street, London. Taken in 1874, it is the photograph referred to below. In a letter to W. F. Pollock on 23 July 1874 Edward FitzGerald wrote: 'The Photo of Miss Thompson herself gives me a very favourable impression of her. It really looks, in face and dress, like some of Sir Joshua's Women.' (*The Letters of Edward*

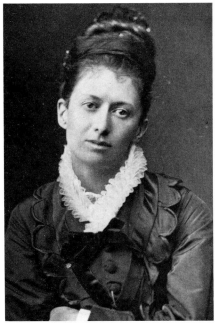

[128]

FitzGerald (1980), ed. by A. M. and A. B. Terhune, Vol. 3, p. 506). *Author's collection*

'Of course, the photographers began bothering. The idea of my portraits being published in the shop windows was repugnant to me. Nowadays one is snapshotted whether one likes it or not, but it wasn't so bad in those days; one's own consent was asked, at any rate. I refused. However, it had to come to that at last. My grandfather simply walked into the shop of the first people that had asked me, in Regent Street, and calmly made the appointment. I was so cross on being dragged there that the result was as I expected – a rather harassed and coerced young woman, and the worst of it was that this particular photograph was the one most widely published. Indeed, one of my aunts, passing along a street in Chelsea, was astonished to see her rueful niece on a costermonger's barrow amongst some bananas!'
Elizabeth Butler, *An Autobiography* (1923), p. 114

ABRAHAM COOPER, RA (1787–1868)

Painter of sporting, battle and historical pictures.

129 *Carte-de-visite*, albumen print by Maull & Polyblank, London. In a letter dated 23 May to John Watkins, who also photographed the artist, Cooper wrote: 'I fear that my nose is too big to be *placed* so *near* the lens.' The artist is probably holding one of his own pictures – rather untypically, since photographers at this date, *c.*1850, usually supplied their own props. *Photograph and letter: Author's collection*

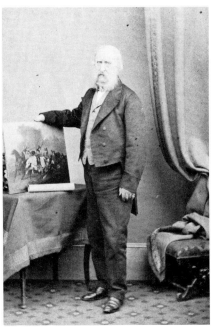

[129]

'Amongst others I remember Abraham Cooper, nicknamed "Horse Cooper" to distinguish him from Sidney Cooper who was called "Cow Cooper".'
George Dunlop Leslie, RA, *The Inner Life of the Royal Academy* (1914), p. 28

THOMAS SIDNEY COOPER, RA, CVO (1803–1902)

Indefatigable animal painter who exhibited at the Royal Academy, without a break, from 1833 to 1902 – a record.

130 (on p. 74) Photograph by Ralph W. Robinson, 198 × 145 mm, published in *Members and Associates of the Royal Academy of Arts, 1891, photographed in their Studios* (1892). The picture on the easel is typical of Cooper's prodigious output. *National Portrait Gallery, London*

'In manner he was abrupt, almost curt, at times ungenerously bitter; but he could be kind and sympathetic when he wished. His early privations had undoubtedly added hardiness to his character, but they are greatly responsible for the somewhat harsh and forbidding mould in which his nature had been cast. At one period of his life he had made himself very unpopular among his fellow artists by his penetrating sarcasm and bitterness of tongue. He has been accused of being anything but liberal, but this statement has led to an exaggeration of fact. At home he was a warmhearted husband and father.'
E. Keble Chatterton, *Sidney Cooper, His Life and Art* (1902), p. 40

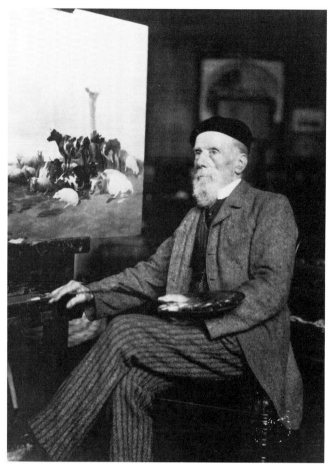

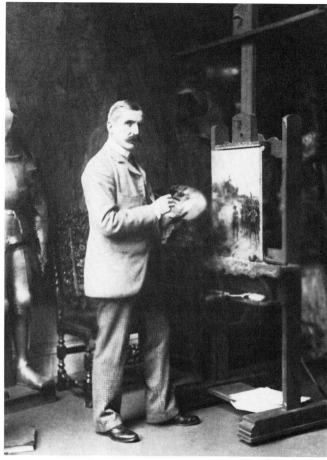

[130] [131]

'One morning coming down to breakfast Sir William Orchardson met Sidney Cooper coming in with a canvas under each arm. The old painter showed off his work to the young one and explained with pride that he painted two pictures before breakfast every morning in his life. [Orchardson said,] "No wonder his pictures are all alike and all equally bad; he has perfected his imperfections".'

Hilda Orchardson Gray, *The Life of Sir William Quiller Orchardson* (1930), p. 195

ERNEST CROFTS, RA (1847–1911)

A disciple of Meissonier (q.v.), he painted battle pictures, chiefly from the English Civil War, the Napoleonic and Franco-Prussian Wars.

131 Photograph by Ralph W. Robinson, 194 × 147 mm, published in *Members and Associates of the Royal Academy of Arts, 1891, photographed in their Studios* (1892). The picture on the easel is *Oliver Cromwell at Marston Moor* (1877). Note the armour in the studio: a prerequisite of any historical painter. *National Portrait Gallery, London*

'Crofts had a handsome face, a pleasant voice, and extremely refined manners.'

George Dunlop Leslie, RA, *The Inner Life of the Royal Academy* (1914), p. 63

ANDREW CARRICK GOW, RA (1848–1920)

Painter of military and historical subjects, portraits and genre.

132 Photograph by Ralph W. Robinson, 200 × 154 mm, published in *Members and Associates of the Royal Academy of Arts, 1891, photographed in their Studios* (1892). Note the historical props. *National Portrait Gallery, London*

'In striking contrast to [Marcus Stone] was the clever historical painter, A. C. Gow, the most unassuming of men.'

Allan Fea, *Recollections of Sixty Years* (1927), p. 214

GEORGE JONES, RA (1786–1869)

Painter of battle pictures, historical and military genre. Librarian of the Royal Academy, 1834; Keeper, 1840–50; acting President 1845–50.

133 *Carte-de-visite*, albumen print by John Watkins, London. Evidently Watkins, with his photographs of artists, was aiming to publish an album consisting of forty portraits of RAs and ARAs, as may be inferred from this letter from Jones to Watkins, dated 15 October 1865:

'Thanks, and many, for the sight of, your volume of my worthy colleagues – I am proud to be one of the Forty – vide – "Arabian Nights", yet their aspects are awful, I should appear like their Captain – Death – leading them to execution.

'Your able hand tells too much truth for me, but as you have Phoebus for your master, I must fly to Hades for escape, for I ought to be there already, however, when you have immortalized the thirty-nine, you shall not be deficient of the fortieth, though I hope that you will indulge me, as you have kindly done, for one gentleman, by shewing his back, which I dare say, with me, as with him, might prove the most satisfactory part, in your luminous and scientific development.

'I consider photography as a *Providential* discovery, to teach man how, *how* ugly he is, and your zeal in demonstrating the truth, places you among the philosophers of this, or

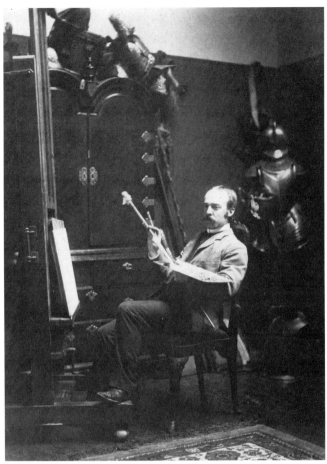

[132]

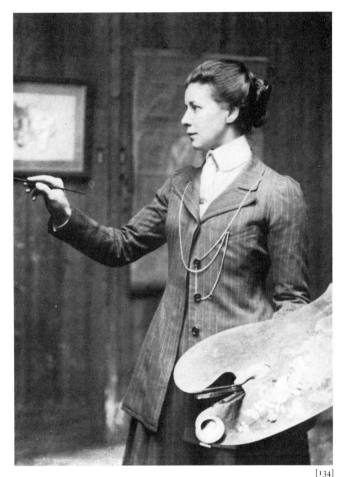

[134]

[133]

of any age, and it is only devotion to a cause, that can carry men, or Institutions, to a result that may be useful to mankind. . . .'

Photograph and letter: Author's collection

'Jones, whilst Librarian [of the Royal Academy], made no addition to the library. . . . Although it has been pretended that he framed an instructive catalogue, the less about it the better. . . . Jones, upon Hilton's death, exchanged the office of Librarian, to which he was appointed in 1834, for that of the Keepership. . . . There was nothing in the worthy man to warrant the selection. . . . Upon becoming Keeper Jones went abroad, for the purpose of informing himself of the course of instruction pursued in the foreign Schools of Art. No great result followed there from. . . . It is related of him that it was his habit to patrol nightly through the rooms of the Royal Academy armed with a sword, and attended by two porters carrying lanterns. Jones's Biography of his friend Chantrey was not a success. When the publisher pointed out to him its shortcomings . . . he answered Mr Longman by saying, "I am not a maker of books; I have done what I think right."'

Solomon Alexander Hart, RA *Reminiscences* (1882), pp. 42–6

'Mr George Jones, RA, . . . specially prided himself on his resemblance to the Duke of Wellington, and used to "dress up to the character". Some one mentioned the likeness to the Duke, and added, "It must be great, for people in the street often speak to him for your grace." "Very strange," muttered the great man, "no one ever spoke to me for Mr Jones!"'

Edmund Yates, *His Recollections and Experiences* (2nd edition, 1884), Vol. 1, pp. 25–6

Lucy Elizabeth Kemp-Welch (1869–1958)

Horse and animal painter and teacher of painting.

134 Mechanical process on postcard, *c.* 1900. *Author's collection*

'Once when she was painting a sketch for Mr King in Manor House Field, she noted in her diary: "Whilst at lunch cows came and licked the whole thing off; began again in the afternoon."

'While painting "The Incoming Tide" at Thurleston in South Devon in 1902, to achieve the effect she was seeking, she had to stand beneath the cliffs up to her waist in water, everyday for three weeks. This sort of work demanded a great deal of physical stamina. She almost literally threw herself into it and could easily lose all track of time. Frequently when disturbed for meals she couldn't remember whether it was breakfast, lunch, dinner or tea. These had no importance at all compared with her need to paint. . . .

'Her canvases were generally enormous so that the horses depicted were often life-size and certainly bigger than the artist herself. It was always a matter of astonishment for people meeting Lucy Kemp-Welch after seeing her pictures that so small a lady should possess such a man-size facility for describing animals with such veracity and power.'
David Messum, *The Life and Work of Lucy Kemp-Welch* (1976), p. 19

SIR EDWIN HENRY LANDSEER, RA (1802–73)

Animal, portrait and landscape artist, draughtsman, etcher and sculptor. This celebrated painter was much patronized by Queen Victoria and Prince Albert. Son of John (q.v.), brother of Thomas (q.v.) and Charles (q.v.) Landseer.

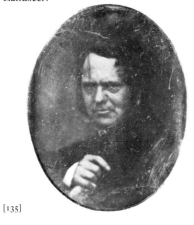

[135]

135 Daguerrotype by an unidentified photographer, oval, 55 × 44 mm, *c.* 1845. *Royal Photographic Society*

136 Cabinet portrait, albumen print, published by the London Stereoscopic & Photographic Company. This photograph was published by various photographers at differing times, usually as a *carte-de-visite*, suggesting that the copyright changed hands.
Her Majesty The Queen

Frith's daughter, Cissie, later Mrs Panton, met Landseer at about the age of 9: 'I was enraptured. He was small and compact, and wore a beautiful shirt with a frill in which was placed a glittering diamond brooch or pin, I do not know which; and he looked to me like one of his own most good-humoured white poodles. He was curled and scented and exquisitely turned out. . . . He spoke with a slight stutter or drawl.'
Mrs Panton, *Leaves from a Life* (1908), pp. 93–4

'He was a short, undistinguished-looking little man, with shy manners and a rough voice, and his grey beard and moustache gave him an unkempt appearance; but it was all redeemed

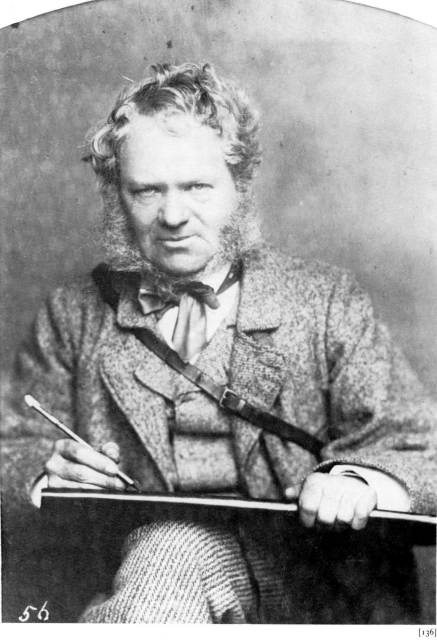

[136]

by the fine forehead and high brow, under which his bright sparkling eyes looked out with an expression of wistful interest and keen appreciation of whatever appealed to him or whatever he might be painting.'
Lady St Helier, *Memories of Fifty Years* (1909), p. 26

'BALMORAL 1st Oct, 1873. After luncheon heard that the great artist and kind old friend [Sir Edwin Landseer] had died peacefully at eleven. A merciful release, as for the last three years he had been in a most distressing state, half out of his mind, yet not entirely so. The last time I ever saw him was at Chiswick, at Bertie's garden party, two years ago, when he was hardly fit to be about, and looked quite

dreadful. He was a great genius in his day, and one of the most popular of English artists. It is strange that both he and Winterhalter, our personal, attached friends of more than thirty years' standing, should have gone within three or four months of each other! I cannot at all realise it. How many an incident do I remember, connected with Landseer! He kindly had shown me how to draw stags' heads, and how to draw in chalks, but I never could manage that well. I possess thirty-nine oil paintings of his, sixteen chalk drawings (framed), two frescoes, and many sketches.'

The Letters and Journal of Queen Victoria (1926), 2nd series, Vol. 2, pp. 282–3

BRITON RIVIERE, RA, MA, DCL
(1840–1920)

Animal painter. One of a very small number of artists to take an Oxford degree. In 1896 he lost the Presidency of the Royal Academy to Poynter (q.v.) by only a few votes.

137 Photogravure after J. P. Mayall, 215 × 160 mm, reproduced in *Artists at Home* (1884), by F. G. Stephens, facing p. 72. The animal painter's studio was usually much more untidy than this photograph suggests: it was no stranger to horses, dogs, geese and many other animals. He painted wilder beasts such as lions and leopards mainly from 'cumulative experience'. Like other animal painters he chose to live near London Zoo. *Author's collection*

ARCHIBALD THORBURN (1860–1935)

Animal painter and illustrator, especially of game birds. Son of Robert Thorburn, the miniaturist (q.v.).

138 Platinum print by an unidentified photographer, 350 × 112 mm. *Author's collection*

JOSEPH WOLF, RI (1820–99)

Animal and bird draughtsman, and illustrator of notable talent. Born in Germany, he came to England in 1848, where he was employed by the British Museum. He contributed to *Birds of Great Britain* by John Gould.

139 Photogravure by an unidentified photographer, 134 × 99 mm, *c.* 1870. Frontispiece to *The Life of Joseph Wolf* (1895), by A. H. Palmer.

'In answer to the tinkle of the bell at No. 2 Primrose Hill Studioes [*sic*], a tall, broad-chested old gentleman appears, pipe in hand, at a door which is fringed with climbing convolvulus and ivy. Happily there is nothing "artistic" about him, unless it be a knitted "Tam o'Shanter" cap. His hale, upright figure is clothed in the well-cut vestments of a quietly disposed Londoner (to whom eccentricity would be as unnatural as slovenliness), and his short, grey beard and moustache are neatly trimmed. A pair of very large round spectacles rests on a nose which has the strong angular bend of the Eagle's beak about it, but nothing of the semicircular Jewish curve. The wide nostrils appear to be drawn back so as to cause upon the cheeks the furrows to which the expression of the face is partly due. Behind the spectacles are very kindly, true-looking, grey eyes, in which a merry twinkle is not unknown.'

A. H. Palmer, *The Life of Joseph Wolf* (1895), p. 226

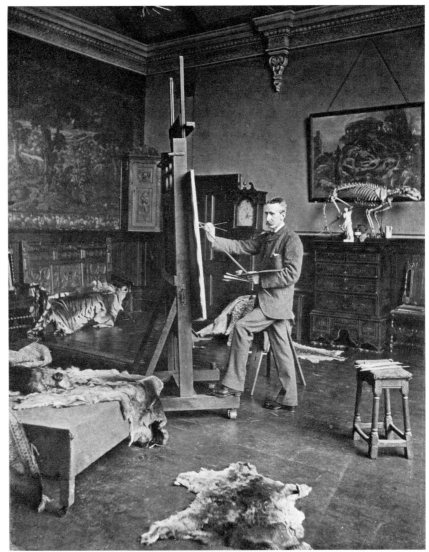

[137]

[138]

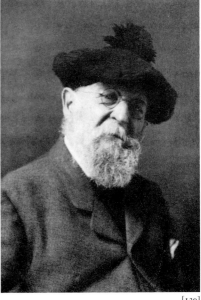

[139]

— 4 —
NUDE &
STILL-LIFE
PAINTERS

NUDE and still-life painting flourished during Queen Victoria's reign, the former not without a little difficulty. The 'great frost of Victorian prudery', as Kenneth Clark called it, was always a formidable obstacle. Legs were called 'limbs'; one carved not the white breast of a chicken but its 'bosom'; people never went to bed, they 'retired'; nude statues in stately homes were sometimes draped. Prudery on the one hand and prurience and unabashed enjoyment of nudity in art on the other led to strange inconsistencies in public attitudes. George Du Maurier complained of the low *décolletages* he saw at dinner parties, yet there were always flagrantly, voluptuously nude paintings to be seen at the Royal Academy. That nude painting came to survive at all may seem surprising, but the reasons for its survival are threefold and simple. First was the prestige of art in general and 'High Art' in particular. As the sculptors found, the human form was God's highest creation, and the celebration of it was perfectly consistent with high ideals, purity and innocence. The prestige of classical art as a civilizing influence in an expanding middle-class society was generally acknowledged. This neo-classicism was successively maintained by Flaxman, Canova, Thorwaldson, Gibson and most sculptors up to the last few decades of the nineteenth century. There was general enthusiasm for classical antiquity, which gained further respectability as an attraction to the academic mind. But even without these high-minded sentiments some of the new class of patrons, the hard-headed business men of the Midlands, cared little for such preciosity and revelled in pictorial nudity without a care in the world. That great patron of artists Joseph Gillott once saw a girl, *décolletée* and voluptuous, run out of a house in the Clerkenwell Road, and rushed her off to Etty to pose for a picture. Etty himself despatched a 17-year-old girl to

Constable claiming 'all in front' to be 'memorably fine'.

There were several art schools in London where painting from the undraped form was taught, notably Sass's and Heatherley's, and nude models also posed at the Langham Sketch Club in Clipstone Street. And there was always the Life School at the Royal Academy. Even so, arguments raged throughout the century on the propriety of the life class. In 1860 an indignant member named George Haddo, fired with moral zeal, put forward a motion in the House of Commons that government subsidies to art schools should be withdrawn where it was discovered that students were painting from the naked female model: he had found that no less than four out of twelve of these schools had adopted this practice. Happily, that motion was defeated by a large majority. But this did nothing to silence the persistent braying of the puritan lobby. A lady signing herself 'A British Matron' wrote a letter to *The Times* attacking nude painting. The cause was taken up by J. C. Horsley, RA, who read a paper to the Church Congress of 1885, earning himself the nickname 'Clothes Horsley' and Whistler's quip 'Horsley soit qui mal y pense'.

But the lowest depths of absurdity were plumbed when women were persistently barred from seeing that which they already possessed, a female body. To little avail Louise Jopling complained that 'it is no shock to a girl to study from life'. Some, like Lady Butler, simply gave up: she devoted herself to painting large battle pictures. Others resorted to the calmer waters of still-life painting. One of the few who braved the critics was Henrietta Rae, who had studied from the naked form at a class for women run on co-operative principles. Even so, when she exhibited a diaphanous *Ariadne* at the Royal Academy she was attacked by another morally indignant person, who urged her 'to

pause upon the brink' before subverting her artistic gifts in such a manner.

There were, in fact, many Victorian painters who excelled at painting the nude, particularly those of the neo-classical school – Leighton, Poynter, Albert Moore and Alma-Tadema. Earlier in the century William Mulready had shown a remarkable talent for drawing from the nude, while F. R. Pickersgill, who was much influenced by Etty, often painted romantic nude subjects. Later, both Sargent and Wilson Steer painted superb nude subjects, as did Conder, Whistler and Sickert. But the two artists most readily associated with nude painting were William Etty and William Frost. Etty's nude paintings were often defiantly voluptuous, painted with evident relish. All his life he had to parry the onslaughts of the critics who, in that pious age, could be sure of support. Frost's nudes were more delicate, pearl-tinted and less provocative. Coincidentally, both these artists were gentle, shy, sweet-natured men who led blameless lives and were much loved by their contemporaries. Etty and, to a much lesser extent, Frost were also able painters of still-life.

Away from the turbulent eddies of hostility which swirled around the painters of the nude, the world of the still-life painters presents a more placid picture, albeit a paradoxical one. Still-life painting prospered in response to the increasing materialism of the wealthy middle classes and to the exhortations of Ruskin to pursue the earnest study of nature. Interest in geology is evident in his own work and in that of those artists whom he praised, like John Brett. But it was William Henry Hunt who brought the art of rustic still-life painting to its finest expression. Others, like George Lance, were more in the tradition of the sophisticated Dutch still-life school. At the end of the Queen's reign, William Nicholson painted still-lifes with a refinement rarely achieved by other painters. At the opposite extreme was Marianne North who, spurning the blandishments of the studio, spent her lifetime in jungles, mountains and plains throughout the five continents, painting rare and exotic plants in the service of botany and art, to the ultimate ruination of her health.

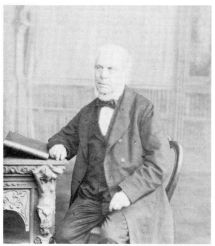

[140]

VALENTINE BARTHOLOMEW (1799–1879)

Flower painter, as was his second wife Anne Bartholomew (1800–1862). Appointed Flower Painter-in-Ordinary to Queen Victoria.

140 Uncut proof albumen print by Ernest Edwards, 76 × 70 mm, 1865, published in *Portraits of Men of Eminence* (1866), by A. W. Bennett, Vol. 4. The artist wrote to Bennett on 6 May 1865:

'I received through my friend Mrs Alfred Watts your notes and the numbers of the Photographic Portraits which I consider most successfully executed. I shall have most pleasure in complying with your request and will communicate with Mr Ernest Edwards and arrange for a sitting.

'I will do my best to supply you with such matter as will enable you to put together a short memoir to accompany the Photograph.' *Author's collection*

WILLIAM ETTY, RA (1787–1849)

Together with William Frost (q.v.), Etty was one of the most celebrated British painters of nudes of the century. He also painted portraits and still-lifes.

141 Calotype by David Octavius Hill (q.v.) and Robert Adamson, 208 × 157 mm, taken on 16 October 1844. Etty visited Edinburgh with his brother Captain Charles Etty and his niece, later Mrs Binnington, in October 1844, as guest of honour at a Royal Scottish Academy dinner. This and another photograph from the same sitting were later used by Etty in painting a self-portrait. *Sotheby's*

On the train to Rome in 1822: 'The third seat was occupied by a short thin young man with very light hair, his face marked with the small-pox, very gentle in his manner, with a shrill

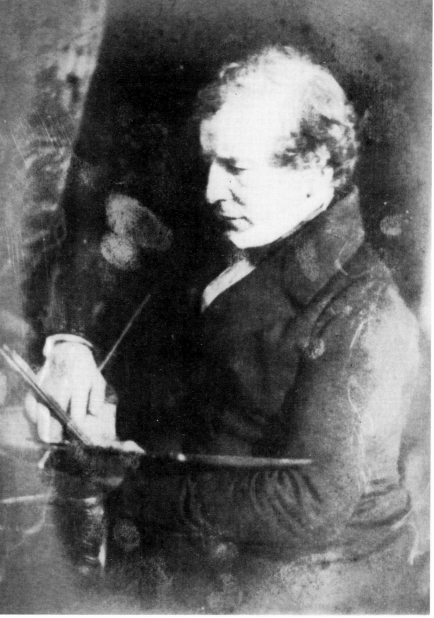

[141]

and feeble tone of voice, whom we found a very accommodating and agreeable travelling companion, and whom through all his after-life I found a very warm friend.'
(William) *Macready's Reminiscences, and Selections from his Diaries and Letters* (1875), ed. by Sir Frederick Pollock, Bt., Vol. 1, p. 266

'Etty, as I remember him, was short and stout, with rather a large head, dressed in a frock coat tightly buttoned, and close-fitting trousers, a costume often seen in the illustrations to Dickens's earlier novels.'
George Dunlop Leslie, RA, *The Inner Life of the Royal Academy* (1914), p. 145

WILLIAM EDWARD FROST, RA (1810–77)

After Etty (q.v.), the most celebrated painter of nudes of his day. Again like Etty, he had a shy retiring personality.

142 Albumen print by an unidentified photographer, 173 × 143 mm, *c.* 1852. *Author's collection*

'W. E. Frost, RA, was another perfect "old dear", unaffected, simple and almost stone deaf; and as sweet and gentle in nature as he was true and tender in his work.'
Mrs E. M. Ward's Reminiscences (1911), ed. by Elliott O'Donnell, p. 177

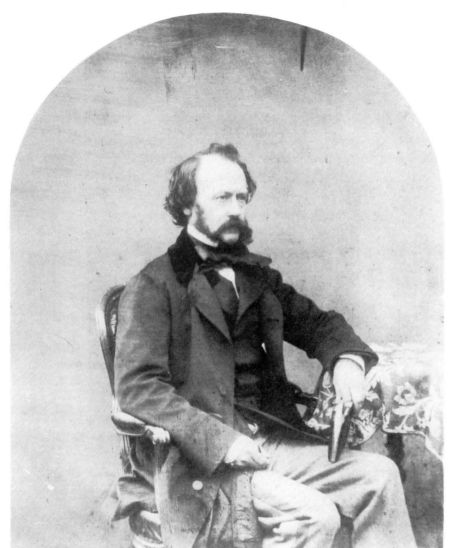

[142]

GEORGE LANCE (1802–64)

Still-life painter and pupil of B. R. Haydon.

143 *Carte-de-visite*, albumen print by Maull & Co., London, *c.* 1858. *Author's collection*

'George Lance – whom all esteemed and many loved for his very kindly nature, suave and gentle manners, and generous sympathies – painted fruit and "still life" as few ever painted them before or since: he sought, in vain, admission into the Academy, although year after year, for very many years, his pictures were leading attractions of the Exhibitions. He was of the middle height, with dark, abundant hair and striking exterior.'

Samuel Carter Hall, *A Book of Memories of Great Men and Women of the Age* (1877), p. 490

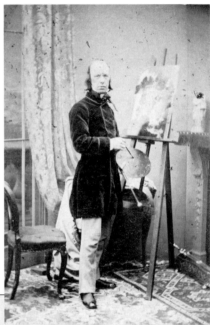

[143]

ALBERT DURER LUCAS (1828–1918)

Flower painter and son of the sculptor Richard Cockle Lucas.

144 Daguerrotype by an unidentified photographer, 70 × 57 mm. Enclosed in the case is a note in the artist's hand: 'My shirt collar is dirty and the reason is that I had that morning been removing the screen from the Models of the Parthenon during the closed week of the Museum in Dec^r 1845 A. D. Lucas'. *Author's collection*

My shirt collar is dirty and the reason is that I had that morning been removing the screen from the Models of the Parthenon during the closed week of the Museum in Dec^n 1845

A.D. Lucas.

[144]

ANNIE FERAY MUTRIE (1826–93)
MARTHA DARLEY MUTRIE (1824–85)

Sisters, who were painters of fruit and flower pictures. They exhibited their separate pictures at the Royal Academy and elsewhere for about thirty years, from the early 1850s to the early 1880s.

145 *Carte-de-visite*, albumen print by Maull & Co., London, *c.* 1860. *Author's collection*

[145]

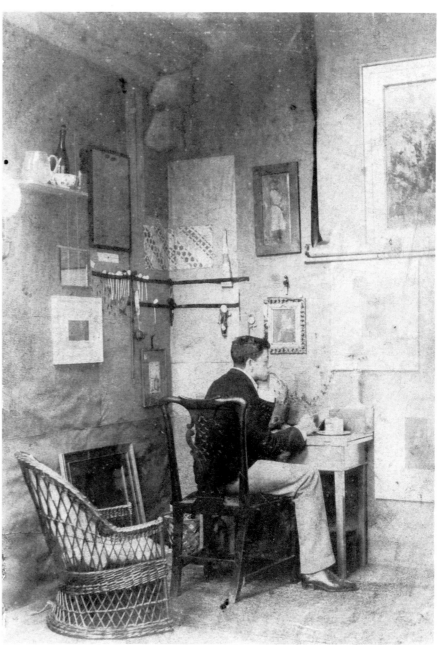

[146]

SIR WILLIAM NICHOLSON (1872–1949)

Studied under Sir Hubert von Herkomer (q.v.). Became a painter of portraits, landscapes and still-life, being notably skilled at the latter.

146 Photograph taken in a billiard room lent to the young artist by his father to serve as a studio in his house at Newark.
Phyllis Graham

'William Nicholson was a friend of my father's in his early days. As a boy I remember his coming to Streatham where we lived for many years. He looked very youthful, I recall, at a distance but old and worn in appearance at close quarters. He gave the same impression later in life.'

Oliver Brown, *Exhibition: Memoirs* (1968), p. 146

— 5 —

WATER-COLOURISTS

THE most commonly painted subject in Victorian times was landscape and the medium most widely employed was water-colour. Painting in water-colours was considered to be, like playing the piano, one of the accomplishments of a well-educated and civilized person, particularly for women. However, while women comprised the majority of amateur water-colourists, very few became professionals, until the latter half of Victoria's reign. And even then, suitable subject matter appeared to be garden scenes, at which Helen Allingham and Mildred Anne Butler excelled, or fanciful book illustration like that of Eleanor Vere Boyle, Beatrix Potter and Kate Greenaway. There were, of course, exceptions. Pretty, ideal subjects were increasingly painted from the 1870s onward, notably by Marie Spartali and Edith Martineau. When travelling on the Continent, besides keeping a diary, it was customary for the ladies in the party to paint views. These, like photographs, found their way into albums, and are now often regarded as white elephants by the descendants of the artists, who view them with concern and despair, because, while they ought somehow to be kept out of family loyalty, they are often (judged by professional standards) of mediocre quality.

When Queen Victoria came to the throne in 1837 the professional water-colour tradition in Britain, which had its origins in the middle of the eighteenth century, was in a vigorous state, many of its greatest practitioners being young and with much of their careers still to run. In fact, it is sometimes disconcerting, in a medium so strongly associated with an earlier period, to be reminded of the number of exponents of this art who became respectable Victorians. The list is headed by the greatest of them all – Turner – and includes David Cox, Peter de Wint, J. S. Cotman, W. H. Hunt, J. Scarlett Davis, David Roberts, J. F. Lewis,

W. J. Müller, James Holland, Joseph Nash, T. S. Boys (whose best work was done before the early 1840s), Copley Fielding, John Varley and Samuel Palmer. William Callow was born seven years before Queen Victoria in 1812, the year of Napoleon's retreat from Moscow, and died seven years after her death, in 1908, the year that Wilbur Wright flew an aeroplane for 30 miles in 40 minutes.

Cox, de Wint and Constable can be conveniently grouped together as the three artists who, together with Turner (in another manner altogether), may be considered as the main begetters of the nineteenth-century landscape water-colour. Constable in particular had set the example of the naturalistic treatment of landscape, which became the fundamental aim of the water-colour school. Turner, with his eruptions of prismatic iridescence, set a more difficult example. Famously championed by Ruskin, Turner had no really able followers until long after his death, those being Alfred Hunt and Albert Goodwin, the latter presumably having been influenced by his friendship with Ruskin. Ruskin himself was, as is well known, not only an influential critic, prose stylist, lecturer and social philosopher, but a water-colourist of extraordinary refinement, his subjects reflecting his interests and travel. He practised what he preached: 'Go to nature in all singleness of heart, selecting nothing, rejecting nothing.' Hence the studies of rock formations, botanical specimens, birds and architecture. His interests coincided very much with the Victorian interest in natural history in all its forms.

Water-colour artists were very conscious of the traditions of working in that medium and jealous for the integrity and future direction of their profession. This resulted in the innumerable institutions set up in its name. In the early years of the century the Royal

Academy provided the only arena for the display of water-colours, but there they were relegated to badly lit rooms, 'skyed' and hung in juxtaposition with oils considered too inferior to be placed in the Grand Exhibition Room at Somerset House, where the Academy then was. Hence the foundation in 1804 of the Royal Society of Painters in Water-Colours. This body, after various vicissitudes, survives as the Old Water-Colour Society, still flourishing in its new home, by the Thames. Water-colourists could now exhibit freely on their own terms.

After several years the water-colour societies began to proliferate, with frequent and often bewildering changes of name, constitution and address, and usually founded in a secessionist spirit as splinter groups from earlier institutions. There emerged as the two main bodies, at the end of the century, the Royal Society of Painters in Water-Colours (otherwise the Old Water-Colour Society) and the Royal Institute of Painters in Water-Colours (which had been formed in 1831 as the New Society of Painters in Water-Colours). The societies were strongly conservative in their traditions, being suspicious of alien techniques such as the excessive use of body-colour and *louche* or esoteric subject matter. Nudity was especially unwelcome. Such rigidity led to famous *frissons* when artistic movements collided. One of the most gentle and uncontentious artists of the period, Burne-Jones, became an associate of the Old Society in 1863 and made his début there in 1864 with four of his pictures. (It is probably at about this date that the status-conscious *carte-de-visite* photographer John Watkins lured him into his studio. See Plate 178.) These four pictures were all 'skyed' and were met with abuse from other members and the press. He continued to exhibit there, but mounting conflict with the society came to a head in 1870 when he was accused of painting an indecent picture, *Phyllis and Demophöon*, whose treatment owed much to the influence of Giorgione, Carpaccio and the example of Rossetti, and which today would be regarded as not even mildly erotic. Burne-Jones promptly resigned his membership, but this treatment became a memory which rankled until the end of his life.

The experience of Burne-Jones draws attention to an interesting facet of nineteenth-century British painting. Whereas in the eighteenth century oil and water-colour painting was rarely combined in one artist, there were few artists in the following century who were not equally proficient in both media. To mention but a few: amongst landscape, marine and animal painters, Creswick, T. S. Cooper, Lear, Martin, Danby, Turner, Lewis, Roberts, Müller and Sargent were all outstanding water-colourists; and amongst figure and subject painters, nearly all Pre-Raphaelite and neo-classical painters were excellent water-colourists and draughtsmen, as were Frost, Elmore, Dadd, Mulready and Gregory.

Three artists, all of whom were more or less distinguished in the medium of water-colour, became excellent photographers. Philip Delamotte, Professor of Drawing at King's College, became a calotypist, then a collodion photographer and author of a number of books on photography; William Lake Price took photographs for only eight years, but his achievement was outstanding (Plate 9); even more so was that of David Octavius Hill and Robert Adamson; and the water-colourist Sir J. D. Linton was a keen amateur photographer of considerable merit.

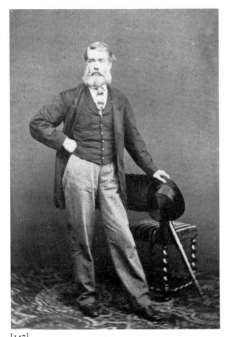

[147]

[149]

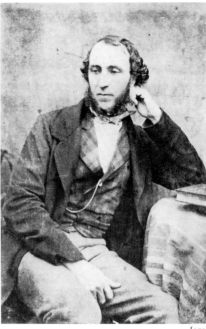

[150]

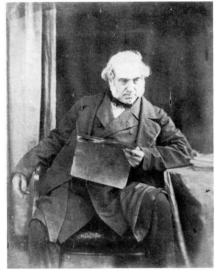

[151]

JOHN ABSOLON (1815–95)

Painter in oils and water-colours, and an illustrator.

147 *Carte-de-visite*, albumen print, *c.* 1860. *Author's collection*

HELEN ALLINGHAM (née Paterson), R W S (1848–1926)

The wife of William Allingham (q.v.), whom she married in 1874. A popular and prolific painter of water-colours, mainly of country cottages.

148 Duplicate of a photograph; whereabouts now unknown

[148]

MADAME EUGÈNE BODICHON (née Barbara Leigh Smith) (1827–91)

Amateur painter and water-colourist, who married a French diplomat. She was a famous philanthropist and one of the founders of Girton College, Cambridge.

149 *Carte-de-visite*, albumen print by Disderi, Paris, *c.* 1860. In front of the artist, to the left, is Princess Murat, her husband's niece. From the collection of the Rossetti family. *Mrs Imogen Dennis*

'[8 November 1853] Ah if you were only like Miss Barbara Smith! a young lady I met at the Howitts', blessed with large rations of tin, fat, enthusiasm, and golden hair, who thinks nothing of climbing up a mountain in breeches, or wading through a stream in none, in the sacred name of pigment.'
D. G. Rossetti to Christina Rossetti in *Letters of Dante Gabriel Rossetti* (1965), ed. by O. Doughty and J. R. Wahl, Vol. 1, p. 163

WILLIAM CALLOW, R W S (1812–1908)

Painter of sea-pieces and picturesque buildings, mainly on the Continent. He was a teacher with many distinguished pupils, including the children of Louis Philippe.

150 Calotype by an unidentified photographer, 140 × 102 mm, *c.* 1845. *Private collection*

GEORGE CATTERMOLE (1800–68)

Chiefly known for his figure subjects, most of them of a historical character.

151 Calotype by an unidentified photographer, 200 × 165 mm, *c.* 1850. *Private collection*

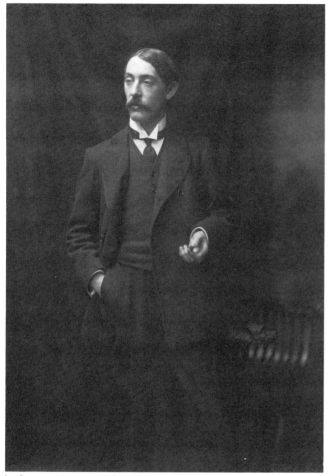

[152]

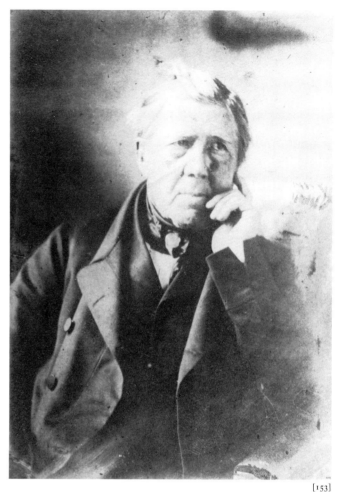

[153]

CHARLES CONDER (1868–1909)

Best known for his delicate water-colours on silk, some of which were fan designs. Descended from Roubiliac, the sculptor, he was a mild person of *fin de siècle* decadence.

152 Platinum print by H. Walter Barnett, London, 196 × 145 mm. *Given to the author by Mrs Helen Pawson, the artist's niece*

'Thin and ruddy of complexion, his long hair falling lankly like a bather's, Charles's fine head stood out darkly against the wall washed with yellow in the Whistler style. . . . Conder was like Oscar Wilde as Toulouse Lautrec drew him. . . . Ash lay thick on his nankin trousers, on the carpet, on the chintz covering the sofa. He smoked sixty large cigarettes a day. Furtively he left us at lunch time to go up to his room, where he wiped off what he had painted, or to spoil a canvas which he had that morning begun, half sodden with drink.'

Jacques-Emile Blanche in 1904 in *The Life and Death of Conder* (1938), by Sir John Rothenstein, pp. 198–9

DAVID COX, Sr, RWS (1783–1859)

Highly accomplished and prolific painter of English and Welsh scenery, mostly in water-colours, sometimes in oils.

153 Calotype by an unidentified photographer, 134 × 94 mm, *c*. 1855. *Private collection*

'There was nothing about him that was showy, in person, manner, or surroundings. In all ways he was artless and simple as a child. In person he was ever scrupulously clean and neat; in dress plain and unpretending. . . . David Cox was a sociable, companionable man, by no means shy or reserved in manner. Without being at all what is understood as a talker, or aiming at conversation, he was "chatty" and agreeable, always showing the nice feeling of a gentleman.'
William Hall, *A Biography of David Cox* (1881), pp. 190, 196

EDWARD DUNCAN, RWS (1803–82)

Painter mostly of marine subjects.

154 Calotype by an unidentified photographer, 136 × 102 mm, *c*. 1848. *Private collection*

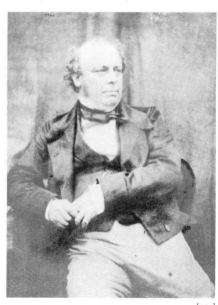

[154]

'There was really nothing of the sailor about Duncan. The "rolling deep" was never "his home". What he knew of these matters he mostly picked up ashore in the society of sea-captains and the like. . . .'
John Lewis Roget, *A History of the Old Water-Colour Society* (1891), Vol. 2, p. 309

MYLES BIRKET FOSTER, RWS (1825–99)

Water-colourist and illustrator. His early work was confined almost entirely to illustration, drawing huge numbers of illustrations on to woodblocks. In about 1859 he limited himself almost completely to water-colours, mostly of children frolicking in landscapes.

155 *Carte-de-visite*, albumen print by Cundall, Downes & Co., London. The prints are unidentified. *Author's collection*

'Tall and erect, no one would credit that he is over sixty years of age, whilst his open countenance and hearty welcome quite belie the somewhat stern appearance in which his portraits always clothe him.'
Marcus B. Huish, *Birket Foster, his Life and Work* (1890), p. 23

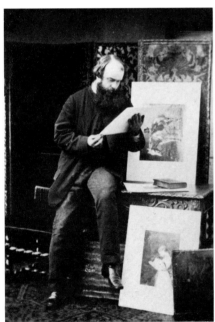

[155]

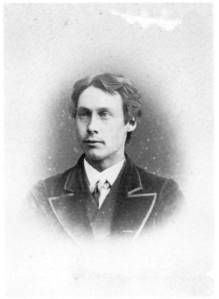

[156]

ALBERT GOODWIN, RWS (1845–1932)

Painter in water-colours and oils. His subjects were landscape and sometimes highly imaginative allegorical and biblical subjects. One-time pupil of Arthur Hughes (q.v.), Ford Madox Brown (q.v.) and John Ruskin (q.v.). Taught Lord Clark art at Winchester College.

156 *Carte-de-visite*, albumen print by an unidentified photographer, *c.* 1865. From the collection of T. Hamilton Trist, wine merchant from Brighton and patron of artists. *Author's collection*

'. . . we all knew him to be a singularly honest and straightforward man.'
The Professor, Arthur Severn's Memoir of John Ruskin (1967), ed. by James Dearden, p. 62

JAMES DUFFIELD HARDING, OWS (1797–1863)

Water-colourist and writer on art.

157 Calotype by an unidentified photographer, 142 × 107 mm, *c.* 1850. *Private collection*

'I found him a cheerful – indeed, a delightful man, full of information and very entertaining.'
T. Sidney Cooper, *My Life* (1890), Vol. 1, p. 230

GEORGE JAMES HOWARD, 9TH EARL OF CARLISLE, HRWS (1843–1911)

Amateur artist, and pupil of Alphonse Legros (q.v.) and Giovanni Costa. He was on intimate terms with Burne-Jones (q.v.), Leighton (q.v.) and Watts (q.v.). When conditions permitted he was rarely seen without a sketchbook in hand.

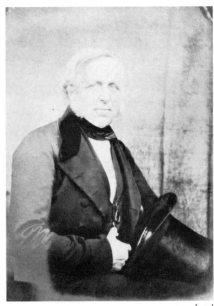

[157]

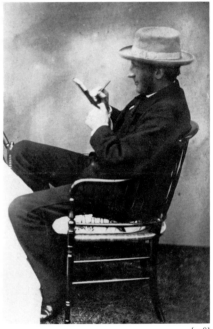

[158]

158 Albumen print by an unidentified photographer, 95 × 67 mm, *c.* 1864. *Author's collection*

'He was a man of remarkable social charm, though not free from moods of cynicism and irony.'
Dictionary of National Biography

WILLIAM HENRY HUNT, OWS
(1790–1864)

One of the great water-colourists of the nineteenth century. Much of his early work was of a delicate topographical nature. His middle and later work was strong in rich harmonious colouring. Excelled at interiors with women, and at fruit and flower pieces. He was nicknamed 'Bird's Nest' Hunt.

159 Albumen print by an unidentified photographer, *c.* 1860. The palette in the artist's left hand is now with the Royal Water-Colour Society. *Victoria & Albert Museum, London*

'[8 April 1854. Rossetti] told me in conversation that W. H. Hunt had a morbid conviction of his own ugliness and desired that all record of him to the present in the way of portraits or letters should be destroyed.'
The Diaries of George Price Boyce (1980), ed. by Virginia Surtees, p. 13

'A very little man he was, almost a dwarf, with a big head, but with a kindly and pleasant countenance, as pure and simple as the cowslip he loved to paint.'
Samuel Carter Hall, *A Book of Memories of Men and Women of the Age* (1877), p. 490

'No one at first sight – unless his head was seen first – would have suspected him to be a great man. He had a splendid cranium, otherwise he was diminutive and deformed, and with no pretension to polish. . . . Hunt was a born painter, a real genius. In this he shone as a bright star. But he was not otherwise brilliant. His deformed figure must have kept him from society, had his tastes been that way – which they were not. Nor did his education fit him for it. Those, however, who could appreciate the man found him genial and pleasant in company. He was habitually good-humoured. I do not remember ever seeing him lose his temper. He would "confisficate" anything that worried him, but beyond that temperate degree of malediction I never knew his thermometer to rise.'
William Collingwood in the *Magazine of Art* (1898)

'His deformity consisted in weak legs, not properly attended to in childhood, so that his knees and toes turned in, and he could only shuffle along.'
John Lewis Roget, *A History of the Old Water-Colour Society* (1891), Vol. 2, p. 191n

SAMUEL JACKSON (1794–1869)

British-born water-colourist and friend and pupil of Francis Danby (q.v.). (See Plate 15.)

SIR JAMES DROMGOLE LINTON, PRI
(1840–1916)

Painter in water-colours, mainly of figure subjects. Painted also some portraits and historical pictures in oils. He was an experienced amateur photographer, who often used his photographs as an aid to painting. Became President of the (Royal) Institute of Painters in Water-Colours in 1884; also first President

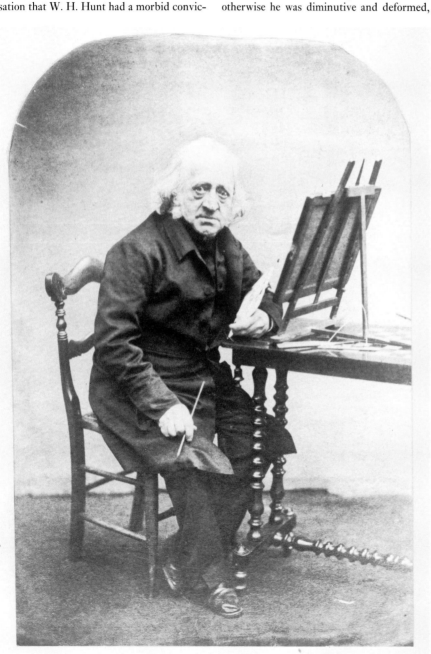

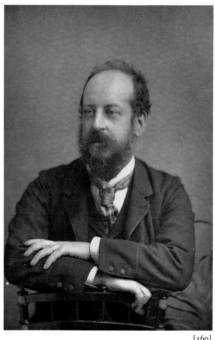

of the Royal Institute of Oil Painters from 1883 to 1897. Knighted in 1885.

160 Carbon print by W. & D. Downey, London, 140 × 93 mm, published in *The Cabinet Portrait Gallery* (1890), 1st series. *Author's collection*

'He was a typical Bohemian in appearance. His hair hung down over his shoulders, he favoured a Titian-shaped beard and moustache, a salmon-coloured tie and brown velvet coat; his eyes were intelligent, his face refined, and he smoked good cigars, which he handed round in a liberal fashion.'
Harry Furniss, *My Bohemian Days* (1919), p. 62

JOSEPH NASH (1808–78)

Water-colourist and lithographer, skilled at architectural drawing.

161 *Carte-de-visite*, albumen print by John Watkins, London. *National Portrait Gallery, London*

[162]

[161]

OCTAVIUS OAKLEY, RWS (1800–67)

Water-colourist, first in portraits then landscapes with gypsies, for which he became famous.

162 *Carte-de-visite*, albumen print by Cundall, Downes & Co., London. *National Portrait Gallery, London*

'Of somewhat elegant appearance, and comparatively slight in physique. . . .'
John Lewis Roget, *A History of the Old Water-Colour Society* (1891), Vol. 2, p. 269

[163]

SAMUEL PALMER, RWS (1805–81)

Painter in water-colours and oils, and an etcher. One of the most remarkable British artists of the nineteenth century. His creative years spanned the years from his friendship with Blake, the visionary Shoreham period, and his friendship with John Linnell (q.v.), whose son-in-law he became in his later years, until his death.

163 *Carte-de-visite*, albumen print by Cundall, Downes & Co., London, *c.* 1865. *Private collection*

'If you've a mangy cat to drown, christen it "Palmer".'
Letter to George Richmond, 19 August 1835, in *The Life and Letters of Samuel Palmer* (1892), by A. H. Palmer, p. 189

'Palmer's lack of social adroitness, of ability in superficial verbal insincerities with rich patrons was a handicap to him. He looked odd, and moved awkwardly: a bespectacled man in an ill-fitting frock coat with pockets bulging with artists' materials. In October 1837 an official at the *mairie*, Calais, described him on his passport as "*Agé de 32 ans, taille un mètre 73 centimètres, cheveux châtain-clair, sourcils –* [illegible], *front haut, yeux bleus, nez fort, bouche moyenne, barbe châtain; menton rond, visage ovale, teint coloré.*" Although "average mouth" tells us little, the high forehead, strong nose, auburn hair, combined with a red, round face add up to a striking picture.'
Edward Malins, *Samuel Palmer's Italian Honeymoon* (1968), p. 19

JOHN SAMUEL RAVEN (1829–77)

Water-colourist. Most of his paintings are of Scotland, Wales and Sussex, and his work shows a marked Pre-Raphaelite influence. His sister married Henry Holiday (q.v.). Raven died from drowning while bathing.

164 Albumen print by an unidentified photographer, *carte-de-visite* size. From the collection of J. Hamilton Trist, wine merchant from Brighton and patron of artists. *Author's collection*

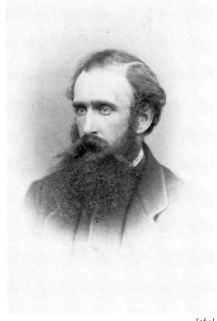

[164]

FREDERICK SMALLFIELD, ARWS (1829–1915)

Painter in oils and water-colours; his works sometimes reveal the influence of the Pre-Raphaelites. A slight but genuine talent.

165 *Carte-de-visite*, albumen print by an unidentified photographer, *c.* 1860. *Author's collection*

JOHN FREDERICK TAYLER, PRWS (1802–89)

Water-colourist who studied under Horace Vernet and shared a studio with Bonington in Paris. His subjects were mainly sporting and country scenes and historical illustrations.

166 Calotype by an unidentified photographer, 136 × 101 mm, *c.* 1845. *Private collection*

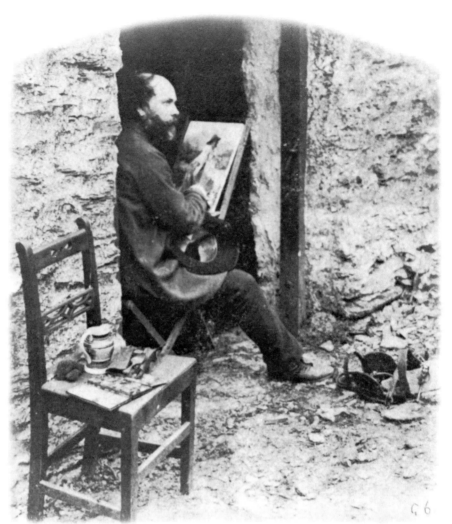

[167]

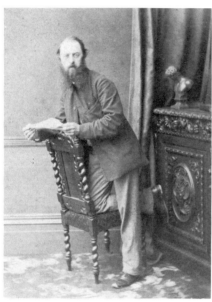

[165]

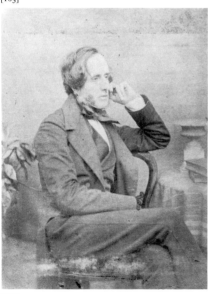

[166]

[168]

FRANCIS WILLIAM TOPHAM (1808–77)

By turns calligraphic, heraldic and line engraver, he subsequently became a water-colourist. The drawings he made in Spain in 1852–3 were very popular.

167 Photograph of the artist sketching out of doors. *Tom Pocock, Esq., grandson of the artist*

LOUISA, MARCHIONESS OF WATERFORD (1818–91)

Amateur water-colourist and occasional painter in oils. She was the daughter of Lord and Lady Stuart de Rothesay and a celebrated beauty in her youth. She married the Marquis of Waterford, who was killed some years later in a hunting accident. She was on friendly terms with Ruskin (q.v.), Burne-Jones (q.v.) and G. F. Watts (q.v.).

168 Cabinet portrait, albumen print by F. J. Bright & Son, Bournemouth, signed and dated 1890. *Her Majesty The Queen*

'[25 June 1855] A Stunner. . . .'
D. G. Rossetti to William Allingham in *Letters of Dante Gabriel Rossetti* (1965), ed. by O. Doughty and J. R. Wahl, Vol. 1, p. 257

'[28 May 1861] Last evening I dined with Lord Lansdowne. . . . The beautiful Lady Waterford was there, and I had a long talk with her. She is rather handsomer than when I saw her seven years ago – a little stouter, and certainly the *noblest-looking woman I ever saw.*'
Sir John Everett Millais in *The Life and Letters of Sir John Everett Millais* (1899), by J. G. Millais, Vol. 1, p. 363

SIR ERNEST ALBERT WATERLOW, RA, PRWS (1850–1919)

Painter in water-colours and oils of landscape and animal subjects. He was elected President of the Old Water-Colour Society in 1897. Knighted in 1902.

169 Photograph by Ralph W. Robinson, 202 × 153 mm, published in *Members and Associates of the Royal Academy of Arts, 1891, photographed in their Studios* (1892). The picture on the easel has not been identified. *National Portrait Gallery, London*

'The Ernest Waterlows were there on their honeymoon, and I can remember the exquisite vision of Mrs Waterlow, of them both indeed, for he was a handsome young man, and they were a fitting couple, like the prince and princess of a fairy tale. She was tall and fair, and wore her beautiful hair in two long plaits down her back.'
A. M. Reynolds, *The Life and Work of Frank Holl* (1912), p. 133

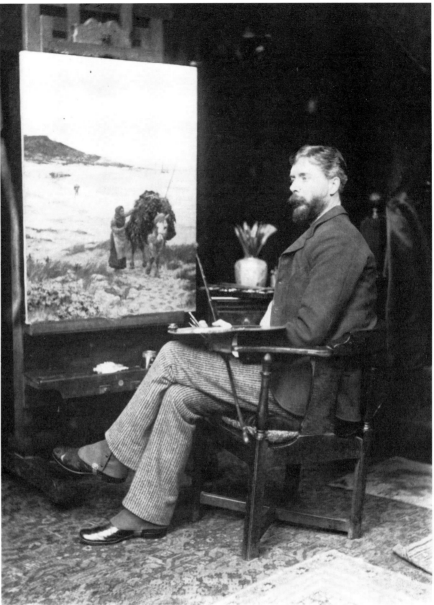

[169]

THE PRE-RAPHAELITES & THEIR FOLLOWERS

PRE-RAPHAELITISM was not only the most influential art movement ever to be initiated in Britain – some would say that it is the only movement to be initiated here – but also the most widely documented. Indeed, the wealth of documentation is so prodigious and detailed that it has even become a source of envy and the object of derision to scholars of Renaissance and pre-Renaissance art who, when scratching about for crumbs of information about artists whom they consider to be superior in every way, regard it as being out of all proportion to the true merit of its artists.

Much of Pre-Raphaelite literature grew out of the desire of its proponents and their descendants to set the record straight for posterity. William Michael Rossetti was the first to chronicle the life and works of his more celebrated brother, usually with a scrupulous regard for truth and fairness, in numerous books and articles. Holman Hunt, to redress the balance, published his massive *Pre-Raphaelitism and the Pre-Raphaelite Brotherhood* in 1905. This was followed by an even larger version in 1913, after his death, edited by his widow Edith. Both of these editions had been preceded by William Bell Scott's *Autobiographical Notes*, published posthumously in 1892. This caused considerable annoyance owing to the slighting references to Rossetti, with whom he was considered to have professed a lifelong friendship. Sidney Colvin went further and added that it was 'a book . . . which I have found almost unfailingly inexact in every one of its statements that I have had means or occasion to check.' It is, however, still a valuable record, and its defects even have the positive effect of countering uncritical adulation of Rossetti. Then followed *Ford Madox Brown, A Record of his Life and Work* by Ford Madox Hueffer (changed later to Ford), the artist's grandson, in 1896. Another massive biography, this time of

Millais, rather carelessly written by his son J. G. Millais, was published in two volumes in 1896.

The later phase of Pre-Raphaelitism is represented by a further two volumes in 1904, the *Memorials of Burne-Jones*, by his widow Georgiana. Add to these the sympathetic critical attention lavished on the Pre-Raphaelites by two original members of the Brotherhood, F. G. Stephens and W. M. Rossetti, art critics for the *Athenaeum* and the *Spectator* respectively, not to mention the diaries of G. P. Boyce and William Allingham, together with the publication of letters to the latter by Rossetti and other members of the circle; the writings of Hall Caine; the recent publication of Rossetti's letters; and recent exhibition catalogues – all this amounts to only a fraction of the available documentation. Most of the members of this circle were articulate, while some were highly literate, and vast collections of their letters are conserved in libraries and museums in England and America.

So familiar is the history of the formation of the Brotherhood that I will do no more here than barely trace the outlines. It had its origins in a revolutionary impulse to regenerate art, and this had its roots in various movements in art, such as the pious idealism of the German Nazarene School, the fashion for botanical observation, the intensification of scientific inquiry, the High Church movement, the revolt against worn-out creative conventions, and the fallacious sentimentalism of many contemporary painters; but above all the desire to seek purity and truth by emulating the manner of artists before the time of Raphael. Although the idea that the invention of photography had anything to do with the movement has often been dismissed, I cannot see the force of the argument. William Bell Scott, who was one of the earliest associates, wrote, 'Every movement has its genesis, as every flower its seed; the seed

of Pre-Raphaelism [*sic*] was photography.' Like many ardent movements initiated by young men, it was all rather muddled, but no less vigorous for that.

The movement was absolutely revolutionary in the truest sense of the word, and its immediate impulse grew out of the general revolutionary spirit of 1848 to which almost every capital in Europe fell victim. John Everett Millais and William Holman Hunt had each just delivered a painting for the Royal Academy Summer Exhibition when they witnessed sympathetically the great procession of Chartist demonstrators bound from Kennington Common to Westminster on 10 April 1848. Together they decided that the moment was ripe for a revolt in painting, and enlisted the enthusiastic support of the mercurial Dante Gabriel Rossetti, who was already tiring of the rigid artistic discipline imposed upon him by Ford Madox Brown, whom he had sought out as a teacher. Rossetti became the galvanizing force and gave the movement its first sense of direction, even if it was slightly erratic. For no very good reason, except perhaps because he lived next door, Rossetti enrolled Thomas Woolner, the sculptor. Again for no really discernible reason, James Collinson, 'a born stunner', was enlisted. A more plausible recruit was Rossetti's brother, William Michael, who was to become secretary to the group. Finally, Hunt introduced Frederic George Stephens, who made several attempts to become a painter before finally deciding to take up writing on art. Thus was the Pre-Raphaelite Brotherhood formed.

The writings of John Ruskin, whose *Modern Painters* had begun to be published in 1843, contained an exhilarating endorsement of their aims. In a much-quoted passage Ruskin urged young artists

. . . to go to Nature in all singleness of heart and walk with her laboriously and trustingly, having no other thoughts but how best to penetrate her meaning and remember her instruction; rejecting nothing, selecting nothing and scorning nothing; believing all things to be right and good, and rejoicing always in the truth. Then when their memories are stored and their imaginations fed, and their hands firm, let them take up the scarlet and gold, give reins to their fancy and show in what their heads are made of.

Again and again throughout his early writings Ruskin urged the spirit of truth to nature. This apparent advocacy gave the Pre-Raphaelites timely encouragement when their aims became known and the wrath of the Old Guard and the critical establishment came down on them. Although throughout the ensuing years painters of the old school such as Frith, Cope, Horsley, Creswick, Roberts and others never ceased to heap derision on the Pre-Raphaelites, their own work began to show a noticeable improvement in technique, with even a Pre-Raphaelite touch here and there, most discernible in the work of Frith, one of the more articulate of their critics.

Paradoxically, as the Brotherhood itself began to weaken and disintegrate within a matter of some three years of its inception, as a general movement it began to gather momentum. Before long, any young painter was faced with the choice of either embracing its aims or following a more traditional path. Two of the Old Guard, Augustus Egg and William Dyce, became closely associated with the movement, while a slightly younger artist, but older than the Pre-Raphaelites themselves, Ford Madox Brown, became one of its leading exponents. A host of major artists from the middle years of the century became closely identified and are regarded as Pre-Raphaelite painters; these included Arthur Hughes, Frederick Sandys, James Smetham, William Windus, C. A. Collins, Thomas Seddon and Robert Martineau. Two painters, Henry Wallis and W. S. Burton, are remembered for a single Pre-Raphaelite masterpiece each – *The Death of Chatterton* and *The Wounded Cavalier* respectively. One sculptor, Alexander Munro, a friend of Arthur Hughes, came under the spell, and executed a few imaginative works before succumbing to discouragement and ill-health.

The three leading members of the original Brotherhood soon went their several ways. Rossetti painted ideal visions from the world of Dante and Beatrice, balanced variously between painting and poetry. His special contribution was the linking of the world of the Pre-Raphaelites with the world of literature, and he also added a further dimension by somehow allowing his friends and associates to invade the world of paintings, by making them pose for him. As one gains familiarity with his pictures, so, increasingly, they become a mirror image of his lively circle. Millais, the most naturally talented of them all, painted some of the finest pictures of his period before forsaking the rigours of Pre-Raphaelite technique and adopting a freer manner and ever more sentimental subject matter in a bid for popularity and worldly success. Holman Hunt was an unrepentant Pre-Raphaelite to the last. A far slower worker than Millais, each picture was to him like one of the labours of Hercules. Selecting nothing and rejecting nothing until after even Impressionism had

passed into history, he toiled away until he wore his eyes out, and was blind during his last years.

The second, more amorphous, phase of Pre-Raphaelitism began with the meeting of Edward Burne-Jones and William Morris as undergraduates at Oxford, and their discovery of Ruskin and Pre-Raphaelite pictures. Burne-Jones saw the work of Rossetti in 1855 and met him and Ruskin for the first time in January 1856. He promptly took some thirty informal lessons from Rossetti and by 1860 he was a painter. The friendship of Morris and Burne-Jones with Rossetti, Ruskin and Madox Brown, in particular, ensured the continuing development of Pre-Raphaelitism. Morris's poetry was the later counterpart to the poetic element in Rossetti, and Burne-Jones evolved a special kind of ideal female beauty from the earlier example of Rossetti. He lived to become an internationally celebrated painter, while the establishment of the firm of Morris, Marshall, Faulkner & Co., with Rossetti, Madox Brown and Burne-Jones as co-directors, channelled Pre-Raphaelitism into stained glass, wallpapers, furniture and fabrics. Inevitably, this second wave of Pre-Raphaelitism was more diffuse, more vitiated and more vulnerable to alien influences, such as the cult of Aestheticism, which had its origins in the doctrine of *L'Art pour L'Art* formulated in the works of Gautier and Baudelaire and, later, in England, in the writings of Walter Pater.

To this later phase of Pre-Raphaelitism belong such figures as the dissolute Simeon Solomon, the beautiful Marie Spartali, the asthmatic Spencer Stanhope, J. M. Strudwick, T. M. Rooke (Burne-Jones's studio assistant), Charles Fairfax Murray and Evelyn De Morgan. Mention might be made, if only because he seems to defy classification, of J. W. Waterhouse, for although he was undoubtedly influenced by Burne-Jones, he was decidedly not a Pre-Raphaelite.

It is not merely the paintings of the Pre-Raphaelites that make these artists so compelling as a group,

although between them they produced some of the great masterpieces of the nineteenth century. It is their enormous influence upon the art and literature of the time, the strain of romanticism which lasted well into the twentieth century, their friendships, their diaries and letters, their women, the extraordinary good looks of nearly all the men when young, their habit of posing for each other's works, but above all the legacy of their paintings, now the nucleus of all the English collections in the great provincial galleries. The movement had its adherents in all branches of art from portraiture to sculpture, to illustration, to the manufacture of artefacts, even to modes of behaviour and dress. One of the original members of the PRB became PRA (Hunt's joke not mine), but this elevation was not intended in any way as condonation or recognition of the movement, for Millais had long since ceased to be identified with its original aims. In personal terms, Millais's defection and his acceptance as one of the most popular painters of his day was a symptom of wider and almost complete disintegration of Pre-Raphaelitism. It comes as something of a shock to read the doleful summary of the ensuing animosities recorded by William Michael Rossetti in his *Reminiscences*, written with all the wisdom and tolerance of old age:

It is a sad and indeed humiliating reflection that, after the early days of *camaraderie* and of genuine brotherliness had run their course, followed by a less brief period of amity and goodwill, keen antipathies severed the quondam P.R.B.s . . . Woolner became hostile to Hunt, Dante Rossetti, and Millais. Hunt became hostile to Woolner and Stephens, and in a minor degree to Dante Rossetti. Stephens became hostile to Hunt. Dante Rossetti became hostile to Woolner, and in a minor degree to Hunt and Millais. Millais, being an enormously successful man while others were only commonly successful, did not perhaps become strictly hostile to anyone; he kept aloof however from Dante Rossetti, and I infer from Woolner.

GEORGE PRICE BOYCE, RWS (1826–97)

Water-colour painter and friend of the Pre-Raphaelites. His diaries, reissued in 1980 (ed. by Virginia Surtees), make delightful reading and are an important source book.

170 Photograph by David Wilkie Wynfield (q.v.). *Royal Academy of Arts*

'Boyce was a well-grown young man, of agreeable person and address.... He was very unlucky in the way of accidents, breaking a leg more than once, etc.: however, these mishaps did not greatly affect him in the long run, and he attained a good old age.... Intercourse with Boyce was always, in my experience, pleasant and easy: he was not readily ruffled, but had somewhat precise and punctilious habits, characteristic of an art-collecting bachelor.'
William Michael Rossetti, *Some Reminiscences* (1906), Vol. 1, p. 153

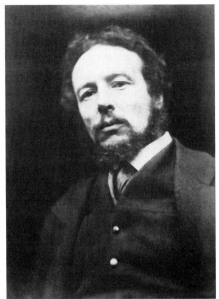

[170]

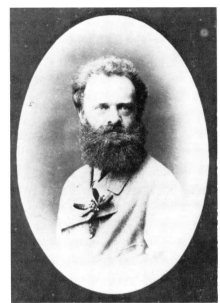

[171]

JOHN BRETT, ARA (1830–1902)

A painter of coastal scenes and landscapes, Pre-Raphaelite in technique, with the later works tending towards geology and botany in subject.

171 *Carte-de-visite*, albumen print by Garnier Arsene, Guernsey, *c.* 1860. *P. J. Brett, Esq.*

172 Photograph of John Brett, his wife Mary and their seven children, by an unidentified photographer, *c.* 1885. *P. J. Brett, Esq.*

'[6 April 1895] He is a prodigiously hairy person, a forest which invades even his ears and the end of his nose.'
The Journal of Beatrix Potter from 1881 to 1897 (1966), ed. by Leslie Linder, p. 364

'[12 May 1863] When we came to talk of Brett, about whom [Rossetti] knew Ralston and myself to be interested, he spoke with so much unfairness & malignity of Brett as a man and as a painter, that Ralston's warm-hearted sensitive nature closed up at once into silence, and I was as indignant as he. Brett is opinionative and *entêté*; true: therefore Rossetti called him insufferable, ignorant, and (with unconscious irony) the very opposite of himself(!).'
Munby, Man of Two Worlds: The Life and Diaries of Arthur J. Munby 1828–1910 (1972), ed. by Derek Hudson, p. 160

'His Putney house was designed entirely on utilitarian principles. The floors and flat roofs were of asphalt, the ceilings brick vaults, the heating done by hot water pipes, everything to minimise human labour and avoid dirt. The house was electrically protected against burglars and other uninvited intruders.'
Dictionary of National Biography

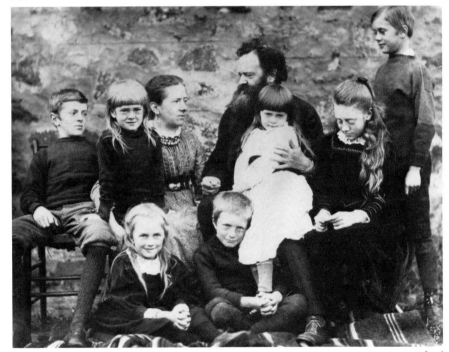

[172]

FORD MADOX BROWN (1821–93)

Although he had studied in Belgium under Baron Wappers, he became associated with the aims and ideals of the Pre-Raphaelite Brotherhood. While he achieved only modest fame and success during his lifetime, he is now regarded as one of the most important British artists of his age.

173 (on p. 96) Photograph, possibly taken in Liverpool in November 1858 by a photographer named Lee. Brown wrote to his wife Emma: 'Yesterday I ... had my photograph taken by a man named Lee the same person who took Windus's picture. They took 3 before a satisfactory one was obtained. The last one is very like me I believe but looks intensely knowing and conceited.' Madox Brown was, for much of his working life, plagued by gout in the hands. For obvious reasons he did all he could to disguise his complaint: most of his photographs show him with one or both hands in his pockets, or wearing a glove and sometimes concealing his other hand in it. *Private collection*

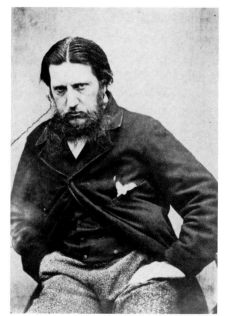

[173]

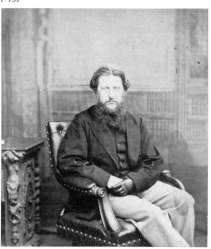

[174]

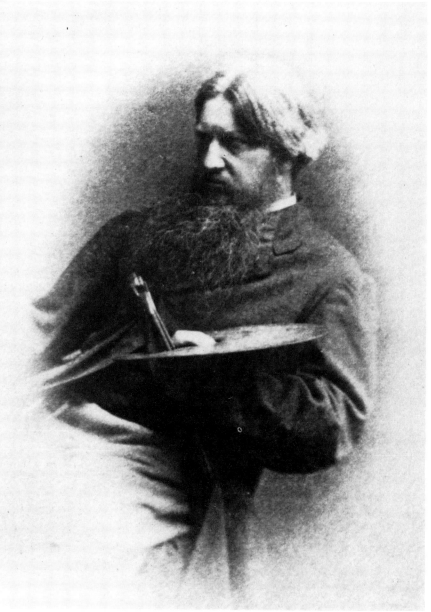

[175]

174 Uncut proof, albumen print by Ernest Edwards, 87 × 78 mm, 1865. Another from the same sitting was published in *Portraits of Men of Eminence* (1866) Vol. 4. On 25 April 1865 Brown wrote to the publisher, Alfred W. Bennett: 'I shall be very happy to give the necessary sitting to Mr Edwards and otherwise facilitate your object. . . . Perhaps someday next week would suit for the sitting.' *Photograph and letter: Author's collection*

175 Platinum print by Frederick Hollyer (q.v.), taken in about 1870. *Royal Photographic Society*

176 Cabinet portrait, albumen print by William Pae, Newcastle-upon-Tyne, inscribed by the artist. Given to the author by Miss Joan

Linnell Ivimy, great-granddaughter of John Linnell (q.v.). *Author's collection*

'[As a young man] he was of middling stature, with a thoughtful, resolved, and well-moulded face; as to actual good looks he improved as he got older, and was at his best towards the age of forty, and as an oldish man was impressively patriarchal. What struck us at first more than his personal aspect was his slow, deliberate, uniform voice, slow but in no way hesitating, nor wanting in copiousness of discourse.' William Michael Rossetti, *Some Reminiscences* (1906), Vol. 1, p. 136

'He was one of the kindest, gentlest, handsomest old gentlemen that ever lived. . . . His cheeks were pink, and he had blue eyes, and his hair fell straight down on both sides of his face nearly to the bottom of his ears, and my grandmother cut it straight and even all the way round behind. It was wonderfully thick and pure snow white, and so was his beard. He wasn't very tall, but his shoulders were broad, and he looked somehow grand and important.'

Juliet Soskice, *Chapters from Childhood* (1921), p. 30

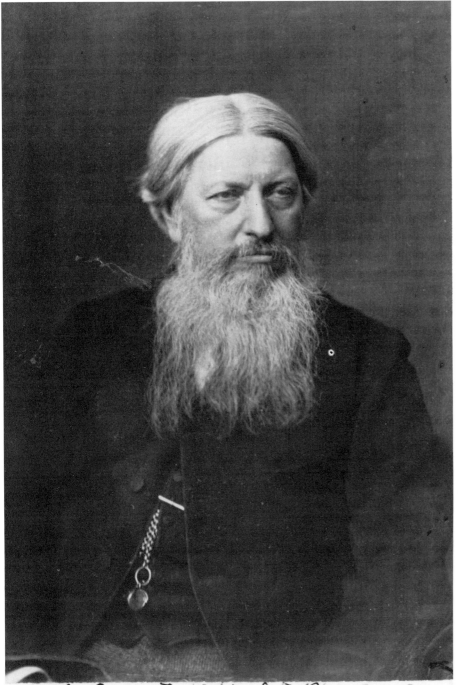

[176]

OLIVER MADOX BROWN (1855–74)

Son of Ford Madox Brown (q.v.), who had a precocious, albeit short-lived, career as a novelist and painter.

177 Photograph by Frederick Hollyer (q.v.). *Royal Photographic Society*

'When he was about fourteen or fifteen he commenced wearing glasses, and used them to the end of his life. . . . His hair was brown, streaked with gold, and was worn parted down the centre. His eyes were grey.'
John H. Ingram, *Oliver Madox Brown* (1883), p. 227

'A wonderfully clever youth. . . . I seem to re-member that young Madox Brown had quite a fancy for toads, frogs, snakes, and other kinds of reptiles not often found in private houses.'
William Tinsley, *Random Recollections of an Old Publisher* (1900), p. 282

[177]

SIR EDWARD COLEY BURNE-JONES, BT.
(1833–98)

The most celebrated artist of the later Pre-
Raphaelite School, and the one who acquired
the greatest international reputation. He was
a painter in oils and water-colours, although
he preferred the use of mixed media; he was
also a designer for stained glass and tapestries.

178 *Carte-de-visite*, albumen print by John
Watkins, London. One of the earliest surviv-
ing photographs of the artist and not hitherto
published. It was discovered in a *carte-de-
visite* album, inscribed underneath 'E. B.
Jones'. In accordance with the practice where-
by *carte* photographers approached artists
when they had been elected to prestigious
societies, it was probably taken in 1864 when
Burne-Jones was elected an Associate of the
Old Water-Colour Society. *Author's collection*

179 Photogravure after B. Scott & Son, Car-
lisle, 156 × 90 mm. Burne-Jones, aged 41, was
photographed at Naworth Castle, Cumber-
land, seat of his friend George Howard, 9th
Earl of Carlisle (q.v.). *Author's collection*

[179]

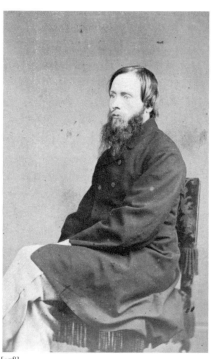

[178]

[80]

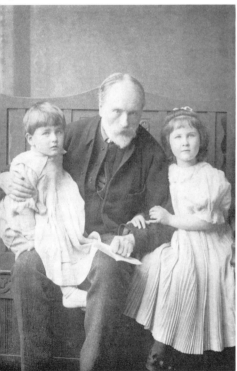

[81]

180 Photograph by Barbara Leighton, 1890, of the artist painting *The Star of Bethlehem* in the garden studio of The Grange, his London house. The painting was commissioned by the Corporation of Birmingham. *Private collection*

181 Platinum print taken by H. & R. Stiles, London, 151 × 102 mm, 1895, showing the artist with two grandchildren, Denis Mackail (1892–1971) and Angela Thirkell (1890–1961), both to become novelists. *Author's collection*

'Burne-Jones was a man of fair stature, with a clear but pale complexion, deep-set eyes very serious and candid-looking, a noticeably spacious high forehead, and yellowish hair, which had thinned before he became elderly. His manner was very gentle, and utterly alien from any vaunting self-assertion. . . . His nature had the musical ring of glass, not the clangour of iron.'
William Michael Rossetti, *Some Reminiscences* (1906), Vol. 1, pp. 209–10

'Jones's face melts all away into its smile like a piece of sugar candy – he is white and fair – I never saw so beautiful an expression in any other person's face, I mean – an expression of that kind carried to the same degree – all done in *Light* – the lips hardly smiling at all.'
John Ruskin to Margaret Bell, 6 April 1859, in *The Winnington Letters* (1969), ed. by Van Akin Burd, p. 157

EDWARD CLIFFORD (1844–1907)

A rather peripheral figure in later Pre-Raphaelite circles who specialized in portraiture and biblical subjects. Made several exact copies of Burne-Jones's pictures. Later in life he worked for the Church Army.

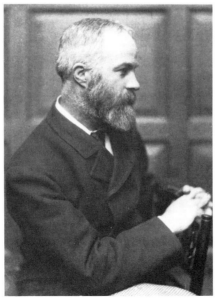

[182]

182 Platinum print by Frederick Hollyer (q.v.), 1887. *Royal Photographic Society*

'Farther along [in Kensington Square] was Edward Clifford who so astonishingly united a deep and active feeling of religion, a passion for duchesses, and a marvellous gift of water-colour painting. . . . He lived with a very tall friend whom we knew simply as "the giant". Clifford is dead now, with his funny affected voice, his strange mixture of romantic snobbism and religion, his kindness and capacity for friendship.'
Angela Thirkell, *Three Houses* (1931), pp. 37, 39

CHARLES ALLSTON COLLINS (1828–73)

The son of William Collins, RA, brother of Wilkie Collins (q.v.) and son-in-law of Charles Dickens (q.v.). In 1858 he gave up a brief but talented career in painting to become a writer.

183 Uncut proof *carte-de-visite*, albumen print by Charles Watkins, London. *Author's collection*

'He was slight, with slender limbs, but erect in head and neck, and square in the shoulders; although not broad, a very proper man, having beautifully cut features, large chin, a crop of orange-coloured hair, and blue eyes that looked at a challenge without sign of quailing.'
William Holman Hunt, *Pre-Raphaelitism and the Pre-Raphaelite Brotherhood* (1905), Vol. 1, pp. 293–4

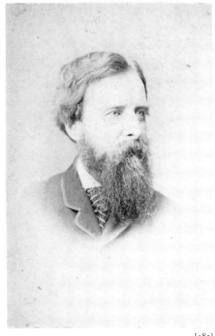

[183]

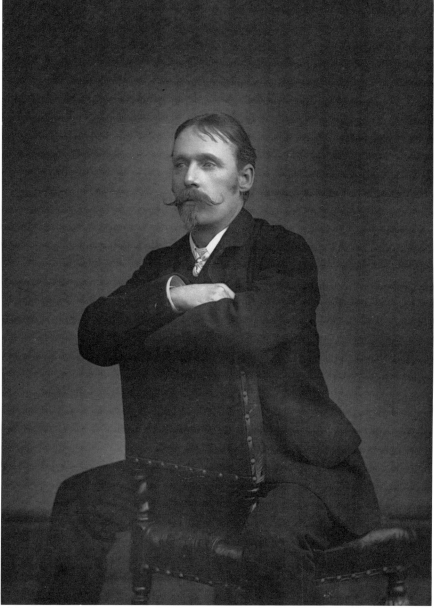

[184]

WILLIAM DE MORGAN (1839–1917) MRS WILLIAM DE MORGAN (née Evelyn Pickering) (1855–1919)

William was a painter and designer of pottery, tiles, ceramics and stained glass. During the last years of his life he became a successful novelist. Evelyn, who married William in 1887, was a pupil of her uncle, R. Spencer Stanhope (q.v.). Her pictures were inclined to the Symbolist School.

185 Cabinet portrait, gelatine silver print by Montabone, Florence. Inscribed on the reverse: 'William De Morgan, an excellent likeness'. *Author's collection*

186 Cabinet portrait, albumen print by Montabone, Florence. Inscribed on the reverse: 'Evelyn De Morgan, taken in Italy (too dark)'. *Author's collection*

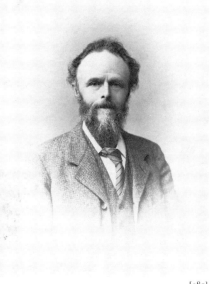

[185]

[186]

WALTER CRANE, R W S (1845–1915)

Decorative artist of versatile talents: he painted allegorical and other figure subjects, landscapes and portraits. He was also an illustrator and designer of textiles, wall-papers and room interiors; and he wrote books on design.

184 Carbon print by Barraud, London, 247 × 180 mm. *Author's collection*

'Kindly, gentle Walter Crane; I fear that life was rather a disappointment to him. He was hardly strong enough to bear the burden of his own great gifts which were, in a way, a misfit and made for a bigger man. His art did not advance, its movement rather was retrograde. He was shy and without self-confidence, making few friends and seeming to find communication with his fellow-men increasingly difficult. He looked weary: a friend of mine, meeting him for the first time towards the end of his life, exclaimed passionately to me, "No man has the *right* to be so dull".'

W. Graham Robertson, *Time Was* (1931), p. 42

187 Snapshot by Charles H. Davis, of New York, 195 × 240 mm, of William and Evelyn De Morgan in a gondola, Venice, in 1914. The De Morgans wintered in Florence every year from 1890 to 1914. *Author's collection*

'My first impression of him was that of a tall man, slender of figure, with a curiously striking physiognomy. So unusual was the development of his head and wide brow that it seemed to throw the rest of his face out of proportion, making his features appear smaller than was actually the case. I promptly recognized all manner of strange possibilities in that remarkable head; but it took half a life-time to appreciate to its full the unvarying sweetness and gentleness of disposition which was combined with his fine, versatile intellect. De Morgan could be strong and yet tender; determined and yet unfailingly gentle. . . . It was indeed characteristic of William and Evelyn De Morgan in later years that few people mentioned them without a smile. Their delightful irresponsibility, their dauntless pluck, their complete lack of worldly wisdom and their selfless absorption in their work, their unvarying knack of viewing the great things and the small of life from a standpoint all their own, rendered them refreshingly unique.'
A. M. W. Stirling, *Life's Little Day* (1925), pp. 224, 233–4

'One evening I met at dinner William De Morgan, whose artistic tiles were then being sold in a Brompton shop window. No one surely ever started as a professed writer of fiction at an age so advanced, and his artist-wife it was who saved his first *brouillon* from the flames. He seemed to me very frail himself, very unobtrusive, and in no way buoyant, a memory rather than a force.'
Walter Sichel, *The Sands of Time* (1923), p. 223

LOWES CATO DICKINSON (1819–1908)

Successful portrait painter and friend of the Pre-Raphaelites.

188 Calotype by an unidentified photographer, 131 × 103 mm, *c.* 1850. *Private collection*

HENRY TREFFRY DUNN (1838–99)

Engaged by D. G. Rossetti (q.v.) as studio assistant in 1869; he helped with backgrounds. He also acted as secretary and managed Rossetti's house in Cheyne Walk until 1881.

189 *Carte-de-visite*, albumen print by J. Mitchell, Pydar Street, Truro. Inscribed on the reverse: 'Harry Treffry Dunn'. *Private collection*

'He was a man of middle height, with a narrow visage, a rather dark but ruddy complexion, dark, telling eyes, and a full crop of hair, prematurely grey.'
William Michael Rossetti in the prefatory note to *Recollections of Dante Gabriel Rossetti and his Circle* (1904), by Henry Treffry Dunn, ed. by Gale Pedrick, p. 7

[188]

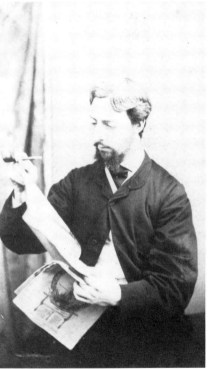

[189]

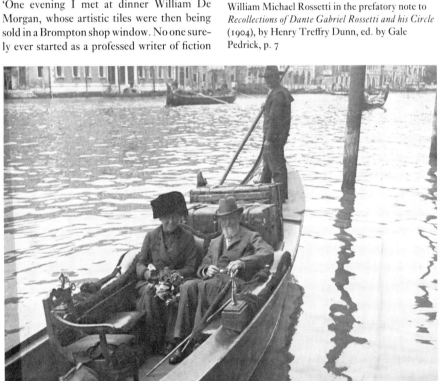

[187]

WILLIAM DYCE, RA (1806–64)

An artist of many talents. His paintings are mythological, historical and biblical; his later work was much influenced by Pre-Raphaelitism. He was also a scholar and musician.

190 *Carte-de-visite*, albumen print by John and Charles Watkins, London. *Author's collection*

'One of the least agreeable, and most dry and half-sneering mannered men I have ever met.'
Sarah Spencer, Lady Lyttelton, in *Correspondence of Sarah Spencer, Lady Lyttelton* (1912), ed. by the Hon. Mrs Hugh Wyndham, p. 368

'A very gentlemanly man, of attractive exterior, with a fine intellectual head, and expressive, if not particularly handsome features; wanting, perhaps, in warmth of character and fervour of feeling – disadvantages that affected his manners and influenced his works.'
Samuel Carter Hall, *A Book of Memories of Great Men and Women of the Age* (1877), p. 492

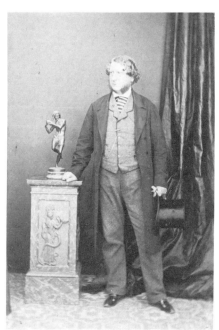

[190]

HENRY HOLIDAY (1839–1927)

Painter and worker in stained glass, after an earlier very promising career as an illustrator.

191 Albumen print, probably taken by a brother of Mrs Robert Newall (née Lee Pattinson) in 1871, 130 × 92 mm. The suit of chain-mail (a studio prop) was also worn by Effie Newall (q.v.). From Henry Holiday's collection. *Author's collection*

192 Silver bromide photograph, taken by London News Agency Photos Ltd in about 1905, 154 × 205 mm. From Henry Holiday's collection. *Author's collection*

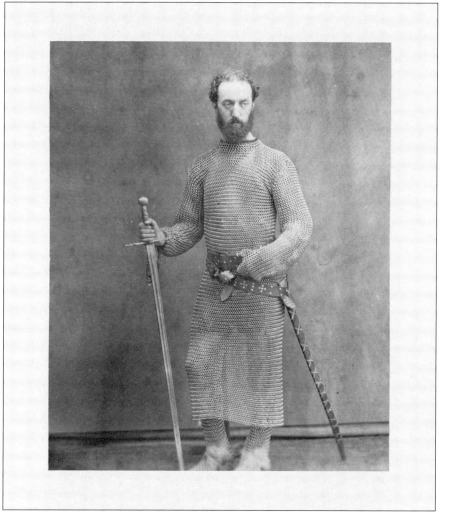

[191]

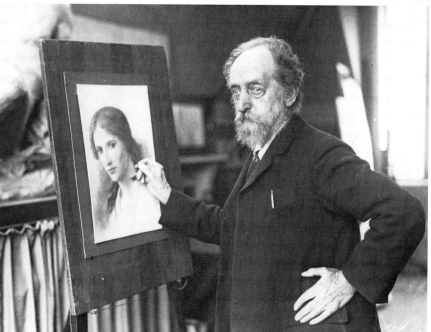

[192]

'His *Reminiscences of my Life*, published in 1914, convey a vivid impression of his exceptional personality and undoubted gifts, even if his mind cannot be described as having been either profound or original.'
Dictionary of National Biography

ARTHUR HUGHES (1832–1915)

One of the most talented painters who came within the Pre-Raphaelite influence. Some of his best-known works are *April Love, Home from the Sea, The Long Engagement* and *The Tryst*. His superb talent in painting declined after about 1870, but much of his skill, however, survived in his book illustrations.

193 Albumen print, probably by W. & D. Downey, South Shields. The address of the photographer does not prove so much of a mystery as at first appears. Downey had studios in London and Newcastle-upon-Tyne. There was probably also a branch at South Shields, which is only a few miles from the latter. Two identical *cartes-de-visite* (author's collection) show Hughes in another pose at the same sitting. One belonged to John Munro, son of Alexander Munro (q.v.), and the other to Holman Hunt (q.v.) who wrote on the reverse: '1858 about. Taken in ante room of Munro's studio', which was in London. Both these *cartes* have a small paper label with the photographer's name and 'South Shields' address carelessly stuck on the reverse; this is very uncharacteristic of *carte-de-visite* photographic firms, which normally printed their addresses in a flamboyant style. This suggests that the label was a temporary measure. *National Portrait Gallery, London*

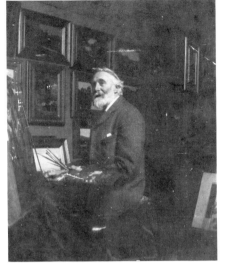

[194]

194 Gelatine silver print by an unidentified photographer, 100 × 75 mm. Sent to F. G. Stephens (q.v.) as a New year's greeting card in 1906. *Author's collection*

'Mr Arthur Hughes, who is still living and very young for his years, was, when I first knew him, an Academy student just starting as an exhibiting painter. His face, giving evidence of his Welsh parentage, was singularly bright and taking – dark abundant hair, vivid eyes, good features, and ruddy cheeks which earned him among his fellow-students the nickname of "Cherry". If I had to pick out, from amid my once-numerous acquaintances of the male sex, the sweetest and most ingenuous nature of all, the least carking and querulous, and the freest from "envy, hatred and malice, and all uncharitableness", I should probably find myself bound to select Mr Hughes.'
William Michael Rossetti, *Some Reminiscences* (1906), Vol. 1, p. 147

WILLIAM HOLMAN HUNT, OM, RWS (1827–1910)

An original member of the Pre-Raphaelite Brotherhood and the only painter to remain faithful to its principles to the end. One of the most important scriptural painters of the nineteenth century. With Frith (q.v.), Goodall (q.v.) and E. M. Ward (q.v.), Hunt was one of the most photographed artists of his age.

195 *Carte-de-visite*, albumen print by Elliott & Fry, London, taken late in 1865, together with the *carte* of Fanny Waugh (q.v.). In a letter to Mrs Tennyson, dated 29 November 1865, Hunt tells her of their engagement, encloses a photograph of the portrait of himself and one of Fanny and writes: 'I send one also of myself – it is unfortunate in its plagiarism

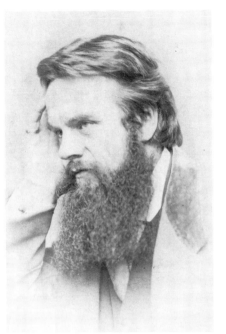

[195]

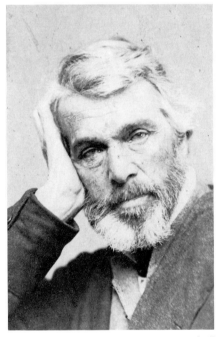

[196]

of the Carlyle pose – but for this I am not responsible – in all other respects it seems to me more than satisfactory, much more than just if many published by London photographers are faithful representations of me.' The Carlyle photograph referred to is probably Plate 196. *Photograph: Author's collection; letter: Tennyson Research Centre, Lincoln Public Library*

196 Thomas Carlyle, *carte-de-visite*, albumen print by Elliott & Fry, London. *Author's collection*

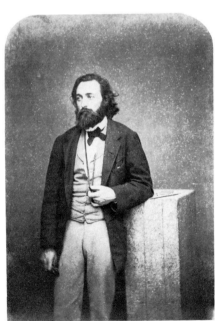

[193]

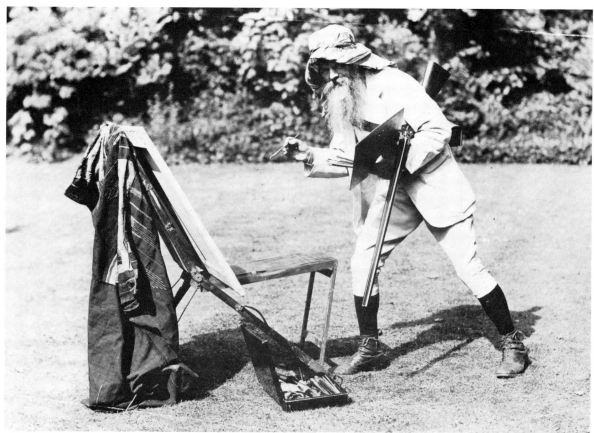

[197]

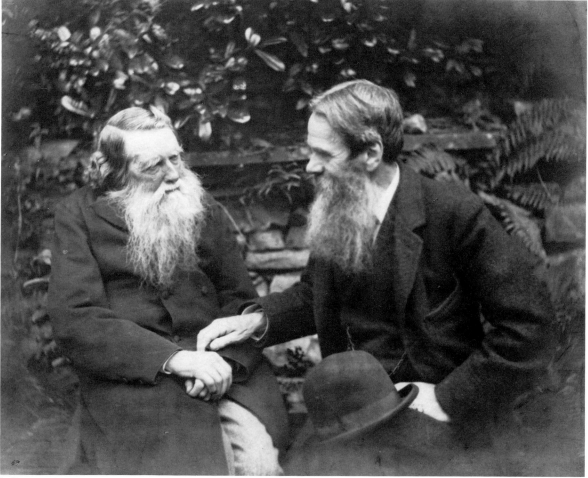

[198]

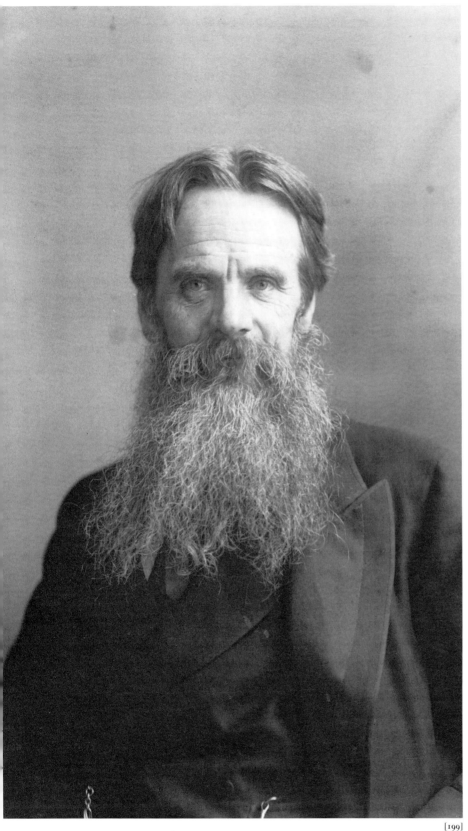

W Holman Hunt

[199]

197 Albumen print by an unidentified photographer, 175 × 225 mm, re-enacting the painting of *The Scapegoat* (R A, 1856) by the Dead Sea. The photograph was probably taken in the garden of his London house in about 1895. The gun was a defence against marauding bandits. From the collection of Holman Hunt. *Author's collection*

198 Silver bromide print by Frederick Hollyer, 245 × 275 mm, September 1894, showing the last meeting between Holman Hunt and (left) John Ruskin (q.v.), taken in the garden of Ruskin's house at Coniston. From the collection of Holman Hunt. *Author's collection*

199 Platinum print by Walery, London, 294 × 177 mm, taken 9 August 1891. From the collection of Holman Hunt. *Author's collection*

200 (on p. 106) Snapshot, 52 × 80 mm, from an album compiled by Hunt's son, Cyril. Taken after 1901 in the parlour of Sonning Acre, Sonning-on-Thames, a house built by Hunt for his retirement; he was nearly blind at the time. *Author's collection*

'You know I shall now have to sit to every photographer in London, so if one is an unjust representation of me the others will correct the unfavourable idea established in the public mind.'
From a letter from Holman Hunt to F. G. Stephens, 1 June 1864, Bodleian Library MS don. e 66 f. 88–9

'[3 February 1861] From an omnibus top saw Holman Hunt with nose high in air.'
G. P. Boyce, *Diaries* (1980), ed. by Virginia Surtees, p. 32

After describing Hunt's seven-year struggle to paint *The Triumph of the Innocents*: 'This shows the dogged perseverance and patience of the man, signs of which one read in his face, with its deep-set blue eyes, the sharp, aggressive nose, and the square jaw draped in red beard and moustache, while a mane of auburn hair, parted in the middle, hung over a high, broad forehead. I can still hear his curious, dry, and rather drawling voice, as he told of his early adventures, or inveighed against the evils of the Royal Academy.'
G. P. Jacomb-Hood, *With Brush and Pencil* (1925), p. 57

'He [Henry James] gave me a depressing account of Holman Hunt's conversation, which he likened to a trickle of tepid water from a tap one is unable to turn off. "There must be some way," he said, "one could do *so*, or *so*, or *so*" (imitating the gesture of turning a tap this way and that), "but no, nothing will stop it, on it goes. Once I had occasion to visit an obscure street in Chelsea, and after trying for some time to find it, in an evil hour" (here his voice became sinister) "I met Holman

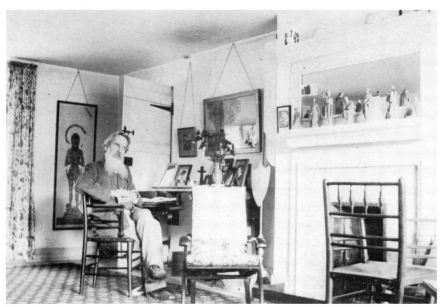

[200]

Hunt, who professed knowledge of it and offered to guide me. And for two mortal hours we wandered through the byways of Chelsea, while he talked on and on and on. He chose the not unattractive subject of Ruskin's marriage; but even that topic, which might in other hands have been alluring, proved in his not otherwise than DULL.'''

Henry James in conversation with Edward Marsh in *The Legend of the Master* (1947), compiled by Simon Nowell-Smith, pp. 84–5

ROBERT BRAITHWAITE MARTINEAU (1826–69)

Genre painter, and friend and pupil of Holman Hunt. Like Hunt, a slow and conscientious painter: he painted about seven pictures between 1852 and 1862.

201 *Carte-de-visite*, albumen print by W. E. Debenham, London. From the collection of Holman Hunt. *Author's collection*

'Martineau was a short-lived man, dying at the age of forty-three. He did not look delicate, but was of masculine build, with a full-coloured visage. He was a very sensible person, not given to much talk, and with a mind rather steady-going than lively, highly trusty and well-principled, and worthy of the utmost regard. He had much taste and some natural gift of music.'

William Michael Rossetti, *Some Reminiscences* (1906), Vol. 1, p. 158

'[21 May 1855] Martineau common looking & silent.'

The Diary of Ford Madox Brown (1981), ed. by Virginia Surtees, p. 138

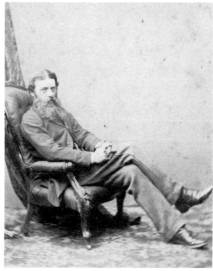

[201]

SIR JOHN EVERETT MILLAIS, BT., PRA (1829–96)

An original member of the Pre-Raphaelite Brotherhood and one of the most talented of the nineteenth-century British artists. Early in his career he abandoned the rigours of Pre-Raphaelitism and adopted a looser manner, treating popular and sentimental subjects. In his later years he was much in demand as a portraitist. Succeeded Leighton as President of the Royal Academy in 1896, a few months before his death.

Millais was undoubtedly vain of his handsome appearance and, feeling that he looked his best in profile, usually posed that way. Several letters from Millais to photographers survive. Of two letters in the author's collection, one is to A. W. Bennett, the publisher,

refusing a sitting to Ernest Edwards (15 April 1865). In another to Charles Watkins (25 October 1861) he asks him 'to let us have some impressions of ourselves as soon as it is convenient as we have promised our friends portraits.'

202 Albumen print by Herbert Watkins, oval, 195 × 147 mm. In a memoir of his father, J. G. Millais dates the photograph to 1854. *Author's collection*

203 Photogravure after J. P. Mayall, 165 × 220 mm, reproduced in *Artists at Home* (1884), by F. G. Stephens, facing p. 16. The architectural cabinet, now at Hatfield House, was used for the background of Millais's painting *Princess Elizabeth in Prison at St James's*, now in the Royal Holloway College. *Author's collection*

204 Albumen print, possibly by W. & D. Downey or Elliott & Fry, 150 × 100 mm. *Author's collection*

'Millais was a very handsome, or more strictly a beautiful, youth: his face came nearer to the type which we term angelic than perhaps any other male visage that I have seen. His voice hardly corresponded to his countenance; it was harsh rather than otherwise. In talk he was something of what one calls "a rattle"; saying sprightly things in an off-hand way, but not entering into anything claiming the name of conversation.'

William Michael Rossetti, *Some Reminiscences* (1906), Vol. 1, p. 74

'He had a magnificently shaped head, faultless classic features, a superbly elegant figure, tall and slim, and was quite one of the handsomest men I have ever seen.

'In conversation he was charming, not the least affected; but on the contrary so frank, boyish, and breezy in his manners that he completely captivated the hearts of the fair sex – indeed everyone, men, women, and children, particularly children, loved Millais.'

Mrs E. M. Ward's Reminiscences (1911), ed. by Elliott O'Donnell, p. 77

On 24 January 1873 Millais, at the suggestion of Ruskin, invited Donovan, the phrenologist, to visit him: 'After a little manipulation, carried on in silence, with the exception of a few monosyllables, Donovan said, "Well, sir, there is one thing quite clear from my examination – that is, that you are wholly devoid of any qualifications for pursuits requiring imagination"; then a little after, "devoid of any feeling for colour." "Indeed," said Millais. "Yes, sir; I dare say you have heard of persons who are colour-blind?" "Well," said our friend, "I have never noticed it in myself." "Not," continued the manipulator, "that I mean to say that you are colour-blind but your

sense of colour is very imperfect. City busi-
ness, sir – active city business for you; go in
for being a merchant, sir, or for banking; but
for anything requiring the imagination – for
poetry or for literature – you're quite unsuited
– quite unsuited."'

F. M. Redgrave, *Richard Redgrave, CB, RA: A
Memoir Compiled from his Diary* (1891), p. 323

'Millais mounted the sitter's chair vacated by
me, when I observed for the first time the red
mark on his left eye or eyelid. All men of
genius, unhappily, are not so handsome as
Millais was then. I asked him how he had
caught the irritation, or wound, or whatever
it was. No, he had not caught it, he had had
it all his life; "there are spots on the sun, you
know!" was his exclamation as he laughingly
placed himself in position on the model's
chair. I laughed too, but looked at him nar-
rowly. There was no expression of self-conceit
or vanity, it was mere exuberance of spirits
and amusing chaff.'

William Bell Scott, *Autobiographical Notes* (1892),
Vol. 1, p. 308

'[30 May 1870] So by rail to Onslow Square,
to a large musical party at the Theodore Mar-
tins. While I was in the tea room before going
upstairs, J. E. Millais and his wife came in.
She, the wife of two men, has lost the beauty
that got her a second husband in the friend
of her first; but looked well enough & was
sumptuously drest. He is still a fine man; but
red and gross in the face, and with his old vain
and sneering expression changed for one of a
coarser hardness. He spoke gruffly to his wife,
who answered not: and so they went upstairs
to smile.'

*Munby, Man of Two Worlds: The Life and Diaries
of Arthur J. Munby 1828–1910* (1972), ed. by
Derek Hudson, pp. 284–5

[202]

[204]

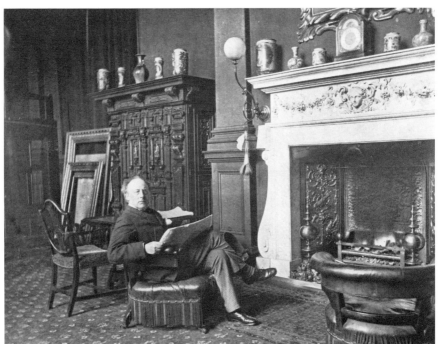

[203]

WILLIAM MORRIS (1834–96)

Poet, designer and founder, with the assistance of Rossetti, Ford Madox Brown, Burne-Jones (all q.v.), Philip Webb and others, of the firm of Morris, Marshall, Faulkner & Co., which designed and produced wall-papers, stained glass and other objects of applied art.

205 Photogravure by Walker & Cockerell, 270 × 97 mm, reproduced in *Memorials of Burne-Jones* (1904), by Georgiana Burne-Jones, Vol. 1, facing p. 96. *Author's collection*

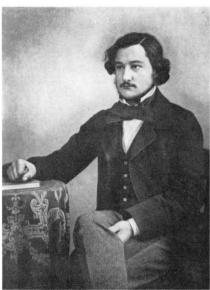

[205]

[206]

206 Cabinet portrait, albumen print by the London Stereoscopic & Photographic Company. From the collection of Holman Hunt. *Author's collection*

'Morris was bluff and jovial; and had I been informed that the reputed poet of "The Earthly Paradise", Socialist agitator, artistic printer, and designer of wallpapers was in reality a merchant-skipper, I should not have been a whit surprised.'
R. E. Francillon, *Mid-Victorian Memories* (1913), p. 172

CHARLES FAIRFAX MURRAY (1849–1919)

Painter, connoisseur, collector and dealer. His paintings were influenced by the Pre-Raphaelites and the spirit of the Italian Renaissance. The major part of his collection of Old Master drawings was bought by Pierpont Morgan.

207 *Carte-de-visite*, albumen print by H. T. Reed, London. From the Rossetti family collection. *Mrs Imogen Dennis*

'Charles Fairfax Murray was an extraordinary man. Well below normal height, with severely bowed legs, he possessed a keen intelligence, a tremendous memory and a superb eye for quality in pictures.'
Rowland Elzea in *Delaware Art Museum Occasional Paper*, No. 2 (February 1980), p. 2

[207]

SIR JOSEPH NOËL PATON, RSA (1821–1901)

Scottish painter of allegorical, historical, mythological and biblical subjects. He was sympathetic to the aims of the Pre-Raphaelites, and became a friend of Millais (q.v.). He was a man of culture and intellect with a wide range of interests. He was appointed Her Majesty's Limner for Scotland. Knighted in 1866.

208 Albumen print by an unidentified photographer, 166 × 156 mm, *c.* 1860. One of a series of three photographs (the remaining two are views of the artist's studio). This is a remarkably early photograph of the artist in his own studio. Such prints at so early a date are rare because of the difficulty in obtaining sufficient lighting. The photographer may well have been David Octavius Hill (q.v.), whose second wife, Amelia Robertson Paton, the sculptress, was Nöel Paton's elder sister. *Author's collection*

'Handsome, suave Sir Noël Paton, the Queen's Limner for Scotland, and the *beau idéal* of a Highland Chief, good to look at and delightful to talk to, a poet and an artist.'
A. M. W. Stirling, *Victorian Sidelights* (1954), p. 267

'Sir Joseph Paton was a tall and very fine-looking man: he received us with a stately courtesy, in which some degree of shyness seemed to be lurking. He expressed himself with much modesty in respect to his own performances, with warm recognition of those of Madox Brown. He had a handsome well-kept house, comprising a very noticeable collection of armour.'
William Michael Rossetti, *Some Reminiscences* (1906), Vol. 2, pp. 495–6

'Sir Noël's is so notable a figure that it would mark him out among a thousand as that of a man of distinguished parts and position. To a head that would have served, in his prime, as a model for a Jupiter Tonans, he unites a frame that is almost Herculean in breadth of shoulder and depth of chest.'
Alfred Thomas Story, *The Life and Work of Sir Joseph Noël Paton* (1895), p. 31

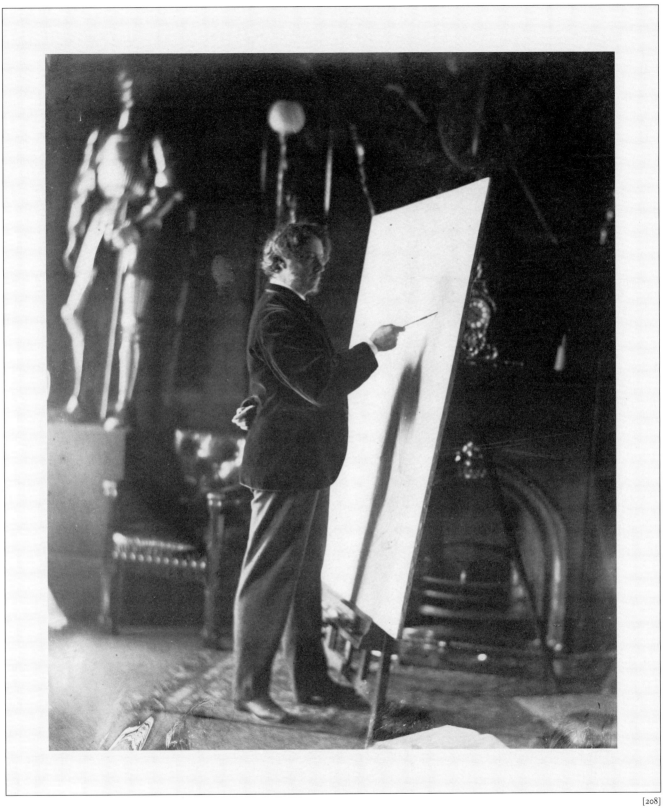

JOHN HUNGERFORD POLLEN (1820–1902)

Artist and author. A friend of Turner, which in turn led to friendship with Ruskin. On friendly terms too with Rossetti, Millais, Holman Hunt, Burne-Jones and William Morris (all q.v.). Joined the Church of Rome in 1852. Decorated many private houses in England and did much to reform taste in decoration and furniture, at home and abroad.

209 Cabinet portrait by Maull & Fox, London. From the collection of Holman Hunt. *Author's collection*

[209]

[210]

DANTE GABRIEL ROSSETTI (1828–82)

Painter, illustrator and poet. One of the original seven members of the Pre-Raphaelite Brotherhood, and a dominating figure in a wide circle of artists and literary people.

210 Photograph by Mark Anthony, *c.* 1853. W. M. Rossetti described it exactly in the *Magazine of Art* (1889):

'On one occasion my brother and I stood for Anthony to photograph together; my brother held my right arm. He appears at half-length . . . the forehead large and broad, the facial line tapering towards the point of the chin. This photographic print [W. M. Rossetti's own, it must be stressed] has now nearly faded off the paper – which is a pity, as it seems to be the only sun-picture of Rossetti taken at such an early date.'

This print is laid, nearly perfectly preserved, in a copy of *The Germ*, the literary organ of the Pre-Raphaelites, now at the Beinecke Library. *Beinecke Rare Book and Manuscript Library, Yale University Library, USA*

211 Cabinet portrait, albumen print by W. & D. Downey, taken in December 1862 and inscribed: 'To Fanny [Cornforth] D.G.R. 1863.' On the reverse: 'given to me this day (March 24, 1898) by Fanny . . . Sam'l Bancroft, Jr.' In the *Magazine of Art* (1889) W. M. Rossetti wrote:

'The photograph is an excellent likeness; easy in pose, unconstrained and straightforward in expression – the type, to my eye, far more Italian than English. My brother is represented full-fronting the spectator, with an Inverness cape loose over his shoulders. . . . The contour of the face is now round and full, all the slenderness of early youth having departed; the hair has continued receding from the largely developed brow; the eyes look somewhat darker than they really were. In this photo-graph . . . the cheeks are still shaven, and remained so until (I think) 1870, when my brother ceased shaving, and he never resumed the practice. . . . There is a great deal of expression in this photograph, of a rather complicated kind. The face is thoughtful and rather dreamy, yet with an alert aspect as of a man ready to open or continue a conversation. An external alacrity, an internal contemplation; in both an unembarrassed simplicity and directness; something of an intense yet indolent nature, easily capable of imposing its will upon others, but indifferent to ordinary modes of effort. I can read all this in the photograph partly perhaps because I knew it so well in my brother's character.' *Samuel and Mary R. Bancroft Collection, Delaware Art Museum, USA*

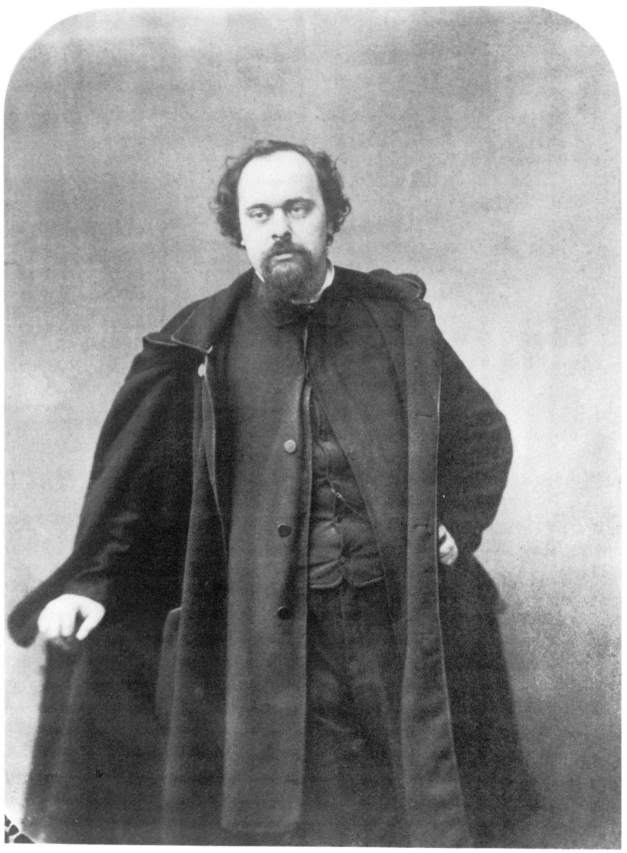

212 Cabinet portrait of Rossetti and Ruskin (q.v.) by William Downey. From the collection of Henry Holiday (q.v.).
Author's collection

213 *Carte-de-visite*, albumen print of Rossetti, John Ruskin (q.v.) and William Bell Scott (q.v.) by William Downey. From the collection of James Leathart (q.v.). *Author's collection*

The facts concerning these two photographs are the subject of much recent scholarship and are of considerable interest. It has been proved that they were taken on 29 June 1863 in the garden of Rossetti's house in Chelsea by William Downey. He had arrived from Newcastle, presumably to photograph W. B. Scott

and Rossetti. It has been suggested that Ruskin happened to call that day, and was included in the two photographs. Scott's dislike of Ruskin makes it unlikely that he was invited by him. Downey had difficulties in obtaining a satisfactory pose. He brought into the garden the chair on which Rossetti liked to paint. 'I ... asked Mr. Ruskin if he would kindly sit down, and allow Mr. Rossetti and Mr. Bell Scott to stand,' Downey recalled in later years. 'To my dismay, Mr. Ruskin flatly and sternly declined to avail himself of my invitation to sit. "Sit in the presence of Rossetti? Never!" he exclaimed. And I was compelled to take them as they are here.'

In the picture shown here (Plate 212) Scott, to the left in the original photograph, has been

almost completely removed, as often occurred in reproduction, partly, doubtless, because Scott has a menacing, even hostile expression on his face, and partly because he was considered, according to his reminiscences, published posthumously in 1892, to have wronged the memory of Rossetti, with whom, during his lifetime, he had professed friendship. Ruskin's top hat lies on the grass behind him; Rossetti crumples his 'wide-awake' hat carelessly in his hand; Scott (off camera) still wears his bowler. Ruskin's attitude towards the photograph was ambivalent. To his father he declared that 'bad as it is, I like the one with Rossetti and Scott fifty times better than any ... yet taken'. In November 1863 he wrote to a friend, Ellen Heaton, 'I don't think it like me. ... I dislike my face on entirely simple and certain laws – because it is bad in colour and form.' The chair in the photograph was designed by Rossetti. The original photograph is reproduced three-quarter-length in William Michael Rossetti's *Some Reminiscences* (1906), Vol. 1, facing p. 291.

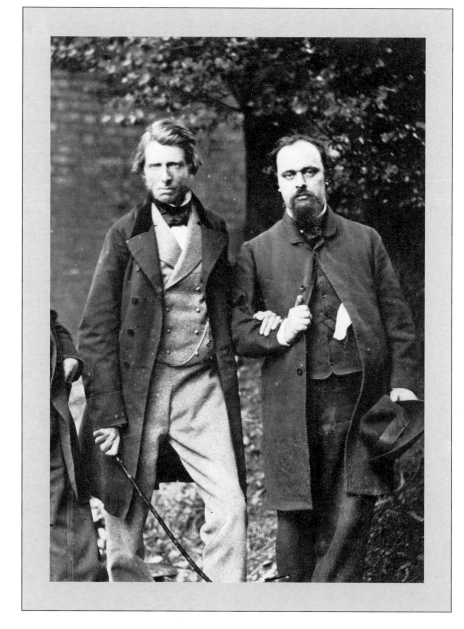

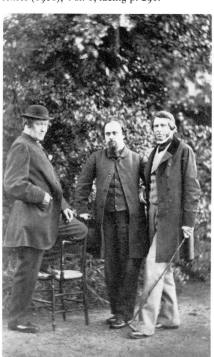

[213]

Downey did not recall that he took a second photograph (Plate 213). He had clearly told Rossetti to tuck his handkerchief in and correct his posture, but was evidently unable to persuade Ruskin to hold his stick less menacingly 'in the presence of Rossetti'. Nor could he prevent Scott from moving his head as he opened the shutter. The glass negative of Plate 212 exists to this day, as do other Downey negatives, in the Radio Times Hulton Picture Library. The negative of Plate 213

[214]

has not been preserved. This photograph, once owned by another Newcastle man, James Leathart, who was a great patron of Rossetti, must be regarded as exceedingly rare. W. M. Rossetti (q.v.) apparently never even saw the photograph, since it is not described in his definitive list of portraits of his brother (*Magazine of Art*, 1889). Of the portrait of Rossetti in Plate 212 he wrote, 'I think this version second to none for genuine and agreeable likeness.'

The two photographs are further related to a third photograph of Ruskin (Plate 329), who was taken into the house and photographed sitting in the very chair in which he had previously declined to sit.

214 Albumen print by Lewis Carroll, taken at Tudor House, 16 Cheyne Walk, Chelsea, on 7 October 1863. D. G. and W. M. Rossetti stand to the left and right, Christina Rossetti (q.v.) is seated left, with Mrs Rossetti, their mother, seated right. Carroll took five photographs in Rossetti's garden, and recorded the event in his diary. W. M. Rossetti regarded his brother's portrait 'an excellent likeness, in an easy and simple attitude'. *Sotheby's*

215 Albumen print, *carte-de-visite* size, probably by William Downey, taken in the gardens of Rossetti's house in Cheyne Walk, *c*. 1863. Not recorded by W. M. Rossetti (q.v.), possibly due to the rare presence of Fanny Cornforth (q.v., Rossetti's housekeeper/mistress). A. C. Swinburne (q.v.) sits uncomfortably to the left; W. M. Rossetti

stands to the right. Almost certainly the photograph of Fanny was taken at the same session as Plate 348 since she is wearing the same dress, although in the latter she has removed the decoration at her throat. The photograph was given to Sir Sydney Cockerell by Charles Fairfax Murray (q.v.) in December 1916. *Virginia Surtees*

'The appearance of my brother was to my eye rather Italian than English, though I have more than once heard it said that there was nothing observable to bespeak foreign blood. He was of rather low, middle stature, say five feet seven and a-half. . . . Meagre in youth, he was at times decidedly fat in mature age. The complexion, clear and warm, was also dark, but not dusky or sombre. The hair was dark and somewhat silky; the brow grandly spacious and solid; the full-sized eyes blueish-grey; the nose shapely, decided, and rather projecting, with an aquiline tendency, and large nostrils, and perhaps no detail in the face was more noticeable at a first glance than the very strong indentation at the spring of the nose below the forehead; the mouth moderately well shaped, but with a rather thick and unmoulded underlip; the chin unremarkable; the line of the jaw, after youth was passed, full-rounded and sweeping; the ears well formed and rather small than large. His hips were wide, his hands and feet small; the hands very much those of the artist or author type, white, delicate, plump, and soft as a woman's. His gait was resolute and rapid, his general

aspect compact and determined. . . . Some people regarded Rossetti as eminently handsome; few, I think, would have refused him the epithet of well-looking. . . . He wore moustaches from early youth, shaving his cheeks: from 1870, or thereabouts, he grew whiskers and beard, moderately full and auburn tinted, as well as moustaches. His voice was deep and harmonious; in the reading of poetry, remarkably rich, with rolling swell and musical cadence.'
William Michael Rossetti in *Recollections of Dante Gabriel Rossetti and his Circle* (1904), by Henry Treffry Dunn, ed. by Gale Pedrick, pp. 78–9

'[Familiar to many was] the round, John-Bullish, bluntly cordial manner of speech, with a preference for brief and bluff slang words and phrases which seemed scarce in keeping with the fame and character of the man as the most quintessentially, romantically poetic of painters and writers.'
Sir Sidney Colvin, *Memories & Notes of Persons & Places 1852–1912* (1921), p. 62

'I cannot say that Rossetti's presence was enlivening [in his later years]. My most representative recollection of him is of his sitting beside Mrs. Morris, who looked as if she had stepped out of any one of his pictures, both wrapped in a motionless silence as of a world where they would have no need of words. And silence, however poetically golden, was a sin in a poet whose voice in speech was so musical as his – hers I am sure I never heard.'
R. E. Francillon, *Mid-Victorian Memories* (1913), p. 172

'[5 March 1883] Papa asked Mr. Millais yesterday what he thought of the Rossetti pictures. He said they were all rubbish, that the

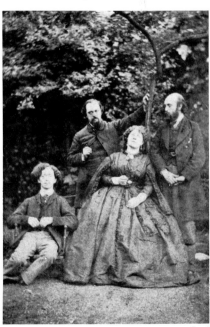

[215]

people had goitres – that Rossetti never learnt drawing and could not draw. A funny accusation for one P.R.B. to make at another.'
The Journal of Beatrix Potter from 1881 to 1897 (1966), ed. by Leslie Linder, p. 31

'... D.G.R., poet and imaginative inventor, who never made a memorandum of anything in the world except the female face between sixteen and twenty-six....'
William Bell Scott, *Autobiographical Notes* (1892), Vol. 2, p. 44

'I have been at Rossetti's house at Cheyne Walk, and he has been to me in Victoria Street. I liked him on both occasions, but from what I hear he could hardly have been a comfortable man to abide with. He collected Oriental china and bric-à-brac, and had a congregation of queer creatures – a raven, and marmots or wombats, &c. – all in the garden behind his house. I believe he once kept a gorilla. He was much self-absorbed.'
F. Locker-Lampson, *My Confidences* (1896), p. 166

WILLIAM MICHAEL ROSSETTI (1829–1919)

Son of Gabriele Rossetti and brother of Dante Gabriel (q.v.) and Christina Rossetti (q.v.). One of the original seven members of the Pre-Raphaelite Brotherhood. Became a clerk in the Excise Office in 1845. Published occasional art criticisms and several books on his brother and Pre-Raphaelitism.

216 *Carte-de-visite*, albumen print by W. & D. Downey, Newcastle-upon-Tyne, 1858. Rossetti with William Bell Scott (q.v.), who had first met the Rossettis in 1850. Comparison with Plate 219 shows that these two photographs were taken at the same session; the curtain and the carpet are identical, as is Scott's check suit. From the collection of Holman Hunt (q.v.). *Author's collection*

217 Albumen print by Julia Margaret Cameron, 1865. *Christopher Wood, Esq.*

'Some people undergo mishaps which raise a smile rather than a compassionate sigh. I am one of them. In boyhood I had an uncommonly thick crop of black hair; but towards 1848 it began thinning, and by June 1850, before I was of age, this process had reached such a pass that I was advised to have my head wholly shaved as the most likely method of retrieval. I acquiesced, and wore a wig for a year or so. The wig was eventually discarded, but the hair was not recovered. Thus I have been a baldish or bald man throughout my adult life. This, in youth, was anything but pleasant to me. In particular, I used to dislike entering a theatre or other public place with my hat on, looking, as I was, quite juvenile, and then, on taking off my hat, presenting an appearance more like a used-up man of forty. People who knew little of the facts were wont to tell me that my baldness must be due to overstudy or (according to some) to premature dissipation. But the truth is – and I have already confessed it – that I had not studied half enough; and I had dissipated not at all – unless the mere habit of keeping late hours at night is to count as dissipation.'
William Michael Rossetti, *Some Reminiscences* (1906), Vol. 1, p. 106

'He had a head and face that, joined together, were an exact oval. His head was perfectly bald and shiny on the top, but he had a little white tufty fringe at the back that reached right down to his collar. He was tall and rather bent, and he wore a black frock-coat with a turn-down collar, and rather wide trousers. He had thick white eyebrows and dark eyes. We loved him almost better than anyone, because he was so gentle.'
Juliet Soskice, *Chapters from Childhood* (1921), p. 9

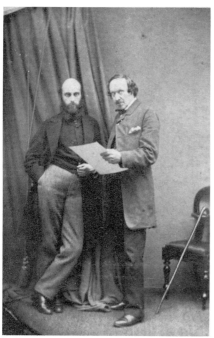

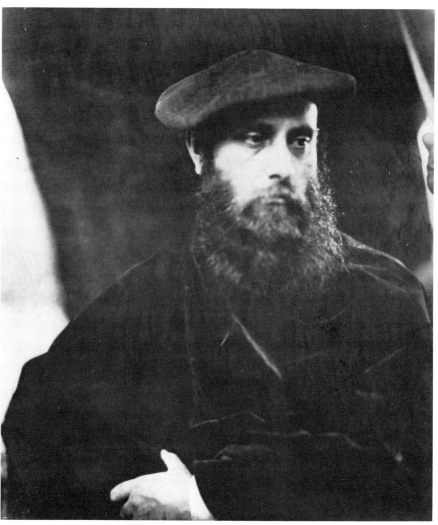

'If William Rossetti had a sweet and modest nature, he was by no means the "fool for a brother" that Morris proclaimed him to be; on the contrary, he was an admirable critic of literature and art; he had kept his faith in the power of art bright and clean; and his outlook on life was broad and humane.'

Sir William Rothenstein, *Men and Memories* (1931), Vol. 1, p. 230

ANTHONY FREDERICK AUGUSTUS SANDYS (1829–1904)

One of the most talented of all the artists who came under the influence of the Pre-Raphaelites. He was a painter in oils and water-colours, a draughtsman in crayons, and a black-and-white illustrator. His pictures were mythological subjects and portraits.

218 Platinum print by Frederick Hollyer (q.v.), 221 × 182 mm, *c*. 1890. *Author's collection*

'Frederick Sandys . . . preserved to the last a scrupulous regard for his personal appearance. Tall and distinguished, he was always dressed in well-cut clothes, resplendent in highly varnished footwear, his shapely hands and spotless linen beyond reproach. He was usually to be found towards the last at the "Punch Bowl", where he held his court surrounded by a crowd of admirers enthralled by his stories. Here he could sip his grog in peace and comfort, the cost being defrayed by his audience, and when in the small hours the party separated, the trifling sum for his cab fare was pressed into his hand without loss of dignity to the lion of the evening. His was a proud spirit which even his penniless condition had failed entirely to break, and to the last he produced these wonderful drawings which had brought him enduring fame, but had failed to provide a sufficiency of means to enable him to spend his declining years in reasonable comfort.'

Edwin A. Ward ('Spy'), *Recollections of a Savage* (1922), pp. 106–7

WILLIAM BELL SCOTT (1811–90)

Poet, painter, art and literary critic. Moved in Pre-Raphaelite circles, becoming particularly friendly with the Rossettis. Before he married Letitia Norquoy in 1852 they had consulted John Varley, the astrologer and water-colourist: he had foretold 'a highly favourable scheme of fortune for her'. Later, Scott wrote, 'after forty years, I fear either the planets or the expositor have made a mistake!' In 1859 he met Alice Boyd (1823–97) of Penkill Castle, Ayrshire, and then began a 'perfect intercourse' for thirty-one years. Although Mrs Scott outlived her husband, Scott and Alice Boyd were buried in the same grave. The posthumous publication of his *Autobiographical Notes* (1892) caused some consternation, on account of the rancour and spite expressed towards some of his friends, particularly Rossetti.

219 *Carte-de-visite*, albumen print by W. & D. Downey, Newcastle-upon-Tyne, *c*. 1858. Comparison with Plate 216 shows that these two photographs were taken at the same session; the curtain, carpet and Scott's check suit are identical. From the collection of his friend and patron James Leathart (q.v.). *Author's collection*

'Sometimes [Rossetti's] rhymes would take off, quite harmlessly and pardonably, some physical trait of their subject, as this concerning a senior member of the circle, the shrewd, thoughtful, and interesting but technically less than half-accomplished Scottish artist and verse-writer, William Bell Scott. Scott, a man

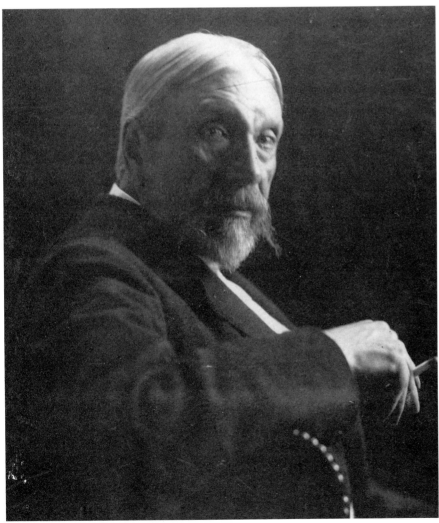

[218]

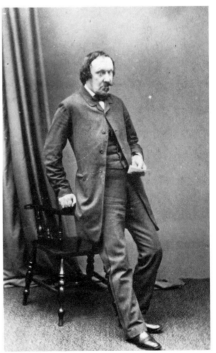

[219]

by this time bald and ageing, was commonly known among his friends as "Scotus":

> There's a crabbèd old fellow called Scott,
> Who seems to have hair but has not;
> Did he seem to have sense
> A still vainer pretence
> Would be painfully obvious in Scott.

That is all very well; but could the same friend be expected to take it kindly when the essential weaknesses of his talent were faithfully and scathingly hit off as follows?:

> There's a queer kind of painter called Scotus,
> A pictor most justly ignotus;
> Shall I call him a poet?
> No, not if I know it,
> A draggle-tailed bungler like Scotus.

Scott may in truth very likely never have heard the second of these staves: but had he heard and resented it he could scarcely have paid off the score more ill-naturedly, and at the same time more inaccurately, than by his treatment of Rossetti in his posthumously published *Autobiographical Notes*: a book, I may allow myself to remark by the way, which I have found almost unfailingly inexact in every one of its statements that I have had means or occasion to check.'

Sir Sidney Colvin, *Memories & Notes of Persons & Places 1852–1912* (1921), pp. 73–4

'[26 June 1864] Down to Chelsea and find D. G. Rossetti painting a very large young woman, almost a giantess, as "Venus Verticordia". I stay for dinner and we talk about the old P.R.Bs. Enter Fanny Cornforth who says something of W.B. Scott which amuses us. Scott was a dark hairy man, but after an illness has reappeared quite bald. Fanny exclaimed, "O my, Mr. Scott *is* changed! He ain't got a hye-brow or a hye-lash – not a 'air on his 'ead!" Rossetti laughed immoderately at this, so that poor Fanny, good-humoured as she is, pouted at last – "Well, I know I don't say it right," and I hushed him up.'

William Allingham, *A Diary* (1907), p. 100

THOMAS SEDDON (1821–56)

Son of a cabinet maker and brother of John Pollard Seddon, the architect. He was an early associate of the Pre-Raphaelites, and accompanied Holman Hunt (q.v.) on his first journey to the Holy Land. In 1856 he returned to Cairo where he died of dysentery.

220 Albumen print by an unidentified photographer, 145 × 103 mm, *c.* 1853. From the collection of Holman Hunt, who had inscribed on the reverse: 'a very good likeness'. Probably the only known photographic print of this artist. *Author's collection*

'Thomas Seddon was a good-looking man, a general favourite with all sorts of people. He had very high spirits, with a keen eye for the funny side of things, and would laugh consumedly over the diverting anecdotes which he told in abundance. Here is one. His mother had recently engaged a young female servant, whose richly curved proportions soon excited some amount of observation in the family. Mrs. Seddon, whose standard of decorum was of the highest, took the matter up. "Susan," said she, "I am sorry to interfere upon any such point, but you must not mind my speaking about the size of your bustle; it would really be better if you would wear a smaller one." "Why, ma'am," replied the reddening damsel, "I don't wear one at all." With all his jocularity, Thomas Seddon was a serious-thinking man, increasingly subject to strong religious impressions.'

William Michael Rossetti, *Some Reminiscences* (1906), Vol. 1, p. 143

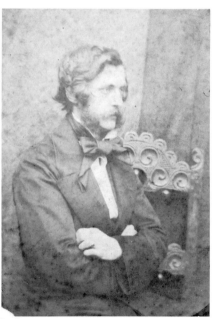

[220]

FREDERIC JAMES SHIELDS, ARWS (1833–1911)

Manchester painter, water-colourist and decorator. He was a provincial Pre-Raphaelite associate who became the friend of Rossetti (q.v.) and Ford Madox Brown (q.v.). His work was mostly biblical.

221 Photogravure after a photograph by C. E. Fry & Son, 48 × 100 mm, taken in 1903. Frontispiece to *The Life and Letters of Frederic Shields* (1912), ed. by Ernestine Mills.

'I remember . . . the great gloomy studio lighted only in one spot by a tall gas-stand with a reflector, with grim lay figures attitudinising in dark corners, and more than one skeleton in the cupboard. And then out of the darkness would step a figure, rather below the average height, always thin almost to emaciation, with large head and towering brows, crowned with long wavy hair, with earnest deep-set eyes, and what seemed to a child a terrifying expression, until a smile irradiated the whole face, and the outstretched hands inspired confidence.'

The Life and Letters of Frederic Shields (1912), ed. by Ernestine Mills, p. 351

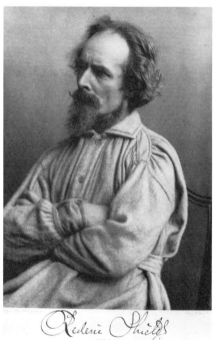

[221]

JAMES SMETHAM (1821–89)

A Pre-Raphaelite associate and friend of Rossetti, one of whose 'lame ducks' he became. His art, mainly religious in feeling and content, linked the pastoral visionary school of Blake and Palmer (q.v.) to that of the Pre-Raphaelites. Religious melancholia and madness darkened the last twelve years of his life.

222 Cabinet portrait, albumen print by Elliott & Fry, London, taken in 1873. From the collection of Denis Smetham, grandson of the artist. *Author's collection*

'His appearance in youthful manhood was striking. . . . His hair grew in a sort of reckless profusion, tending to the leonine in mass and hue, not reddish, but a low-toned chestnut. His face was harmonious and proportionate, the features delicate, the forehead well pronounced, lofty, and expansive; the nose aquiline, not over-prominent; the mouth firm, rather small, delicately cut; the lips ample, inclining to fulness; the chin refined in mould. . . . His figure was tall and rather spare, with a slight tendency towards the student's stoop. He always wore a frock-coat, a loose necktie, the bow carelessly tied by his own hand, and invariably clothed throughout in black. There was a sort of wavering or undulating motion in his gait, slightly expressed. . . . The expression of the eye was feminine in softness, but at the same time wide and earnest, laden with the spirit's message. His manner was distinctly reposeful, and had nothing of haste or fidgetiness in it. He was always gentle, kindly and courteous to all.'
The Letters of James Smetham (1891), ed. by Sarah Smetham and William Davies, pp. 30–1

SIMEON SOLOMON (1840–1905)

Younger brother of Abraham (q.v.) and Rebecca Solomon, both painters. The only Jewish associate of the Pre-Raphaelites. Although he was extremely talented he led a very disreputable life. In 1871 he was arrested for homosexual offences and was socially outcast. He was reduced to extreme poverty, living mainly in St Giles Workhouse, Holborn, in London. His death was due to chronic alcoholism.

223 Albumen print by David Wilkie Wynfield, *c.* 1870. *Royal Academy of Arts*

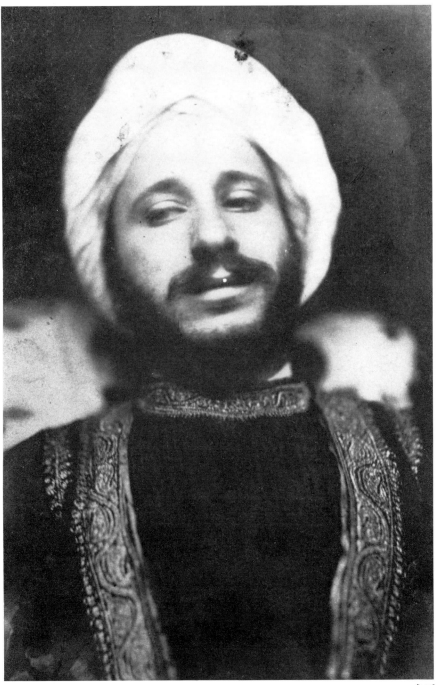

[223]

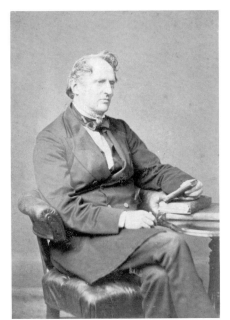

[222]

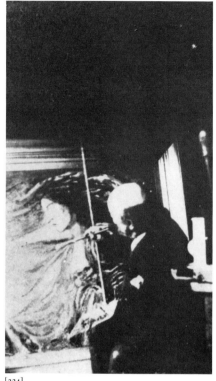

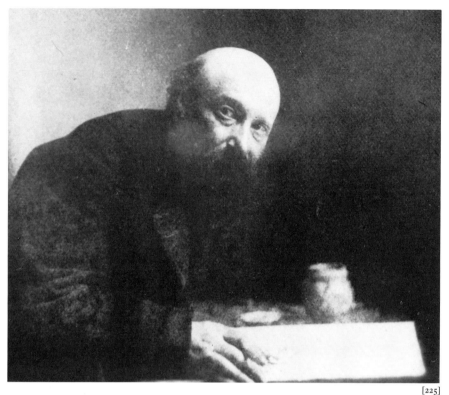

[224] [225]

224 Photograph of Solomon painting. He was described as: 'Middle-aged and somewhat of a vagabond'. *Salaman family; photo reproduced by courtesy of the Syndics of Cambridge University Library and the executors of Dr R. N. Salaman, FRS*

225 Photograph, entitled 'The Outcast'. *Salaman family; photo reproduced by courtesy of the Syndics of Cambridge University Library and the executors of Dr R. N. Salaman, FRS*

'Simeon Solomon was a fair little Hebrew, a Jew of the Jews, who seemed to have inherited a great spirit, an Eastern of the Easterns, facile and spasmodically intense, sensitive to extreme touchiness, conscious of his great abilities, proud of his race, but with something of the mystic about him which was Pagan, not Christian. Quaint was his humour. He touched all subjects lightly and with so much brilliancy that the follies he uttered and wrote seemed to be spontaneously wise and witty sayings. He twisted ideas, had a genius for paradox, and when in a humorous vein, speaking with assumed seriousness, he convulsed his friends with laughter by his strange, weird imagination.'
Sir William Blake Richmond in *The Richmond Papers* (1926), by A. M. W. Stirling, pp. 160–1

'Simeon Solomon died in August, 1905. He was then 65. Age, combined with hardship, had made of the little red man, with the cheerful, laughing eyes, one of those sombre, unforgettable figures who live in the drawings of

Gustave Doré. He was quite bald, but a great bushy reddish-white beard made up for his lack of hair. Being of small stature, he seemed rather over-weighted by his luxuriant chin growth. He had no fear of death, and when inclined to be moody recited to himself snatches of poetry from Keats, Shelley and Dante.

'Sometimes he would startle his fellow-paupers by repeating aloud whole passages from the *Song of Solomon*, his favourite inspiration, or by intoning *Kol Nidrei*, the prayer uttered by devout Jews on the eve of the great White Fast, or, as if unconscious of the incongruity of the mixture, humming one of the Gregorian chants heard in the Carmelite Church, Kensington.'

Bernard Falk, *Five Years Dead* (1937), p. 330

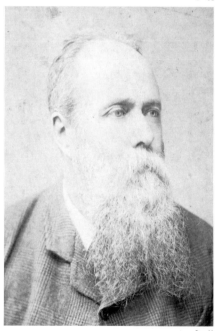

[226]

JOHN RODDAM SPENCER STANHOPE
(1829–1908)

A pupil of G. F. Watts (q.v.) but he became a painter in the Pre-Raphaelite manner. From 1880 he lived permanently in Florence. He was uncle and teacher of Evelyn De Morgan (q.v.).

226 Cabinet portrait, albumen print by Montabone, Florence. *Author's collection*

'Roddam, an apostate from the traditions of his class, with the elasticity of an adaptable temperament, was equally at home in Bohemia or in fashionable society. He was full of originality, of humour; and his merry philosophy of life, his extreme warm-heartedness and his generosity, endeared him to all.'

A. M. W. Stirling, *Life's Little Day* (1925), p. 105

FREDERIC GEORGE STEPHENS
(1828–1907)

One of the original seven members of the Pre-Raphaelite Brotherhood. Having little success as a painter, he turned to art criticism, becoming art critic on the *Athenaeum* from 1861 to 1901. In his early years his handsome features were frequently used as a model, notably for the head of Christ in Ford Madox Brown's *Christ Washing Peter's Feet*. See also Plates 334 and 335.

227 *Carte-de-visite*, albumen print, probably by Cundall & Co., London. From the collection of the Rossetti family. Stephens wrote to W. M. Rossetti (q.v.) on 6 April 1859:

'I want you to come to Cundall's and be photographed with me as agreed, I write to Hunt to know if he will do so likewise on Saturday at 2 p.m. . . . You would I doubt not like to be with Hunt and I better than any others of the old set as we three have best maintained the old relationship together. Hunt is so busy and has besides such a way of making a bother about this sort of thing that there is small chance of him. . . . Cundall will do the negatives for 5/- each and each positive therefrom for 2/6, which is cheap enough.' *Photograph: Mrs Imogen Dennis; letter: University of British Columbia*

'Stephens is a man of firm and settled opinions and of character far from supple – even rather unbending – but none the less with a certain quality of personal diffidence which tells in his conversation.'
William Michael Rossetti, *Some Reminiscences* (1906), Vol. 1, p. 68

MRS WILLIAM J. STILLMAN (née Marie Spartali) (1844–1927)

Daughter of a Greek merchant established in London. She was a talented artist in watercolours, painted in the later Pre-Raphaelite manner, and was a noted beauty. She married, as his second wife, W. J. Stillman (q.v.) in 1871.

228 Albumen print by Julia Margaret Cameron, 300 × 322 mm, published by Colnaghi's. On the reverse is a pencilled quotation in the photographer's hand from Tennyson's *Ode to Memory*, and an inscription, under the photograph, 'From Life Registered photograph Freshwater Sep 1868 Julia Margaret Cameron'. *Sotheby's*

'I always recommended would-be but wavering worshippers to start with Mrs. Stillman (Marie Spartali), who was, so to speak, Mrs. Morris for Beginners.

'The two marvels had many points in common: the same lofty stature, the same long sweep of limb, the "neck like a tower", the night-dark tresses and the eyes of mystery, yet Mrs. Stillman's loveliness conformed to the standard of ancient Greece and could at once be appreciated, while study of her trained the eye to understand the more esoteric beauty of Mrs. Morris and "trace in Venus' eyes the gaze of Proserpine".'

W. Graham Robertson, *Time Was* (1931), p. 95

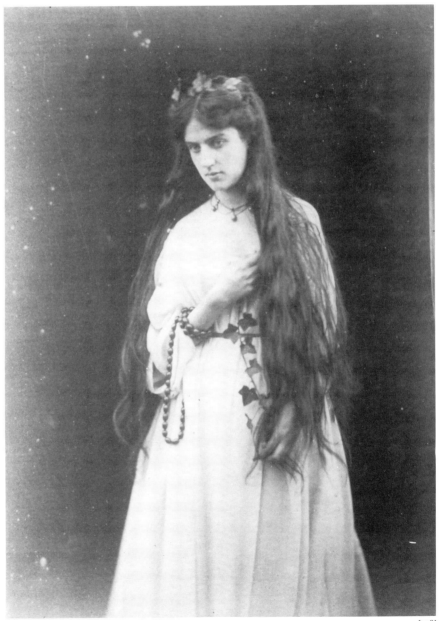

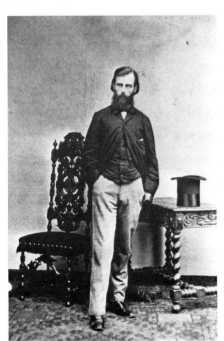

[227]

[228]

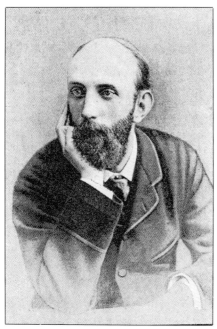

[229]

JOHN MELHUISH STRUDWICK (1849–1937)

Painter of mythological and allegorical figure subjects. Working in the studios of Spencer Stanhope (q.v.) and Burne-Jones (q.v.) gave his work a late Pre-Raphaelite character.

229 Photograph, reproduced in the *Art-Journal* (1891)

WILLIAM LINDSAY WINDUS (1822–1907)

Liverpool Pre-Raphaelite painter. A fragile talent was shattered when Ruskin (q.v.) severely criticized his picture *Too Late* (1859, now at the Tate Gallery). This, plus a nervous constitution, being run over by a cab, the loss of his wife, and having independent means all contributed to his virtually ceasing to paint. He made a bonfire of many of his paintings.

230 Photograph, reproduced in the *Magazine of Art* (1900)

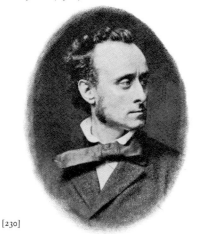

[230]

'At Liverpool in his young days, Mr Windus is remembered as a man of medium height, with refined and delicate features, bearing, as has been remarked, a strong resemblance to those of Millais. He was well read, cultured, and intellectual; genial in temperament, and with a fine sense of humour, which distinguished his conversation.'
H. C. Marillier, *The Liverpool School of Painters* (1904), pp. 252–3

THOMAS WOOLNER, RA (1825–92)

Sculptor, poet and part-time picture dealer, he was one of the original seven members of the Pre-Raphaelite Brotherhood. In 1852 he went to Australia to make his fortune in the gold-fields. Disappointed, he returned to England in 1854. He executed statues, busts, monuments and medallions.

231 Cabinet portrait, albumen print by J. P. Mayall. Woolner is seen sculpting a bust of his friend Lord Tennyson (q.v.), which was completed in 1873. From the collection of F. G. Stephens (q.v.). *Author's collection*

'Woolner was of middle height, sturdily built, with a strong, animated look – dark eyes, rather short nose, and a fine crop of ginger-yellow hair. His manner was frank, decisive, self-confident, and full of warmth to persons whom he liked. I was indisputably numbered among these. His talk was somewhat varied, for he always took an interest in several matters outside the range of his art: it was entertaining, pointed, often incisive, and well stored with observation and reflection. He knew how to say a sharp thing sharply. He talked rather one-sidedly, in this sense – that he rated cheaply the abilities and performances of most men in his own branch of art, and indeed of several men in all departments of affairs, and where he disliked he was very

ready to denounce. Notwithstanding any scantiness in his education, he had read amply (in English alone), and was a vigorous admirer of fine things in poetry, and in literature generally. He was a steady smoker; in other matters very moderate, or even abstemious.'
William Michael Rossetti, *Some Reminiscences* (1906), Vol. 1, pp. 64–5

'[13 February 1872] I went today to see Thomas Woolner, the sculptor – a good plain, conceited fellow and respectable artist, living, with an intensely pre-Raphaelite wife, in a charming old house, full of valuable art-treasures: a delightful place.'
Henry James Letters (1978), ed. by Leon Edel, Vol. 2, p. 99

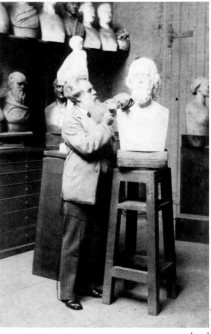

[231]

— 7 —

NEO-CLASSICAL PAINTERS

FROM the earliest years of the nineteenth century historical painting was regarded with the highest esteem, far higher than the next most esteemed subject, portraiture. At a time when the various branches of painting were graduated, it was historical painting which aspired most closely to the condition of 'High Art', a rather nebulous phrase which was earnestly applied to what was noblest, purest and most ideal in conception. This lofty idealism was no less central to sculptors, to whom the human figure was the most perfect of God's creations, than to the painters of historical subjects. Had not two of the earliest Presidents of the Royal Academy lent to historical painting the prestige of their support? Sublimity, heroism, nobility, purity and virtue – these could only be given fullest expression in the treatment of historical and religious subjects. And in the execution of such an aim, the need for a whole supporting list of qualifications and requirements was implicit: a deep and searching mind, academic learning, diligent training and dexterity of execution. That so many failed to live up to these grandiose aspirations is hardly surprising, although their validity was never in question.

It was in this high-mindedness that there inevitably lay the seeds of worldly success based on respect, namely high academic office. No one could hope to fulfil all these requirements, but those who came closest were within grasp of the highest office of all, the Presidency of the Royal Academy. Thus it was that Sir Charles Eastlake, with better credentials than any of his contemporaries, filled this office with great ability from 1850 to 1865. The appointment in 1866 of his successor Sir Francis Grant, a mere portraitist and sporting painter, was considered by many, led by Queen Victoria herself, to be an affront to the altar of Art, for all his aristocratic background, but he remained in office until his death in 1878.

It was the revival of interest in classical antiquity in the 1860s, largely due to the impact of the new archaeological discoveries of the ancient world, that in turn revived the prestige of 'High Art', gave it, through the neo-classical painters, a new dimension, and invested its school with the attributes required for, as it were, the natural ruling party. Long before the death of Grant, Frederic Leighton had been seen by many as his natural and far more worthy successor. So openly expressed was this feeling, not only by Leighton himself (not deliberately, merely by his example) and his supporters, that Grant clearly showed his resentment (see text accompanying Plate 105).

The painters of the neo-classical school in Britain have been aptly called the Olympians, and there was no one more Olympian than Leighton, whose Presidency of the Royal Academy lasted from 1878 to 1896. The average Royal Academician felt instantly inferior in his presence, so grand was he in his attainments, so meticulous in the execution of his official duties, so magnificent in his home, in his Jove-like appearance, with his hyacinthine curls, in his command of languages – in all, in his utter perfectness. This perfectness was almost complete before he reached the age of 20. He had long before become fully conversant with classical legend, fully fluent in French, Italian and German. A superb education in art on the Continent put the finishing touches to this paragon among men. All his life it seemed that he had been preordained for the Presidency and when in that office he worked ceaselessly to raise the prestige of the Royal Academy and to promote the arts generally, painting and sculpting the while. His peerage, his lying in state and his burial in St Paul's seem entirely appropriate to the grandeur he embodied.

The succession at his death of Millais, already mortally ill, was more by way of being a tribute to a man who, it was felt, deserved the highest accolade, although it is doubtful whether he could have fulfilled the duties with anything like the same distinction, had he retained his health. Millais's Presidency lasted for only a few months in 1896.

The natural order of things was properly restored by the election of Sir Edward Poynter as President in 1896 (albeit only narrowly defeating Briton Riviere who, be it noted, was the first to introduce neo-classical settings into animal painting), which post he held, to the mounting irritation of younger artists, until 1918. Although his credentials were on a par with Leighton's and the fulfilment of his many onerous duties was discharged with the same sense of dedication, he somehow failed to exude, had he even wanted to, the same aura as Leighton. As his cousin Lord Baldwin recorded:

Within the virtuous, artistic, and high-minded Edward Poynter there dwelt a bleak spirit that could stoop neither to excuse the second-rate nor often to applaud the most deserving. Yet not a few had cause to remember his generosity and kindness. But his very sensitiveness to the beauties of nature and art seemed to be balanced by an equal insensitiveness to demonstrative human affections. Unlike the poet Landor, his absorbing love for the two unattainable beauties, Nature and Art, left him with no time to warm even one hand at life's fireside.

All the same, his pursuit of those elevated ideals, blending with the full range of the virtues most respected by the Victorians, prevailed. Not only did he serve as Slade Professor at University College, London, but he was Director for Art and Principal of the National Art Training Schools at South Kensington, and he also succeeded Sir Frederick Burton as Director of the National Gallery. A true Olympian indeed! Cosmo Monkhouse, prefacing the only monograph so far to have appeared on this excellent painter, draughtsman, medallist and illustrator, remarked, in an equally Olympian tenor of prose, 'that without drawing any comparisons between Sir Edward Poynter and his predecessors in the high office to which he has been recently called, it may at least be said that few of them have possessed those many qualifications which it demands from its possessor. As a painter he has attained

an eminent position by the nobility and purity of his aims, by his profound knowledge of his craft and his technical skill.' Monkhouse then went on to the very heart of the matter: 'As it happens, Sir Edward Poynter is a figure and historical painter, and is moreover one of the very few representatives of British Art who gives us scholarly, serious and intellectual work inspired by the principles and style of classical art.'

When Poynter resigned in 1918 neo-classical painting was completely out of fashion and discredited, and he was succeeded by a distinguished architect, the first ever to become President, Sir Aston Webb. As though, once again, to put matters right, Webb was succeeded in 1924 by a painter in the full nineteenth-century romantic idealist tradition, Sir Frank Dicksee, also a portraitist. It is noteworthy, too, that this idealist tradition embraced two other leaders of the Victorian artistic Establishment (the connotation of which word, incidentally, being of recent origin, would not have been known at that time): Sir Frederick Burton, Director of the National Gallery from 1874 to 1894, and Sir James Linton, first President of the Royal Institute of Oil Painters from 1883 to 1897, and one-time black and white illustrator on the *Graphic*.

The most accomplished of the neo-classical painters, Sir Lawrence Alma-Tadema, was also the most earthbound of the Olympians. He eschewed the world of classical mythology in favour of ancient social and military history, every bit as classical as the subjects chosen by his contemporaries and, in the authenticity of archaeological detail, quite as academic. Although pragmatic and materialistic, he never sought any office at the Royal Academy, to which he was always devoted, but he revelled in public recognition and honours, receiving a knighthood in 1899 and the Order of Merit in 1907. Like Leighton, who lived in splendour in Holland Park Road, Tadema was no stranger to grandeur, and he converted Tissot's recently vacated house in St John's Wood into an extraordinary pseudo-Pompeian palace, where he entertained with dinners, concerts (with performers like Caruso and Tchaikovsky) and 'At Homes'. Amongst his intimate friends were members of the royal family, the Burne-Joneses, Paderewski, George Eliot, Conan Doyle, Winston Churchill and Robert Browning, as well as leading scientists, politicians and royalty from all over the world.

LADY ALMA-TADEMA (née Laura Epps) (1852–1909)

Painter. She was the daughter of Dr George Napoleon Epps and second wife of Sir L. Alma-Tadema (q.v.).

232 Carbon print, with her husband, taken in about 1906 by an unidentified photographer, 112 × 76 mm. Inscribed: 'Wish you hearty good wishes, Laura Alma-Tadema L Alma-Tadema'. *Author's collection*

'Mrs Tadema was one of the London beauties, of good stature, auburn-haired, with the warm body of a milkmaid, and a gentle, Greek face.' Julian Hawthorne, *Shapes that Pass* (1928), p. 123

SIR LAWRENCE ALMA-TADEMA, OM, RA (1836–1912)

Painter of Greek and Roman subjects, which attained enormous popularity. He was a native of Holland, but settled in London in 1870. Received letters of denizenship in 1873. Became RA in 1879; knighted in 1899.

233 Photograph, taken in about 1870. *Private collection, Holland*

234 Photogravure by J. P. Mayall, 166 × 198 mm, reproduced in *Artists at Home* (1884), by F. G. Stephens. Taken in the studio at Townshend House, near Regent's Park in London. Above the fireplace is a bust of his wife, Laura, by E. Onslow Ford. The engraving on the floor is *Anthony and Cleopatra*; the water-colour on the easel is *The Old, Old Story*. On the easel just visible to the right is *Hadrian in England: Visiting a Roman-British Pottery*, destined to become 'Picture of the Year' at the Royal Academy in 1884. A reviewer in the *Magazine of Art* (1884) noted that 'Mr Alma Tadema, as unlike himself as possible, leans boldly and airily on the chimney-piece'. *Author's collection*

[232]

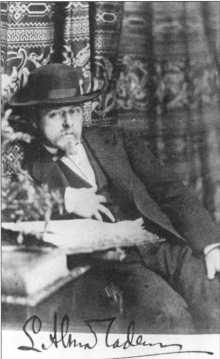

[233]

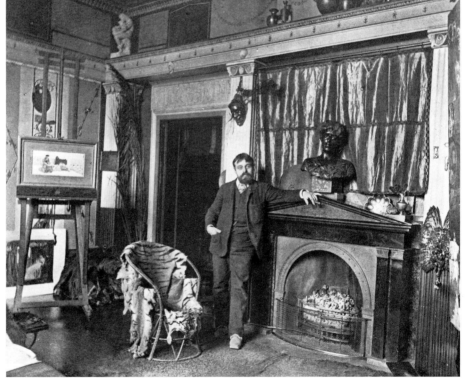

[234]

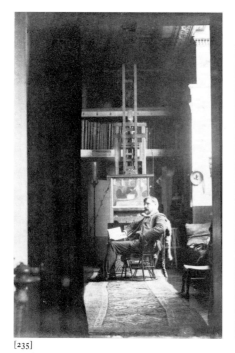

[235]

Perhaps you don't know the back of your old friend Alfred Tadema X.Mas greetings to you all 4

[236]

235 Photograph of the artist in his studio. *Dr Vern Swanson*

236 Photograph showing rear view of the artist. *Dr Vern Swanson*

237 Photograph by Fradelle and Young, reproduced in the *Magazine of Art* (1900), facing p. 136, entitled *The Alma-Tadema Celebration*. A knighthood was conferred upon Sir Lawrence Alma-Tadema in the Birthday Honours List of 1899. It was an honour which was most popularly acclaimed by his fellow artists and the event was marked by one of the most celebrated banquets of Queen Victoria's reign. This was held on 4 November 1899 at the Whitehall Rooms, London. The 160 guests included most of the important artists of the day. Tadema's speech was greeted with rapturous applause. One Academician left his seat to kiss the artist's hand and was in turn embraced by him. Comyns Carr (q.v.), of Grosvenor Gallery fame, had composed for this occasion a piece of doggerel, set to music by George Henschel who also sang

[237]

it. The chorus, here transcribed, has acquired a degree of fame:

Who knows him well he best can tell
 That a stouter friend hath no man
Than this lusty knight who for our delight
 Hath painted Greek and Roman.

Then here let every citizen
Who holds a brush or wields a pen
Drink deep as his Zuyder Zee

To Alma-Tad
Of the Royal Acad
Of the Royal Academee.

In the photograph Alma-Tadema may be seen on the left rising to his feet in front of the toastmaster. *National Portrait Gallery, London*

'A rather short, broad, blond personage stood before us: a broad forehead, pale grey eyes with eyeglasses, a big humorous mouth hardly hidden by a thin, short, yellow beard. His front face was blunt, jolly, and unremarkable; but his profile was fine as an antique cameo.... The vitality and energy of his aspect and movements and the volume of his voice were stunning; but this was in the first moments only; he was always very much alive, but in general demeanour and speech there was a soft incisiveness, almost a subtlety, with variety of intonation and emphasis, and expressive gestures, and intense earnestness now and then. But his great, delighted laugh constantly recurred, resounding through the beautiful rooms.... Withal, he was civilised and fine to the bone, and his utmost boisterousness never struck a wrong note.'
Julian Hawthorne, *Shapes that Pass* (1928), pp. 122–3

SIR FRANK DICKSEE, PRA (1853–1928)

Member of a painting family. Painted genre pictures and portraits. Elected President of the Royal Academy in 1924; knighted in 1925.

238 Photograph by Ralph W. Robinson, 201 × 153 mm, published in *Members and Associates of the Royal Academy of Arts, 1891, photographed in their Studios* (1892). A writer in the *Art-Journal* of 1890 commented that 'the photograph was probably taken after sending-in day, when an artist has earned the right to place a chair in the most comfortable corner of his studio, and devote an hour or two to the sister art. For a subject-painter like Mr Dicksee, this becomes almost a necessity, particularly when he chooses such a subject as his Academy picture for this year, "The Redemption of Tannhauser".... The spot

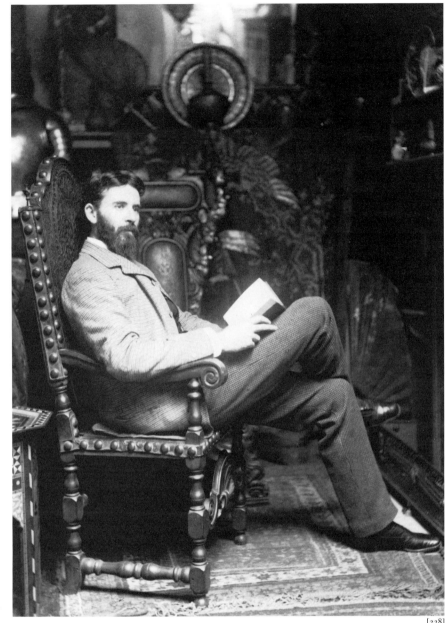

[238]

where Mr Dicksee is seated is at the farther corner of the studio, where the fire glows and crackles, an architectural arrangement suitable enough for one, but likely to provoke dissension where many are gathered together. From his comfortable corner the painter looks up the whole length of the studio, which is broken by his large Academy picture.'
National Portrait Gallery, London

'Mr Dicksee is tall, dark, spare, bearded, well-groomed, well-looking, and not readily to be suspected of the years recorded against him. A characteristically English aloofness at first contact, soon thaws to a manner which, although quiet and undemonstrative, is not lacking in pleasant evidences of a willingness to serve even a monographer intent upon subjecting him to treatment for which he professes a disrelish.'
E. Rimbault Dibdin, *Frank Dicksee, his Life and Work* (1905), p. 28

'He told me he was an admirer of Mussolini, and was himself a Fascist – "though I am too old to take an active part".... [As President of the Royal Academy] his height, good looks, and charm of manner made him an attractive and popular figure.'
Gladys Storey, *All Sorts of People* (1929), p. 208

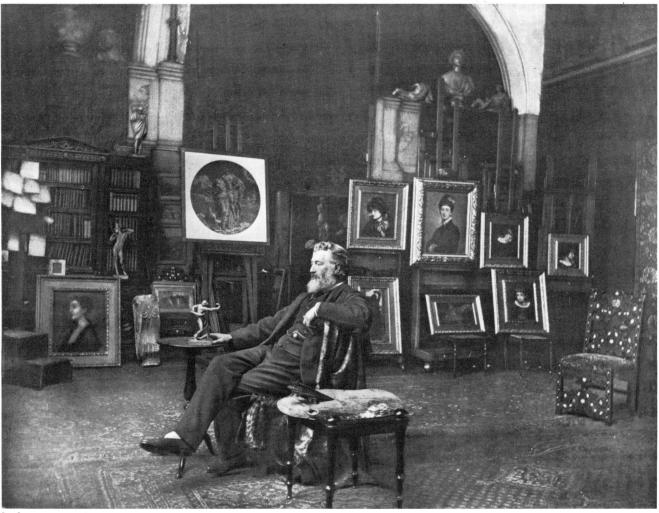

[240]

[239]

BARON LEIGHTON OF STRETTON, PRA
(1830–96)

One of the great figures of Victorian art. Painter of mythological and neo-classical pictures, and leader of that School. He also sculpted. His first Academy picture of 1855, *Cimabue's Madonna*, was bought by the Queen on the advice of Prince Albert. He became President of the Royal Academy in 1878, was knighted in 1878, and raised to the peerage the day before his death.

239 *Carte-de-visite*, albumen print by an unidentified photographer, taken in 1862. *Author's collection*

240 Photogravure by J. P. Mayall, 163 × 320 mm, reproduced in *Artists at Home* (1884), by F. G. Stephens, facing p. 4. Leighton's studio was at 2 Holland Park Road. The pictures illustrated include *Letty* (1884), behind the artist's head to the right, and another of the same title on the extreme right. Partly obscured by his left elbow is *Phyrene at Eleusis* (*c.* 1882). The roundel on the easel is a design for the dome of St Paul's. On the book-case is a model of *The Sluggard* (1882–5); on the table is a model of *The Athlete Struggling with a Python* (1874–7). A reviewer in the *Magazine of Art* (1884), discussing Mayall's book, described Leighton, in the photogravure, as 'a sufferer, but resigned'. *Author's collection*

241 Photograph by Walery, London, 255 × 180 mm, *c.* 1890. Inscribed to T. S. Cooper, RA (q.v.). *Author's collection*

[242]

242 Photograph by Henry Dixon & Son, London, of Lord Leighton lying in state in the Octagon Room at the Royal Academy. On the coffin were his palette, brushes and mahlstick. At his feet was a cushion on which lay the foreign honours he had won. At the head was a bust of him by Brock (q.v.). *Royal Academy of Arts*

243 Photograph by Symmons & Thiele, London. The artist was buried in St Paul's on 3 February 1896. The funeral cortège left Burlington House at eleven o'clock, led by a detachment of Artists' Rifles. Behind the coffin walked the pall-bearers, including Millais (q.v.), who followed him to the Presidency and, a few months later, to St Paul's. *Royal Academy of Arts*

'Sir Frederick is a mixture of the Olympian Jove and a head waiter.'
Vernon Lee's Letters (1937), ed. by I. Cooper-Willis, p. 123

Julian Hawthorne and a friend visited Leighton at his house in Holland Park Road: 'Fred, in one noble attitude after another, welcomed us at the terminus of a series of handsome rooms, each of which gave the impression of being the ante-room to another yet more handsome, culminating in the lofty spaciousness of the great studio. Two or three other guests were present, whether male or female and of what aspect I have forgotten; they were mere properties on the stage. Fred wore a black velvet lounging sack and pearl-grey pantaloons; his feet in shining pumps, his countenance superb; he was almost too beautiful. He stood with legs somewhat apart, hands in his sack pockets; or he would pose himself on one leg with the other aslant. He would stroke his sable-silvered beard as he conversed, turning his head now to one side, now to the other; now and then he would comb his fingers backward through his hyacinthine curls; his conversation was affable, but it was difficult to distract your attention from how he looked to what he said. His eyes – the only fault in his face – were a trifle too small; I could fancy that when things were not going his way he might turn uncongenial.'
Julian Hawthorne, *Shapes that Pass* (1928), p. 175

'And yet in spite of all his cordiality and sweetness such an impenetrable halo of perfection seemed to surround the man, and all that he said and did, as rendered it impossible for us to converse with him quite in the same free and brotherly way that we could with one another. The conscientiousness, thoroughness, and punctuality with which he performed every duty of his office, his high ideals, the exquisite grace and courtesy of his manners, the universality of his talents and accomplishments – these things were altogether hopelessly beyond any attainment on our parts.'
George Dunlop Leslie, RA, *The Inner Life of the Royal Academy* (1914), p. 183

Lord Leighton's lying in state at the Royal Academy (Leighton died at his house at 2 Holland Park Road on 25 January 1896):

'Leighton's death was a national event, and it aroused widespread grief and consternation, as if some seemingly impregnable bulwark had collapsed. . . . His death, coming at a crucial turning point in the history of British art, left a vacuum which no-one could fill.

'News of Leighton's death was conveyed to the Academy by Val Prinsep. A council meeting was called on Saturday evening, and the minutes refer to the "deepest emotion" and to a "unanimous expression of heartfelt sorrow & regret". . . . The decision that he should be buried in St Paul's was made at this council meeting, and a sub-committee was set up to make the necessary arrangements. . . . The Royal Academy was to bear the cost, but in all other respects this was to be a public funeral.

'The body meanwhile had been placed in the studio of 2 Holland Park Road, surrounded by the president's latest pictures, many of them incomplete, which were decorated with flowers. A steady stream of friends left their cards at the door. Not until a week after his death were Leighton's remains transferred to the Royal Academy. Here again he lay in state, in the octagon room, surrounded by flowers. Among the mass of wreaths was one from the Prince and Princess of Wales. . . .

'On the day of the funeral, Monday, 3 February 1896, many of the academicians went to the octagon to stand for a few minutes in silence. On the coffin were Leighton's palette, brushes and mahlstick, and, on a cushion at his feet, the foreign honours he had won. At the other end was the bust of him by Brock, and his chain of office as president.

'The funeral cortège left Burlington House at eleven o'clock, led by a detachment of Artists' Rifles. Behind the hearse walked the pall-bearers, including only one artist and academician, John Millais. . . .

'The day was glorious; "his characteristic good fortune to the end", as Henry James put it. Outside St Paul's a large crowd had gathered, and by half past eleven the cathedral itself was full, the wreaths piled high in the centre. Representatives of every sort were present, as well as many artists and personal friends. . . .

'As the coffin was carried up the steps of the cathedral, Schubert's "March Solonelle" and Chopin's "Funeral March" were played on the organ. Just before the coffin entered by way of the west doors, Beethoven's "Equale for Four Trombones" rang out, for the first time since the composer's own funeral. The Artists' Rifles lining the central aisle stood with arms reversed, while the

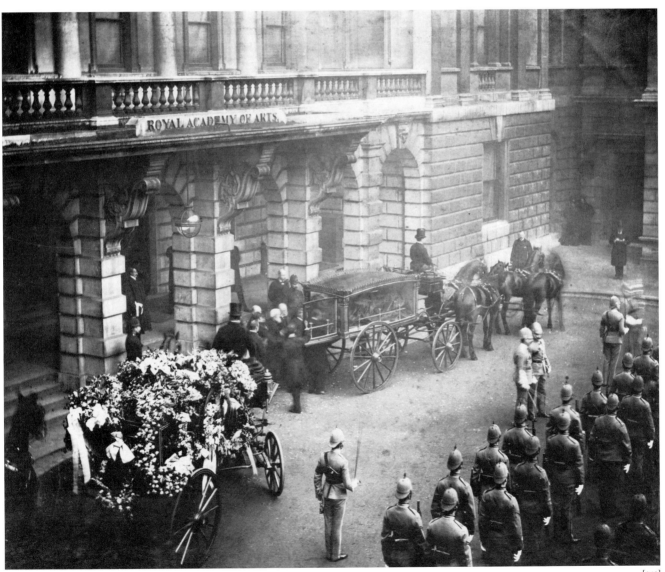

procession came down to Croft's setting for
the opening sentences of the funeral service.
Hervey's version of the Ninetieth Psalm fol-
lowed, and then a reading of the magnificent
passage from the first book of Corinthians,
beginning "But now is Christ risen from the
dead, and become the first fruits of them that
slept." The opening chorus of Brahms's
"German Requiem" followed, and the coffin
was lowered into the crypt to Purcell's setting
of "Thou knowest, Lord, the secret of our
hearts".'

Leonée and Richard Ormond, *Lord Leighton*
(1975), pp. 145–7

ALBERT JOSEPH MOORE, ARWS
(1841–93)

Neo-classical painter and brother of Henry
Moore, RA (q.v.). He was a remarkably refined
and sophisticated painter who combined ex-
quisite draughtsmanship with subtlety of
colouring.

244 Platinum print by Frederick Hollyer
(q.v.). *Royal Photographic Society*

'His was a strange and interesting figure in the
world of art. Few people knew him well, for
he seldom took the trouble to make friends,
yet he was the most gentle and affectionate of
men. His splendid Christ-like head with its
broad brows and great visionary brown eyes
was set upon an odd awkward little body that
seemed to have no connection with it.

'His favourite attitude of repose was squat-
ting on his heels like a Japanese, and when
settling himself for a talk, he would suddenly
subside thus upon the floor, to the amazement
of casual beholders.

'His usual indoor costume was a very long
and very large ulster, far too big for him and
once, in remote ages, the property of an elder
and taller brother. With this he wore a large
broad-brimmed straw hat without a crown.'

W. Graham Robertson, *Time Was* (1931), pp. 57–8

'Moore was a man of a difficult temperament.
He was wedded to his Art, devoted to its com-
munication, was intolerant of all patronage
and claimed recognition by pure right of Art.
He was not given to studying his words when
in a critical mood, and was clear and even pun-
gent in his remarks upon painting which did
not please him.'

Bryan, *Dictionary of Painters*

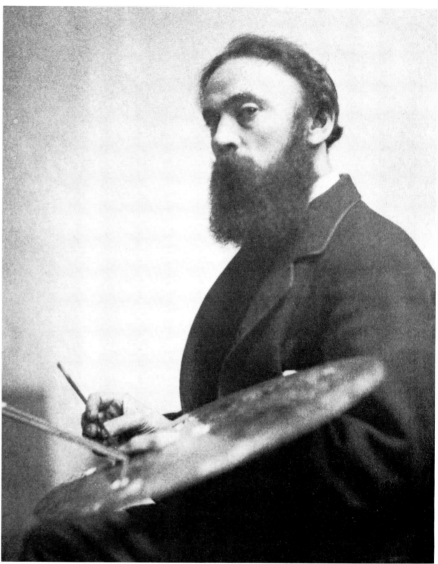

[244]

SIR EDWARD JOHN POYNTER, PRA, RWS
(1836–1919)

Neo-classical painter who shared a studio in
Paris with Thomas Lamont, Thomas Arm-
strong and George Du Maurier (q.v.). During
the 1860s he drew book illustrations. He
became President of the Royal Academy in
1896 on the death of Millais (q.v.), was the
first Slade Professor at University College,
London, as well as Principal of the National
Art Training Schools in South Kensington
and, from 1894 to 1905, Director of the Nation-
al Gallery. He was made a baronet in 1902.
He is buried in St Paul's Cathedral. His wife
was the sister of Georgiana Burne-Jones (q.v.)
and an aunt of Rudyard Kipling.

245 Woodburytype by Lock and Whitfield,
London, 114 × 92 mm, *c.* 1870. *Author's
collection*

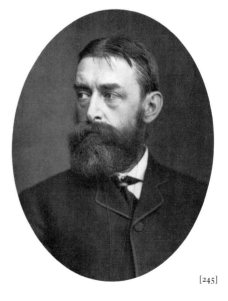

[245]

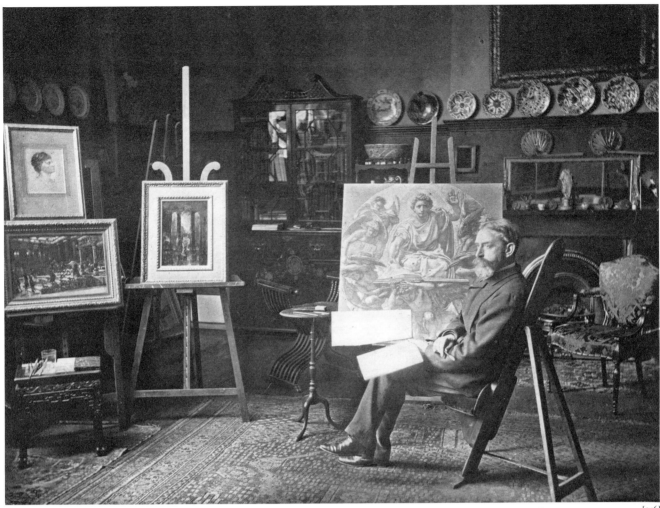

[246]

246 Photogravure after J. P. Mayall, 164 × 219 mm, reproduced in *Artists at Home* (1884), by F. G. Stephens, facing p. 82. The lower painting on the easel to the left is a small version of *The Meeting of Solomon and The Queen of Sheba* (the large version is in the Art Gallery of New South Wales). On the easel to the right is a small version of *The Ides of March* (the large version is in the Manchester City Art Gallery), and the large painting on the third easel is one of the designs for the dome of St Paul's Cathedral.
Author's collection

The young Poynter was the model for the character of Lorrimer in George Du Maurier's *Trilby*. Lorrimer-Poynter was described as 'Tall, thin, red-haired, and well-favoured,

he was a most eager, earnest and painstaking young enthusiast, of precocious culture, who read improving books, and did not share in the amusements of the Quartier Latin, but spent his evenings at home with Handel, Michael Angelo, and Dante, on the respectable side of the river. Also, he went into good society sometimes, with a dress-coat on, and a white tie, and his hair parted in the middle!

'But in spite of these blemishes on his otherwise exemplary record as an art student, he was the most delightful companion – the most affectionate, helpful and sympathetic of friends.'
George Du Maurier, *Trilby* (1895), pp. 140–1

'Many of his old friends have assured me that his heart was in the right place, but I feel

certain that the same could not be said for his liver, and chronic dyspepsia is not very improving to the temper.'
W. Graham Robertson, *Time Was* (1931), p. 51

'That particular day Mr. Edward Poynter, not then President of the Royal Academy, but always a dignified and rather unapproachable personality, had just entered, and was going up to Lady Lindsay with that unaccountably melancholy and aloof expression which he always wore in public, when Jimmy [Whistler] intercepted him, and, patting him loudly on the back, shrieked out, "Hullo, Poynter. Your face is your fortune, my boy! Ha! Ha!"

'Poynter passed on without the ghost of a smile.'
Mrs J. Comyns Carr, *Reminiscences* (n.d.), p. 58

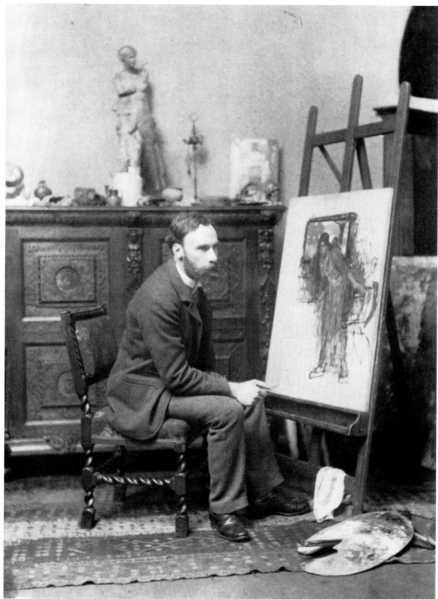

[247]

JOHN WILLIAM WATERHOUSE, R A
(1849–1917)

One of the great English painters of the second half of the nineteenth century. He began painting somewhat in the manner of Alma-Tadema (q.v.) and Edwin Long (q.v.) before evolving his own personal style with romantic literary subject matter.

247 Photograph by Ralph W. Robinson, 200 × 153 mm, published in *Members and Associates of the Royal Academy of Arts, 1891, photographed in their Studios* (1892). The unfinished picture on the easel is one of several versions of *The Lady of Shallot*. *National Portrait Gallery, London*

— 8 —
ILLUSTRATORS

THE subject of illustrative work during the nineteenth century is vast and complex, and almost wholly unyielding against any attempt at synthesis. Illustration occupies a position between art and the written word, whether poetry, fiction, news reporting, science or, in fact, the whole world of knowledge, of enlightenment. It has an essentially interpretive function: it is the art of realization. There was hardly an artist of note who did not at some time, or even for a considerable period, become involved in one of the heterogeneous branches of illustration, to the extent that it became an essential part of the creative process itself. More usefully, it offered an option which was open to any artist for the furtherance of his career. All that was required was an element of training thus enabling that artist to meet the requirements of the blockmaker, engraver or printer, and, above all, the simple ability to draw, which was in any case the *sine qua non* of every Victorian artist. Some artists devoted their careers entirely to illustrative work; others acquired a reputation in this field parallel to that of formal subject painting.

Illustration – essentially the art of black and white – is as old as any of the media of communication, more particularly the varieties of engraving, which gave it expression. In Britain Hogarth was the exemplar in the eighteenth century; his engravings were to be the most potent influence on later illustrators. This influence spread through the great age of the political cartoon – the Regency period – and the age of Gillray, Isaac Cruickshank and Rowlandson continues to be seen in the work of the book illustrators of the 1860s, and even in the later political cartoons in *Punch*, by artists such as Sir John Tenniel, Linley Sambourne and Sir Bernard Partridge. When Victoria came to the throne in 1837 steam printing was in full spate and illustrated journals abounded. Anyone wishing to read a full account of these and to understand the art of illustration during the period of Victoria's reign is strongly advised to turn to the *Dictionary of British Book Illustrators and Caricaturists 1800–1914*, to which is modestly appended the sub-title *With introductory chapters on the rise and progress of the art* (1978), by Simon Houfe. The author of this most excellent survey (which so far as I could see contains only one startling but engaging howler, 'the discovery of the daguerrotype'), to whom I am much indebted, enumerates all these journals, albums, pamphlets, magazines and illustrated anthologies in the most illuminating detail. Just to make a list of them would fill this page to the exclusion of all else. Houfe, in turn, records his debt, as all who treat this subject must, to the excellent *Illustrators of the Sixties* (1928) by Forrest Reid, who was the first editor, virtually, of the influential illustrated art periodical *Studio*.

The proliferation of illustrated publications was mainly in response to the overwhelming thirst for information and self-improvement, and they contained a truly awesome variety of subject matter: fashions, society beauties, rustic scenery, erudite articles on sea urchins, illustrations of Anglo-Saxon shoe buckles. Although some of these illustrations were appallingly inaccurate and must have ranged from pure fiction to enlightened guesswork, they gradually improved in pace with education. The problems of authenticity were most dramatically highlighted when, during the early stages of the Crimean War, home-based magazine illustrators were expected to produce elaborate reconstructions of battles, based entirely on news reports.

Magazines were a primary source of employment for the illustrators and the circulation of some of the more popular ones was enormously high. The editors of these, unlike the editors of illustrated books, could

afford to take on new and untried talent because circulation had its own predictable momentum and failures could be discreetly dropped without being noticed. The editors of illustrated books, on the other hand, with their own particular finality and permanence, tended to employ artists with proven reputations. A small group of magazines, all begun in the 1840s, soon dominated this branch of illustrative journalism.

Punch was first issued on 17 July 1841, with Mark Lemon as its first editor, which post he held for nearly thirty years. This famous magazine quickly creamed off existing talent, each one of its early illustrators leaving his mark for others to match. John Leech, Richard Doyle, Kenny Meadows and (briefly) Alfred Crowquill all worked for the early numbers, and they were later joined by Tenniel, Keene, Du Maurier and Linley Sambourne. Less than a year later, on 14 May 1842, appeared the first issue of the *Illustrated London News*, which relied less on the personality of its illustrators. Superb editorship, techniques and publicity machinery ensured, by 1851, a circulation of 100,000. As its title implied, it specialized in the graphic reporting of news, and it quickly attracted several of the best illustrators of the period, some even from the ranks of *Punch*. John Gilbert was the most accomplished and popular, both with the public and his editors. His output was prodigious and his drawing was faultless. His facility was such that he could quickly visualize any scene, fictitious, historical or contemporary, and rapidly transfer the image on to a woodblock, with scarcely any reference to props and never to models. Gilbert had a voracious craving for money, not cheques or bank notes, but real golden sovereigns. Publishers and engravers, aware of this, would despatch their boy messengers who would place a little pile of sovereigns on the table beside him if they wanted a job done quickly. After a grunt, the boy would be sent away, to return for the completed drawing in an hour or two.

The publication in 1860 of the *Cornhill Magazine*, with Thackeray as its editor, was another milestone. The first serialization of novels by Thackeray himself, Anthony Trollope, George Eliot, Mrs Gaskell and Wilkie Collins, and the works of Matthew Arnold and Elizabeth Barrett Browning, ensured that the major artists of the day were attracted to its pages as illustrators. Frederic Leighton and Frederick Sandys were early recruits, as was Frederick Walker. But it was the employment of Millais as an illustrator to Trollope that set the tone for the great age of illustration in the 1860s. For while the publication of new magazines grew apace, most notably with *Once a Week* in 1859 and *Good Words* in 1860, it was in the illustrated anthologies published in that golden decade that much of the true genius of English book illustration appeared. Its great period, it should be said, extended from before 1855 to after 1870, but most of the best work was done in the 1860s.

Perhaps a brief word on the technique of reproducing the illustrator's art would not come amiss. The artist made his drawing in pencil direct on to a block of hardwood, usually box, sawn across the grain and highly polished. The block was then placed with a firm of engravers (the Dalziel brothers and John Swain being the most favoured at that period), where the engraver, using a burin and other tools, cut away all those parts which were not to be printed. Inevitably, the original drawing ceased to exist except through its translation by the engraver. Most artists mastered this technique early in their careers, and it always stood them in good stead. There were those, of course, who never properly developed this skill. Rossetti, typically, for he was always deficient in any techniques, was one. 'How,' asked the Dalziel brothers of Arthur Hughes about Rossetti, 'is one to engrave a drawing that is partly in ink, partly in pencil and partly in red chalks?'

The Pre-Raphaelite painters were all excellent draughtsmen, thus natural illustrators, and they specialized in designs for contemporary poets, as well as sacred and biblical subjects. Of the former group, the illustrations to William Allingham's *The Music Master* of 1855, and the Moxon edition of Tennyson's poems, published two years later, were the most important. Many little masterpieces are scattered throughout these publications, and the compositions and themes found echoes through subsequent paintings and illustrations. The two media were always to be mutually influential up to the end of the century.

Of all the Pre-Raphaelite illustrators, Millais was both the finest and most influential. The cool mastery of line, the precision of drawing, the eloquence and grace of the compositions, the dramatic intensity and the faithfulness to the narrative which his work showed had a marked effect on the work of his contemporaries and successors. These were a veritable galaxy of talent who, between them, revitalized the art of book illustration, bringing it to a peak of perfection against which subsequent illustrations could be judged, given changing fashions and techniques. Their illustrations, often in juxtaposition with the more traditional work of Gilbert, Creswick, Clarkson Stanfield and F. R.

Pickersgill, adorned nearly all the popular anthologies and magazines of the period. The greatest of Millais's successors in this field were J. W. North, M. J. Lawless, J. D. Watson, Frederick Sandys, Whistler, George Du Maurier, Charles Keene, G. J. Pinwell, Arthur Boyd Houghton and Fred Walker. The deaths of the last three, all in 1875 and when they were all young, came as a sickening blow to their contemporaries.

When, at the very end of this great decade, it might have seemed that this extraordinary vitality was on the point of peaking, there occurred an event which gave book and magazine illustration an entirely new stimulus. This was the publication in December 1869 of the first issue of the *Graphic* magazine under the enlightened editorship of W. L. Thomas, who had a sharp eye for illustrators. Intended as an illustrated news magazine, the news fell straight into its lap with the start of the Franco-Prussian War of 1870. A. S. Hartrick, who was later employed as an illustrator, recalled that Thomas 'quickly enrolled on the staff . . . what was probably the ablest band of young illustrators who have ever been brought together in one such enterprise in England. Nearly every one of them made a reputation for himself and the paper within the next few years, not to mention a fortune for its directors. [Luke] Fildes, E. J. Gregory, [Frank] Holl, [Hubert von] Herkomer did much of their best work for the paper.' Fildes, Holl and Herkomer, in fact, founded between them a new social-realist school based on their experiences on this periodical. The impact of the *Graphic* illustrators was felt by many foreign artists, amongst them Vincent van Gogh, who began to form a collection of wood-engravings in which he found a stimulus to set to work with renewed zest. In all these 'fellows I see an energy, a determination and a free cheerful spirit that animate me'.

The successive inventions of line and half-tone blocks, the method of transferring the photographic image to the surface of a block, and the advent of colour printing made for radical changes in the art of illustration. Black and white, however, was brought to further peaks of perfection at the hands of Aubrey Beardsley and Phil May. Walter Crane, Randolph Caldecott, Kate Greenaway and Beatrix Potter all made their reputations in the new colour printing.

The social status of illustrators is of interest – just as it was to themselves. Although they were generally held in high esteem by the reading and magazine public, it seems that the high society to which many of them aspired was a little wary of their connection with the commercialities of art. If Millais could be shocked to the core to observe a picture by Richard Ansdell *in a shop-window*, what hope was there for a hack artist who depended for his livelihood on the whims of a money-grabbing editor in grimy offices in the city? John Leech found solace on the hunting-field, and wished above all that he could find the talent to paint. Standing in front of a quite remarkably bad painting, he confided to Sir Joseph Boehm, 'I would rather have been the painter of that picture than the producer of all the things I have ever perpetrated!' Boehm greeted this observation with incredulous laughter. Dicky Doyle, who also harboured hankerings to be regarded as a painter, and George Du Maurier, who was to pursue an illustrious career in the realms of literature, both never felt happier than at the dinner tables of fashionable society. Sir John Tenniel, with his distinguished appearance and bearing, was probably just content to be occasionally taken for a general rather than a cartoonist. Quite incidentally, the last two named managed to devote long careers to a profession requiring the most fastidious concentration and observation, with only two eyes between them. One morning in 1857 Du Maurier was drawing from a model, 'When suddenly,' as he later recalled, 'the girl's head seemed to me to dwindle to the size of a walnut. I clapped my hand over my left eye. Had I been mistaken? I could see as well as ever. But when in its turn I covered my right eye, I learned what had happened. My left eye had failed me; it might be altogether lost. It was so sudden a blow that I was as thunderstruck.' He had in all probability suffered a detachment of the retina, followed by a haemorrhage at the back of the eye. Tenniel lost one of his eyes quite as suddenly during a fencing match.

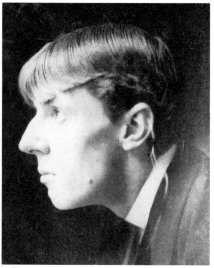

[248]

AUBREY BEARDSLEY (1872–98)

Black-and-white illustrator, caricaturist, poster-designer and novelist, whose influence after his early death was extensive.

248 Photogravure by Frederick H. Evans, 122 × 91 mm, 1895. *Sotheby's*

'... a face like a silver hatchet, with grass-green hair.'
Oscar Wilde in *The Romantic 90s* (1926), by Richard Le Gallienne, p. 173

THE HON. MRS RICHARD BOYLE, 'E V B' (née Eleanor Vere Gordon) (1825–1916)

Illustrator of children's books and poetry.

249 Photograph by an unidentified photographer, *c.* 1865. *Mrs Michael de Wend Fenton*

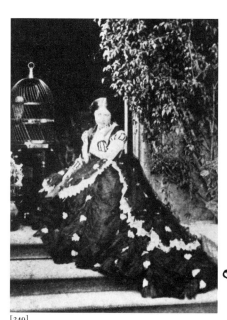

[249]

'E.V.B. is an aesthete of Ruskin's school, a lover of beautiful things, of what is decent and quiet and old, of gardens, of nature in selections, and of art.'
Writer in *The Bookman* (October 1908)

ALFRED CROWQUILL (Alfred Henry Forrestier) (1804–72)

Writer and comic artist, caricaturist and illustrator often of a highly fantastic and grotesque character.

250 Uncut proof albumen print by Charles Watkins, London, 78 × 58 mm, *c.* 1860. *Author's collection*

'Forrester [*sic*] was notable for his jovial appearance and manners. He had a cheery laugh at command for his own small jokes, and had schooled himself to bear the ordinary annoyances of life in a pleasant philosophical way. While uncommonly mindful of his own interests he was always ready to make the best of whatever ran counter to them, and passed through life with a smiling countenance.'
Henry Vizetelly, *Glances Back Through Seventy Years* (1893), Vol. 1. p. 207

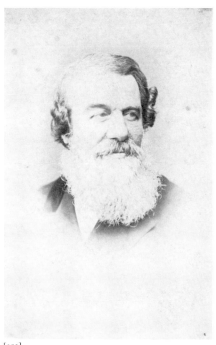

[250]

GEORGE CRUIKSHANK (1792–1878)

Artist, etcher and caricaturist during an exceedingly long career. Was converted to the teetotal cause in the late 1840s and became a fervid polemicist on temperance.

251 (opposite) Albumen print by Maull & Polyblank, London, 200 × 147 mm, 1856. *Author's collection*

252 Uncut proof albumen print by Ernest Edwards, 90 × 78 mm, published in *Portraits of Men of Eminence* (1866), by A. W. Bennett, Vol. 1. *Author's collection*

'Nobody who met the artist could ever forget him: the vivacity and whimsical humour of his light blue eyes: his queer old-fashioned whiskers, starting on the upper lip from where the modern apology for a moustache terminates; long hair stroked over the crown of his large head and brought well over the ears in later Georgian fashion.'
Allan Fea, *Recollections of Sixty Years* (1927), p. 105

Cruikshank, over eighty years old: 'active as a grasshopper, and looking like one.... Cruikshank, whose drawings had entranced me from his edition of *Grimms' Fairy Tales* down, was the fulfilment of a childhood dream. His wonderful little capering imps and hobgoblins had been portraits of himself; he was Rumpelstiltskin, the Bottle-Imp, and all the rest; had I had a book in my pocket, I would have put him between the leaves and carried him home. He didn't walk, but hopped hither and thither and fantastically gesticulated.'
Julian Hawthorne, *Shapes that Pass* (1928), pp. 86–7

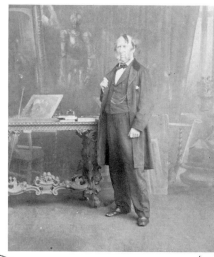

[252]

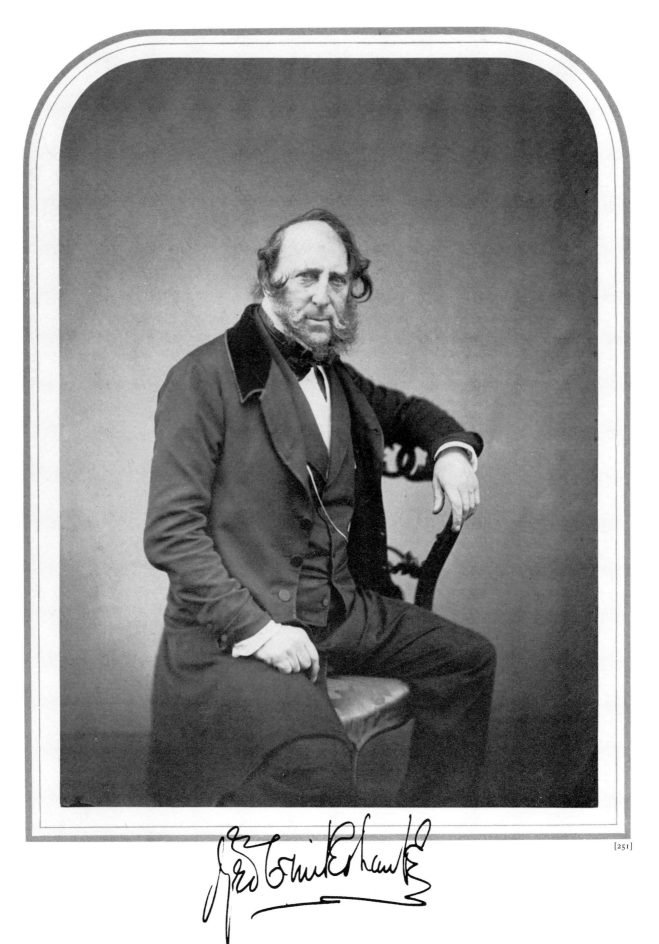

[253]

CHARLES ALTAMONT DOYLE (1832–93)

Illustrator of the humorous and fantastic. Brother of Richard Doyle (q.v.). His son, Arthur Conan (1859–1930), was the famous creator of Sherlock Holmes and writer of historical romances.

253 *Carte-de-visite* of Charles Doyle with his son Arthur Conan, oval, 1865, by Hay of Edinburgh. *Private collection*

'His large head, small rimless glasses and long beard lent him an academic air, and indeed his enthusiasm for excruciating puns and comic riddles was distinctly donnish at times.'
Michael Baker, *The Doyle Diary* (1978), p. lx

RICHARD DOYLE (1824–83)

Son of John Doyle, a painter of miniatures from Dublin, who settled in London and, as

[254]

'HB', became a celebrated political cartoonist. Brother of Charles Doyle (q.v.). Richard was famous for his fairy subjects and his contributions to *Punch*.

254 *Carte-de-visite*, gelatine silver print by Naudin, London. From the collection of Holman Hunt (q.v.) and incorrectly inscribed 'W. B. Scott' by his wife Edith (q.v.). *Author's collection*

'Dear Dicky! of incomparable quiet humour, of fantastic and joyous imagination, quite Celtic in its romantic genius. Acceptable wherever he went, welcome in any society, fashionable or Bohemian, Dicky had a unique personality. How quiet he was, how delightful his Irish accent, his attractive but somewhat shy manner, his modesty regarding his own attainments, his generosity in his estimation of fellow-artists!'

Sir William Blake Richmond in *The Richmond Papers* (1926), by A. M. W. Stirling, pp. 185–6

GEORGE DU MAURIER (1834–96)

Artist in black and white, cartoonist and novelist. Regular contributor to *Punch*.

255 Albumen print by an unidentified photographer. *Author's collection*

'Du Maurier . . . had a long crane-like neck.'
Walter Sichel, *The Sands of Time* (1923), p. 170

[256]

'[23 March 1886] Du Maurier was most sympathetic and delightful; his greatest joy is children; he is quite absurdly like Alma-Tadema. He looks and speaks 35, though he told me he is really something near 50.'

A Victorian Diarist, Extracts from the Journals of Mary, Lady Monkswell 1873–1895 (1944), ed. by the Hon E. C. F. Collier, p. 125

[255]

SIR JOHN GILBERT, RA, PRWS (1817–97)

A mainly self-taught and prolific illustrator, he also painted in oils and water-colours.

256 Photogravure after J. P. Mayall, 165 × 256 mm, reproduced in *Artists at Home* (1884), by F. G. Stephens, facing p. 64. The large picture to the right is *The Fair St George* of 1881 (Guildhall Art Gallery), according to Stephens, 'one of the most refined examples Sir John Gilbert has given us'. A reviewer in the *Magazine of Art* (1884) observed, facetiously one presumes, that the artist 'has the sun in his eyes, and comes out very white and vague'. *Author's collection*

'Gilbert was a prolific illustrator. He had regularly contributed drawings to *Punch* from its first issue on July 17th, 1841, but severed his connection after the editor had complained that he did not need a Rubens on his staff!'
The Young Du Maurier (1951), ed. by Daphne Du Maurier, p. 280

KATE GREENAWAY, RI (1846–1901)

Celebrated illustrator of children's books, and friend of John Ruskin (q.v.).

257 *Carte-de-visite*, albumen print by Elliott & Fry, London. *Alan Sandal, Esq.*

'She was a small, plain, dumpy, quiet, amiable spinster.'
Mary Clive, *The Day of Reckoning* (1964), p. 91

'Quiet, shy, and gentle, she withdrew herself almost timorously upon herself at the slightest hint of publicity; and where she expected no sympathy she shrank from the advances of the most distinguished in the land.'
M. H. Spielmann in the *Magazine of Art* (1902)

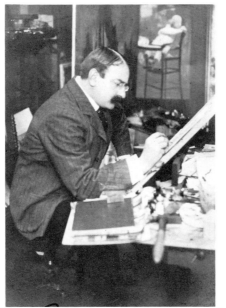

[258]

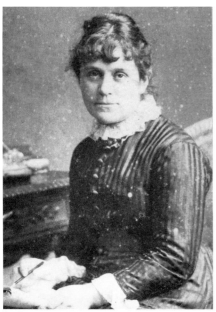

[257]

DUDLEY HARDY, RBA, RI (1865–1922)

Painter in oils and water-colours, and an illustrator. He also made poster designs.

258 Silver bromide on postcard, *c.* 1895. *Author's collection*

CHARLES SAMUEL KEENE (1823–91)

Great draughtsman and humorous artist. His drawings were admired by Degas.

259 Photograph by Horace Harrall. *National Portrait Gallery, London*

'He was without exception the most delightful and quaintly humorous personality I have ever met. I can see him now, in his grotesque little jacket, which looked as though he had made it himself, very short about the hips and innocent of any attempt at fit, hanging in picturesque but distinctly untailorlike folds

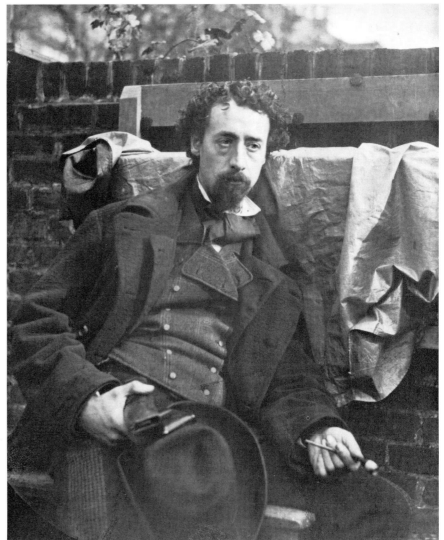

[259]

about his meagre person; his flannel shirt very limp about the collar and cuffs, and his ancient slippers, in which he would shuffle about the house and garden in company with the most constant of his attendants – his pipe. At meal-times he would keep the table in a perpetual bubbling of mirth. His own laugh, though it broke out but rarely, was a thing to wonder at: a silent, hilarious chuckle, which doubled him up in ecstasy at some joke or remembrance. . . . In spite, however, of his humour, there was something pathetic about Keene, with his poor old frayed coat and down-trodden slippers, his long lean neck, and cadaverous, strongly-marked face.'

A. M. Reynolds, *The Life and Work of Frank Holl* (1912), pp. 259–60

JOHN LEECH (1817–64)

Very popular humorous artist, who contributed some 3000 drawings to *Punch* from 1841 until his death.

260 *Carte-de-visite*, albumen print by an unidentified photographer, *c.* 1860. *Author's collection*

'The keynote of his character, socially, seemed to be self-effacement, high-bred courtesy, never-failing consideration for others. He was the most charming companion conceivable. . . . He was tall, thin, and graceful, extremely handsome, of the higher Irish type, with dark hair and whiskers and complexion, and very light greyish-blue eyes; but the expression of his face was habitually sad, even when he smiled. In dress, bearing, manner, and aspect he was the very type of the well-bred

English gentleman and man of the world and good society.'

George Du Maurier in *The Life and Letters of Sir John Everett Millais* (1899), by J. G. Millais, Vol. 1, p. 262

PHILIP WILLIAM ('PHIL') MAY, R I (1864–1903)

A highly talented humorous draughtsman.

261 Silver bromide on postcard, which, used, is post-marked 1903. *Author's collection*

'In appearance May was slightly above average height, perhaps about five feet eight, with a slight figure and something of the appearance of a groom, to which his fondness for wearing riding costume contributed. He had exquisitely beautiful and delicate hands, and his keen, alert face, with straight, smooth fringe, grey discerning eyes, and firm mouth . . . He once explained that the straight fringe . . . was purely a result of maternal affection. "All owing to my dear old mother," he declared. "She would pat my head and smooth my hair down and tell me I was a pretty boy, and I think she believed it! But anyhow it won't lie any other way now". . . . Toward the end of his life he was very sensitive about the disfigurement that drink had wrought on his face, a disfigurement that disappeared as if by magic when he died.'

James Thorpe, *Phil May – Master-draughtsman and Humorist* (1932), pp. 61–2

'The last time we met was when he came to his studio door wearing the loudest suit I have ever seen. Seeing my look of surprise he smiled and said, "Come in and listen to it, dear boy."'

John Lavery, *The Life of a Painter* (1940), pp. 81–2

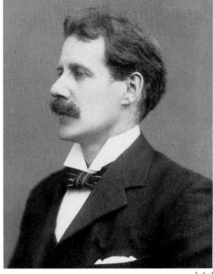

[262]

SIR BERNARD PARTRIDGE, R I (1861–1945)

Punch cartoonist and painter. Knighted in 1925.

262 Cabinet portrait, gelatine silver print by Bassano, London, *c.* 1890. *Author's collection*

HELEN BEATRIX POTTER (Mrs Heelis) · (1866–1946)

Illustrator of children's books, and daughter of Rupert Potter (1832–1914). Her family was on friendly terms with Millais (q.v.). For a short period she kept a diary which contains valuable observations of the art world of the period.

263 Photograph taken in 1881 by the artist's father. *Frederick Warne PLC*

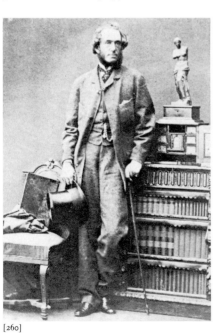

[260]

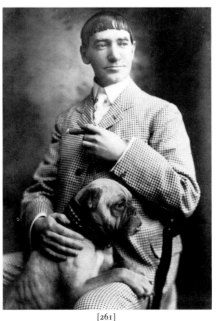

[261]

[263]

EDWARD LINLEY SAMBOURNE
(1844–1910)

Black-and-white artist, cartoonist and designer. On the retirement of Tenniel in 1901 he became First Cartoonist of *Punch*.

264 Cabinet portrait, albumen print by Elliott & Fry, London, *c.* 1890. *Author's collection*

'"Sammy" was loved by his colleagues, who were amused by his naïvety and respectful of his goodness. Nobody knew whether his mistakes were intentional, mistakes like "There was such a silence afterwards that you could have picked up a pin in it", "You're digging nails in your coffin with every stroke of your tongue", or "I don't care for Lady Macbeth in the street walking scene." He certainly enjoyed the amusement they produced.'

R. G. G. Price, *A History of Punch* (1957), p. 118

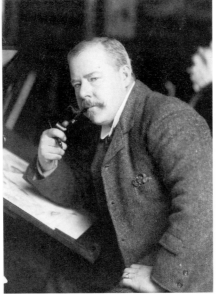

[264]

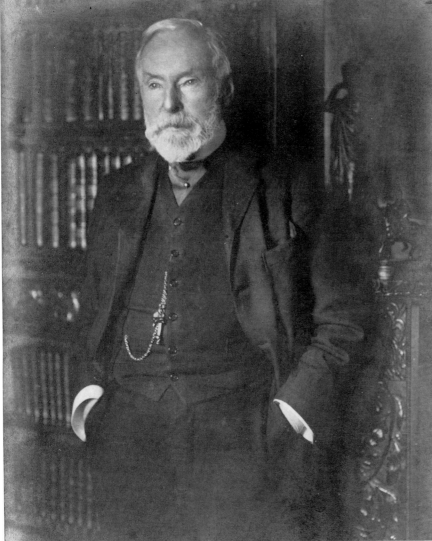

[266]

SIR JOHN TENNIEL (1820–1914)

Artist and cartoonist in black and white. On the staff of *Punch* from 1850 to 1901 and drew over 2000 cartoons.

265 *Carte-de-visite*, albumen print by John and Charles Watkins, London. Tenniel evidently had strong feelings about his photographic image, as this letter of 24 July 1862 to John Watkins concerning this photograph reveals:

'I saw one of my portraits in a window yesterday and confess to have felt decidedly the reverse of gratified at finding that it was the one I especially dislike – the one sitting, with the chin on the hand and the head turned round. The position is constrained and affected, and – as all my friends agree – not a bit characteristic of the "party".

'I shall therefore feel much obliged if you will print from it no more, or better still, cancel the image altogether, the pose is so evidently "got up" that it annoys me whenever I see it. The standing figure with the hat and whip is considered the best.

'I am very anxious to see the proofs of the new negatives.' *Photograph and letter: Author's collection*

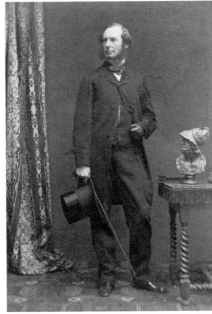

[265]

266 Silver bromide print by 'L. N. A. Photo'. Inscribed 'To Miss Stevenson – with the very kindest regards of John Tenniel. April 22, 1909 (his 90th year!)'. *Author's collection*

'Tenniel was a tall, handsome, gentlemanly fellow, blind of one eye, which had been injured in fencing.'

W. J. Linton, *Recollections* (New York, 1894), p. 59

'Tenniel was reserved and conventional both in manner and outlook. He seemed to be eternally struggling to conquer a reticence which overpowered him. Neither in ordinary conversation did he appear to have any spontaneous sense of humour. At the merry dinner-parties given at Sunnyside, while he appreciated the jests and good stories of others, it was remarked that he never originated any of his own.'

A. M. W. Stirling, *Victorian Sidelights* (1954), p. 266

'Tenniel, with his long white moustache, was like a retired General.'

Allan Fea, *Recollections of Sixty Years* (1927), p. 160

FREDERICK WALKER, ARA (1840–75)

Illustrator, water-colourist and painter in oils. His pictures of rustic simplicity and domestic pathos had an enormous influence on contemporary art.

267 *Carte-de-visite*, albumen print by C. A. Du Val, Manchester. *Author's collection*

'Everything about him betokened an early death, not because he was frail and delicate, for frail and delicate men sometimes drag out the thread of life to great lengths, nor, as in the case of his host, was he in any danger from over-industry and application. His mind was not very cultivated; he was inarticulate, and his conversation gave no idea of his powers. His intellect, I should opine, was of rather a slow and lethargic cast. Never did artist groan as he did in the throes of production. It was

painful to see him; he would sit for hours over a sheet of paper, biting his nails, of which there was very little left on either hand; his brows would knit and the muscles of his jaw, which was square and prominent, would twitch convulsively like one in pain; and at the end all that could be discerned were a few faint pencil-scratches, the dim outline of a female figure perhaps, but beautiful as a dream – full of grace, loveliness and vitality.... When annoyed even by trifles, he was beside himself. He had a passion for telegraphing; when the fit was on him he would send off messages at intervals all day. It was terrible to hear him complain of the injustice and ill-treatment of which he supposed himself a victim, quite unreasonably as it appears to me, as the world seems to have agreed to treat him indulgently as a delicate and spoiled child of genius.'

J. E. Hodgson, RA, in the *Magazine of Art* (1889)

JOHN DAWSON WATSON, RWS (1832–92)

Painter in oils and water-colours, but best remembered as one of the great illustrators of the 1860s. His sister was married to Myles Birket Foster (q.v.).

268 Proof albumen print, *carte-de-visite* size, by John and Charles Watkins, London. *Author's collection*

'He was very quiet and reserved in manner, extremely modest, nay, almost shy.... In personal appearance he was tall and handsome. He had one of those faces which seem to improve and become more dignified as time

creeps on. In his later days, when his hair, moustache, and pointed beard were of a uniform grey, he looked as if he had stepped out of the frame of one of Vandyke's portraits.'

Henry Stacy Marks, *Pen and Pencil Sketches* (1894), Vol. 1, pp. 255–6

HARRISON WILLIAM WEIR (1824–1906)

Animal painter and illustrator, who became the longest-serving artist on the *Illustrated London News*. He was a friend of Darwin and married the daughter of the animal painter J. F. Herring. He wrote a large work entitled *Poultry and All About Them* (1903).

269 Cabinet portrait, albumen print by Elliott & Fry, London, *c.* 1875. *Author's collection*

'Weir ... is a gifted and brilliant conversationalist, brimful of anecdote – humorous and otherwise, a genial companion and an old friend.'

The Brothers Dalziel, A Record of Fifty Years of Work (1901), p. 182

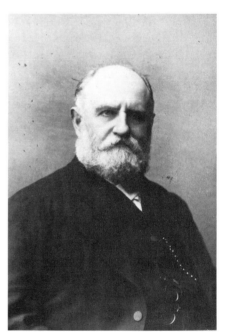

[269]

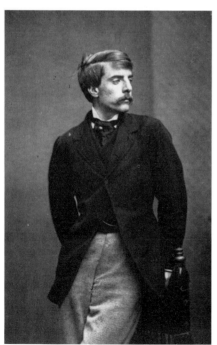

[267]

[268]

BRITISH ARTISTS
IN FOREIGN LANDS

MANY foreign artists came to Britain in search of a lucrative market or to escape from political turmoil or military conflict in their own countries; on the other hand, many British painters and sculptors made journeys all over the world. In all their diversity they set forth to record exotic or luxuriant landscapes, teeming oriental bazaars, tranquil Alpine scenery, Italian lakes, Moorish temples, classical remains, rare and fantastic birds, settlements of nomadic tribesmen, harems and odalisques, snow-capped mountains in Africa, Far-Eastern ports choked with junks, or merely Breton peasant folk. Wherever there was colour, novelty, excitement, wars, strange customs or apparel, there they went, sketched and painted, exhibiting the fruits of their labours back in England.

Ever since the ending of the Napoleonic Wars, the urge to travel abroad had become almost a national obsession. The Grand Tour, the prerogative of the aristocracy, had given way to democratic freedom of movement on a continually increasing scale, rendered ever more possible as the railways spread their tentacles through Europe. Two years after the opening of the Liverpool and Manchester railway in 1830, France had taken over the lead and by 1870 most of Europe had been opened up by the railway. There had, too, been an enormous increase in the manufacture of steamships, while channel packets plied daily from London Bridge, Dover, Folkestone, Brighton and Southampton. Guide-books proliferated. Those of Baedeker and John Murray offered guidance and advice on everything from the mysteries of Gothic fenestration to remedies for vermin, poisoning, blistered feet, the effects of rarefied air and snake-bites. Little was left to chance and counsel was forthcoming on the management of savages, securing prisoners, methods of intoxicating fish in tropical climates, ways of coping with enraged animals and removing fluids from their paunches to quench thirst, and stopping bolted camels. Advice was also proffered from on high: should you stumble on a revolution, wrote Walter Bagehot, you were safe 'if you go calmly and look English'.

For most of the century it was the English who predominated as travellers in Europe and the Middle East. Artists formed a large part of their numbers, and in some cases, except for arctic and tropical explorers, were as intrepid as any. Guide-books often quoted the experience and advice of Edward Lear, given in his travel books. He was one of the most indefatigable of all the artist travellers. His journeys began in 1831 but his main excursions started in Rome, in 1837, where he remained and taught until 1848, when he visited Greece, Albania and Malta. The following year found him in Egypt. After a few years in England, he resumed his travels, visiting, from 1853 to 1857, Greece, the Holy Land and Egypt again. It was here that he met a pilot on the Nile who had taken on his boat the equally indefatigable Marianne North, the flower painter, and her father. She had evidently left a good impression: 'This Bint,' said he – the word then not having acquired its derogatory connotations – 'This Bint was unlike most other English Bints, being, firstly, white and lively; secondly, she was gracious in her manner, and of kind disposition; thirdly, she attended continually to her father . . .; fourthly, she represented all things on paper. . . . She was a valuable and remarkable Bint!' This truly 'remarkable Bint' visited India, Ceylon, Japan, Egypt, Malaya, Borneo, Java, Australia, New Zealand, Tasmania, South Africa, Brazil, Chile, Canada, North America, Jamaica, Italy, Portugal and the Canary and Seychelles Islands.

By 1860 Lear was living almost entirely abroad, based successively at Cannes, Corfu and San Remo.

From 1872 to 1874 he visited India and Ceylon. All the while he painted incessantly in oils and water-colours, enduring sometimes indescribable (which is hardly the word, for describe he did) hardships and dangers. In Albania he was pelted with stones by natives who thought he was the devil. In Petra he almost lost his life when he was attacked by hysterical Arab robbers, had his clothes torn, his beard pulled, and his pocket picked of everything 'from dollars and penknives to handkerchiefs and hard-boiled eggs'. Reluctant to use his '5-barrelled revolver', he paid them off with twenty dollars and fled, only to be repeatedly attacked by large bands of *fellaheen* who left him penniless. Even central Europe had its dangers. In Italy landscape artists were often attacked by *banditi* who, although leaving them more or less alive, took their money. Painting in the Alps, too, was fraught with hazard: an unfortunate young artist, one Henry Telbin, was, in the words of an obituary in the *Art-Journal* of 1866, 'out sketching on a lofty rock near Grütli, in Switzerland, when his foot slipped, as he attempted to resume the seat from which he had risen and he was precipitated over the edge into the lake below'.

Because of its ease of access and proximity Europe was the most popular area for artists, particularly the water-colourists like Louis Haghe, T. L. Rowbotham, William Callow and James Holland. Rome was an international centre for art and artists, and some British painters and sculptors lived or were based there for years at a time. These included John Gibson, the sculptor, and Richard Buckner, the portraitist; Leighton's first Academy picture, *Cimabue's Madonna*, was painted there; and J. F. Lewis's sojourn in that city, together with his eleven years in Cairo, resulted in his being struck off the list of members of the Water-Colour Society, until he wrote asking to be reinstated. Alfred Stevens, the sculptor, lived in Italy from 1833 to 1842, and Leighton's friend George Heming Mason lived in a state of near penury in Rome, having walked there across Europe.

A handful of artists visited America, notably the subject painter C. R. Leslie, the illustrator Arthur Boyd Houghton and, in 1852, Eyre Crowe, chiefly in his capacity as secretary to his cousin Thackeray, who was on a lecture tour. After coming to live in England, Edwin Austen Abbey, an American, paid only a few brief visits to his homeland. Sargent, born in Europe of American parents, went several times to America from 1887. Australia saw the arrival, for a short stay, of Thomas Woolner, the PRB sculptor, lured by the goldfields. Charles Conder, who had been born in India, studied art at Sydney and Melbourne and then left for Europe in 1890; he lived and worked in Paris, before coming to live principally in England from 1897. Mortimer Menpes was one of the few artists, together with Sir Alfred East, who spent time in Japan and allowed his works, like East's, to be influenced by the art of that country. Spain had a profound effect on the manner and subject matter of several artists: John Phillip and J. F. Lewis both earned the nickname 'Spanish'; and J. B. Burgess was another who specialized in Spanish subjects.

But it was the Middle East which had the greatest allure for many artists. Orientalism never cast quite such a spell over British artists as it did over their French colleagues. Indeed, so numerous were the French Orientalist painters that they were classified as a School, which even formed in 1893 its own 'Salon des Peintres Orientalistes Français'. Orientalism in England was less collective in spirit. Palestine, Egypt and her two dependent countries Syria and the Lebanon, India and Asia Minor were the countries most favoured by the British. David Roberts and Lear were interested in topography and natural scenery; J. F. Lewis and W. J. Müller were drawn to Arab interiors, to the market place and bedouin encampments; outdoor domestic life by oases was a favourite subject of Frederick Goodall. Reconstructions of life in the harem with luscious odalisques were rarely attempted by the English, unlike their French counterparts. The English usually needed to hire models, since Moslem women would not sit for them; this was a permanent source of irritation to that stickler for authenticity, Holman Hunt.

War in faraway countries attracted a very special kind of artist, since depicting it often called for the same kind of courage required of an infantryman in the front line. The Crimean campaign was the first to be covered by the war artist, a particular breed that was soon 'covering' actions and skirmishes everywhere. The first such artist was William Simpson – 'Crimean' Simpson – who, since neither he nor anyone else had had any experience of visual war reportage, placed himself, shortly after his arrival at Sebastopol, in front of the batteries and began to sketch. He recorded that he was vaguely aware from time to time of objects falling around him, only realizing that they were cannon balls when an officer shouted to him. Melton Prior, a later artist, caught the special flavour of the dangers confronted by the war artist in this exchange in his

memoirs: 'A shell burst under my horse's belly and took him off his legs. I manfully held on, with my sketchbook in one hand, the reins in the other, no harm done. "Hallo, Prior, you had a close shave that time," said Stanley, as he rose and took a big slug out of the wall two inches off where my head had been.' Edward Armitage, RA, was perhaps the only other painter in oils who ventured out to the Crimea. He had been despatched there by Gambart, where he made sketches for two large pictures, *The Battle of Inkerman* and *The Charge of the Heavy Brigade at the Battle of Balaclava*.

It was while he was toiling away at *The Scapegoat* by the shores of the Dead Sea that Holman Hunt was brought news of the Battle of Inkerman. While the allure of the scenery and the people of the Middle East appealed to many artists, there were those for whom it provided the authentic background to their religious pictures. Hunt was their supreme exemplar. In all, he paid four visits to the Middle East during his lifetime and all his religious pictures, apart from earlier paintings including *The Light of the World*, had their origins in the Holy Land. The hardships and dangers he endured for Art were quite as distressing as those undergone by his friend Edward Lear. Another friend of Hunt, Thomas Seddon, who accompanied him on his first journey to the Holy Land, went back to Cairo in the autumn of 1856, caught dysentery and died there at the age of 35.

How fitting that it is possible to include photographic portraits of two artists in Arab dress – Müller and Lewis – and another of Hunt, only just not courting a hint of absurdity, re-enacting the painting of *The Scapegoat* later in life (Plate 197). Pleasing, too, that it is possible to include what is probably the only known photograph of Seddon (Plate 220), which belonged to Hunt and which is reproduced in the second edition of his memoirs.

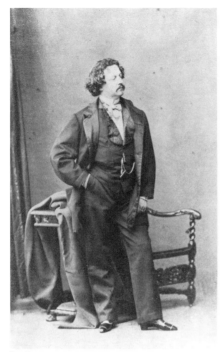

[270]

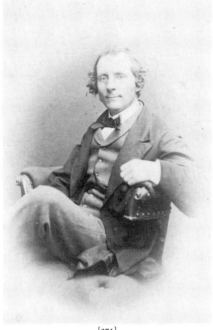

[271]

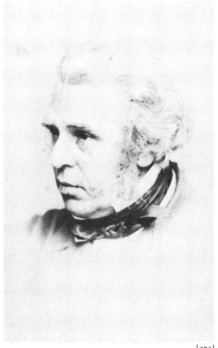

[273]

RICHARD BUCKNER (*fl.* 1820–97)

Portrait painter who lived in Rome from 1820 to 1840. Returned to London in about 1845 to become a successful painter of aristocratic and fashionable women. Took up residence in Rome occasionally thereafter.

270 *Carte-de-visite*, albumen print, from an album compiled by Prince Albert in 1860. *Her Majesty The Queen*

'Buckner is hard at work, and finishes off slight pictures at steam pace – about 17 since his arrival, or in two months, of which I have bought one for Seventy pounds. He is doing portraits of no less than seven persons, all young and handsome. He dines with us frequently and is very obliging in giving advice, and pointing out faults.'
The Earl of Kilmorey in a letter to John Lucas in *John Lucas, Portrait Painter* (1910), by Arthur Lucas, pp. 71–2

FREDERICK GOODALL, RA (1822–1904)

Member of a painting family. Painted mainly Middle-Eastern and biblical subjects, normally of a repetitive and rather uninspired nature. Also painted occasional portraits and landscapes. Goodall appears to have been one of the most photographed of all Victorian artists. Apart from the obvious conclusion that, like Frith, Ward and others, he saw the publicity potential, it also reveals the degree of esteem with which these artists were regarded by their public.

271 *Carte-de-visite*, albumen print by John and Charles Watkins, London, *c.* 1862. The artist wrote to John Watkins as follows: 'I enclose a cheque for the last photographs sent. The impressions are very satisfactory and with thanks.' *Photograph and letter: Author's collection*

272 Mechanical process on postcard. The picture on the easel is *While Shepherds Watch their Flocks by Night* (RA, 1902). A message at the foot demonstrates the public acceptance of these cards as a means of communication. *Author's collection*

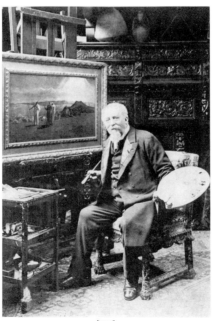

[272]

JAMES HOLLAND, RWS (1799–1870)

Painter, mainly in water-colours, but also in oils. Many of his views were continental.

273 *Carte-de-visite*, albumen print by John and Charles Watkins, London. *Royal Academy of Arts*

'He was a man of many acquaintances, and his disposition by no means reserved.'
John Lewis Roget, *A History of the Old Water-colour Society* (1891), Vol. 2, pp. 249–50

EDWARD LEAR (1812–88)

Writer, caricaturist, nonsense poet and painter of landscape in oils and water-colours. A friend of Holman Hunt (q.v.). Gave Queen Victoria drawing lessons in 1846.

274 *Carte-de-visite*, albumen print by McLean, Melhuish and Haes, London. *National Portrait Gallery, London*

How pleasant to know Mr Lear!
　Who has written such volumes of stuff:
Some think him ill-tempered and queer,
　But a few think him pleasant enough.

His mind is concrete and fastidious,
　His nose is remarkably big;
His visage is more or less hideous,
　His beard it resembles a wig.

He has ears, and two eyes, and ten fingers,
　Leastways if you reckon two thumbs;
Long ago he was one of the singers,
　But now he is one of the dumbs.

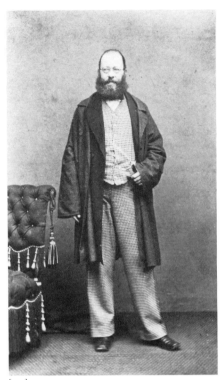

[274]

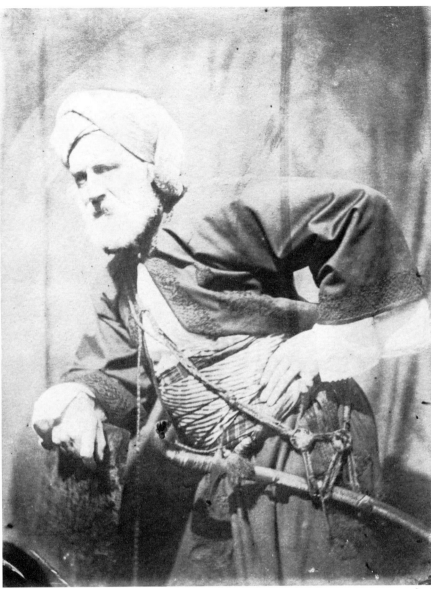

[275]

He sits in a beautiful parlour,
 With hundreds of books on the wall,
He drinks a great deal of Marsala,
 But never gets tipsy at all.

He has many friends, laymen and clerical,
 Old Foss is the name of his cat,
His body is perfectly spherical,
 He weareth a runcible hat.

When he walks in a waterproof white,
 The children run after him so!
Calling out, 'He's come out in his night-
 gown, that crazy old Englishman, oh!'

He weeps by the side of the ocean,
 He weeps on the top of the hill;
He purchases pancakes and lotion,
 And chocolate shrimps from the mill.

He reads but he cannot speak Spanish,
 He cannot abide ginger-beer:
Ere the days of his pilgrimage vanish,
 How pleasant to know Mr Lear!
Edward Lear in *Edward Lear: Landscape Painter
and Nonsense Poet* (2nd edition, 1968), by Angus
Davidson, p. xv

JOHN FREDERICK LEWIS, RA, RWS (1805–76)

Painter in oils and water-colours of animals,
Spanish and Near-Eastern subjects. A great
traveller and brilliant artist. Spent eleven
years in Rome and ten in Cairo.

275 Albumen print by an unidentified pho-
tographer, 140 × 108 mm. The oriental dress,
perhaps assumed in London for the occasion
of the photograph, is apt. *Private collection*

'You remember J —, and what a dandy he was,
the faultlessness of his boots and cravats, the
brilliancy of his waistcoats and kid gloves; . . .
A man [Lewis] – in a long yellow gown, with
a long beard, somewhat tinged with grey, with
his head shaved, and wearing on it first a white
wadded cotton night-cap, second, a red tar-
boosh – made his appearance and welcomed
me cordially. . . .

'He shuffled off his outer slippers before he
curled up on the divan beside me. He clapped
his hands, and languidly called "Mustapha".
Mustapha came with more lights, pipes, and
coffee; . . .

'He had adapted himself outwardly, how-
ever, to the Oriental life. . . . He wears a very
handsome grave costume of dark blue, con-
sisting of an embroidered jacket and gaiters,
and a pair of trowsers, which would make a
set of dresses for an English family. His beard
curls nobly over his chest, his Damascus sci-
mitar on his thigh. His red cap gives him a
venerable and Bey-like appearance. . . . I
should say that he is a Major General of Engi-
neers, or a grave officer of State. . . .

'Here he lives like a languid Lotus-eater –
a dreamy, hazy, lazy, tobaccofied life. He was
away from evening parties, he said; he needn't
wear white kid gloves, or starched neckcloths,
or read a newspaper.'
W. M. Thackeray, *Notes of a Journey from Cornhill
to Grand Cairo* (3rd edition, 1865), pp. 195, 198–9,
200–1

GEORGE HEMING MASON, ARA (1818–72)

Painter who travelled to Rome, mostly on foot, 1843–5, and made a living painting portraits. He then painted rustic genre pictures and returned to England in 1858. He was a great friend of Leighton (q.v.), who encouraged him, and he was widely admired during his lifetime, particularly by his fellow artists.

276 *Carte-de-visite*, albumen print by John Watkins, London. According to a letter written by Mason to Watkins on 2 February 1869, he promised to call on him 'to sit for the photograph you wish for, tomorrow at two o'clock P. M., trusting to the chance of your being disengaged. . . . I shall probably bring with me a lady who wishes to sit for her photograph to you.' *Photograph: National Portrait Gallery, London; letter: Author's collection*

'[14 November 1872] Lowes Dickinson tells Brown that Mason, when he resided in Rome years ago, was most notoriously impecunious, and any one rambling with him through the streets was liable to have a long round to make, so as to save Mason from passing sundry "trattorie" etc. where bills had been run up against him. He frequently passed days without any tolerably adequate meal, and no one at that time expected him to take any distinguished position as a painter.'
The Diary of William Michael Rossetti (1977), ed. by Odette Bornand, p. 211

[276]

George Mason

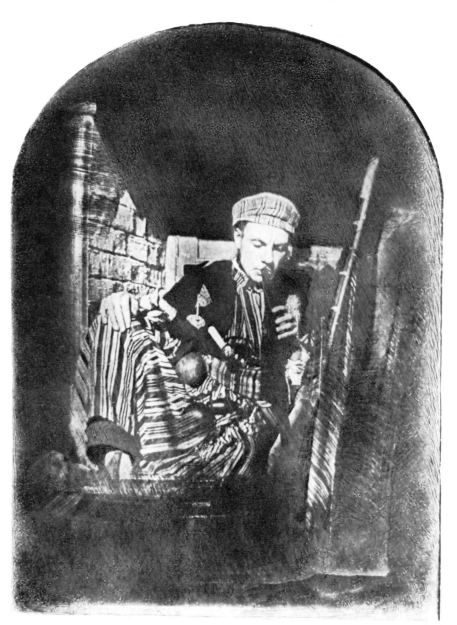

[277]

WILLIAM JAMES MÜLLER (1812–45)

Bristol landscape painter in oils and watercolours. He made numerous sketches of oriental life and scenery. He was the son of J. S. Müller, a Prussian, who was curator of the Bristol Museum.

277 Print taken from a daguerrotype, *c.* 1845. *Print: City of Bristol Museum and Art Gallery; daguerrotype: Private collection*

'He looked somewhat older than he was, of middle height, flat chested, not particularly broad shouldered, but wiry, well knit, and active. His hands were small, and his fingers long and slender like the hand of an Arab. He had a dark complexion and dark hair (worn long), brown eyes, square forehead, and full massive brows; the expression of his countenance was intelligent, but so resolute that no one who saw him could avoid looking at him twice. Being short sighted, he used an eye-glass, which he applied occasionally to one eye when looking at nature, and then dropped whilst actually engaged in drawing or painting. One eye was brown and one grey, and he used to say jokingly that with one eye he saw colour and with the other he saw form.'
N. Neal Solly, *Memoirs of the Life of William James Müller* (1875), pp. 30–1

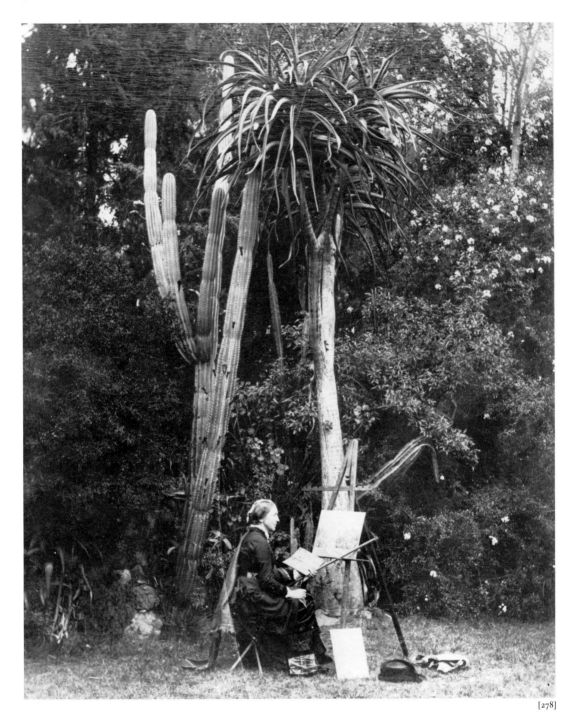

[278]

MARIANNE NORTH (1830–90)

Flower painter and pupil of Valentine Bartholomew (q.v.). Travelled all over the world. She presented her paintings to Kew Gardens, building a gallery for them at her own expense. It was opened in 1882.

278 Photograph by an unidentified photographer in Grahamstown, South Africa, in 1882. *Royal Botanic Gardens, Kew*

'Miss North's singular charm of character is sufficiently proved by the welcome which she everywhere received, when travelling alone in the wildest and remotest districts. The letters published by her sister show the refinement, quiet dignity, and love of natural beauty, which won the affection of her hosts as her energy gained their respect. Her paintings are valuable for artistic merits, but still more for the fidelity with which they preserve a record of vegetation now often disappearing. Five species, four of which she first made known in Europe, have been named after her.'
Dictionary of National Biography

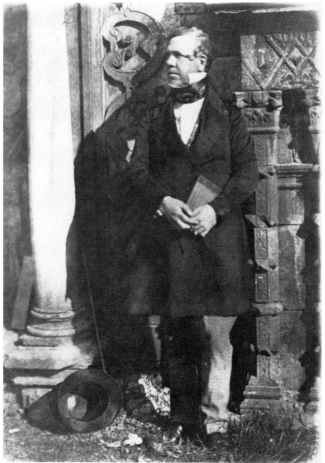

[279]

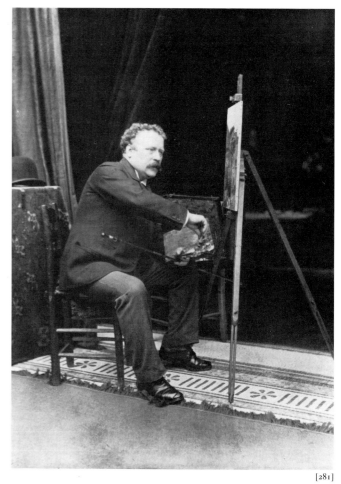

[281]

DAVID ROBERTS, RA (1796–1864)

Painter in oils and water-colours. Much trav-
elled in Europe and the Middle East, he was
an artist of considerable stature. He was one
of the Commissioners for the Great Exhibi-
tion of 1851.

279 Calotype by David Octavius Hill (q.v.)
and Robert Adamson, 192 × 152 mm. The
photograph was taken in September 1844 at
Dennystoun's Tomb, Greyfriars Churchyard,
Edinburgh. The top hat on its side recurs fre-
quently in the photographs of Hill and Adam-
son. *National Gallery of Scotland*

'Simple, unpretending, and apparently indif-
ferent to celebrity, he courted society very
little, was most at home when before his easel.
. . . He was of a nature genial and kindly; pru-
dent and cautious, as most of his country men
are. . . . As a young man he had a certain
gauche exterior. His face was round, and not
peculiarly expressive: his manner became
much more refined as he grew older and mixed
in society; yet it was always comparatively

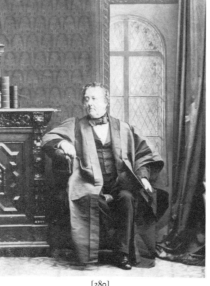

[280]

rough. It bespoke sincerity, however, and
thorough honesty.'
Samuel Carter Hall, *A Book of Memories of Great
Men and Women of the Age* (1877), pp. 474–5

HENRY WARREN (1794–1879)

Studied sculpture under Nollekens, then
turned to painting in oils and water-colours.
His principal pictures were of Eastern scenes
and incidents, which was a remarkable feat,
since he had apparently never travelled to the
East.

280 Albumen print, *carte-de-visite* size, by
an unidentified photographer, *c.* 1860.
Author's collection

HENRY WOODS, RA (1846–1921)

Painter of Venetian life. At the suggestion of
his brother-in-law Sir Luke Fildes (q.v.), he
went to Venice in 1876. He settled there
permanently.

281 Photograph by Ralph W. Robinson,
204 × 153 mm, published in *Members and As-
sociates of the Royal Academy of Arts, 1891,
photographed in their Studios* (1892). *National
Portrait Gallery, London*

FOREIGN PAINTERS & SCULPTORS IN ENGLAND

GREAT Britain was attractive to foreign artists in the nineteenth century for several very good reasons. The first was its prosperity. During the greater part of the period – until, that is, the 1870s and 1880s when other countries began to catch up – England was by far the richest country in the world. This wealth was regarded by all other nations as quite fabulous. It has recently been estimated that in 1860 *per capita* incomes in the United Kingdom, France and Germany were, respectively, £32.6, £21.1 and £13.3. In the twenty years from 1851 to 1871 the gross national income (in another recent estimate) grew from £523.3m in 1851 to £668m in 1861 and to £916.6m in 1871. All over the world Britain's manufacturers, skills and services were at a premium. National self-confidence had never been greater, and this expressed itself nowhere more flamboyantly than in the Great Exhibition of 1851. Everything from the great glass building which housed it to the manufactures themselves struck awe and admiration in the hearts of foreigners. Up to that time Britain had been, to them, a little-known country. Suddenly, this wealth and industry, this sense of limitless potential was revealed to the world. The boom continued, with occasional lapses, until the Franco-Prussian War and then began to run out of steam in 1873, the year of the Great Depression, aspects of which were poignantly recorded by artists of the social-realist school – Holl, Fildes, Herkomer and others. The Depression did not finally lift until about 1895, when Britain was additionally beset with competition and national rivalries.

So, for much of the period, Britain was attractive as a market for selling pictures and sculpture, and, for the whole period, as a refuge from political upheaval on the Continent and in America. In 1848 there were revolutions in Paris, Berlin, Vienna, Venice, Rome, Milan, Naples, Prague and Budapest. Even in England the Chartist movement was for a while a serious threat. It is surprising that so few European artists took refuge in England at that time in view of the political turmoil on the Continent. It took a war and catastrophic defeat of France by Germany in 1871 to precipitate the largest migration of artists to Britain.

But until that time, and for a considerable time afterwards, it was Britain as a source of patronage, an expanding, seemingly unlimited market, that became the magnet to artists. In 1854 Ernest Gambart, exploiting the new-found friendship between France and Britain during the Crimean War, put on the first regular annual exhibition of French artists in Pall Mall, London. These exhibitions continued, in other hands, long after he had retired, well into the twentieth century. The first included works by Rosa Bonheur, Delacroix, Delaroche, Meissonier, Théodore Rousseau, Scheffer and Troyon. On Gambart's early committees were British artists such as Stanfield, Maclise, J. D. Harding, F. Goodall and others, and one man whose goodwill it was necessary to enlist – S. C. Hall, editor of the *Art-Journal*.

Soon the Royal Academy itself began to be discovered as a useful outlet for pictures. It is quite astonishing to note the numbers of foreign artists who exhibited there in the nineteenth century, a practice scarcely heard of today. Meissonier, Delaroche, Delacroix and Winterhalter had all exhibited pictures there long before this time. Meissonier was the first, in 1841, with two pictures, but none thereafter, being well supplied with other markets, although he was elected Honorary Royal Academician; the second, Delaroche, exhibited three times, in 1844, 1847 and 1850; the third, Delacroix, showed one picture in 1830, a scene from *Quentin Durward*; the fourth, Winterhalter, showed

four pictures in 1852, 1853, 1856 and 1867. The visit of Delacroix to England in 1825 must have been one of the very few by a foreigner not motivated by anything other than intellectual curiosity. English ways, literature and art – in particular, the paintings of Constable – had attracted him and he had altered part of *The Massacre at Chios* under the influence of those of Constable's paintings he had seen at the Salon of 1824. Although by no means uncritical of the English and their way of life, the experience marked him for life, even in his manner, appearance and dress.

Other foreign exhibitors at the Academy included Daubigny, who exhibited four pictures from 1866 to 1870 including a view of the Thames at Woolwich, and Corot, with two pictures in 1869. Rosa Bonheur showed two pictures in the same year, while her brother Isadore exhibited *animalier* bronzes in 1875 and 1876, her sister Juliette Peyroll a picture in 1876, and her brother François three pictures from 1857 to 1874. Rosa Bonheur had been invited to England in 1855 by Gambart who, while exhibiting her picture *The Horse Fair*, introduced her to Edwin Landseer and other celebrities. In the following year Gambart took her on a triumphal tour up to Scotland, the first time a foreign artist had been thus deliberately promoted by a dealer in Britain. Louis Gallait, the Belgian painter, another of Gambart's protégés, was similarly promoted and in 1869 was elected Honorary Royal Academician, together with Meissonier, Gérôme and others. Gallait exhibited three pictures in 1872, and Gérôme six from 1870 to 1893. Bouguereau followed with two pictures in 1884 and 1892, and then with another eight from 1894 to 1904. But it was the still-life painter Fantin-Latour (who made several visits to England) who exhibited more pictures at the Royal Academy than the sum of all the above: twelve from 1862 to 1870, and thereafter without a break from 1876 to 1900.

It was the Franco-Prussian War, followed by the Commune in 1870–1, which drove away French artists to England. Tissot came and stayed for over twenty years, only retiring to France after the death of his mistress Mrs Kathleen Newton. Gérôme, a lifelong friend of Eyre Crowe, RA, and no stranger to Britain, came over in 1870 with his wife and family, staying about a year. Others to arrive were Fantin-Latour, who had already worked in England in 1861; Claude Monet, who had been painting in Le Havre and Trouville, and in September 1870 had hopped on a boat to England, staying until late 1871; Camille Pissarro, who followed

him by another route and stayed until June 1871. Sadly, the pictures the latter two artists submitted to the Royal Academy were rejected.

Pissarro's son Lucien remained in England, and Camille visited these shores again in 1890, 1892 and 1897. Manet, Daubigny and Corot had preceded them, and in 1874 Alfred Sisley, born in Paris of English parents, visited Britain. Another famous refugee was Paul Durand-Ruel, the French dealer who mounted at the end of 1870 the first exhibition to show Impressionist pictures in London. This was followed by others during the subsequent three years.

Two other refugees were the sculptors Jean Baptiste Carpeaux and Jules Dalou. Carpeaux later returned to France; Dalou stayed on until 1880, helping to reshape the course of British sculpture, resolutely speaking only French like his countryman Alphonse Legros, who had been in England since 1863, and was to stay until his death in 1911, having been naturalized in 1881. Gustave Doré, too, was a frequent visitor to England, and the drawings he did in London in 1867–71 caught the attention of Van Gogh, who worked in the London branch of the Goupil Gallery from 1873 to 1875.

Apart from the German-speaking contingent – the Bavarian-born Hubert von Herkomer, the water-colourist Carl Haag, the visiting portrait painters Winterhalter and von Angeli, the sculptor Boehm, and the Belgian water-colourist Louis Haghe – the largest other colony of artists were the Americans, including Whistler, Sargent and E. A. Abbey. The first and last of these came to England, because, as Tom Taylor put it, writing in the *Fine Arts Quarterly Review*, London provided 'a more extensive and better paid employment for painters than has ever been known in any period of history of any century'. Sargent, born in Florence of American parents, was more naturally European than American and he settled in England in 1885–6.

One of the immigrants in the second half of the century to achieve the greatest popularity in Britain was Sir Lawrence Alma-Tadema. Ernest Gambart, in mid-career as a dealer, had 'discovered' him in his native Holland. Tadema paid several visits to London in the 1860s, but it was in 1869, when he came over to consult the physician Sir Henry Thompson, that he finally decided to stay. It was no coincidence that Gambart's favourite engraver, the veteran Auguste Blanchard, who had engraved Frith's *Derby Day*, now began to engrave Tadema's work; this French engraver exhibited eleven engravings after Tadema's works at the Royal Academy from 1874 to 1893.

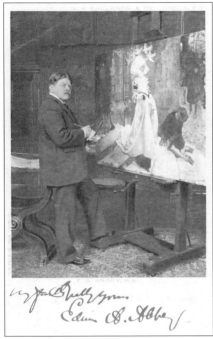

[282]

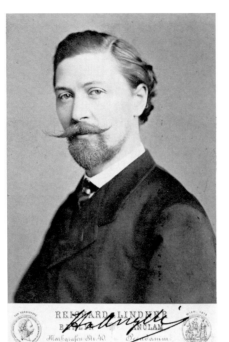

[283]

EDWIN AUSTIN ABBEY, R A (1852–1911)

Painter and illustrator of historical subjects. Born and brought up in Philadelphia, he settled in England in 1880. His widow left a bequest of £50,000 to the Royal Academy to form 'The Edwin Austin Abbey Memorial Trust Fund for Mural Painting in Great Britain'.

282 Mechanical process on postcard, c. 1900. *Author's collection*

'He was a most lovable and delightful man, with a dry, quaint way of saying things, with a roguish look from gleaming, spectacled eyes, and a smile which was almost a grin, showing a sparkle of gold in a tooth.'
G. P. Jacomb-Hood, *With Brush and Pencil* (1925), p. 119

BARON HEINRICH VON ANGELI (1840–1925)

Austrian painter. After the death of Winterhalter (q.v.) in 1873 he was widely employed as portrait painter by Queen Victoria and by several European courts.

283 Cabinet portrait, albumen print by Reichard & Lindner, Berlin, c. 1875. *Author's collection*

'He is considered one of the best portrait painters of the day, is a regular "Wiener", and speaks the strongest "Wienerisch". He is youngish, agreeable, and clever.'
Queen Victoria in *The Letters and Journal of Queen Victoria* (1926), Vol. 2, p. 384

SARAH BERNHARDT (properly Henrietta Rosine Bernard) (1844–1923)

Actress and a legendary figure in the theatre world. She was a sculptress of considerable repute. She was a frequent visitor to London and had several friends in the art world, notably Frith (q.v.) and Ernest Gambart (q.v.).

284 *Carte-de-visite*, albumen print by W. & D. Downey, London, probably taken in 1879.

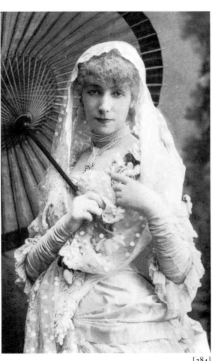

[284]

Sarah Bernhardt came to London in that year with the Comédie Française and became an idol of the theatre-going public. William Downey recalled in the *Pall Mall Budget* of 19 March 1891, 'I am rather proud of the fact that Sarah Bernhardt has never been photographed in England except by us, and although she is most difficult to persuade to keep her appointments, she has generally succeeded in finding time to come to us on each of her visits to London. She has written several very complimentary lines in our autograph book, the following on the spur of the moment being very characteristic: – "Mon chez Downey, vous êtes le plus aimable des hommes, et le roi des photographs, et quoique le France soit en [*sic*] République, je crie, Vive le roi Downey."' *Author's collection*

'As we entered [the studio] a boy dressed in white, with yellow hair, sprang from a sofa and greeted us warmly. The seeming boy was Miss Sarah Bernhardt, whose masculine attire was assumed for the convenience it afforded for the practice of the art she loves far more than that in which she is so famous. She made the astounding declaration to me that she hated acting; and would rather succeed in painting or sculpture, or in both, than in any other earthly calling.'
W. P. Frith, R A, *My Autobiography and Further Reminiscences* (1887), in 3 vols, Vol. 2, p. 140

THOMAS MARIE AUGUSTE BLANCHARD (1819–98)

French engraver, who engraved several works by British artists, including Holman Hunt, Alma-Tadema and Frith (all q.v.). His engraving of *The Derby Day* by the latter contributed greatly to its fame.

285 (on p. 154) *Carte-de-visite*, albumen print by an unidentified photographer, c. 1860. *National Portrait Gallery, London*

'In September of the next year (1867) I returned to England with my child. My picture [*The Finding of the Saviour in the Temple*] was bought by Gambart and exhibited by itself, and an engraving of it was made by Blanchard.

'On my way home, as I had arranged with Gambart, I stopped in Paris in order to visit the engraver. His house was about sixteen miles beyond Paris, and having a few minutes to spare at the station, it seemed to me desirable to provide myself with some French book to read by the way to break my tongue of Italian: in looking over the stall I saw *Monsieur de Camors* [by Octave Feuillet] which a lady in Florence had praised as a book exempt from some strictures I had expressed on French novels in general, a book in fact which

she had selected for a nephew. In half an hour's reading of this book I had grown astonished at the lady's judgment, for although I had not met with a coarse word, it overflowed with pernicious sentimentalism and revolting immorality.

'However, I carried it to my journey's end and put it on the hall table. . . . On returning to the drawing-room we found the family assembled, models of mutual reverence and politeness. . . . With the *déjeuner* completed we moved into the hall, and Mr Blanchard's eyes fell upon my book lying there.

'Suddenly unaffectedly horrified, he exclaimed, "Whoever has brought that abominable book into my house?"

'I avowed that it was I who had bought it at the station, seeing that it was a novel I supposed to be admirable, its author being a member of the Academy. "Oh!" he said, "such books are not written for Frenchmen: I assure you no respectable Frenchman would consent to have such a book in his house. Do," he begged, "hide it away somewhere until you go to your train", and so I did until I parted with the good man and his family.'

William Holman Hunt, *Pre-Raphaelitism and the Pre-Raphaelite Brotherhood* (2nd edition, 1913), Vol. 2, pp. 202–3

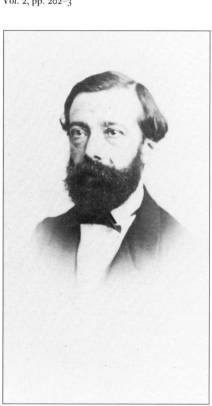

[285]

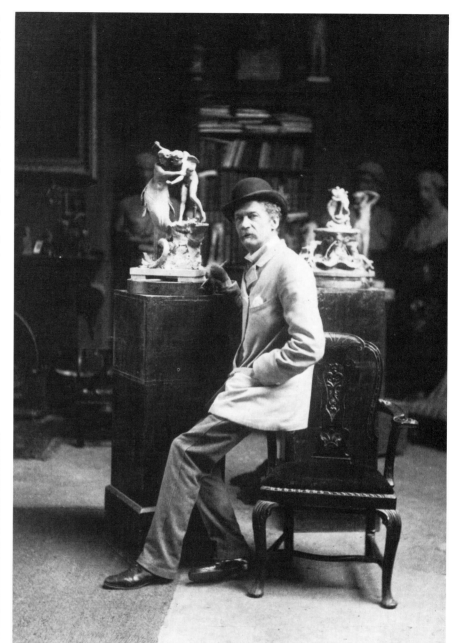

[286]

SIR JOSEPH EDGAR BOEHM, BT, RA
(1834–90)

Sculptor-in-Ordinary to Queen Victoria. Born in Vienna, he began exhibiting at the Royal Academy in 1862. Created baronet in 1889.

286 Photograph by Ralph W. Robinson, 203 × 155 mm, published in *Members and Associates of the Royal Academy of Arts, 1891, photographed in their Studios* (1892). *National Portrait Gallery, London*

'Boehm was a native of Hungary, a handsome, unaffected, polished gentleman, full of humour and dignity. A born actor, a very sincere friend, and an accomplished man of the world.'

Sir Alfred Gilbert in *Alfred Gilbert* (1929), by Isabel G. McAllister, pp. 33–4

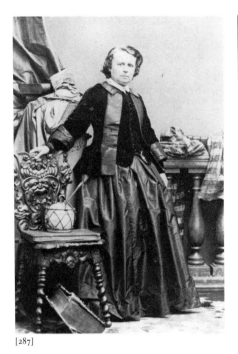

[287]

ROSA BONHEUR (1822–99)

French animal painter of immense contemporary popularity. A visit to England and Scotland in 1856 at the invitation of the dealer Ernest Gambart (q.v.) had a considerable influence on her work. Her most famous picture, *The Horse Fair*, is at the Metropolitan Museum, New York.

287 *Carte-de-visite*, albumen print by Disderi, Paris, c. 1858. *Author's collection*

'Rosa was of commanding presence, and looked essentially a being above the common herd. Her dress was a compromise between that of a man and a woman; she wore her hair in a brown, curly crop, and she rode on horseback astride to the horror of all kirk-going folk.'
Jeannie Adams-Acton in *Victorian Sidelights* (1954), by A. M. W. Stirling, p. 30

WILLIAM ADOLPHE BOUGUEREAU (1825–1905)

French painter whose father was of English middle-class origin. His work was admired in England and his pictures bought. He attended a dinner given by the Lord Mayor of London on the occasion of the exhibition of French paintings at the Guildhall in 1898. He exhibited at Birmingham, Glasgow, Liverpool, Edinburgh and London.

288 Albumen print by an unidentified photographer, 93 × 55 mm. *Author's collection*

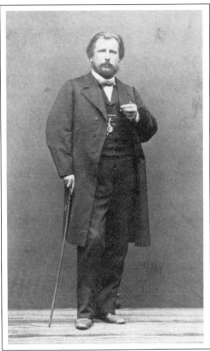

[288]

AIMÉ-JULES DALOU (1838–1902)

French sculptor, who fled to London in 1871, having been implicated in the Commune. He was greeted by his student contemporary, A. Legros (q.v.), who helped to establish him in London. Became teacher of modelling at the Royal College of Art, 1877–80. He exerted great influence on many British sculptors before returning to Paris in 1880.

289 Albumen print by Reutlinger, Paris, 55 × 38 mm. *Author's collection*

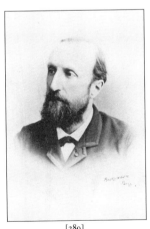

[289]

EDGAR DEGAS (1834–1917)

French painter associated with the Impressionists. Visited London in 1872 on his way to America via Liverpool. He spoke little English, and was not popular in England. He was a great admirer of Charles Keene (q.v.) as a draughtsman, and was also a friend of Millais, Tissot, Legros and Whistler (all q.v.).

290 Photograph by an unidentified photographer. *Collection Viollet, Paris*

'Degas in appearance has something of [the poet W.E.] Henley and something of Meredith, but was too heavy for Meredith, and too finely featured for Henley. His raised brows and heavily-lidded eyes gave him an aspect of aloofness; and in spite of his baggy clothes, he looked the aristocrat that he was.'
Sir William Rothenstein, *Men and Memories* (1931), Vol. 1, p. 103

[290]

FERDINAND VICTOR EUGÈNE DELACROIX (1798–1863)

French painter. Visited England in 1825. He admired several British painters: Bonington, Constable, Lawrence, Gainsborough, Etty (q.v.) and Wilkie.

291 Photograph by Nadar, taken in 1861. *Collection Viollet, Paris*

GUSTAVE DORÉ (1832–83)

French painter and illustrator. A large number of his illustrated books were written by British authors and he paid many visits to England. His drawings executed in London in 1869–71 caught the attention of Van Gogh. For many years from 1869 he had his own gallery in London, on the site now occupied by Sotheby's.

292 *Carte-de-visite*, albumen print by Nadar, Paris. *Author's collection*

'He was born in Strasbourg. I should have thought him a Parisian. He has the fire, the verve, the audacity, the brio, of a child of Paris. He paints, he draws, he chats, he comes and goes, he pauses, runs from one picture to another, laughs and romps about, then argues with you. . . . Gustave Doré [in 1865] is very young, and yet it will soon be fifteen years since he *electrically* won his reputation. . . .

'Doré is small, slim, lively, elegant. . . . He is thinking of illustrating Shakespeare, Ossian – and then? – the *Arabian Nights*, the *Niebelungen*. His ardour is wild; he embraces everything.'
Jules Claretie in *Gustave Doré, a Biography* (1980), by Joanna Richardson, p. 72

IGNACE HENRI JEAN FANTIN-LATOUR (1836–1904)

French painter of portraits, genre and still-life. He made several journeys to Britain and exhibited regularly at the Royal Academy from 1862 to 1900.

293 Albumen print by an unidentified photographer, 54 × 38 mm. *Author's collection*

'Everything about him was simple and unpretentious: a few commonplace chairs, a sofa, small table, and many shabby, ample portfolios ranged against the walls. . . . And Fantin himself, stout, baggily dressed, with list slippers on his feet and a green shade over his eyes, looked like one of Daumier's artists. His talk was quiet and unpretentious; there were no fireworks nor sharp wit, as with Whistler or Degas, yet what he said was wise and to the point.'
Sir William Rothenstein, *Men and Memories* (1931), Vol. 1, pp. 262–3

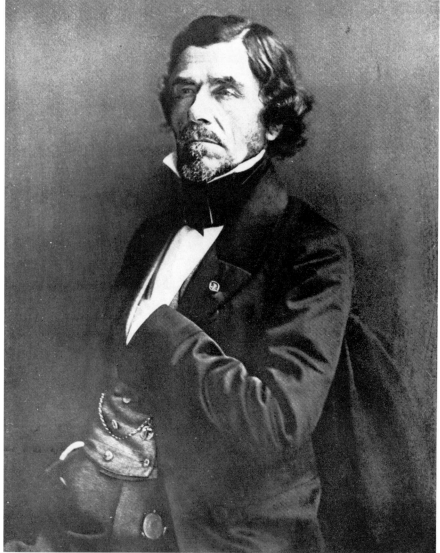

[291]

[292]

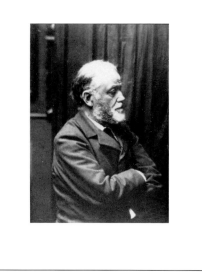

[293]

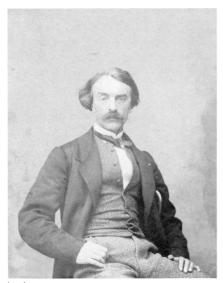

[294]

JEAN LÉON GÉRÔME (1824–1904)

French painter of oriental subjects. He was elected an Honorary Royal Academician in 1869. He exhibited there in the following two years and again in 1888 and 1893. He was a lifelong friend of Eyre Crowe (q.v.). Towards the end of his life he ceased painting, declaring that his work was of inferior quality, and took up sculpture.

294 Albumen print by an unidentified photographer, 98 × 80 mm. *Author's collection*

'[In about 1878] I made an appointment with the painter, and called in his studio. He was then about fifty-four, with handsome features, an air of distinction, and a very grave earnest manner.'
William Michael Rossetti, *Some Reminiscences* (1906), Vol. 2, p. 376

CARL HAAG, RWS (1820–1915)

Bavarian painter who came to England in 1847 and worked mainly in water-colours. Patronized by Queen Victoria and Prince Albert. Later achieved fame with his Middle-Eastern subjects.

295 *Carte-de-visite*, albumen print by John Watkins, London. *Author's collection*

ALPHONSE LEGROS (1837–1911)

French painter, sculptor and etcher, who came to England in 1863. Became naturalized (when a Frenchman asked him what he had gained from this, he replied, '*J'ai gagné la bataille de Waterloo!*'). Was Slade Professor of Fine Art at University College, London, 1876–92.

296 Albumen print by David Wilkie Wynfield. *Royal Academy of Arts*

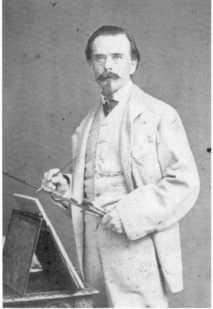

[295]

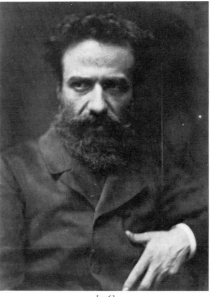

[296]

'A thick-set figure of medium height, with a massive head, slightly bald, black curling hair and beard, and of a rather sombre and lowering expression, he would have been more useful as a teacher if he could have spoken English.'
G. P. Jacomb-Hood, *With Brush and Pencil* (1925), p. 11

RUDOLF LEHMANN (1819–1905)

German painter of portraits, historical and genre subjects. Settled in England in 1866.

297 *Carte-de-visite*, albumen print by an unidentified photographer, *c.* 1885. *Author's collection*

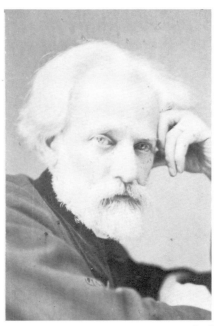

[297]

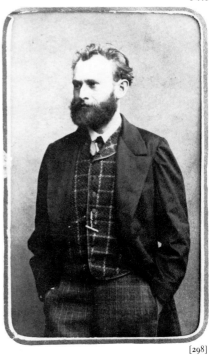

[298]

EDOUARD MANET (1832–83)

French Impressionist painter. He visited Britain in 1868 and 1869, and pictures by him were shown at the exhibition mounted in London by Paul Durand-Ruel in 1872, which showed Impressionist paintings for the first time in London.

298 *Carte-de-visite*, albumen print by an unidentified photographer. *Collection Viollet, Paris*

'Manet . . . had been pointed out to me, and I had admired the finely-cut face from whose prominent chin a closely-cut blond beard came forward; and the aquiline nose, the clear grey eyes, and decisive voice, the remarkable comeliness of the well-knit figure, scrupulously but simply dressed, represented a personality curiously sympathetic.'

George Moore, *Modern Painting* (1893), pp. 30–1

JEAN LOUIS ERNEST MEISSONIER (1815–91)

French painter of historical and contemporary, often military, genre. Although he learnt the language, was immensely popular in England, and was made an Honorary Royal Academician in 1867, there is no actual evidence that he came to England. Some of his early illustrative drawings were engraved in England, and he frequently exhibited here. He was patronized by the 4th Marquess of Hertford (q.v.) and Lord Rothschild.

299 Albumen print by an unidentified photographer, *c.* 1860. *Author's collection*

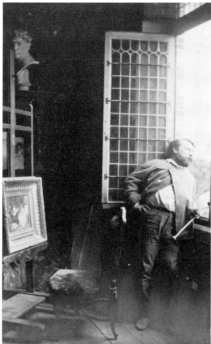

[299]

[300]

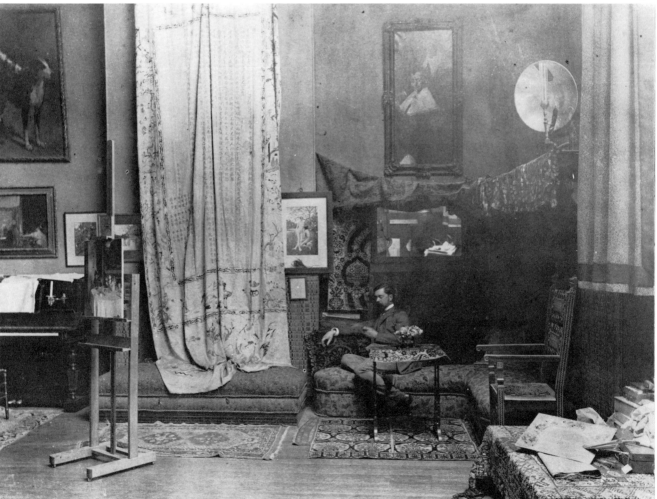

[302]

MORTIMER MENPES, RI, RBA (1860–1938)

Painter, water-colourist, etcher and illustrator. Born in Australia and came to Britain in the early 1880s. His broad delicate style shows the influence of his friend Whistler (q.v.).

300 Photograph by an unidentified photographer, probably taken on the same occasion as other photographs which show Menpes with Whistler in the same garden. One of this series is reproduced facing p. 152 in *Whistler As I Knew Him* (1904), by Mortimer Menpes. *Sotheby's*

CLAUDE MONET (1840–1926)

One of the creators of Impressionism and one of its most consistent exponents. He spent the years of the Franco-Prussian War in England, and a series of views on the Thames resulted from this. He spent the last years of his life as a recluse at Giverny.

301 Albumen print by an unidentified photographer, 53 × 38 mm. *Author's collection*

[301]

JOHN SINGER SARGENT, RA (1856–1925)

Born in Florence, the son of an American physician. Perhaps the most celebrated portrait painter of his age, although he also achieved fame through his landscapes in oils and water-colours.

302 (opposite) Photograph, *c.* 1883, of the artist in his Paris studio. *Ormond family*

303 Photograph, *c.* 1911, showing the artist painting at the Simplon Pass, Switzerland. *Ormond family*

'An American, born in Italy, educated in France, who looks like a German, speaks like an Englishman, and paints like a Spaniard.'
William Starkweather, 'The Art of John S. Sargent', in *Mentor* (October 1924)

'A sepulchre of dulness [*sic*] and propriety.'
James McNeill Whistler in *John Singer Sargent* (1970), by Richard Ormond, p. 55

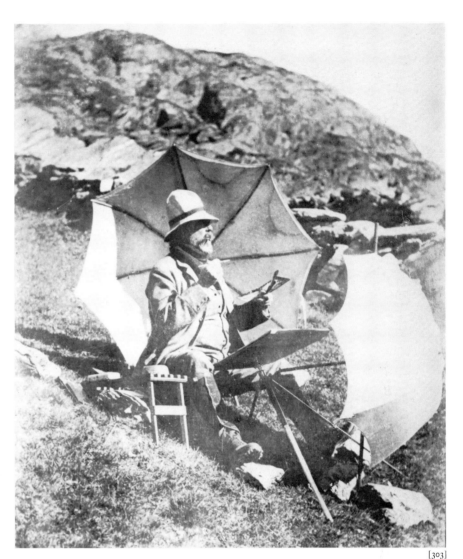

[303]

'John is very stiff, a sort of completely accentless mongrel . . . rather French, faubourg sort of manners. Ugly, not at all changed in features, except for a beard. He was very shy, having I suppose a vague sense that there were poets about. . . .'
Vernon Lee (Violet Paget) in *John Singer Sargent* (1970), by Richard Ormond, p. 21

WILLIAM J. STILLMAN (1828–1901)

American landscape painter and journalist. Came to England in 1849 and met Ruskin (q.v.) and Turner. He returned to America to found the art magazine *The Crayon*. After the suicide of his first wife in 1869 he came back to England and settled in London. He recommended the drug chloral to Rossetti to combat sleeplessness, but which contributed to his death. Married Marie Spartali (q.v.) in 1871.

304 *Carte-de-visite*, albumen print by Valentine Blanchard, London. From the Rossetti family collection. *Mrs Imogen Dennis*
'I have never known anyone more earnest and

[304]

[305]

faithful in his desire and search for spiritual improvement. His character is one of very marked individuality. It is too intense, too self-introverted to be happy, and the circumstances of his life have been so sad as to make it one long suffering. He is not well, and the combination of ill health with too much care and too hard work has made him low-spirited, and has put him out of heart so far as a man who has a sure, reliant trust in the goodness and constant love of God can be put out of heart. I long to do something to help him.'
The Letters of Charles Eliot Norton (1913), ed. by Sara Norton and M. A. De Wolfe Howe, p. 133

JAMES (JACQUES JOSEPH) TISSOT (1836–1902)

French genre and portrait painter. Came to England in 1871, after probable earlier visits in the 1860s, following the fall of the Com-mune, and painted the conversation pieces for which he is best known. In about 1876 Mrs Kathleen Newton (1854–82), a divorcée, became his mistress, and she appears in many of his pictures. After her death from consump-tion in 1882, Tissot returned to France and devoted the remainder of his life to religious paintings, finally becoming a recluse.

305 Photograph of the artist with his mis-tress, Mrs Kathleen Newton, taken three months before her death in 1882. *David S. Brooke*

'James Tissot was a charming man, very hand-some, extra-ordinarily like the Duke of Teck, or rather the Prince, as was then his title.

 'He was always well groomed, and had nothing of artistic carelessness either in his dress or demeanour.'
Louise Jopling, *Twenty Years of My Life, 1867 to 1887* (1925), p. 60

JAMES ABBOTT MCNEILL WHISTLER (1834–1903)

American-born painter, etcher and lithogra-pher. His early creative years were spent in Paris, and in 1859 he came to England. Always a celebrated and controversial figure, he stood out from most of his contemporaries. The English artist with whom he had most affinity was Albert Moore (q.v.). He was also on friendly terms with Rossetti (q.v.).

306 *Carte-de-visite*, albumen print by Carjat & Cie, Paris, *c.* 1865. Not listed in *Portraits and Caricatures of James McNeill Whistler* (1913), by A. E. Gallatin, thus presumably a rare photograph. *Author's collection*

307 Snapshot, possibly by Mortimer Menpes (q.v.). The artist holds a mahlstick under his arm. This was taken on the same occasion as Plate 300. *Sotheby's*

'I never saw any one so feverishly alive as this little, old man, with his bright, withered cheeks, over which the skin was drawn tightly, his darting eyes, under their prickly bushes of eyebrow, his fantastically-creased black and white curls of hair, his bitter and subtle mouth, and, above all, his exquisite hands, never at rest.'
Arthur Symons, *Studies in Seven Arts* (1906), p. 124

'Read any page of *The Gentle Art of Making Enemies*, and you will hear a voice in it, and see a face in it, and see gestures in it. And none of these is quite like any other known to you. It matters not that you never knew Whistler, never even set eyes on him. You see him and know him here. The voice drawls slowly, quickening to a kind of snap at the end of every sentence, and sometimes rising to a sudden screech of laughter; and, all the while, the fine fierce eyes of the talker are flashing out at you and his long nervous fingers are tracing extravagant arabesques in the air. No! you need never have seen Whistler to know what he was like. He projected through printed words the clear-cut image and clear-ringing echo of himself. He was a born writer, achieving perfection through pains which must have been infinite for that we see at first sight no trace of them at all. . . .'
Max Beerbohm in *Whistler: a Biography* (1974), by Stanley Weintraub, p. 342

[307]

[306]

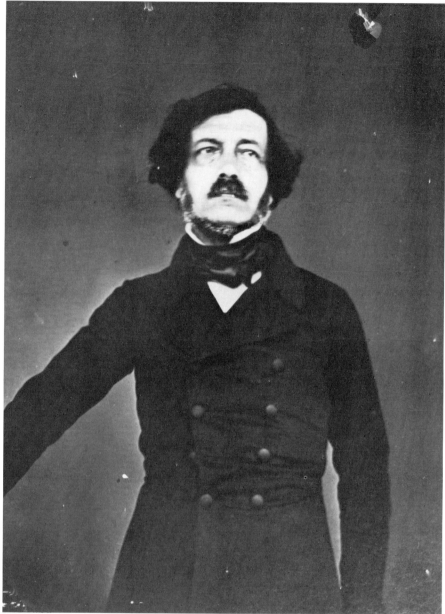

[308]

FRANZ XAVER WINTERHALTER (1805–73)

Celebrated German portrait painter, who painted most of the royal families of Europe and much of the aristocracy. He was the favourite portrait painter of Queen Victoria and Prince Albert and there are over a hundred of his works in the Royal Collection.

308 Photograph, taken on 27 June 1854, by Dr E. Becker, Librarian to Prince Albert.
Her Majesty The Queen

'[6 May 1863] I want now to trouble you with another commission. Winterhalter is most provoking, saying he won't come to England, that he has Russians and Poles to paint, that he is very ill and that he will paint me in Germany. This he cannot, for I go to Germany to be out and to see old friends and be quiet and not to be painted. He may give way, but I doubt it.'

Queen Victoria to the Crown Princess of Prussia ('Vicky') in *Dearest Mama: letters between Queen Victoria and the Crown Princess of Prussia 1861–1864* (1968), ed. by Roger Fulford, p. 209

ROYAL PATRONS

WHEN Prince Albert came to Britain and married Queen Victoria in 1840 he was unfortunate enough to have arrived at a time when the country was passing through a particularly severe phase of xenophobia. Mistrusted and disliked by all those with whom he had no lasting personal contact, particularly the aristocracy and landed classes, he was even considered by those who could observe him at court to have the mental equipment of a second-rate German professor, with a ponderous lack of spontaneity, in contrast to the sheer intuitive intelligence, the opposite pole to intellect, of the Queen. Although in courtly functions he was guided by the stiff formality of the Germanic tradition, which merely served to fuel prejudice against him, the mainspring of his life was a strong vein of artistic instinct. It is only part of his personal tragedy that the delicate shoots of his highly refined sensibilities had to thrust through the alien and largely Philistine terrain of his adopted country. Within the narrow confines of his official position, he was an innovator, a brilliant organizer with sound political judgement, whose love of the arts was increasingly stifled by ever more onerous public commitments.

For there is little doubt that love of the arts and deep respect for artists and musicians were the single most powerful elements in his nature. No biography has yet more than hinted at this important aspect of his personality. He was an excellent musician, a composer of some twenty-nine romances and lieder, and eight chorales and anthems. Only two years after his marriage observers were astonished to receive a foretaste of his respect for the arts when he accorded Mendelssohn, a frequent visitor to Buckingham Palace, the deference more customarily due to a prince of equal standing.

Very soon after his marriage Albert acquired the habit of dropping in, on occasions unannounced and with an equerry, to artists' studios to scrutinize work in progress, often stabbing the air with a sharp instrument to suggest improvements. Aware of this habit and wishing to protect the surface of a portrait in progress of the Prince of Wales, George Richmond had the picture glazed before an impending visit. 'When the gold pencil was produced as usual to make suggested improvements, it clicked harmlessly against the glass, and the Prince, much surprised, could subsequently indicate only by a few flourishes of his toothpick the alterations which he considered should be made.' On another occasion the Prince had to be politely reproved for venturing to take a peep at a picture which had been turned with its face to the wall, it being tacitly agreed among artists that pictures were placed in that position for the very good reason that the painters did not want them to be seen. Frith had a deep respect for Albert's opinions and even altered parts of his *Derby Day* in accordance with various suggestions made by the Prince. Always, Albert surprised artists by the ease and familiarity of his manner and by his obvious respect for them.

Albert and Victoria both had instruction from artists – Edwin Landseer, in particular – and their friendship with this artist is well known. Rather touchingly, they would commission him separately and secretly to paint pictures for each other to exchange as presents at Christmas and on birthdays. The Queen took lessons, too, from Edward Lear and William Leitch. While she achieved a certain facility in painting, drawing and etching, Albert had little time for creative work. They both actively patronized artists and bought works by Wilkie, Landseer, Lear, Callcott, Grant, Frost and many others, including such famous pictures as *Ramsgate Sands* by Frith, and Leighton's first Royal Academy picture, *Cimabue's Madonna*. They commissioned

work from Landseer, Frith, C. R. Leslie and Phillip; for portraits, Winterhalter was their first choice. Albert was one of the first to advocate the white instead of the more usual gold mount when framing drawings.

He was an enlightened collector of Old Masters and pioneered interest in the early Italian Schools. At the age of 22, having had less than two years' experience of England, he was appointed by the Prime Minister, Sir Robert Peel, to be chairman of the Royal Commission, 'to take into consideration the Promotion of the Fine Arts of this country, in connexion with the Rebuilding of the House of Parliament', which had burned down in 1834. No one should have been surprised, although of course they were, when he took his duties extremely seriously.

In the context of this book it is interesting to note that the Queen and Prince Albert took a keen interest in early photography, having a dark-room installed at Windsor Castle. They kept photograph albums and in 1860 Albert compiled an album composed entirely of photographs of artists, some of which are reproduced here. They attended photographic exhibitions, appointed Royal Photographers and inspected new inventions. Queen Victoria often plied artists with photographs as an aid in painting portraits.

When Albert died on 14 December 1861 at the age of 42 the nation was stunned. Scarcely believing the truth, congregations throughout the country wept when his name was left out of the Litany on the Sunday that the announcement came. With a heavy heart, A. J. Munby, the diarist, scoured the photographic shops of Regent Street for a photograph of the Prince, without success – they were sold out. He managed to buy one of the Queen and Albert a week later for four shillings instead of the usual eighteen pence.

In the fullness of time and after the publication of all the autobiographies of those Victorian artists that had written them, it became apparent that in every single case where the artist had had direct personal experience of Albert, his death had been seen as one of the greatest tragedies in their lives. No section of the community had more reason to mourn his loss. Lady Eastlake wrote in her diary, 'I am overwhelmed by this incalculable affliction which has befallen us all', and quickly penned an obituary for the *Quarterly Review* which brilliantly summed up the Prince's achievements and counted the loss to the arts. Richard Redgrave wrote in his diary, 'What a terrible shock! too terrible for belief.' J. A. Manson, the biographer of Landseer, captured the mood of artists when he wrote, 'Prince Albert was a man with a real love of art, whose considerable services to Aesthetics and Education have never been appraised at their proper value, in consequence of the unrestrained adulation beneath which the measure and significance of his work lie buried. He was, indeed, a greater man than his flatterers imagined.'

When Albert died, much of the Queen's interest in the arts died with him. On her own she had no special fondness for art, although she continued to patronize Landseer and over the years she added to the Royal Collection. Her allegiance to Winterhalter, who died in 1875, was transferred to Heinrich von Angeli, and in sculpture she patronized Sir Joseph Boehm. Portraiture was always important to her, particularly as a means of expressing the idea of monarchy, and the photographic portrait was especially dear to her, being an essential enclosure in the extensive network of correspondence among her large, widely dispersed family.

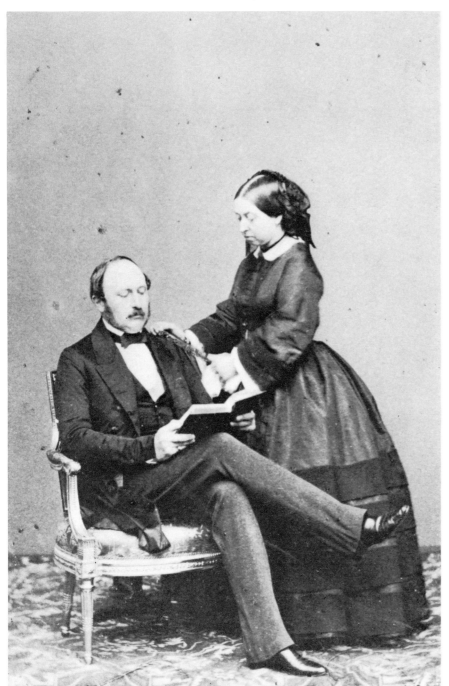

[309]

QUEEN VICTORIA (1819–1901) and PRINCE ALBERT (1819–61)

The Queen and her brilliant Consort were enthusiastic patrons of living artists and sculptors, the latter in particular. Prince Albert's early death was probably more deeply mourned by the artistic fraternity than any other.

309 *Carte-de-visite*, albumen print by J. P. Mayall, taken at Buckingham Palace, 15 May 1860. Mayall took *carte* portraits of the whole royal family in the summer of 1860. It was the publication of these portraits in August of that year that contributed greatly to the popularity of *cartes-de-visite*. After her first sitting to Mayall in 1855, Queen Victoria had commented: 'He is the oddest man I ever saw, but an excellent photographer. He is an American, and a tremendous enthusiast in his work.' *Author's collection*

'Very nearly half a century ago, a beautiful Prince, quite as handsome as any hero of a fairy tale, came from a foreign country to woo and win the love of the great Queen of England. Prince Albert of Saxe-Coburg and Gotha was beyond question, not only mentally, but physically also, one of the most remarkable men of his own or any other time. To the most fascinating outward appearance, the Prince added the most gracious and courtly manner that could be imagined. What wonder, then, that he proved irresistible even to a Queen?'
W. P. Frith, RA, *My Autobiography and Further Reminiscences* (1887), in 3 vols, Vol. 3, p. 165

'He was a man of the most refined taste, with a fervent love for art, and a high esteem for its professors.'
T. Sidney Cooper, *My Life* (1890), Vol. 2, p. 66

'In his short time he did more for artists than any king or prince ever did before or since.'
Mrs Panton, *Leaves from a Life* (1908), p. 40

PATRONS, DILETTANTI & WRITERS ON ART

To avoid needless repetition while on the subject of patronage, I would refer readers to the chapter on dealers and print-publishers. However, at the risk of some repetition, it is still necessary to set out the situation as it was on the accession of Queen Victoria in 1837. The Reform Bill of 1832 had reduced the political power of the aristocracy, but social change, particularly in attitudes towards art, was slow to gather momentum. The age of the Grand Tour was over and the aristocracy had virtually ceased buying (genuine) Old Masters; the new rich, however, temporarily in emulation of the old aristocracy, were for the moment indulging in a spending spree on Old Masters, many of which were fakes, for they were unable to see, through lack of formal education and necessary environment, their dubious nature. It was largely through the campaigns against fakes in the press, particularly by the editor of the *Art Journal*, S. C. Hall, as well as several well-advertised court cases, that the picture-buying public had, by the early 1850s, begun to buy almost exclusively the work of living painters.

As Tom Taylor wrote in his biography of C. R. Leslie:

The nobleman is no longer the chief purchaser of contemporary pictures. It is mainly to our great manufacturing and trading towns that the painter has to look for the sale of his works. The class enriched by manufactures and commerce is now doing for art in England what the same class did in earlier times in Florence, Genoa, and Venice, for the art of Italy; in Bruges, Antwerp, and Amsterdam for that of the Low Countries and Holland. The change may have its evil as well as its good. There may be some risk that it will multiply the manufacture and increase the homeliness of pictures, to say nothing of less direct and obvious ill-consequences.

The new patronage came with the great tycoons of the industrial Midlands and quite a few from London and what is nowadays called 'the affluent South'. The new picture buyers were the cutlers, colliery owners, cotton kings, textile merchants, shipping magnates and ironmasters. A few aristocrats, like Lord Northwick, attempted to wean themselves of the habit of buying Old Masters (his gallery was full of 'very questionable' examples, according to Frith) and to acquire work by living painters; but they were the exception. With new paint on pictures fresh from the easel, the new patron knew exactly where he stood: questions of authenticity and attribution in old pictures was to them so much mumbo-jumbo.

Some of the early patrons were a colourful lot. There was the ferocious horse-dealer Robert Vernon, whose collection is now at the Tate Gallery; and John Sheepshanks, whose collection is now at the Victoria & Albert Museum. William Wells, the ship-builder of Redleaf, Kent, was another who graduated from Old Masters to contemporary works: his hall was filled with pictures by Landseer. The whale-oil dealer Elhanan Bicknell bought pictures by Turner and David Roberts; B. G. Windus of Tottenham, variously believed to be a retired coach-builder and the owner of a proprietary opiate, was an avid buyer of all kinds of contemporary works, including Pre-Raphaelite pictures. Another typical mid-Victorian patron was Albert Grant (whose real name was Gottheimer), one-time MP for Kidderminster and for some reason better known as Baron Grant. His enormous collection was sold in 1877 owing to his bankruptcy. It had been intended for a vast pile called Kensington House, which had once been a lunatic asylum. Since his entire collection of modern pictures had been confined to a pantechnicon, it was only at the sale that Baron Grant was to see his collection in its entirety.

In sheer munificence, Joseph Gillott, the inventor and first mass-producer of the steel pen nib (known as 'His Nibs' to his employees), outshone them all. In a correspondence with a large part of the London art trade and many leading artists lasting nearly thirty years until his death in 1872, he kept a daily watch on the comings and goings of pictures. So prodigious was the scale of his speculations in pictures, precious stones, violins and other stringed instruments, that he was considered by some artists to be more a dealer than a patron. A long friendship with the dealer Gambart proved to be a considerable mutual benefit.

The patrons of the Pre-Raphaelites were generally better educated. They certainly needed to be, because of the often arcane subject matter which sometimes presupposed a good working knowledge of classical and medieval mythology and of Italian Renaissance poetry, not to mention some of the remoter passages of the Bible and even the Talmud. When a knowledge of the Books of Isaiah, Leviticus and the Talmud was necessary to explain the meaning of one picture, *The Scapegoat*, it is quite understandable that Hunt had difficulty in finding a buyer for it. It was finally bought (through the dealer, White) by B. G. Windus, who probably just liked the way it was painted. Thomas Combe of Oxford was another of Hunt's patrons, as well as of Millais and others. Further great collections of Pre-Raphaelites were made by Thomas Plint, a stockbroker of Leeds; John Miller, a merchant of Liverpool; Francis McCracken, a shipping agent of Belfast; George Rae, a banker from Birkenhead; and James Leathart, a lead merchant from Newcastle. These were joined by William Graham, MP, and F. R. Leyland, the shipping magnate and patron of Whistler, with whom he quarrelled over the famous Peacock Room in his house in Chelsea.

The later years of the century saw the return of the patron of the earlier mould, typified by George McCulloch. He bought with little discrimination but on a vast scale so that inevitably he acquired some fine pictures, notably by Leighton and Waterhouse. Perhaps one of the strangest of these patrons was not really a patron at all, but simply a collector of pictures by living artists; he bought none of them direct from the artists but nearly all, over a two-year period, at Christie's. This was Thomas Holloway, manufacturer and distributor of Holloway's Ointment and Holloway's Pills. Amongst the fine pictures netted in this wonderful extravaganza was Edwin Long's *Babylonian Marriage Market*, for which he paid a world-record price for the work of a living British painter (6300 guineas), and two masterpieces by Fildes and Holl.

Dilettanti were a feature of the eighteenth century. They were simply lovers of the fine arts and in the nineteenth century the term 'amateur' was often used to describe such a person. It was not until more recently that the term has come to be used in a pejorative sense. 'Amateur' in its historical meaning, and in this context, is taken to mean, therefore, a lover of the fine arts and, by extension, someone, usually from another less apparently attractive occupation who, to compensate, likes to seek involvement with them. Such a breed of person was so common in the nineteenth century, often combining with others into societies, that I have singled out just one individual, Lewis Pocock, as an example. He is actually described in the *Dictionary of National Biography* as an art amateur. He took a leading part in the founding of the Art Union of London in 1837, was on the visiting committee of Gambart's first French exhibition, and collected Johnsoniana. (He also published, in 1842, a work on life assurance.) Although an exceedingly busy man, with close involvement with art and artists, he seemed to glide effectively yet invisibly through the nineteenth century, eliciting no comment nor description, that I can find, in any reminiscences of the period.

An important element in the multifarious structure of the art world was the power of the written word. If the dealer stood between the artist and his public, so also did the writer on art. Those armed with sufficient self-confidence were at liberty to ignore either, but the generality of artists, patrons and dealers could not but be affected by the critics and writers on art. A writer in the *Art-Journal* of 1892 noted that at the Private View of the Royal Academy that year 'no fewer than three hundred knights of the pen were present'. Multiplying this figure across the entire span of the Queen's reign, there emerges the picture of an apparently major industry with many thousands of 'knights of the pen' scribbling away in the name of Art.

One of the very first of these was the illustrious figure of W. M. Thackeray who, under the pseudonym of Michael Angelo Titmarsh, wrote lively critical reviews in *Fraser's Magazine* from 1838 to 1845. With sound judgement, rollicking fun and an elegant pen, he lavished both praise and 'strictures on pictures' without qualm, damaging the self-esteem of many an established Academician. In the meantime, wrote Edward FitzGerald to Frederick Tennyson in 1845, Thackeray was 'writing hard for half a dozen Reviews

and Newspapers all the morning; dining, drinking, and talking of a night; managing to preserve a fresh colour and perpetual flow of spirits under a wear-and-tear of thinking and feeding that would have knocked up any other man I know two years ago, at least'. Thackeray's contemporary, Dickens, also contributed notices to *Household Words*, including the celebrated attack on Millais's *Christ in the House of his Parents* of 1850.

A third novelist, Wilkie Collins, the son of William Collins, RA, and brother of the painter and Pre-Raphaelite follower Charles Allston Collins, started early in his career to write about art. In 1848 he published *Memoirs of the Life of William Collins, Esq, RA* in two volumes. How much Wilkie Collins wrote for various periodicals will probably never be fully known because of his penchant for anonymity. However, I can reveal now, for the first time, a substantial addition to his *oeuvre*. This is a series of five articles entitled 'A Walk Through the Studios of Rome', published in the *Art-Journal* from June 1854 to August 1855, and two further articles on related subjects in August and September 1854 in the same journal. All are signed *FLORENTIA* and bear the hallmarks of Collins's style. In a series of letters by various hands to the editor, S. C. Hall, that I acquired recently, is one from Collins dated 1 June 1854, saying, 'May the bearer have a copy of the Art-Journal of this month, to be sent to the writer of the Article on the "Studios of Rome"? Very faithfully yours, W. Wilkie Collins.'

But the first systematic writer on art and the one who stayed the course longest was Samuel Carter Hall, co-founder and editor of the *Art-Journal*, which was known for the first nine years as the *Art-Union*. This, the longest-running magazine of its kind, ran from 1839 to 1912. Unfortunately, Hall, although he exacted a kind of grudging respect by virtue of his office, was almost entirely unsuited to the role he had conferred upon himself. Adequate as a mere editor, his writing on art was a flatulent concoction of oleaginous platitudes delivered with a repellently unctuous authority, derived, he believed, from messages received from another world. At the same time he would gently but persuasively urge his colleagues to be ever mindful, in their writings, of the advertising department of the journal.

Happily, turning away from the windy prattle of Hall, there emerged at this time the first truly great writer on art whose influence reigned supreme for a whole generation. John Ruskin came to notice with the successive publication of the volumes entitled *Modern Painters* from 1843 to 1860. His aesthetic despotism was absolute and, so long as people listened, it was scarcely possible for anyone to paint without reference to his precepts. That he could be almost wilfully wrong-headed at times made little difference. As Burne-Jones remarked one day while working on his picture *Love Leading the Pilgrim* and speaking of critics generally, 'Only Ruskin that was ever worth listening to, and he was far from always right. Even his criticisms often did a world of mischief – but as to these creatures, O God! I think it's much better to do as I do and never read them.' Other intelligent critics, like the American Henry James and the Irishman George Moore, began to write after Ruskin had turned to ethics and social philosophy, but none ever acquired that vital authority. Only some of the sturdier painters withstood the onslaught. David Roberts, who had been attacked in a review by Ruskin, happened to meet him one day. Roberts said loudly so that all could hear, 'Who are ye to attack me? Ye are just a damned scribbling snob! Ye tried to paint yersel! and ye couldna!', then swung round on his heel and strode away.

Another critic who in reality had rather less authority than was generally accorded him by his contemporaries was F. G. Stephens, who was art critic on the *Athenaeum* for forty years ending in 1901. His style was less windy but quite as wordy as Hall's. One of the original Pre-Raphaelite Brotherhood and, with his handsome looks, a frequent model in their pictures, he began to appear old-fashioned about halfway through his career. Other writers on art included William Michael Rossetti, a good, faithful chronicler of his brother's life and work, and of his other contemporaries. Good, too, in their way, were Marion Spielmann, Gleeson White, Alice Meynell and Lady Dilke. The century ended with the writings in the *Athenaeum* of one of the most perceptive and articulate of all the late nineteenth-century critics, the artist Walter Sickert, who had the good sense and courage to champion Frith when it was fashionable to write him off. Stephens was succeeded at the *Athenaeum* by Roger Fry, the greatest of the early twentieth-century critics and the most influential since Ruskin.

[310]

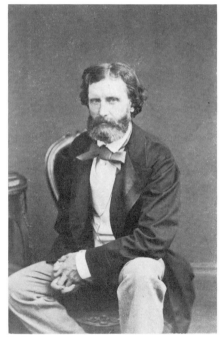

[311]

SAMUEL BANCROFT, Jr (1840–1915)

American Quaker and collector of Pre-Raphaelite works. His collection was formed mainly in the 1880s and 1890s, and is now at the Delaware Art Museum, USA. He was a partner in his father's cotton mill at Wilmington and a politician.

310 Photograph. *Delaware Art Museum, USA*

SIR FREDERICK WILLIAM BURTON, RHA, FSA (1816–1900)

Painter mainly of miniature and water-colour portraits. Director of the National Gallery from 1874 to 1894.

311 *Carte-de-visite*, albumen print by Cundall, Downes & Co., London, probably taken in about 1864. *Author's collection*

WILLIAM WILKIE COLLINS (1824–89)

Novelist; biographer of his father William Collins, RA; and in his early years an occasional writer on art. Friend of artists, including Frith (q.v.) and Holman Hunt (q.v.). He was the brother of Charles Allston Collins (q.v.).

312 *Carte-de-visite*, albumen print by Sarony. *Author's collection*

'I found him sitting in his plethoric, disorderly writing-room: there are two kinds of bachelors, the raspingly tidy sort, and the hopelessly ramshackle; Wilkie was of the latter. Though the England of his prime had been a cricketing, athletic, outdoor England, Wilkie had ever slumped at his desk and breathed only indoor air. He was soft, plump, and pale, suffered from various ailments, his liver was wrong, his heart weak, his lungs faint, his stomach incompetent, he ate too much and the wrong things. He had a big head, a dingy complexion, was somewhat bald, and his full beard was of a light brown colour. His air was of mild discomfort and fractiousness; he had a queer way of holding his hand, which was small, plump, and unclean, hanging up by the wrist, like a rabbit on its hind legs. He had strong opinions and prejudices, but his nature was obviously kind and lovable, and a humorous vein would occasionally be manifest. One felt that he was unfortunate and needed succour.'
Julian Hawthorne, *Shapes that Pass* (1928), pp. 169–70

SIR SIDNEY COLVIN (1845–1927)

Scholar who became Slade Professor of Fine Art at Cambridge in 1873, Director of the Fitzwilliam Museum in 1876, and Keeper of the Department of Prints and Drawings in the British Museum from 1884 to 1912.

313 Photogravure by Edward Arnold, London, 118 × 86 mm, reproduced in *Memories & Notes of Persons & Places, 1852–1912* (1921), by Sir Sidney Colvin. *Author's collection*

'In person he was tall and thin, in manner animated and nervous, sometimes irritable, but charming in demeanour to those whom he liked.'
Dictionary of National Biography

[312]

[313]

MRS THOMAS COMBE (née Martha Howell Bennett) (1806–93)

Like her husband (q.v.) she was very friendly with the Pre-Raphaelites. Shortly after her husband's death she presented *The Light of the World* by Holman Hunt (q.v.) to Keble College, Oxford. Fulfilling her husband's wishes she bequeathed their collection of paintings to the University.

314 Albumen print, 140 × 98 mm. *Sir Jack Sutherland-Harris*

[314]

THOMAS COMBE (1797–1872)

Printer to the University of Oxford. He made a collection of Pre-Raphaelite pictures which, with the exception of Hunt's *The Light of the World* which went to Keble College, Oxford, was bequeathed by Mrs Combe to the University of Oxford, and is now in the Ashmolean.

315 Albumen print, 140 × 97 mm. *Miss I. M. B. Marshall*

'A man of the most cultivated tastes, and highly respected and beloved by every member of the University with whom he came into contact – and his wife was a very counterpart of himself.'
J. G. Millais, The Life and Letters of Sir John Everett Millais (1899), Vol. 1, pp. 87–8

LADY EASTLAKE (née Elizabeth Rigby) (1809–93)

A very formidable lady who was a considerable figure in the artistic-literary world. She reviewed books in the *Quarterly Review*; published a memoir of her husband; and translated Dr Waagen's *Treasures of Art in Great Britain* (1854–7).

316 Calotype by David Octavius Hill (q.v.) and Robert Adamson, 208 × 157 mm. *Private collection*

'[23 March 1870] Lady Eastlake, tall, rather ponderous and pompous. . . .'
The Letters and Journal of Queen Victoria (1926), 2nd series, Vol. 2, p. 12

FREDERICK WILLIAM FAIRHOLT, FSA (1814–66)

Born in London, the son of a German tobacco manufacturer named Farholz, he was an illustrator and drawing master and painted theatrical scenery. Wrote many books of antiquarian interest and articles for the *Art-Journal*.

317 *Carte-de-visite*, albumen print by an unidentified photographer. *Author's collection*

JOSEPH GILLOTT (1799–1872)

Inventor and first mass-producer of the steel pen-nib. Bought and sold works by living and dead artists on such a scale that he was considered by some to be a dealer rather than a

patron. Great friend of the dealer Ernest Gambart (q.v.). Known to his employees as 'His Nibs'.

318 Cabinet portrait albumen print by J. P. Mayall, taken in about 1870. *From the collection of the family*

'Although what is called a "self-made man" Mr. Gillott had very fine perceptions in art, and seldom made a wrong judgment: and it is to his credit that he was among the first to give [John] Linnell large prices. It need hardly be said that he was a "character" in his way – not to say an oddity. When he came to town he used to put up at Furnival's Inn, where he had a suite of rooms, and where he was wont to feast his friends in the most sumptuous manner. Linnell eschewed his dinners, but on one or two occasions took tea with him, and used to recount with amusement how the queer little pen-manufacturer would empty out the pot, and make fresh tea for every cup they drank, saying that they could not drink it stale.'

Alfred T. Story, *The Life of John Linnell* (1892), Vol. 2, p. 21

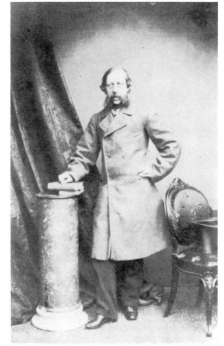

[317]

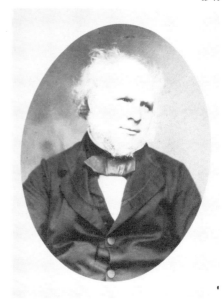

[318]

[316]

[319]

SAMUEL CARTER HALL, FSA (1800–89)
MRS SAMUEL CARTER HALL (née Anna
Maria Fielding) (1800–81)

S. C. Hall was the founder and editor for
many years of the *Art-Journal*. Nicknamed
both 'Shirt-collar Hall' and 'Temperance
Hall' on account of his manner (noted below)
and his views on the drinking of spirits. Mrs
S. C. Hall was intellectually his superior and
the author of numerous books.

319 Albumen prints by an unidentified pho-
tographer, oval, 47 × 39 mm each. *Author's
collection*

'I made the acquaintance of Samuel Carter
Hall – the original of Dickens's Pecksniff –
and his more celebrated wife, at the time the
former was editing an illustrated "Book of

British Ballads" which was printed at our
office. Hall, like many another man given to
persistent affectation, expanded in his palmy
days into a complete caricature of himself.
Although devoid of the slightest critical
faculty, and possessing only commonplace
taste in matters of art, without even the power
of expressing himself logically, Carter Hall
had, with Hibernian self-confidence, set him-
self up as the artistic oracle of the day – Rus-
kin, it should be noted, had not then arisen.
Having been editor of one of the crowd of
illustrated annuals so much in fashion a few
years before, he regarded this as sufficient
qualification, and promulgated his dicta in the
"Art-Union" – nicknamed by "Punch" the
"Pecksniffery" – as the "Art-Journal" was
then called. Pushing young artists and am-
bitious art-manufacturers competed for words
of praise from his pen. Those who made offer-

ings of little studies in oil or water colour, or
choice examples of ceramic ware, were pretty
certain to be belauded. . . . Hall talked even
far more priggishly and foolishly than he
wrote, and I have more than once felt surprised
at hearing him launch out at his own dinner-
table without any attempt being made to check
him by his sensible wife. True, he assumed
an intellectual superiority over her, and she
blandly accepted the false position, but no one
was taken in by this.'
Henry Vizetelly, *Glances Back Through Seventy
Years* (1893), Vol. 1, pp. 304–5

'He knows nothing about art, yet talks and
works at it – in a wholly harmful and mistaken
manner.'
John Ruskin in *The Letters of John Ruskin to Lord
and Lady Mount-Temple* (1964) ed. by John Lewis
Bradley, p. 79

PHILIP GILBERT HAMERTON (1834–94)

Artist, essayist and art journalist. Co-founder of the *Portfolio* which he directed until his death.

320 Photogravure after a photograph by A. H. Palmer, son of Samuel Palmer (q.v.). Frontispiece to *An Autobiography* (1897) by P. G. Hamerton. *Author's collection*

'[His autobiography] was completed and published in 1897 by his widow, better qualified than himself to render justice to the many admirable traits of a sterling character somewhat deficient in superficial attractiveness. . . .'
Dictionary of National Biography

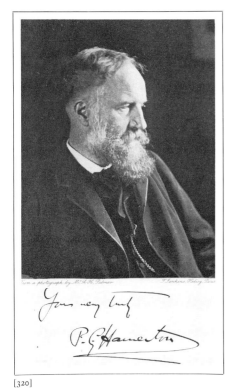

[320]

RICHARD SEYMOUR-CONWAY, 4TH MARQUESS OF HERTFORD (1800–70)

One of the greatest collectors of the Victorian age. After his succession to the Marquisate in 1842 and with an income of some £250,000 a year, he formed the superb collection which went to his natural son, Sir Richard Wallace (q.v.), on his death in 1870. It is now known as the Wallace Collection.

321 Photograph. Outside his house in Paris, called Bagatelle. To the left is the Marquess of Hertford; the woman in the middle is probably his mistress Mme Oger; to the right is Sir Richard Wallace. *The Wallace Collection*

THOMAS HYDE HILLS (1815–91)

Pharmacist and friend of Jacob Bell, the patron of artists. Became a partner in John Bell & Co. after Jacob's death. Hills became the friend of many artists.

(See 'The Four Pilgrims', Plate 25.)

THOMAS HOLLOWAY (1800–83)

Manufacturer and vendor of patent medicine, from which he earned a fortune. Founded the Royal Holloway College at Egham and the Holloway Sanatorium at Virginia Water. Formed an important collection of contemporary pictures bought almost entirely at Christie's over a period of two years.

322 Photograph, *c.* 1875. *Surrey Record Office*

'Last year [Edwin] Long's *Babylonian Marriage Market* [was bought for] £6,615, by a Mr Holloway (pills?), having more money than brains. . . .'
The Journal of Beatrix Potter from 1881 to 1897 (1966), ed. by Leslie Linder, p. 41

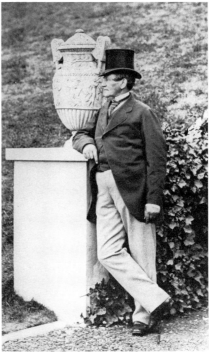

[322]

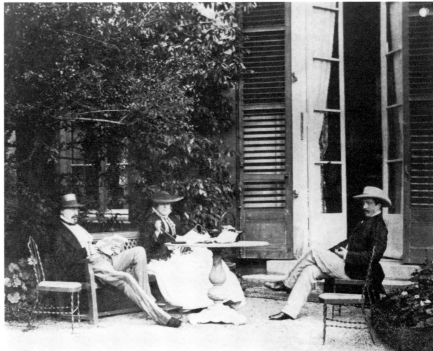

[321]

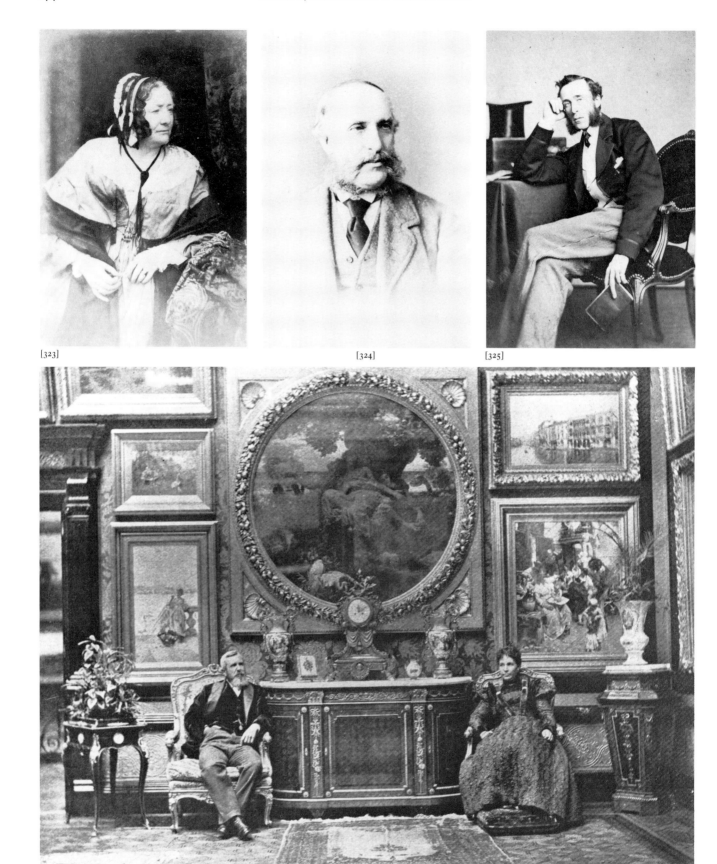

[323]

[324]

[325]

[326]

ANNA BROWNWELL JAMESON (1794–1860)

Author of many books including *Companion to Public Picture Galleries of London* (1834) and *Sacred and Legendary Art* (1848–52).

323 Calotype by David Octavius Hill (q.v.) and Robert Adamson, *c*. 1845. *Sotheby's*

'The charm of her character is evident from the extraordinary wealth in accomplished friends. This is the more remarkable if, as asserted by a writer in the "Athenaeum", probably Henry Chorley, she was heavy and unready in conversation.'
Dictionary of National Biography

JAMES LEATHART (1820–95)

Newcastle patron of artists. Formed a superb collection of Pre-Raphaelite paintings, much of it on the advice of William Bell Scott, Rossetti, Arthur Hughes and Ford Madox Brown (all q.v.). All his income had been spent on collecting, so that his wife and children were obliged to sell the majority of his collection after his death.

324 *Carte-de-visite*, albumen print by an unidentified photographer, taken at Brighton, *c*. 1868–70. *Leathart family*

'Mr Leathart was a kind-hearted, hospitable, agreeable man; his fortunes prospered, and he removed into a large sightly house, Bracken Dene, Gateshead. He married a lady much younger than himself, attractive in all respects.'
William Michael Rossetti, *Some Reminiscences* (1906), Vol. 1, p. 135

FREDERICK RICHARDS LEYLAND (1831–92)

Great patron of artists and a business tycoon. A self-made man, he entered the steamship line of Messrs Bibby of Liverpool, and before the age of 30 he had transformed the business and acquired great wealth. It became known as the Leyland Steamship Line. In 1865 he met D. G. Rossetti (q.v.) who introduced him to Whistler (q.v.), Legros (q.v.), Madox Brown (q.v.) and Burne-Jones (q.v.). He met Albert Moore (q.v.) through Whistler. His daughter Florence was married to Val Prinsep (q.v.). With advice from Murray Marks (q.v.), the art dealer, he built up a superb collection. Whistler painted the famous Peacock Room for him.

325 *Carte-de-visite*, albumen print by J. R. Parsons, London. From the collection of D. G. Rossetti (q.v.). *Mrs Imogen Dennis*

'Frederick Leyland, a remarkable man, tall and stylish, almost showy, very clever and keen.'
Hall Caine, *My Story* (1908), pp. 158–9

[327]

GEORGE McCULLOCH (1848–1907) and Mrs McCULLOCH

A self-made man who earned a huge fortune from Broken Hill gold-mine in Australia which he won in a game of penny nap. He was reputed to have spent more than £200,000 on contemporary art.

326 Photograph, at home at 184 Queen's Gate, London, reproduced from *The McCulloch Collection of Modern Art*, London, RA Winter 1909 Catalogue. Lower picture to the left is *A Venetian Gate* by Cecil van Haanen; in the centre is *The Garden of Hesperides* by Leighton (q.v.) (RA, 1892); to the right, above, is *The Ca d'Oro, Venice*, and below, *La Friulanella* by Henry Woods, RA (q.v.) (RA, 1895).

JOHN MILLER OF LIVERPOOL (*c*. 1800–*c*. 1880)

Great patron of art and artists.

327 *Carte-de-visite*, albumen print by J. Lee, Liverpool. From the collection of D. G. Rossetti (q.v.). *Mrs Imogen Dennis*

'This Miller is a jolly, kind old man, with streaming white hair, fine features, and a beautiful keen eye like Mulready's, a rich brogue [he was Scottish not Irish], a pipe of Cavendish, and a smart rejoinder, with a pleasant word for every man, woman, and child he meets, are characteristics of him. His house is full of pictures, even to the kitchen.'
Ford Madox Brown in *Letters of Dante Gabriel Rossetti to William Allingham, 1854–1870* (1897), ed. by George Birkbeck Hill, p. 151

LEWIS POCOCK, FSA (1808–82)

Described by the *Dictionary of National Biography* as an 'art amateur'. He was a great lover of art and his chief claim to fame was that in 1837 he took the leading part in founding the Art-Union of London and acted until his death as one of its Honorary Secretaries. He was a collector of Johnsoniana.

328 Albumen print by Octavius Watkins, oval, 188 × 138 mm, *c*. 1855.
Author's collection

[328]

JOHN RUSKIN (1819–1900)

Author, artist and social reformer. The most influential critic of his age, quick to recognize the genius of Turner and champion the cause of the Pre-Raphaelites. Married Effie Gray (later Effie Millais) in 1848. The marriage was annulled in 1855 in which year she married Millais (q.v.).

329 Cabinet portrait by William Downey, Newcastle-upon-Tyne, taken on 29 June 1863 at Rossetti's house, 16 Cheyne Walk, Chelsea (see Plates 212 and 213), on the same occasion as the two photographs of Ruskin, Rossetti and W. B. Scott. Ruskin's visit to the house would have been a surprise to Downey, who would have wanted to make the most of an opportunity to photograph such an eminent man. The chair is that which was used by Rossetti when painting. Another photograph from the same session, which differs very slightly from this (the index finger points downwards), is in the author's collection. A defect of the lips (from being bitten there by a dog in his youth), so often commented on by his contemporaries, is not evident in the photograph. W. M. Rossetti (q.v.) regarded this picture as a 'good though not an advantageous likeness'. It was probably this photograph that Ruskin scolded Rossetti about for allowing it to get abroad. Later on Ruskin denounced the red-eyed Downey as a 'mere blackguard' for such a 'visible libel upon me going about England as I hold worse than all the scandals and lies ever uttered about me'. Ruskin was a much-photographed man of eminence. I have had a choice of some twenty photographs; many others have survived. *Author's collection*

330 Carbon print by Frederick Hollyer (q.v.), 270 × 345 mm, taken at his home at Brantwood, Coniston, in September 1894. This photograph was much reproduced in obituaries of him. *Author's collection*

'I like his face. . . . I have seen two portraits, front face and profile, both after he had grown a beard. He was like a Russian peasant.'
Leo Tolstoy in *Friends of a Lifetime: Letters to Sydney Carlyle Cockerell* (1940), ed. by Viola Meynell, p. 82

'My own first sight of Ruskin was in November 1854, when he delivered some lectures, which I attended, upon matters of art. Ruskin was then nearly thirty-six years of age, of fair stature, exceedingly thin (I have sometimes laid a light grasp on his coat-sleeve, and there seemed to be next to nothing inside it), narrow-shouldered, with a clear, bright complexion, very thick yellow hair, beetling eyebrows (which he inherited from his father), and side-whiskers. His nose was acute and prominent, his eyes blue and limpid, the

[329]

general expression of his face singularly keen, with an ample allowance of self-confidence, but without that hard and unindulgent air which sometimes accompanies keenness. His mouth was unshapely, having (as I was afterwards informed) been damaged by the bite of a dog in early childhood. He had a sunny smile, however, which went far to atoning for any defect in the mouth. The cheek-bones were prominent, the facial angle receding somewhat below the tip of the nose. As my brother's report of Ruskin's personal appearance had never been eulogistic, I was agreeably impressed by what I saw of his looks, as well as by his voice and manner. There was a perceptibly Scottish tone in his speech, with a slight Northumbrian burr. . . . Did I like

Ruskin? Most assuredly I did. His manner to me was gentle in the extreme, and almost profusely amiable.'

William Michael Rossetti, *Some Reminiscences* (1906), Vol. 1, p. 177

'[8 November 1860] . . . rising up & down on his toes, after his manner, with his hands in his tail-pockets, and finally jaunting downstairs in the same springy fashion, with the prim smile of Sir Oracle upon his dry lips. Whether one agrees with him or not, nothing can be more offensive than his scornful self-sufficient manner – filliping away with his flippant abuse the careful work of three generations! As usual, he did all the talking

himself. . . . Here is a man vastly one's superior in intellect: and yet where is the grave dignity and modesty & manly reserve, without which a man can neither be truly great nor be revered? This Ruskin, courteous and kindly as he really is, makes you feel, not only in his oracular vein but even more by the demure and pharisaic condescension with which he listens to you, that he looks upon your view as wholly contemptible, and his own as simply impregnable because it is his own. Every honourable and intelligent man must resent such conduct; and the more deeply, because he would fain admire and respect. Those who only know Ruskin in the beauty & worth of his books, had better look no further: the doubts of his virility, and his appearance which confirms them, are alone sufficient to make one feel strangely in his presence. . . .'
Munby, Man of Two Worlds: The Life and Diaries of Arthur J. Munby 1828–1910 (1972), ed. by Derek Hudson, pp. 82–3

'[22 October 1857] At Common Room breakfast met, for the first time, John Ruskin. I had a little conversation with him, but not enough to bring out anything characteristic or striking in him. His appearance was rather disappointing – a general feebleness of expression, with no commanding air, or any external signs of deep thought, as one would have expected to see in such a man.'
Lewis Carroll, *Diaries* (1953), ed. by Roger Lancelyn Green, Vol. 1, pp. 128–9

'Ruskin had many curious characteristics, and it was by no means a bed of roses, living with him. Although extremely kind and generous to a fault, in some ways, he could be just the opposite. No one dared contradict him on any subject without his flying into a passion. What he liked was absolute obedience and in return he would pet and flatter. His ideal was a "kind feudal system", everyone round him willing to help, to obey and to love him. To all such he would be kind and helpful, but woe betide the man or woman who ventured to differ or put him right. Of course a pretty girl could do it a little and it amused him, but hardly any other kind of human being. I did more than any other man in sticking well up to him now and then, but it required courage, and I think he took it from me better than he would from other people. Of course I was very careful to be on the right side and this is not very difficult when dealing with an overwrought and excited brain, as his often was. . . . The only occasions he would condescend to look at a game was when there were some pretty girls playing at it. Once when I was playing tennis with two very bright and pretty specimens, one dark, the other very fair, he came to look on, of course only at them,

[330]

or rather to watch them. This so put them off that at last I asked him to go away. At this he got very cross and went. . . . In the evening I said, "Well Professor, could you see anything in the game?" "What especially struck me," said he, "was that the net seemed always in the way!"'
The Professor: Arthur Severn's Memoir of John Ruskin (1967), ed. by James S. Dearden, pp. 94, 97

'[5 March 1884] Mr. Ruskin [at the Royal Academy] was one of the most ridiculous figures I have seen. A very old hat, much necktie and aged coat buttoned up to his neck, humpbacked, not particularly clean looking. He had on high boots, and one of his trousers was tucked up on the top of one. He became aware of this half way round the room, and stood on one leg to put it right, but in so doing hitched up the other trouser worse than the first one had been.'
The Journal of Beatrix Potter from 1881 to 1897 (1966), ed. by Leslie Linder, p. 70

'Except for a few glimpses, John Ruskin was but an unknown power to me, mostly for good. Once, as I was passing the National Gallery from the West, I saw him approaching along the wide sidewalk. A soft brown hat, brownish clothes, well worn, a drifting brownish beard and vague, forlorn eyes that fixed upon nothing. He drifted from one to the other side of the way, like a blown autumn leaf, astray in a lamentable place.'
Julian Hawthorne, *Shapes that Pass* (1928), pp. 237–8

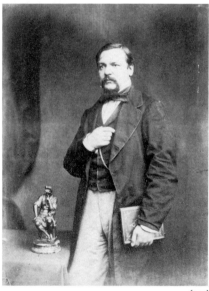

[331]

GEORGE AUGUSTUS SALA (1828–96)

A many-sided man, he learnt to draw at an early age, becoming an illustrator, theatrical scene painter, writer, journalist and art critic on the *Daily Telegraph* for at least thirty-four years.

331 Albumen print by Charles Watkins, London, 200 × 150 mm, *c.* 1860.
Author's collection

'He was of good height, with broad shoulders and a jolly waistcoat, which was always white,

in my recollection, or at least aspired to be so. His spacious trousers were of a black and white check pattern – a small check, which may have come into vogue about 1860, and to which (if he didn't invent it) George Augustus was faithful ever after. There was the gleam of a gold chain across the cheery equatorial protuberance, and in the outer pocket lurked a radiant watch. . . . For all his easygoing, he cultivated a journalistic punctuality, and with a whisk of the right hand and a momentary indrawing of the abdomen would drag forth the timepiece and take his bearings. His coat, wide-skirted, was of black broadcloth, and it floated wide to right and left; there may have been an era, in his younger and leaner years, when it might have been buttoned up round a gallant waist; but his fuller growth ignored buttons, and in hours of friendly relaxation amid boon companions he might even slip out a button or so of the waistcoat, though his habit was never slovenly. . . . The stand-up collar was roomy, to give space for the heroic throat: Gargantuan it was, a sluice-way for potations joyously welcomed – though it must not be inferred that the man was of a tipsy disposition; he respected time and reason, and save on the right occasion and in fitting company would never exceed reasonable limits.'

Julian Hawthorne, *Shapes that Pass* (1928), pp. 329–31

SIR GEORGE SCHARF, FSA (1820–95)

Son of a George Scharf, a German draughtsman who lived in England. Art lecturer and writer, mostly on the subject of portraiture. Became First Secretary of the National Portrait Gallery in 1857; made Director in 1882. Knighted in 1895.

332 Albumen print by Ernest Edwards, 90 × 70 mm, published in *Portraits of Men of Eminence* (1867) by A. W. Bennett, Vol. 6, p. 49. *Author's collection*

'[21 January 1859] Mr. Scharf dined with my uncle Henry and myself at the University Club. I found him a very intelligent, well-informed man, nearly bald, slightly gray, wearing spectacles. Mr. Scharf is evidently very fond of a joke, no matter how highly coloured (blue).'

A Mid-Victorian Pepys: The Letters and Memoirs of Sir William Hardiman (1923), ed. by S. M. Ellis, p. 1.

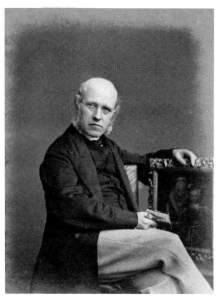

[332]

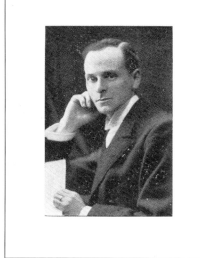

[333]

MARION HARRY (ALEXANDER) SPIELMANN, FSA (1858–1948)

One of the most prolific writers on art of his day. Editor of the *Magazine of Art* from 1887 to 1904. At various times art critic of the *Pall Mall Gazette*, the *Graphic*, the *Morning Leader* and the *Daily Graphic*.

333 Photograph reproduced in the *Magazine of Art* (1899)

'The slim, agile figure of the Art Critic, M. H. Spielmann, glided about more gracefully than any of the waltzers. One could see that he was master of movement and measure as well as being an authority on painting and sculpture.'

Allan Fea, *Recollections of Sixty Years* (1927), p. 209

FREDERIC GEORGE STEPHENS (1828–1907)

See also Plate 227.

334 Carbon print by Frederick Hollyer (q.v.), *c.* 1892. *Royal Photographic Society*

335 Silver bromide on postcard, with Christmas greetings from the Stephenses on the reverse, *c.* 1895, and showing Mr and Mrs Stephens at their home in Hammersmith, London. Above the mantelshelf is a mounted photograph of *Proclaiming Claudius Emperor* (1871) by L. Alma-Tadema (q.v.). Bottom right is an engraving or photograph of *The Alba Madonna* by Raphael. The convex mirror on the wall is reminiscent of the Arnolfini double portrait by Jan van Eyck (National Gallery, London). From the collection of the Linnell family. *Author's collection*

'He wore his hair very long, and was usually attired in a wide "artistic" hat and cloak, while his wife, in an old-fashioned bonnet and shawl, accompanied him and looked after him in a manner touching to behold. He was very lame and plain, and we, as young people, looked upon him as the old gentleman himself, and believed the lameness came from an ill-concealed cloven hoof.'

Mrs Panton, *Leaves from a Life* (1908), pp. 171–2

'He has invented a series of phrases to apply to pictures, painters, and art subjects in general, which are absolutely excruciating in their combination of uselessness, affectation, and incomprehensibility. Sarcasm, abuse, ridicule, remonstrance, and entreaty have been directed against him in vain – nothing and nobody – not even his editor – will, or can induce him to write words which are "understood of the people". If in the dimmest vista of the future he can see the gleam of a lengthy epithet peculiarly inappropriate to his sentence, he will "go for it", as quickly as Artemus Ward for the historical "*taller* candle". The longer, the more foreign, and the more incomprehensible that word is, the better he will be pleased. He revels verbally in "yellow carnations", luxuriates in the "morbidezza of the chiaroscuro", takes a refreshing dip in iridescent luminosity, and completes his sempiternal polysyllabic meanderings with every pedagogic synonym he can find in the dictionary. Is it not permissible to "gently hate and mildly abominate" such a persistent "*deranger* of epitaphs"?'

Harry Quilter, *Preferences in Life and Art* (1892), p. 64

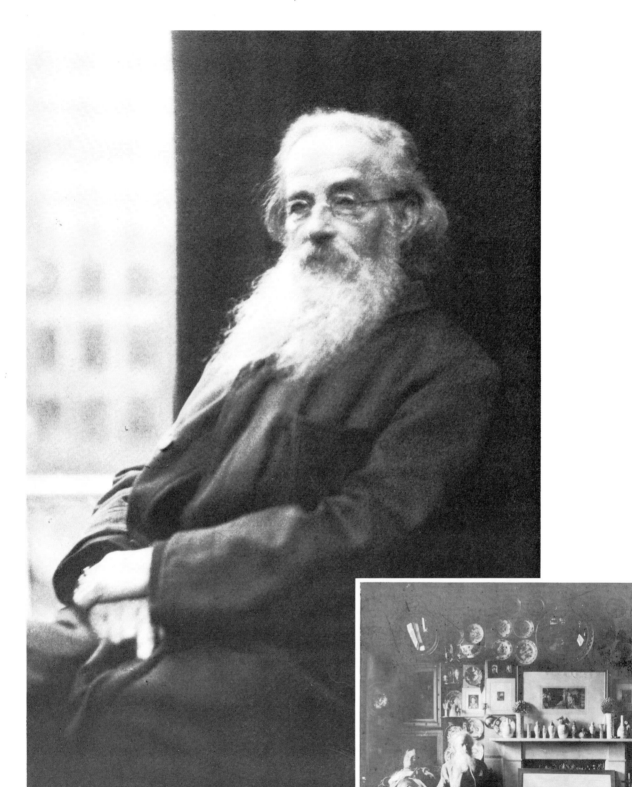

[334]

[335]

[336]

TOM TAYLOR (1817–80)

Dramatist and editor of *Punch*. He was a friend of artists, a writer on art, and frequently reviewed art exhibitions for the national press.

337 *Carte-de-visite*, albumen print by the London Stereoscopic & Photographic Company. *Author's collection*

'At dinner his appearance was remarkable, for he usually wore a black velvet evening suit. A curious trait ... was his absent-minded manner and forgetfulness of convention. Sometimes when walking in the street with a friend he would grow interested, and, to emphasise his remarks, turned to look more directly into the face of his companion, at the same time placing his arm around his waist. In the case of a lady this habit sometimes proved rather embarrassing!

'Mr. Tom Taylor was a man of unbounded kindness in helping everybody who was in need for money or in trouble; his generosity probably made him the object of attentions from all sorts and conditions of people, a fact very soon discovered by his domestics, for one day Mr. and Mrs. Taylor returned from a walk to be met by a startled parlourmaid who announced the presence of a strange-looking man who was waiting to see them. Her suspicions being aroused by his wild appearance, she had shown him into the pantry, fearing to leave him in the drawing-room. On repairing to the pantry with curiosity not unmixed with wonder, they discovered ... Tennyson ... quite at home and immensely tickled by his situation.'

Leslie Ward, *Forty Years of 'Spy'* (1915), p. 57

ANNA MARIA WILHELMINA STIRLING
(née Pickering) (?–1965)

Writer and niece of Roddam Spencer Stanhope (q.v.) and sister of Evelyn De Morgan (q.v.). Wrote mostly novels in the nineteenth century, but in the early years of this century she wrote several useful books on artists, including the De Morgans, members of the Richmond family, etc. For many years she looked after the collection at Old Battersea House. She married Charles G. Stirling in 1901.

336 Silver bromide by an unidentified photographer, 53 × 103 × 82 mm. Inscribed on the reverse: 'Charles & Wilhelmina Stirling, 30 Launceston Place, Kensington, W.8.'. They lived at this address from 1904 to 1932. *Author's collection*

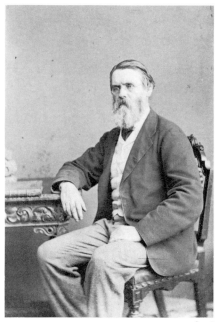

[337]

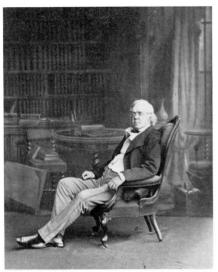

[338]

WILLIAM MAKEPEACE THACKERAY (1811–63)

Novelist, essayist, writer on art and illustrator. Wrote some lively and perceptive art reviews for *Fraser's Magazine* in the 1840s.

338 Albumen print by Ernest Edwards, 87 × 67 mm, published in *Portraits of Men of Eminence*, (1863), by A. W. Bennett, Vol. 1. Everything in the photograph, except the chair Thackeray sits in, is painted on a backdrop. A writer in the *Magazine of Art* (1891), discussing photographs of Thackeray, singled out this photograph of 'Thackeray in his Study' and quotes his friend Edward Fitz-Gerald as saying that he is seen 'old, white, massive and melancholy'. *Author's collection*

'Mr Thackeray's face is bloodless and not particularly expressive, but notable for the fracture of the bridge of his nose. . . . His bearing is cold and uninviting; his style of conversation either openly cynical or affectedly good-natured and benevolent; his *bonhomie* is forced; his wit biting; his pride easily touched. . . .'
Edmund Yates in *The Garrick Club* (1964), by Guy Boas, p. 36

SIR HENRY THOMPSON, BT (1820–1904)

Eminent surgeon and friend of artists, with an exceptionally wide range of interests, including astronomy and the collecting of porcelain; he was a pioneer of cremation, an authority on diet and a man of letters. Studied painting under Alfred Elmore (q.v.) and Alma-Tadema (q.v.). Exhibited pictures at the Royal Academy and elsewhere from 1865 to 1901. As a host he was famous for his 'octaves', dinners of eight courses for eight people at eight o'clock.

(See 'The Four Pilgrims', Plate 25.)

SIR RICHARD WALLACE, BT (1818–90)

Connoisseur and collector of works of art. Inherited Hertford House, London, from his father, the 4th Marquess of Hertford (q.v.), in 1870. Created baronet in 1871. The collection was bequeathed to the nation by his widow in 1897, and has been known since as the Wallace Collection.

(See Plate 321.)

GLEESON WHITE (1851–98)

Book decorator, editor and writer on art. He was the first editor of the *Studio*, 1893–4, and was closely involved with the Arts and Crafts movement.

339 Carbon print by Frederick Hollyer (q.v.), *c*. 1897. Hollyer considered this to be among his best portraits. *Royal Photographic Society*

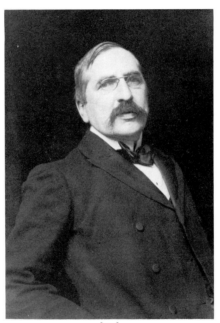

[339]

OSCAR WILDE (1854–1900)

Playwright, essayist and novelist, much preoccupied by the role of the artist in society. It is not generally known that he wrote occasional pieces in various magazines on art, artists and exhibitions. His most complete review is of the Royal Academy exhibition in 1887 in *Court and Society Review*, IV: 147 (27 April). It is better known that he enjoyed sparring publicly with Whistler (q.v.), his equal in wit.

340 Cabinet portrait, carbon print by W. & D. Downey, London, 1891, published in *The Cabinet Portrait Gallery* (1891), 2nd series.

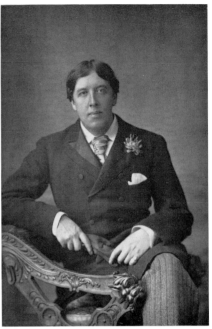

[340]

'Picture a tall, broad, thick-set, slow-moving man, inclined to corpulence; with a large bloodless coarse-skinned face, clean-shaven at a time when moustaches were in vogue, a powerful well-shaped nose, thick purple-tinged sensual lips, long crowded uneven discoloured teeth, fleshy cheeks, heavy jaw, firm mouth, fine brow, long dark carefully-waved hair, and expressive heavy-lidded eyes. . . . His hands were fat and flabby; his handshake lacked grip, and at a first encounter one recoiled from its plushy limpness, but this aversion was soon overcome when he began to talk, for his genuine kindliness and desire to please made one forget what was unpleasant in his physical appearance and contact, gave charm to his manners, and grace to his precision of speech. The first sight of him affected people in various ways. Some could hardly restrain their laughter, others felt hostile, a few were afflicted with "the creeps", many were conscious of being uneasy; but except for a small minority who could never recover from the first sensation of distaste and so kept out of his way, both sexes found him irresistible, and to the young men of his time, says W. B. Yeats, "he was like a triumphant and audacious figure from another age".'
Hesketh Pearson, *The Life of Oscar Wilde* (1946), p. 162

— 13 —
MODELS, MISTRESSES, WIVES & CHILDREN

ARTISTS in their reminiscences have a lot to say about their models, often devoting a whole chapter to them; very little indeed to say about their wives; slightly more about their children; and, of course, nothing whatsoever about their mistresses, if any. However, artists are usually believed by the rest of society to live, by normally acceptable standards, rather disorderly lives, and are even granted a degree of tolerance in matters of domestic morality.

Of course it need hardly be said that the Victorians in their letters and memoirs gave very little away concerning any marital difficulties. How would any of the readers of Frith's bland and entertaining three-volume reminiscences have guessed that beneath the surface lay a very different story? For Frith led a double life. Indeed, this seems to have been a particular speciality of this age – the poet, barrister and friend of artists, Arthur Munby, had been married to his maidservant for over a quarter of a century without any member of his family being aware of it, until it emerged during the reading of his will. So, until the lives of artists are subjected to the scrutiny of modern scholarship, we shall have to accept their own memoirs and their biographical treatment by their contemporaries at face value; with mental reservations!

However, I strongly suspect that, at the end of the day, the cupboards will prove to have contained fewer skeletons than might have been expected, and that most Victorian artists will be found to have led lives of comparative rectitude and virtue. Just as in their photographic portraits many appear little different from barristers, scientists or businessmen, so their marital affairs will, I believe, be found to be very much the same as those in other callings.

Among those who married and, so far as can be ascertained, sustained their marital state were C. W. Cope (who painted several charming pictures of his family); Edward Armitage, happy but childless; Holman Hunt and Alma-Tadema, both of whose first wives died, but who both remarried; Fredrick Goodall; E. M. Ward, whose wife was also a painter (their son was the portrait caricaturist Leslie Ward, better known as 'Spy'); W. H. Hunt (in spite of his misgivings concerning his woeful appearance); G. A. Storey; P. H. Calderon; Samuel Palmer, who married Hannah, the daughter of John Linnell, and who had altogether nine children; the battle painter Lady Butler, wife of a general; J. W. Waterhouse; and Edward Poynter and Edward Burne-Jones, who each married one of the remarkable daughters of the Rev. George Macdonald. (A third sister married John Kipling, father of Rudyard, and a fourth married Alfred Baldwin, MP, their son Stanley becoming Prime Minister.)

Those who never married included Frederic Leighton; Edwin Landseer, who was once playfully urged to marry the French animal painter Rosa Bonheur, who also never married; the two painters of nudes Frost and Etty; Richard Dadd, prevented in any case by insanity; Daniel Maclise; Frederick Walker, who was 'married' to his cat Eel-eye, which achieved fame as model for the kitten on the cradle in Millais's picture *The Flood*; James Collinson, who became engaged to Christina Rossetti, although in the event neither married the other nor anyone else; Charles Keene; Sir John Gilbert, who was probably too mean, although he was in continual demand as godfather to the numerous progeny of fellow artists; W. J. Müller who, like the bachelor Edward Lear, spent much of his time abroad travelling; Richard Doyle, whose field was limited by his Catholicism; and Simeon Solomon, a homosexual reprobate.

Three of the better-known female artists remained single: Marianne North, Lucy Kemp-Welch and Kate Greenaway. Others married men well-known in other occupations: Marie Spartali an American journalist, W. J. Stillman; Helen Allingham the poet William Allingham. Rossetti's wife, Lizzie Siddal, had her own special achievement as an artist; Mrs E. M. Ward's fame as a painter was equal to that of her husband; while Henrietta Rae's exceeded that of her husband Ernest Normand. The most famous actress of her time, Ellen Terry, had been for a short time the child-wife of G. F. Watts, and Georgiana Burne-Jones is widely known as her husband's memorialist. Effie Gray achieved notoriety by obtaining an annulment of her first marriage to John Ruskin and then marrying his protégé John Everett Millais in a blaze of publicity, with everyone taking sides. Lady Eastlake, the formidable literary wife of Sir Charles Eastlake, took the side of Effie.

Some artists had large families, but this was common to the age, for in the early years of the period it was considered necessary to aim for five or six births to ensure two surviving children. So the birth of seven children to John Brett was a relatively modest family by the standards of the day, and John Linnell's nine children did not constitute a large family either when one considers that Edward Lear was the twentieth child of his parents. Francis Danby fathered between seven and ten children.

For sheer prodigality, however, the palm must surely go to William Powell Frith. The master of the crowded canvas was evidently at home in crowds, for not only did his wife Isabelle provide him with twelve children, but his mistress, Mary Alford, produced a further seven, making a grand total of nineteen children. As she lived only a few hundred yards from Paddington station, Frith had an excellent alibi with which to allay any suspicions on the part of Mrs Frith: for two whole years he toiled away at his great canvas *The Railway Station*, set in Paddington. Mrs Frith's suspicions were eventually aroused, however, when, during one of his long absences, she saw him in a street near their house carelessly posting a letter which told her that he was having a nice time in Brighton. Frith married Mary Alford a year and two days after the death of Isabelle.

Some of the offspring of artists achieved distinction. Madox Brown's daughter Catherine, a painter, married the German music critic Francis Hueffer and gave birth to the novelist Ford Madox Ford; his other daughter, Lucy, also a painter, married William Michael Rossetti and their daughter, Helen Rossetti Angeli, became a distinguished writer. Burne-Jones's daughter Margaret married the classical scholar J. W. Mackail; two of their children became novelists, Denis Mackail and Angela Thirkell. George Du Maurier's son became Sir Gerald Du Maurier, the famous actor-manager, and his daughter, in turn, is Dame Daphne Du Maurier, the novelist and widow of Lieut.-General Sir Frederick Browning. Holman Hunt, by marrying successively two of the Waugh sisters, became a brother-in-law of Thomas Woolner, and his granddaughter is the writer Diana Holman-Hunt, cousin of Evelyn Waugh. A son of Charles Altamonte Doyle, the fantastic illustrator and brother of Dickie Doyle, was Sir Arthur Conan Doyle.

Now for the irregularities. Scandals and mere hints of scandals abound as, in the public view of such things, is only to be expected amongst artists. One of the earliest scandals has never been satisfactorily explained: it seems that the painter Francis Danby's wife lived with a fellow artist, Paul Falconer Poole; Danby fled to Paris with his young mistress Helen Evans, seven of his children and three of hers. His exile lasted eight years and when he died in 1861, Poole married his widow. There is also a mystery in the life of William Mulready. Although he was much respected, there were certainly irregularities in his sexual relationships. An early marriage to a sister of the water-colourist John Varley foundered after only a few years, leading to recriminations, mostly from her. That they were incompatible is undeniable: she is alleged to have sneaked into his studio and altered paintings when he was away and, if she was angry, to have painted out the eyes. Amongst her highly coloured accusations was the allegation that he had taken 'a low boy' to his bed. A recent biographer suggests that the 'low boy' was none other than John Linnell, later to become a celebrated family patriarch. In the 1840s and 1850s Mulready made some beautiful paintings and drawings of the female nude, at the same time recording his advice to models that they should take caution against conversing or becoming familiar with male artists, married or otherwise. Yet on 23 September 1856 Madox Brown recorded in his diary that Holman Hunt had dilated much on the want of virtue and principle among RAs and, specifically, that Mulready 'at 70 has seduced a young model who sits for the head and has a child by her; or rather she by him'. Incidentally, the only painting that Mulready was engaged on at that moment was

The Young Brother or *Brother and Sister*, a celebrated picture showing a girl (back view) and her brother playing with a new addition to the family. The picture is at the Tate Gallery.

The same diary entry dents another reputation, previously unsullied – that of H. W. Pickersgill, the highly respected portrait painter. Hunt further regaled Brown with gossip about the 74-year-old artist: 'Old Pickersgill in his own house is found on the rug *en flagrant délit* by the maid who fell over him with the coal scuttle, his own son frequently catching him.'

It seems that only one artist was openly depraved, Simeon Solomon. His arrest on a charge of indecent behaviour in a public lavatory and subsequent misdemeanours including habitual drunkenness make sad reading. The would-be biographer of Solomon was somewhat baulked when he found that most of the information he sought was in the police records. Others were merely amorous and fickle, like Ernest Gambart, the dealer, whose third wife left him because he had 'other fancies'. Rossetti, too, was of a decidedly amorous nature: Fanny Cornforth, his housekeeper, is generally regarded as having been his mistress possibly even before the death of his wife Lizzie Siddal, and there was also the affair with Janey, wife of William Morris. Burne-Jones, his disciple and friend, confided to his studio assistants, according to one of them, T. M. Rooke, *'very slowly and in a low distinct, almost reverent voice,* "I'm *quite sure there's not a woman in the* WHOLE *world* he couldn't have won for himself. Nothing pleased him more though, than to take his friend's mistress away from him."'

'Housekeeper' was a convenient term covering a whole spectrum from someone who did exactly that and no more, to someone who was more kept than keeping; from Turner's Mrs Booth, to the artist Rosa Corder (alas, no photograph, for she was an undoubted 'stunner'). The latter was reputedly a one-time intimate of Rossetti and lived for a time with Charles Augustus Howell, with whom she copied 'certain objectionable drawings by Fuseli'. A stranger liaison was that between William Bell Scott and Alice Boyd. Scott, before marrying Letitia Norquoy in 1839, had consulted the old water-colourist John Varley, in his other capacity as an astrologer, with a view to drawing up a horoscope of his intended. Varley foretold 'a highly favourable scheme of fortune for her'. Duly encouraged, Scott married her, commenting towards the end of his life, 'after forty years, I fear that either the planets or their expositor must have made a mistake!' In

1859 he met Alice Boyd and then began 'a perfect intercourse' of thirty-one years. Mr and Mrs Scott spent every summer at Alice Boyd's house, Penkill Castle in Ayrshire, while she wintered with the Scotts in London. Scott made no secret of their relationship, which followed them to the grave, both being buried together.

The vital necessity of models to the painters of subject pictures, which comprised a very large proportion of Victorian artists, was also, from a domestic point of view, a sometimes acutely vexing one. For an artist to be cooped up for weeks at a time with a young and pretty model, to judge only from the example of Mulready, often required a strong resistance to temptation. The wife of one artist, Walter Crane, flatly refused to allow her husband to paint females, hence the androgynous appearance of his goddesses and Venuses, mostly painted from a young Italian called Alessandro di Marco. Modelling for painters was a thriving industry. During the summer months the Royal Academy Schools employed nine models who could earn up to £5 a week. Models came from all walks of life – tramps, crossing sweepers, retired soldiers, even officers and distressed gentlefolk. Sometimes modelling was a family business, where one started young and posed well into old age.

Italians were a favourite source of models and especially suited the ideal pictures of painters like Leighton, William Blake Richmond and Henry Holiday. Alessandro di Marco, of noble aspect, was a particular favourite as was Gaetano Meo, an Italian of Greek extraction who sat to Burne-Jones, Frank Dicksee, Richmond, Holiday and others. A slim Italian girl named Antonia Cura was a favourite with Leighton and Burne-Jones, who made hundreds of drawings of her. Many of these Italians fled to England from the studios of Paris during the Franco-Prussian War.

In addition to the professional models, there were members of artists' families and friends who were continually pressed into sitting for pictures. Many an artist, Rossetti in particular, would chase after women in the street if they had exactly the right features to suit their style or a particular picture. Church congregations were often a happy hunting-ground for Pre-Raphaelite painters, with the leisurely exit from church providing ample scope for an introduction. Even the prudish J. C. Horsley was not above this kind of approach. In 'deep waters over a picture', he once saw a young woman with 'exactly the face and expression I was wanting', pursued her down the street and persuaded her, with no apparent difficulty, to sit. The

theatre and music hall also provided a further source of models, like Louisa Ruth Herbert, used by such diverse artists as Rossetti and Frith. The latter got her to pose, unsuccessfully, for *The Derby Day*, but later substituted one of his daughters for her. He had much to say on the subject of models, particularly in connection with that picture. Needing acrobats for the figures in the foreground, he found exactly what he wanted, a father and small son, at the Drury Lane pantomime. The boy's idea of posing was to throw continual somersaults, to the peril of casts and draperies. One of the models, called Bishop, was a favourite of Edwin Landseer, but although a fine sitter, he could not pass a public house without going into it, often forgetting his engagements with Frith. Most remarkably, Jacob Bell, the pharmacist who had commissioned *The Derby Day*, displayed an unexpected talent for providing an unending stream of pretty models for the artist. 'What is it to be this time?' he would ask. 'Fair or dark, long nose or short nose, Roman or aquiline, tall figure or small? Give your orders.' 'The order was given,' wrote Frith, 'and obeyed in a manner that perfectly astonished me. I owe every female figure in the *Derby Day*, except two or three, to the foraging of my employer.'

ANNA ALMA-TADEMA (1867–1943)

Painter. Daughter of Sir Lawrence Alma-Tadema (q.v.) and his first wife Marie Pauline (née Cressin). Never married and died in relative obscurity and poverty.

341 Photograph by Robert Faulkner & Co., London, oval, 137 × 113 mm, *c.* 1875. *Dr Vern Swanson*

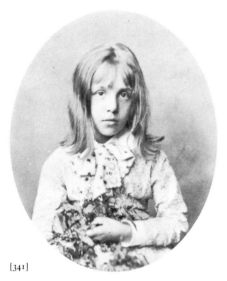

[341]

LAURENCE ALMA-TADEMA (1864–1940)

Writer. Daughter of Sir Lawrence Alma-Tadema (q.v.) and his first wife Marie Pauline (née Cressin). Like her sister, Anna, she died in relative obscurity and poverty.

342 Photograph, circular, 101 mm in diameter. *Dr Vern Swanson*

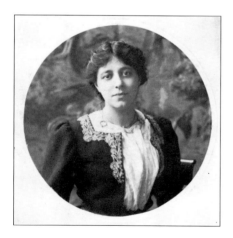

LADY BURNE-JONES (née Georgiana MacDonald) (1840–1920)

Married Sir Edward Burne-Jones (q.v.) on 9 June 1860. One sister married Sir Edward Poynter (q.v.) and two others became the mothers of Rudyard Kipling and Stanley Baldwin.

343 Photogravure, 113 × 90 mm, after a photograph by an unidentified photographer. Taken in 1856, reproduced in *Memorials of Edward Burne-Jones* (1904), by Georgiana Burne-Jones, Vol. 1, p. 134

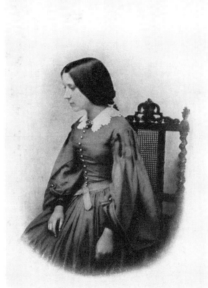

[343]

344 Photograph of the children of Burne-Jones and William Morris. Morris's daughters, May (q.v.) and Jenny, are in the centre. To the left and right are Margaret and Philip Burne-Jones. This photograph belonged to the Rossetti family. *Mrs Imogen Dennis*

'Out through the window I was led, across a lawn to where under a big mulberry-tree sat a tiny lady: as she turned to receive me I met her eyes and became aware of a great personality. The quiet in those wonderful eyes of clearest grey was, I knew, the centre of the strange stillness that lay upon the place, yet beneath and beyond could be sensed an Energy, dominant, flame-like. Eyes like those of Georgiana Burne-Jones I have never seen before or since.'
W. Graham Robertson, *Time Was* (1931), pp. 74–5

THOMAS CARLYLE (1795–1881)

Essayist and historian. Largely scornful of art and artists, particularly portraitists, although he was one of the most photographed and painted figures of his age. See also Plate 196.

345 Photograph by an unidentified photographer. Madox Brown (q.v.), despairing of ever getting Carlyle to sit for his great picture *Work*, had him photographed, probably in 1858. *Birmingham City Art Gallery*

'His face, despite a shade of rickety joylessness, was one of the noblest I had ever seen. His large-orbited blue eyes, deep sunk, had upper lids drooping over the iris, the lower

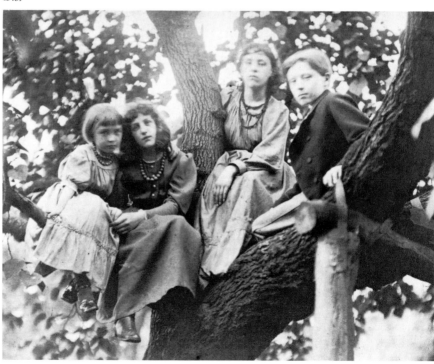

[344]

lid occasionally leaving bare the white below. The brow was prominent, the cranium domed and large, the hair shaggy. His nose and the lower part of his face were of harmonious grandeur, and his figure, when unbent, had a dignity of its own. A trait of weakness revealed itself in the meagreness of his neck, and this want of robust development was accentuated by a slight twist of the spine. His

voice reached the treble when he wished to discourage interruption at the melancholy tone of his philosophy. Following his talk was like listening to the pages of one of his own books. . . . Like all great men I have ever known, he indulged in no pomposity.'

William Holman Hunt, *Pre-Raphaelitism and the Pre-Raphaelite Brotherhood* (2nd edition, 1913), Vol. 1, p. 258

PHOEBE ('EFFIE') COOKSON (née Newall) (1853–?)

Daughter of Robert Stirling Newall (1812–89) and Mary Newall (née Pattinson). Newall was an engineer, scientist and patron of artists. Henry Holiday (q.v.), on a second visit to Newall in April 1871, made sketches of the moon through his 25-inch telescope. Effie Newall married Norman Cookson in February 1873.

346 Albumen print by Henry Holiday, 138 × 100 mm, taken in April 1871. Holiday had been much taken by Effie Newall's beauty when he was shown photographs of her on his first visit to the Newalls in Northumberland

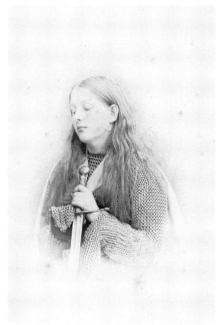

[346]

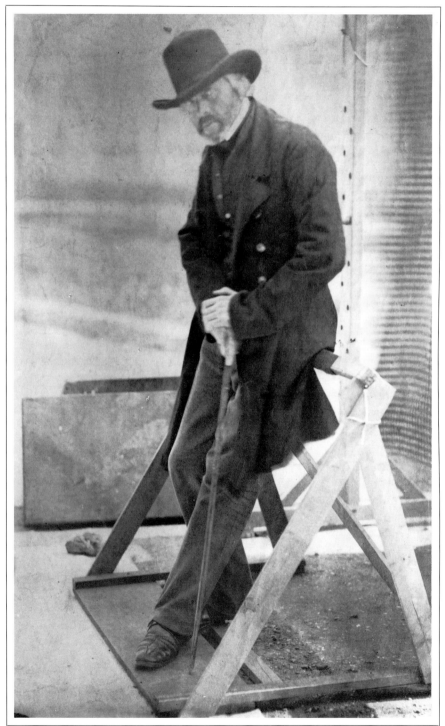

in 1870. On his second visit in 1871 Holiday made drawings of Effie and dressed her up in his chain-mail. In his *Reminiscences* (1914), pp. 172–3, Holiday recalled that Mrs Newall wanted Effie to be painted by G. F. Watts (q.v.), who normally only painted people of his own choosing; however, when Holiday showed him a portrait of her, Watts 'caved in at once and said it was irresistible . . . and painted a delightful [oil] portrait of her' (private collection, England). Holiday, like his friend Charles Dodgson (Lewis Carroll), was inordinately attracted to pretty young girls, particularly, in Holiday's case, if they could be induced to wear his chain-mail. In 1875, when Dodgson was staying with him, Marion Terry, the actress, sat to the photographer in the same chain-mail, while Holiday 'drew her lying on the lawn in the same' (reproduced in his *Reminiscences*, p. 244). From the collection of Henry Holiday. *Author's collection*

[345]

347 Albumen print by Henry Holiday, 143 × 97 mm, taken in April 1871. Drawing-pin holes at the top of the cards on which both these photographs are mounted suggest that Holiday pinned them to his easel as an aid to drawing Effie Newall. From the collection of Henry Holiday. *Author's collection*

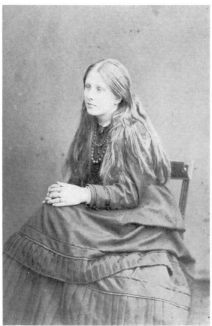

[347]

[349]

FANNY CORNFORTH
(1824–1906)

Model, mistress and housekeeper to D.G. Rossetti from about 1858 until his death.

348 Albumen print by W. & D. Downey, 153 × 133 mm. Taken in 1863 in the garden of Rossetti's Chelsea house. She stands in front of a looking-glass. *Author's collection*

349 *Carte-de-visite*, albumen print by L. Pierson, Paris. *Delaware Art Museum, USA*

'One who must have had some overpowering attractions for [Rossetti was Fanny Cornforth], although I could never see what they were. He met her in the Strand. She was cracking nuts with her teeth, and throwing the shells about, seeing Rossetti staring at her, she threw some at him. Delighted with this brilliant *naïvete*, he forthwith accosted her, and carried her off to sit to him for her portrait.'

William Bell Scott, *Autobiographical Notes* (1892), Vol. 1, pp. 316–17

DOROTHY DENE (properly Ada Alice
Pullan) (1859–99)

Dorothy, a beautiful but indifferent actress, became a favourite model of Leighton (q.v.), posing for some of his most celebrated pictures, notably *Flaming June*, *The Bath of Psyche* and *The Garden of the Hesperides*. She was painted by G. F. Watts (q.v.) as well. Three of her sisters, Edith Ellen (1865–?), Henrietta Sarah (Hetty) (1867–?) and Isabell Helena (Lena) (1873–?), also posed for Leighton. Their father, Abraham, deserted his family, and their mother, Sarah, died in 1881.

350 Silver print by an unidentified photographer, 139 × 94 mm, *c.* 1890. Dorothy is on the left. With her are three of her four surviving sisters (a fifth died young): Edith (top), whose right and left profiles are seen in mirrors, Kathleen Blanch (b. 1871) (right), and Lena (bottom). *Author's collection*

'[Dorothy Dene's complexion had] a clouded pallor, with a hint somewhere of a lovely shell-like pink.'
Mrs Russell Barrington, *G. F. Watts* (1905), p. 88

[348]

[350]

ADA FORESTIER-WALKER (née Mansel) (1880–1960)

351 Gelatine silver print by an unidentified photographer, 76 × 104 mm, taken in about 1916. Ada Forestier-Walker was drawn by Henry Holiday, and she posed for one of his last paintings, *Beatrice on the Lung 'Arno* (1921). Holiday kept up a long correspondence with her, in which it is clear that the artist was infatuated by the young woman: he always addressed her as 'My dear Beatrice' or 'My only Beatrice'. She is seen here wearing the costume of Beatrice which was used for Holiday's celebrated picture, *Dante and Beatrice* (1883). With her is the artist and an unidentified man wearing the clothes of Dante, used for the same picture. Dante and Beatrice are shown dressed for a *tableau vivant* related to one of Holiday's many interests, which was dress reform; he was for a while President of The Healthy and Artistic Dress Union, and he is seen in the photograph dressed, he believed, in a manner which befitted his profession; a self-portrait drawing in which he is dressed exactly as in the photograph is reproduced in his *Reminiscences* (1914), p. 451. From the collection of Henry Holiday (q.v.). *Author's collection*

CONNIE (CONSTANCE) GILCHRIST (afterwards 7th Countess of Orkney) (1865–1946)

Celebrated skipping-rope dancer of the Gaiety Theatre, who modelled for Lord Leighton (q.v.) and Whistler (q.v.). She married the 7th Earl of Orkney in 1892.

352 Albumen print by an unidentified photographer, 90 × 59 mm, *c.* 1885. *Author's collection*

[351]

[352]

'[One fellow] remembered the graceful Connie in short frocks, and hair down her back, promenading the vicinity of Camden Town, like some pretty fairy escaped from a Christmas story-book. The perfect, natural symmetry of her bearing was manifest even to the most unobservant.'
Allan Fea, *Recollections of Sixty Years* (1927), p. 182

'[13 January 1877] . . . one of the most beautiful children, in face and figure, that I have ever seen: I must get an opportunity of photographing her.'
Lewis Carroll, *Diaries* (1953), ed. by Roger Lancelyn Green, Vol. 2, p. 359

LOUISA RUTH HERBERT (*c.* 1832–1921)

Posed for Rossetti (q.v.) for about a year. She also posed for Frith's *Derby Day* until she was replaced by his daughter. She was an actress, and in the play-bills of the time she appears invariably as Louisa Herbert; Rossetti called her Ruth. She married an Edward Crabb in 1855, but in 1858, according to G. P. Boyce (q.v.), she was no longer living with him.

353 *Carte-de-visite*, albumen print. *Mrs Virginia Surtees*

'Blackfriars Bridge [1858] . . . I am in the stunning position this morning of expecting the actual visit, at ½ past 11, of a model whom I have been longing to paint for years – Miss Herbert of the Olympic Theatre – who has the most varied and highest expression I ever

saw in a woman's face, besides abundant beauty, golden hair etc. Did you ever see her? O my eye! she has sat to me now and will sit to me for Mary Magdalene in the picture I am beginning. Such luck! So I must finish and get my things in order for work.'
D. G. Rossetti in a letter to W. B. Scott in *The Paintings and Drawings of Dante Gabriel Rossetti: A Catalogue Raisonné* (1971), by Virginia Surtees, Vol. 1, p. 64

MRS CHARLES (KITTY) AUGUSTUS HOWELL (née Howell) (?–1888)

Kitty (or Kate) was the cousin of Howell (q.v.). They were married on 21 August 1867; Madox Brown's two daughters were bridesmaids.

354 *Carte-de-visite*, albumen print by Silvy, London. From the collections successively of D. G. Rossetti (q.v.) and W. M. Rossetti (q.v.). Inscribed in W. M. Rossetti's hand: '? Kate Howell'. Mrs Howell was a noted beauty, and comparison with a portrait drawing by Rossetti leaves no doubt that this is a photograph of her. *Mrs Imogen Dennis*

'His popular and amiable wife. . . . With her good sense and composed manner, she acted as a foil to [her husband's] buoyant and restless temperament.'
Helen Rossetti Angeli, *Pre-Raphaelite Twilight: The Story of Charles Augustus Howell* (1954), pp. 23, 212

CATHERINE (CATHY) HUEFFER (née Madox Brown) (1850–1927)

Portrait and subject painter. Second daughter of Ford Madox Brown (q.v.) by his second wife Emma Hill. In 1872 she married Francis Hueffer (1845–89), a German music critic who had settled in England. Their son became a famous writer as Ford Madox Ford.

355 *Carte-de-visite*, albumen photograph by Crellin, London, *c.* 1870. From the Rossetti family collection. *Mrs Imogen Dennis*

[355]

EDITH HOLMAN HUNT (née Waugh) (1846–1931)

Younger sister of Fanny (q.v.), Holman Hunt's first wife, who died in 1866. Edith married Hunt (q.v.) in 1875 in Neufchâtel, to evade the Deceased Wife's Sister Act. Their two children, Gladys and Hilary, were often sketched by Hunt. Edith was the model for the Virgin in *The Triumph of the Innocents*.

356 *Carte-de-visite*, albumen print by Elliott & Fry, London. From the Rossetti family collection. *Mrs Imogen Dennis*

357 Snapshot, 252 × 80 mm, from an album compiled by Holman Hunt's son Cyril. Edith is in the dining-room of Sonning Acre, Sonning-on-Thames, which Hunt himself built in 1901. *Author's collection*

W. G. Menzies, a reporter on the *Daily Mail*, had been assigned to obtain an authoritative pronouncement from Holman Hunt concerning rumours that owing to poor health and failing eyesight, much of the work on at least one of the replicas of *The Light of the World* had been done by a pupil: 'It was a delicate

Miss Herbert.

[353]

[354]

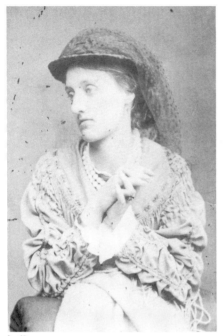

[356]

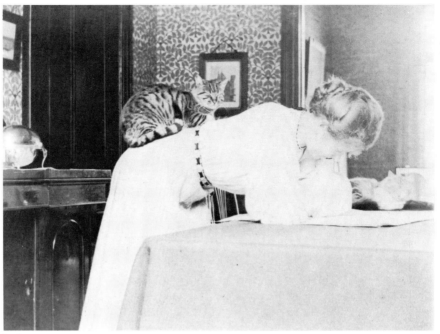

[357]

mission, and Menzies had no great hopes of a favourable reception. He was received by a tall, dour-looking woman, who apologized for her husband's non-appearance, saying that he was too ill to receive visitors. Could she act in his place? Gingerly Menzies explained the purpose of his call, only to receive the following terse reply, "Get out of the house!", an invitation which he did not wait to hear repeated. And to this day he cannot say whether, with the same inquiry to make, anybody else would have fared better at the good lady's hands.'

Bernard Falk, *Five Years Dead* (1937), p. 82

FANNY HOLMAN HUNT (née Waugh) (1833–66)

First wife of Holman Hunt (q.v.) and daughter of George Waugh. She married in 1865, and died in Florence having given birth to a son, Cyril, in 1866. Her sister Edith (q.v.) became Hunt's second wife, and her third sister married Thomas Woolner, the sculptor (q.v.).

358 *Carte-de-visite*, albumen print by Elliott & Fry, London, taken shortly before her marriage to Holman Hunt in December 1865. In a letter to Mrs Tennyson dated 29 November 1865, Hunt tells of his engagement to Fanny Waugh and encloses a photograph of her – probably this one – by Elliott & Fry, as well as one of himself (letter now at the Tennyson Research Centre, Lincoln Public Library). (See Plate 195.) Hunt painted a portrait of her, finished in 1868, based on this photograph. This *carte* (probably the only known one of

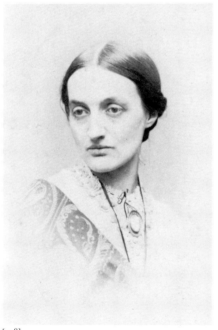

[358]

[359]

Fanny) was placed side by side with Plate 195 (Holman Hunt) in a *carte-de-visite* album by a member of the family of Robert Whitehead, who invented the Whitehead torpedo in 1866 for the Austrian navy at Fiume, Italy. The Hunts were in Italy at the time.
Author's collection

MRS WILLIAM HENRY HUNT (née Sarah Holloway) (c. 1812–57)

Sarah was the daughter of William Hunt's mother's sister. F. G. Stephens (q.v.) wrote

that Hunt (q.v.) had complained sadly that he could not find anyone who would have him, adding, 'What a sad thing it is to be so deformed and miserable looking'. Sarah and William were married on 13 September 1830. Two years later their only child, Emma, was born. Both mother and daughter became favourite models of the artist.

359 *Carte-de-visite*, albumen print by W. Jeffrey, London. The only known photograph of Mrs Hunt, recently found in an album of the artist's drawings. *Author's collection*

LILLIE LANGTRY (properly Emilie Charlotte, née Le Breton) (1853–1929)

Actress and famous beauty. Her sobriquet, 'The Jersey Lily', originated with the title of Millais's celebrated portrait of her. Her fame also spread through the reproduction of the crayon portraits of Frank Miles (1852–91).

360 Albumen print by an unidentified photographer, 124 × 96 mm. She is dressed for a stage role. *Author's collection*

'Her rich brown hair, her large eyes, violet coloured, her shoulders, the poise of her head – these perhaps were her points. Mrs Langtry's conversation did not seem remarkable – but had it the very slightest occasion to be?'
Frederick Wedmore, *Memories* (1912), p. 85

[360]

LADY MILLAIS (Effie, née Euphemia Chalmers Gray) (1828–98)

She first married John Ruskin (q.v.) in 1848. The marriage was a failure and was annulled in 1855, after she and Millais (q.v.) had fallen in love. She married Millais in July 1855. She posed for several of his pictures both before and after their marriage, notably *The Order of Release* (Tate Gallery). Queen Victoria refused to receive Effie at court after her marriage to Millais. When he lay dying she sent Princess Louise to ask if there was anything she could do for him. Millais replied, 'Yes, let her receive my wife.' The Queen consented. The curious irony of this is the existence in one of Queen Victoria's albums of this early *carte-de-visite*.

361 *Carte-de-visite*, albumen print by John and Charles Watkins, London. *Her Majesty The Queen*

[361]

'Effie possessed considerable physical attraction. She was tall and graceful with wavy auburn hair, heavy-lidded grey-blue eyes and a high colour. Her nose was rather long and sharp, however, and the corners of her mouth were inclined to turn downwards in repose.'
Mary Lutyens, *Apollo* (March 1968)

'Mrs Millais, when I knew her, had the remains of good features, without much amenity; she was decisive in manner and voice, brisk and rather jerky in gesture. She always wore a cap; it was not always a smart one. To myself she was uniformly kind, and I remember her with regard.'
William Michael Rossetti, *Some Reminiscences* (1906), Vol. 1, p. 70

'[1 June 1861. Millais] and his wife did a thing the other day, which ought to exclude *her* at least, from all society. Ruskin was in the middle of his lecture "on a Twig" at the Royal Institution, when these two actually came in, and sat down in a front seat before him. Poor Ruskin (and it is the first trait of human feeling I have known in him) at once turned pale and ill, and had to "hop the twig" of his discourse and retire. Now, such an act on Millais's part is atrociously mauvais goût – though he is very absent and careless; but on her part, it is about the most shameless, barbarous, and unwomanly thing that she could have done. A divorced adulteress & her paramour would not do it. . . .'
Munby, Man of Two Worlds: The Life and Diaries of Arthur J. Munby 1828–1910 (1972), ed. by Derek Hudson, p. 97

ANNIE MILLER (1835–1925)

One of the Pre-Raphaelite stunners. Discovered by Holman Hunt in a Chelsea slum, she posed for him for *The Awakening Conscience* (Tate Gallery). He paid for her education with a view to marrying her, prior to leaving for Syria. Rossetti (q.v.), however, snapped her up during Hunt's absence and she sat for him on numerous occasions. She also modelled for George Price Boyce (q.v.) who was equally enamoured of her.

362 *Carte-de-visite*, albumen print by Mayer Brothers, London. Inscribed 'Annie Miller' in the hand of W. M. Rossetti (q.v.). From the collection of D. G. Rossetti (q.v.). *Mrs Imogen Dennis*

[362]

MARY 'MAY' MORRIS (1862–1938)

Second daughter of William and Jane Morris (both q.v.).

363 *Carte-de-visite*, albumen print by Robert Faulkner & Co., London. From the collection of D. G. Rossetti (q.v.). *Mrs Imogen Dennis*

'At May's death in 1938, Sir Sydney Cockerell wrote: "I first met her, a beautiful girl of 23, in 1885 . . . with many excellent qualities she combined a dissatisfied attitude on life which interfered greatly with her happiness and with that of others." Later he added: "If only she could have married the right man what a different, more effective, and far happier woman she would have been!" . . . She was in love with Bernard Shaw before he was famous and he with her. . . . Stanley Baldwin fell in love with

[363]

her too, and so did Burne-Jones." The fact
is, of course, that for May no man could ever
come anywhere near her father in her estima-
tion, though Jenny [her sister] was his favour-
ite. After his death she devoted the rest of her
life to the service of his memory.'

Philip Henderson, *William Morris, his Life, Work
and Friends* (1967), pp. 299–300

MRS WILLIAM MORRIS (née Jane Burden) (*c*. 1829–1914)

Married William Morris (q.v.) in 1859. She
was one of Rossetti's stunners, he having fal-
len in love with her by 1868. For the rest of
his life her features were to dominate his
paintings: he drew or painted her over a
hundred times.

364 Photograph by an unidentified photo-
grapher, at the request of D. G. Rossetti (q.v.),
in the garden of Rossetti's house in Chelsea,
July 1865. Rossetti's drawing entitled *Reverie*
(Ashmolean Museum) and a finished version
(private collection), both dated 1868, are
based on this photograph. *Victoria & Albert
Museum, London*

365 Another photograph taken on the same
occasion. *Victoria & Albert Museum, London*

'All declared [her] to be the ideal personifi-
cation of poetical womanhood. In this case the
hair was not auburn, but black as night;
unique in face and figure, she was a queen,
a Proserpine, a Medusa, a Circe – but also,
strangely enough, a Beatrice, a Pandora, a Vir-
gin Mary.'

William Bell Scott, *Autobiographical Notes* (1892),
Vol. 2, p. 61

[364]

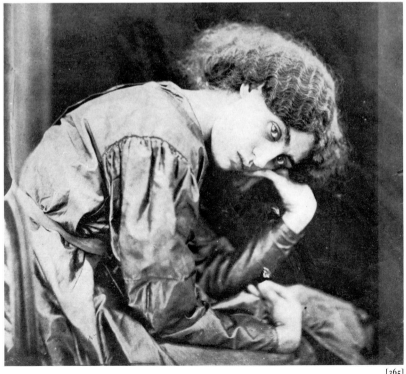

[365]

[366]

BEN NICHOLSON, OM (1894–1982)

Son of Sir William Nicholson (q.v.) by his first wife Mabel, sister of James Pryde. Abstract painter of international renown.

366 Photograph, *c.* 1897, by his father, Sir William Nicholson. *Phyllis Graham*

'In person, Nicholson was a smallish, nimble man of somewhat ascetic aspect, keenly interested in aesthetic discussion, and bringing to it something of the lucidity and precision of his painting.'
Obituary in *The Times* (9 February 1982)

ELIZABETH ELEANOR ROSSETTI (née Siddal) (1829–62)

The first muse of the Pre-Raphaelites, who married D. G. Rossetti (q.v.) in 1860 after a long engagement. Much drawn and painted by him, and often used as a model by the others: Hunt painted her as Sylvia in his *Valentine Rescuing Sylvia from Proteus*; Millais posed her for *Ophelia*; Walter Deverell painted her as Viola in *Twelfth Night*; amongst others. She died from an overdose of laudanum.

367 Photograph by Frederick Hollyer of a daguerrotype, reproduced as the frontispiece to *The Wife of Rossetti* (1932), by Violet Hunt. Although this book has been exposed as a tissue of fiction, there can be little doubt as to the authenticity of this photograph: the book's sole redeeming feature is the choice of photographs, all of which are authentic. However,

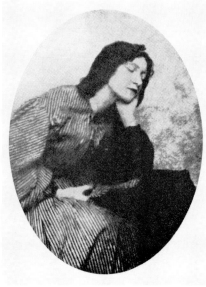

[367]

Georgiana Burne-Jones has this to say in *Memorials of Edward Burne-Jones* (1904), pp. 281–2:

'When Gabriel heard that Mrs. Wheeler was in Great Russell Street, he wrote asking me to tell her that she would soon receive from him a photograph of his wife which he had long intended her to have. Naturally I enquired at once what photograph he meant, for I did not know there were any and was eager to have one; but he answered, "The photographs of Lizzie are only from two of my sketches. On several occasions when attempts were made to photograph her from life, they were all so bad that none have been retained."'

Unlike his brother William Michael, D. G. Rossetti could not be said to have a near perfect memory among his virtues. It is also possible that if he did not retain any photographs, somebody else in his circle might have done.

'A truly beautiful girl; tall, with a stately throat and fine carriage, pink and white complexion, and massive straight coppery golden hair. Her large greenish-blue eyes, large lidded, were peculiarly noticeable.... One could not have seen a woman in whose whole demeanour maidenly and feminine purity was more markedly apparent.'

William Michael Rossetti in *A Victorian Romantic* (1960), by Oswald Doughty, p. 118

MRS WILLIAM MICHAEL ROSSETTI (née Lucy Madox Brown) (1843–94)

Daughter of Ford Madox Brown (q.v.) by his first wife Elizabeth Bromley. She had artistic talent and left several paintings. She married William Michael Rossetti (q.v.) in 1874.

368 *Carte-de-visite*, albumen print by L. Suscipj, Rome, taken in 1873. Given to Samuel Bancroft, Jr, by Fanny Cornforth, by this time Mrs Schott, 'out of her album', 2 April 1898. *Delaware Art Museum, USA*

'Mrs. Rossetti was a woman of wide and varied taste, with unerring admiration for the beautiful, unerring contempt for the sordid, large-hearted, vehement in partisanship, strong in dislikes, almost intemperate in her zeal for justice; and this broad impassioned nature of hers had for its channel of expression a quiet life narrowed by illness, and a rather specialised view of art.'

William M. Hardinge, 'A Reminiscence of Mrs. W. M. Rossetti', in the *Magazine of Art* (1895)

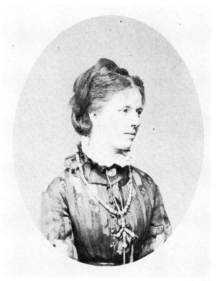

[368]

WINIFRED SANDYS (1875?–1944)

Artist. The eldest in the family of seven daughters and two sons of Frederick Sandys (q.v.). In 1920 she became the second wife of Walter Crane (q.v.) after the death of his first wife, who was her sister.

369 Carbon print by Frederick Hollyer, taken in 1909, signed and dated 1910. *Delaware Art Museum, USA*

'I saw Miss [Winifred] Sandys the other day and she seems to me a very straight and clever girl and you will be pleased to know her when you are next over here. Facially she is very

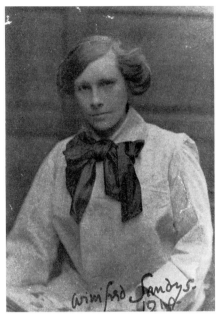

[369]

like her father but doesn't seem to share his weaknesses, fortunately.'
Letter from Charles Fairfax Murray to Samuel Bancroft, Jr, 3 January 1907, in *Delaware Art Museum Occasional Paper*, No. 2 (February 1980), p. 190

DAME ELLEN TERRY (1847–1928)

Actress. Married for a brief period, as a child bride, to G. F. Watts (q.v.), 1864–5; she was divorced by him in 1877. She was his model for his unfinished picture *Watchman! What of the Night?*

370 Albumen print by an unidentified photographer, 114 × 91 mm, *c.* 1880. *Author's collection*

[370]

'. . . Ellen, then about sixteen, of medium height, with crisp, wavy hair and pretty, winsome grey eyes. . . .'
Mrs E. M. Ward's Reminiscences (1911), ed. by Elliott O'Donnell, p. 158

'[21 December 1864] I was very much pleased with what I saw of Mrs Watts – lively and pleasant, almost childish in her fun, but perfectly ladylike.'
Lewis Carroll, *Diaries*, (1953), ed. by Roger Lancelyn Green, Vol. 1, p. 225

EDWARD JOHN TRELAWNY (1792–1881)

Author and adventurer. Befriended Shelley and Byron; was present when Shelley was drowned. He was the model for the old seaman in Millais's *North-West Passage* (Tate Gallery), and it is generally considered to be an excellent likeness.

371 *Carte-de-visite*, albumen print by Fradelle, London. Inscribed in W. M. Rossetti's hand: 'given me by Miss Taylor'. Holman Hunt (q.v.) also owned a similar *carte-de-visite* of Trelawny. From the Rossetti family collection. *Mrs Imogen Dennis*

[371]

ALEXA WILDING (dates not known)

One of Rossetti's (q.v.) stunners. She was used as the model for many of his later pictures.

372 *Carte-de-visite*, albumen print by J. R. Parsons, London. Inscribed on the reverse: 'Miss Wilding' in the hand of W. M. Rossetti (q.v.). From the collection of D. G. Rossetti (q.v.). *Mrs Imogen Dennis*

'[Rossetti] had been on his way to a meeting of the Arundel Club in the Strand: walking quietly along amidst the hurrying folk that thronged the pavement he became aware of a young girl by his side. He turned his head to look at her and was struck with her beautiful face and golden auburn hair. . . . He followed her down a side street and explained that he wanted to paint her. She consented to come the next day to Cheyne Walk, but never turned up. He had given up all hopes of seeing the young lady again and had even abandoned the picture when one afternoon, in company with Howell in the same part of the Strand, he again caught sight of her. He was then in a cab: telling Howell what he was going to do, he stopped the hansom in a side street, got out and darted after the girl and at last overtook her. This time he took her back in the cab with him. She was a thoroughly respectable girl: in fact, dull, although she had ambitions to be an actress.'
Rosalie Glynn Grylls, *Portrait of Rossetti* (1964), pp. 113–14

[372]

DEALERS,
PRINT-PUBLISHERS &
PHOTOGRAPHERS

IF the nineteenth century was 'The Golden Age of the Living Artist', so it was also the age of the comparative newcomers – the dealers, print-publishers and print-sellers. Of course, picture dealing is as old as picture painting, but it was only really from the early 1840s that the true picture-dealing trade became a coherent force in the art world. The first true picture dealers evolved from picture importers, who brought Old Master paintings into Britain from the Continent. These works came in their thousands (14,901 in 1845 alone) and a very large proportion of them were fakes. There was, too, a huge trade in home-grown fake Old Masters. A 'Canaletto Manufactory' in Richmond was reputed to have produced at least eighty 'baked' Canalettos. Another 'manufactory' was at Mr Zachary's house in the Strand where 'Old Masters', recently painted and smoked over a stove, were sold by the score. This is not to say that there were no reputable dealers: some, like William Buchanan, Samuel Woodburn and Paul Colnaghi, acquired distinguished reputations.

From these picture importers and print-sellers, and from the ranks of carvers, gilders, framers and curio dealers, evolved the modern dealer in pictures. This remarkable evolution occurred almost overnight. So scandalous had the malpractices with Old Master paintings become, at the expense of the living painter who was hard put to find a market for his pictures, that there ensued a strong reaction against them, largely in the press and particularly in the newly founded *Art-Journal* under the editorship of S. C. Hall. There were several well-publicized prosecutions and when prospective purchasers were urged to stop buying Old Masters, real or otherwise, they did just that. The campaign was (perhaps fortuitously) well timed because the old aristocracy had nearly ceased buying Old

Masters on any scale and the new rich, lacking the necessary scholarly apparatus, were more than ready to buy pictures from living painters. As Wilkie Collins wrote in his novel, *A Rogue's Life*:

Traders and makers of all kinds of commodities. . . . started with the new notion of buying a picture which they themselves could admire and appreciate, and for the genuineness of which the artist was still living to vouch [as much-copied artists like Linnell and T. S. Cooper were to discover to their cost]. These rough and ready customers . . . wanted interesting subjects; variety, resemblance to nature, genuineness of the article, and fresh paint; they had no ancestors whose feelings, as founders of galleries, it was necessary to consult; no critical gentlemen and writers of valuable works to snub them when they were in spirits; nothing to lead them by the nose except their own shrewdness, their own interests, and their own tastes – so they turned their backs valiantly on the Old Masters, and marched off in a body to the living men.

'These rough and ready customers' very soon found that the artistic temperament and frequent lack of business sense often stood between themselves and artists; so dealers – middlemen – appeared, to act on their behalf. Although not without its problems, this arrangement came to be adopted, and the promotion of artists by dealers began, usually through the press and therefore the critics. Thus was the artist-critic-dealer-patron relationship set in motion, and thus it has remained since.

As it was the age of the subject picture and its concomitant, the reproductive engraving, which sold in its hundreds and thousands and was therefore where the really serious business lay, so also was it the age of the copyright in a picture. If I may be permitted to quote myself (since I cannot express it in any other way) in my book *Gambart: Prince of the Victorian Art World*:

The very foundations of the print trade rested on a simple distinction, crucial to an understanding of the Victorian art world in general. . . . On the one hand there was the picture, and on the other the copyright. Each might be sold as a separate entity. If the picture had features which lent itself to engraving and mass propagation, the copyright would become a valuable property in its own right. Many a picture 'worked out' between a patron and an artist presupposed a copyright by the very nature of the picture's subject and intended treatment, even before it was executed.

The print-publishers became the richest and most powerful people in the art world and the print-sellers' shops the busiest in the same milieu. Most of the print-publishers became dealers and vice versa, and so, at this juncture, the two trades became fused.

The most notable print-publishers were the houses of McLean, Ackermann, Joseph Dickenson, Henry Graves & Co. and Gambart. *Pigot's Directory* of 1839 listed no less than seventy-two print-sellers and publishers in London. In 1855 the *London Post Office Directory* listed eighty-five print-sellers and ninety-two picture dealers. Another great print-publisher was Francis Moon, who became Lord Mayor of London and a baronet, and left a fortune of just under £160,000. The Midlands were dominated by the houses of Grundy and Agnew. The latter came to London in the 1860s and is still with us to this day. Sir William Agnew became one of the leading dealers in the second half of the century: the middle years were dominated by Ernest Gambart and Louis Victor Flatow. They were both extraordinary characters: the first was suave, debonair, clever, industrious and entertaining, and there was scarcely a picture of any importance that did not pass through his hands between 1853 and 1870; the second, Flatow, the son of a Prussian Jew, was coarse, illiterate, without an 'h' to his name, appallingly vulgar, an excellent mimic, and an even better ventriloquist. He was withal a much-loved character and his early death was mourned by many artists. He was alleged to have begun his career as a purveyor of fraudulent Old Masters, before setting up as a chiropodist in London, sporting above the entrance to his house a gilded foot disfigured by gigantic corns. For successfully removing the corn of a cigar merchant named Mr Beckenham, he was introduced to a struggling artist whose pictures he managed to sell. Thereafter he became one of the leading dealers in London. The only known portrait of him is in Frith's *The Railway Station*, a picture that was commissioned, bought and sold by Flatow, who is depicted talking to the engine driver. Some of his deals seem scarcely credible. In 1848 he sold six pictures to Joseph Gillott, the penmaker, including a Ruisdael, a Cuyp and a Schelfhout, in exchange for 2,018,880 steel pens. Gillott patronized a tailor in Conduit Street, named William Wethered, who ran a large picture business on the side and would include sales of pictures on his tailoring bills.

There were other curious combinations such as Woolner, the PRB sculptor who dealt in pictures on the side; Mark Anthony, the artist who dealt in violins, as did the novelist Charles Reade; and the picture-dealing serjeant-at-law, Ralph Thomas, a voracious collector of everything from pictures to warming-pans. In thirty years he occupied thirty different houses; each time he moved he sold part of his collection. It was said that it was dangerous to open the door of his chambers for fear of crushing valuable old violins hanging on the inside of it. He dealt direct with many leading artists, including Frith, Martin and Millais.

Other great dealers of this period were William Vokins, Henry Farrer, FSA, and David Thomas White, all of whom, particularly the latter two, bravely dealt with the revolutionary Pre-Raphaelites, as did Gambart. Flatow, though, preferred safer pictures of a more traditional manner. Gambart's nephews, Charles Deschamps and Léon Lefèvre, also both became celebrated dealers. The former was secretary of Durand-Ruel's first Impressionist exhibition in London, and Lefèvre carried on his uncle's business, which still bears the Lefèvre name to this day. The name of another dealer, the infamous, but clearly entertaining character, Charles Augustus Howell, will be known to those familiar with the story of the Pre-Raphaelites. Every deal of his ended in a cloud of perplexity and he seems in some way to have swindled every artist with whom he came into contact. On the other hand, the two Colnaghis, uncle and nephew, had distinguished careers, even if the brother of one and the father of the other (Martin Colnaghi, Sr) did not. Sir Coutts Lindsay, founder of the Grosvenor Gallery, has never been formally recognized as a dealer, nor have his colleagues Charles Hallé and J. Comyns Carr; yet they fit happily into this section as well.

So, too, do two photographers, David Octavius Hill and Frederick Hollyer; they were, in a sense and to an extent, tradesmen, particularly the latter. The best-known photographers were men of some importance in their way, yet most must have been too busy to think of stepping in front of the camera lens themselves, which is both their loss and ours.

SIR WILLIAM AGNEW, BT (1825–1910)

One of the great art dealers of the nineteenth century and partner in his father's firm of Thomas Agnew & Sons. He was Liberal MP for South-East Lancashire and Stretford from 1880 to 1886. Created baronet in 1895.

373　*Carte-de-visite*, albumen print by Elliott & Fry, London. *Thomas Agnew & Sons, Ltd*

'The house of Agnew exhaled the atmosphere of Consols, and old Sir William himself gave the impression of a successful Lancashire manufacturer.'

Walter Sichel, *The Sands of Time* (1923), p. 293

[373]

JOSEPH WILLIAMS COMYNS CARR (1849–1916)

Writer, critic, playwright, Director of the Grosvenor Gallery and co-founder of the New Gallery in 1888.

374　Photograph by an unidentified photographer, but possibly Frederick Hollyer (q.v.). Carr was 23 when this was taken. Reproduced in Mrs J. Comyns Carr's *Reminiscences* (n.d.), facing p. 31

'Among the eloquent wits and critics who congregate at the Garrick the late Mr Comyns Carr ranked *facile princeps*.'

Walter Sichel, *The Sands of Time* (1923), p. 223

DOMINIC COLNAGHI (1790–1879)

A highly esteemed art dealer with a European reputation. A member of the firm founded by his father Paul Colnaghi.

375　*Carte-de-visite*, albumen print by L. Caldesi & Co., London. *National Portrait Gallery, London*

'Among other things the President [Sir Charles Eastlake] told us, that Dominic Colnaghi, when growing somewhat old, was presented by his wife with another baby, and General Fox, who had heard of it, went in to congratulate him. Putting his hand to his mouth he hallooed into Colnaghi's ear [he was deaf] "Well, Dom! another babe, I hear, the last flicker of the candle, old boy!" On which the "old boy" in his turn shouted out before all in the gallery, "Yes, General, but your candle never flickered at all!" which quite silenced him, as he was childless.'

F. M. Redgrave, *Richard Redgrave, CB, RA: A Memoir Compiled from his Diary* (1891), p. 269

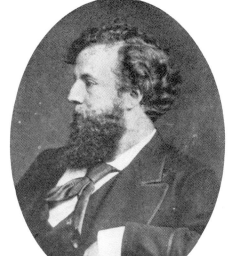

[374]

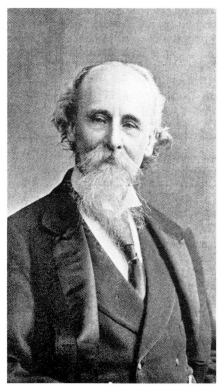

[375]

MARTIN COLNAGHI, Jr (1821–1908)

The son of Martin Colnaghi, Sr, and nephew of Dominic Colnaghi (q.v.). His father was extravagant and irresponsible and was bought out of the original firm of Colnaghi's by his own father, Paul, and his brother Dominic. Martin Colnaghi, Jr, carried on the tradition of connoisseurship at the Marlborough Gallery, 53 Pall Mall, London.

376　Photograph, reproduced in the *Art-Journal* (1896).

'Martin Colnaghi was by far the most distinctive and even distinguished vendor of pictures that I have ever met. . . . A spice of Merlin there was about the picture-wizard – a twisted strand of strange opposites.

'What a contrast appeared between Colnaghi, pushing, jostling at sales, cracking jokes with the commoner dealers, and Colnaghi in his Pall Mall home. It was the difference between the pedlar and the prince, the chafferer and the chieftain, and these two elements pervaded his being. In public he could be by turns composed and choleric. In private he was the same. A thrice-married man he could be heard at once flattering and furious, but always with hereditary finesse.'

Walter Sichel, *The Sands of Time* (1923), pp. 291–2

[376]

CHARLES WILLIAM DESCHAMPS
(1848–1908)

Art dealer and nephew of Ernest Gambart (q.v.). He was Secretary to the Society of French Artists in 1872, which put on Durand-Ruel's third exhibition of French painting in London, containing works by the new Impressionist School. In the 1880s Deschamps had a gallery at 1a New Bond Street, London.

377 *Carte-de-visite*, albumen print by W. & D. Downey, London. *Author's collection*

'Deschamps was clearly an engaging youth, with an ardent, perhaps headstrong character (in contrast with his staider cousin [Léon] Lefèvre), and a pleasing appearance which matched his agreeable Continental manners. He grew his hair fashionably long and full, and a few years later he sported a moustache. His eyes, with their long lashes, reflected the humour that, joined to a gay temperament, must have added much to his charm. Charles was just the sort of young man to get on well with ageing Pre-Raphaelites, and he was a regular guest at Madox Brown's Friday evening parties. He was welcome, Rossetti once told him, because he was a good-looking boy.'
Jeremy Maas, *Gambart: Prince of the Victorian Art World* (1975), p. 215

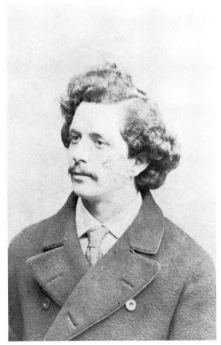

[377]

ERNEST GAMBART (1814–1902)

Of Belgian birth, he was the most original, energetic and powerful art dealer and print-seller in the middle years of the last century. Spent his last thirty years in retirement as Spanish Consul-General in Nice.

378 Photograph, by an unidentified photographer, taken in about 1898. Amongst his decorations were the Order of the Crown of Italy, the Swedish Royal Order of Vasa, the Order of Saxe-Coburg-Gotha, the Order of SS Mauritius and Lazarus of Italy, the Grand Cross of the Order of Isabella the Catholic of Spain, and Chevalier of the Order of Leopold (of Belgium). He was one of the first to be awarded the MVO by Queen Victoria.
British Museum

'Standing 5 feet 5¾ inches in his socks, his frame, with disproportionately short legs, was slight, and a habitual restlessness and abundance of energy quickened every movement. His wispy hair was fair in colour and fine in texture; the forehead fairly high, the nose long and straight: a purposeful, inquisitive nose, fashioned for work. His clear blue eyes were alert, shrewd, quick to anger, restless, foxy and amused, and they missed nothing. The semicircle formed by his eyebrows, which later in life were to complete a full circle with the pouches beneath his eyes, gave him at times an owl-like appearance, hinting at shrewdness and sagacity. His lips were not noticeably full, and his jaw – at this date probably cleanshaven but side-whiskered, well set but not square – completed a face that radiated

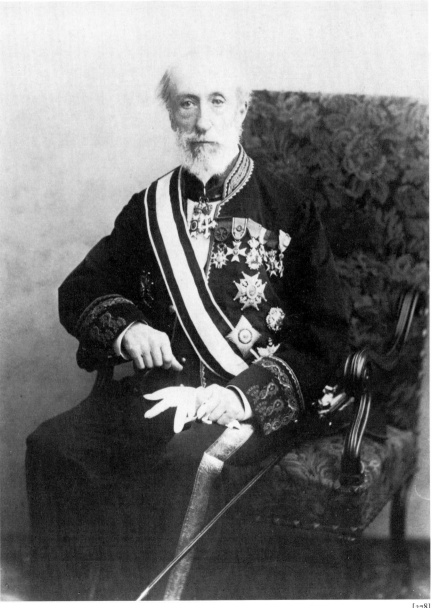

[378]

authority that was at once cool and steady. He was a highly entertaining and voluble conversationalist, a delightful companion, a good raconteur, with an endless fund of droll stories, and a sharp wit, his repartee rarely missing the mark. . . .'

Jeremy Maas, *Gambart: Prince of the Victorian Art World* (1975), pp. 24–5

'There is an old he-wolf named Gambart;
Beware of him if thou a lamb art.
 Else thy tail and thy toes
 And thine innocent nose
Will be ground by the grinders of Gambart.'

D. G. Rossetti in *Gambart: Prince of the Victorian Art World* (1975), by Jeremy Maas, p. 145

CHARLES HALLÉ (1846–1919)

Painter of portraits and figure compositions. Became involved with both the Grosvenor and New Galleries, mainly in an organizational capacity.

379 Photograph by Lizzie Caswall Smith, reproduced in *Notes from a Painter's Life* (1909), by C. H. Hallé. *Author's collection*

'Charles Hallé was certainly an artist; he loved art truly and well and served her faithfully, yet he never found his proper mode of self-expression. . . . His pictures do not bear thinking of, so I will not think of them, but only of the witty, interesting man who I feel sure could have done something or other most beautifully if only he had happened to find out what it was. His appearance was romantic, contrasting oddly with his impish sense of humour. . . .'

W. Graham Robertson, *Time Was* (1931), p. 46

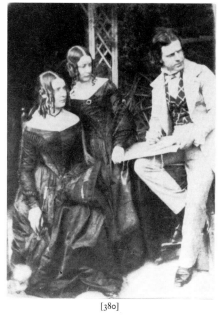

[380]

DAVID OCTAVIUS HILL, R S A (1802–70)

Landscape and portrait painter, and an early pioneer of photography.

380 Calotype by David Octavius Hill (q.v.) and Robert Adamson, 73 × 67 mm. Self-portrait with the Morris sisters, Patricia and Isabella. *Sotheby's*

FREDERICK HOLLYER (1837–1933)

A professional portrait photographer from the 1870s who specialized in portraits of artists in their own surroundings. He devoted only one day a week to this pursuit, spending the remaining days reproducing paintings photographically and with considerable skill.

381 Platinum print, self-portrait. *Royal Photographic Society*

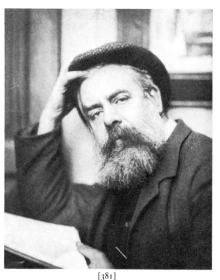

[381]

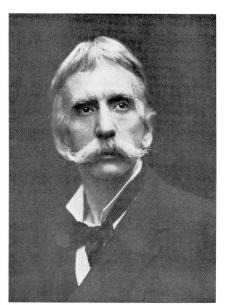

[379]

CHARLES AUGUSTUS HOWELL (c. 1840–90)

Anglo-Portuguese adventurer and art agent whose machinations, while affording amusement, were rarely less than disastrous to all concerned. He entered D. G. Rossetti's (q.v.) life in 1857. The artist introduced him to Ruskin (q.v.) who engaged him as secretary; he was dismissed in 1870 through the influence of Burne-Jones (q.v.). In 1869 Howell played an important role in the recovery of Rossetti's poems from Lizzie Siddal's grave.

382 Photograph, reproduced in *Pre-Raphaelite Twilight: The Story of Charles Augustus Howell* (1954), by Helen Rossetti Angeli. *Author's collection*

'The poor little carte-de-visite shown in this volume may be viewed as a passport photograph of those days, common and unprepossessing.'

Helen Rossetti Angeli, *Pre-Raphaelite Twilight: The Story of Charles Augustus Howell* (1954), pp. 205, 206–7

'He was a somewhat battered person, with the face of a whipped cab-horse.'

Hall Caine, *My Story* (1908), p. 232

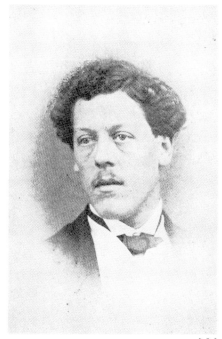

[382]

LÉON LEFÈVRE (c. 1843–1915)

Nephew of Ernest Gambart (q.v.), who continued Gambart's gallery at 1a King Street, London. The gallery, under his name, exists today, in Bruton Street, London.

383 Cabinet portrait, albumen print by John Collier, Birmingham. *Private collection*

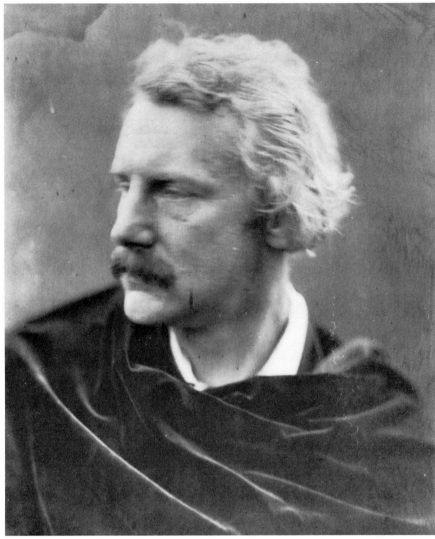

[384]

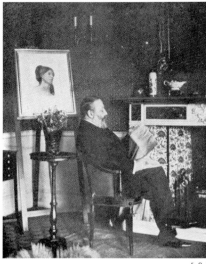

[385]

385 Photograph, reproduced as the frontispiece of *Murray Marks and his Friends* (1919), by G. C. Williamson. On the easel is a red chalk portrait drawing of Mrs Marks by D. G. Rossetti (Victoria & Albert Museum). *Author's collection*

'He was one of the most lovable men I ever met.'
Lord Carmichael in *Murray Marks and his Friends* (1919), by G. C. Williamson, p. 175

WILLIAM VOKINS (1815–95)

Carver and gilder who became a leading picture dealer and noted judge of English water-colours. His first premises were in John Street, off Oxford Street, London until 1858. From that year until his death he had premises at 14 and 16 Great Portland Street and 10 King Street, Pall Mall, London.

386 *Carte-de-visite*, albumen print by Elliott & Fry, London. From the collection of Algernon Graves. *National Portrait Gallery, London*

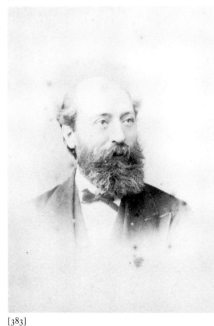

SIR COUTTS LINDSAY, BT, RI (1824–1913)

Painter in oils and water-colours. His main claim to distinction was as founder of the Grosvenor Gallery in 1878. For twelve years it became the focus of the aesthetic movement. Coutts and his artist wife Blanche Fitzroy separated in 1882 and this led to the gradual decline, which became complete in 1890, of the Grosvenor Gallery.

384 Albumen print by Julia Margaret Cameron, 1865. From the scrapbook of Lady Marianne Talbot. *Sotheby's*

MURRAY MARKS (1840–1918)

Famous art dealer of 395 Oxford Street, London. Friend of Rossetti, Whistler, Sandys, Simeon Solomon, Leighton, Napier Hemy (all q.v.) and many others. His trade card (a Chinese ginger jar and peacock feathers) was supposed to have been the joint work of Rossetti with William Morris and Whistler.

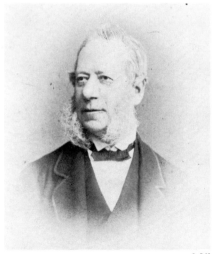

[383]

[386]

— 15 —

SCULPTORS

VICTORIAN sculptors were sufficiently public figures to draw the attention of the *carte-de-visite* photographers, although little originality was shown when it came to actually photographing them. Setting up cumbersome apparatus in the sculptors' studios was one obstacle, and obtaining sufficient light another. The early photograph of Alexander Munro in his London studio shows what could have been achieved on a wider scale with a little imagination and ingenuity. Most photographers were content to place their subjects in the photographic studios, unfurling a vaguely 'arty' backdrop and putting a Parian bust on a nearby surface, as in the photograph of Mary Thornycroft. It was not until some thirty years after the photograph of Munro that Mayall systematically set up his cameras in the studios of sculptors, with telling results. Ralph W. Robinson followed suit in 1891 with a further set.

In society, sculptors in the last century were considered slightly as a race apart, somewhat akin to engravers, although their status was considerably higher. On a personal level, they were generally thought to be rough-hewn like some of their work, with gnarled hands and uncouth ways, and to be less articulate than painters. They seem to have mixed less in society and they draw fewer comments in the autobiographies of their contemporaries. To be sure, there were gentle souls amongst them – the refined Munro, the graceful Foley, the urbane Boehm, the shy and retiring Gilbert – and there were also several talented sculptresses in the mid century, like Mary Thornycroft and the unlikely Princess Louise, most artistic and wayward of Queen Victoria's daughters. But mainly they were a breed of strong, silent men.

Sculpture never achieved the public affection commanded by painting although, as an expression of 'High Art' – the human figure being the noblest of God's works – it was still the object of esteem in the early part of the century. The Elgin Marbles were venerated for a whole generation by painters and sculptors alike, and the cold classicism of Flaxman, the grace of Canova and the severity of Thorvaldsen determined the nature and ideals of early Victorian sculpture. Most of it was derivatively classical, a vitiated version of Roman or Hellenistic models, although often of considerable charm. Amongst the sculptors in this vein were E. H. Bailey, MacDowell, Westmacott, Weekes, Calder Marshall and the supreme exponent, John Gibson, whose life was devoted to ideal beauty in plastic form. This elevated spirit was only occasionally brought to earth as, for example, when Sir William Watkins Wynne told Gibson that he would have bought his graceful *Hylas and the Water Nymphs* had he been prepared to replace the central figure with a clock.

Weaving through the fabric of classicism were the threads of romanticism and realism. Romanticism in English terms reached its height in Munro's *Paolo and Francesca* which, probably based on sketches by Rossetti, is the nearest approach to the Pre-Raphaelite ideal by a sculptor. The classical and romantic approach suffered equally at the hands of the critics, while one of the greatest sculptors of the age, Alfred Stevens, was ignored rather than criticized.

Whether 'classical', 'romantic' or 'realist', however, sculpture in England had, by the 1870s, grown severely limited in scope and ideas. The first step towards a freer, more expressive style was taken by the great sculptor-designer Alfred Stevens, who drew directly upon the Italian Renaissance for inspiration. His influence, together with the arrival in England during the 1870s of three Frenchmen, Jean Baptiste Carpeaux, Jules Dalou and Edouard Lanteri, all of whom taught

here, introduced that brilliant episode in English art known since its own time as the New Sculpture. Two of its leading figures, Alfred Gilbert and George Frampton, had, by 1900, won an international reputation for their highly individualistic, decorative sculpture, in which colour and mixed materials played an important role. Tempering the powerful influence of France and the flamboyance of Salon sculpture with their own feeling for grace and understatement, the English produced, between 1880 and 1910, a national School of their own.

In the age of the polymath, it is not surprising, too, that the Victorian period was notable for the number of artists who practised both painting and sculpture, sometimes achieving remarkable distinction in both forms: notably Stevens, Watts and Leighton. There was always work for the sculptor – worthies to be immortalized in busts; white marble goddesses for baronial halls; statues of Queen Victoria for outside town halls; and elaborate tombs for 'the dear departed'.

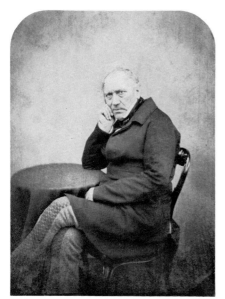

[387]

EDWARD HODGES BAILY, RA (1788–1867)

Monumental sculptor and pupil of Flaxman. He had a large practice but never achieved the popularity of his contemporary Sir Francis Chantrey.

387 Albumen print by Maull & Polyblank, London, published October 1856, 198 × 146 mm. *Author's collection*

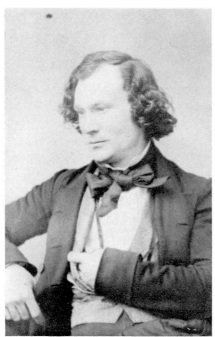

[389]

[388]

SIR THOMAS BROCK (1847–1922)

He was a pupil of J. H. Foley (q.v.) whom he succeeded as supplier of monuments and official statuary. He executed the memorial to Queen Victoria in front of Buckingham Palace in collaboration with Sir Aston Webb. Knighted in 1911.

388 Photograph by Ralph W. Robinson, 202 × 153 mm, published in *Members and Associates of the Royal Academy of Arts, 1891, photographed in their Studios* (1892). To the right is a statuette of Sir Bartle Frere, the statesman (RA, 1888); the finished statue was placed in Embankment Gardens in 1888. *National Portrait Gallery, London*

JOSEPH DURHAM, ARA (1814–77)

Sculptor who excelled in figures of boy-athletes.

389 Albumen print by an unidentified photographer, 90 × 59 mm. *Author's collection*

JOHN HENRY FOLEY, RA (1818–74)

Much of his work is characterized by an innocent charm. He sculpted the figure of the Prince Consort in the Albert Memorial.

390 Calotype by an unidentified photographer, 128 × 100 mm, *c.* 1845. *Private collection*

'I recall him as I knew him in the long-ago – slight, but well formed, the face long and sallow, pensive almost to melancholy; I do not think he was outwardly of what is called a genial nature. He was not "robust" either in body or mind; all his sentiments and sensations were graceful; so in truth were his manners.'

Samuel Carter Hall, *Retrospect of a Long Life from 1815 to 1883* (1885), Vol. 2, pp. 240–1

EDWARD ONSLOW FORD, RA (1852–1901)

Sculptor who studied painting at Antwerp and modelling at Munich. Among his works are the Shelley Memorial at Oxford and the Queen Victoria Memorial at Manchester.

391 Photograph by Ralph W. Robinson, 199 × 153 mm, published in *Members and Associates of the Royal Academy of Arts, 1891, photographed in their Studios* (1892). The Egyptian figure on the left is *The Singer* (RA, 1889, as a statuette in bronze). Statuette to the far right is for the statue of General Gordon on a camel, for the esplanade at Chatham, 1888. *National Portrait Gallery, London*

'Like most sculptors he was physically powerful, although of medium height, but, also like most sculptors, he overworked himself, and probably shortened his life by the energy with which he set about not only his own work but that of other people.'

Dictionary of National Biography

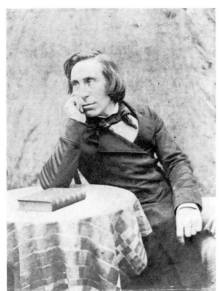

[390]

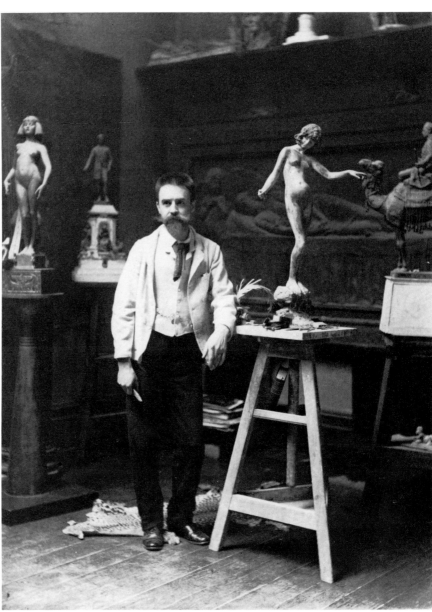

[391]

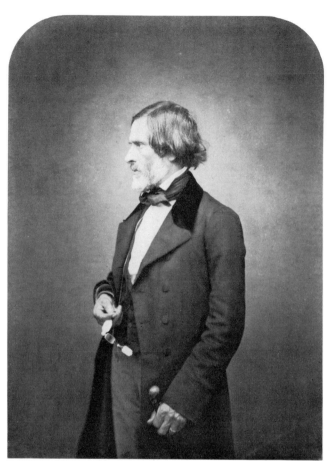

[392]

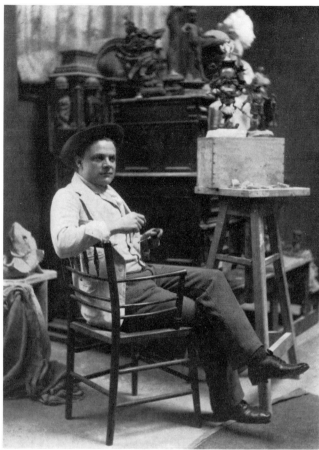

[393]

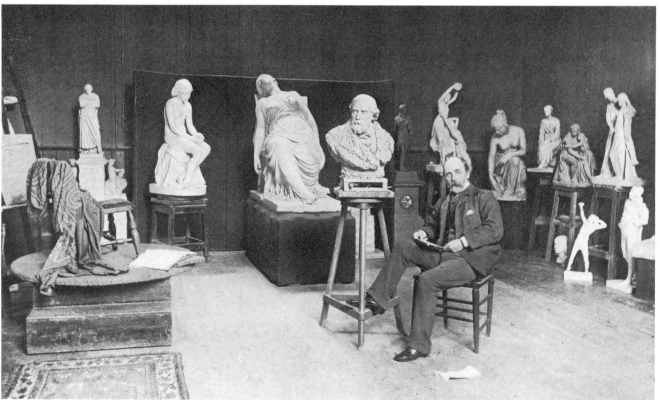

[394]

JOHN GIBSON, RA (1790–1866)

One of the finest British sculptors of his age. Lived in Rome. His most famous statue was the *Tinted Venus*, exhibited at the International Exhibition of 1862.

392 Cabinet portrait, albumen print by Maull & Polyblank, London, 198 × 147 mm, November 1857. *Author's collection*

'He possessed a staunch belief in his own genius. Like Pygmalion, he actually fell in love at times with his own productions, notably in the case of his tinted Venus, about the beauty of which work I once heard him descant to my father in language more like that with which a lover addresses his mistress than that which a workman would use in speaking of his own handicraft.'
George Dunlop Leslie, RA, *The Inner Life of the Royal Academy* (1914), p. 251

SIR ALFRED GILBERT, RA (1854–1934)

One of the most original and gifted of British sculptors. Studied at Heatherley's School and under Sir Joseph Boehm (q.v.). His most famous statue is *Eros* in Piccadilly Circus, London.

393 Photograph by Ralph W. Robinson, 202 × 153 mm, published in *Members and Associates of the Royal Academy of Arts, 1891, photographed in their Studios* (1892). *National Portrait Gallery, London*

'[A] shy and retiring personality.'
Estella Canziani, *Round About Three Palace Green* (1939), p. 186

GEORGE ANDERSON LAWSON (1832–1904)

Studied at the Royal Scottish Academy Schools and in Rome.

394 Photogravure after J. P. Mayall, 164 × 217 mm, reproduced in *Artists at Home* (1884), by F. G. Stephens, facing p. 26. The sculptures, from left to right, are: *Lord Beaconsfield*; *The Girl with a Tortoise*; *Cleopatra* (1881); clay bust, in progress, of the late Mr Dorman; *Come unto These Yellow Sands* (1871); *The Nymph at the Pool*; cast of *Jeannie Deans* (Sir W. Scott) (1862); *Hubert and Arthur* (terracotta); *The Maiden's Secret*; and on the floor, right, a small model of *Retiarus*. *Author's collection*

LOUISE CAROLINE ALBERTA, PRINCESS OF GREAT BRITAIN AND IRELAND, DUCHESS OF ARGYLL (1848–1939)

Sixth child of Queen Victoria and a gifted sculptress who made her home welcome to artists. She married in 1871 the Marquess of Lorne (later 9th Duke of Argyll), from whom she was later estranged. Wrote magazine articles as 'Myra Fontenoy'. Her most celebrated work is the statue of Queen Victoria in Kensington Gardens.

395 Albumen print by W. & D. Downey, Newcastle-upon-Tyne, 186 × 134 mm. *Author's collection*

'A tale runs that one day when [Sir William Blake] Richmond was busily engaged in painting, a maid entered the studio with the announcement, "Please, sir, Princess Louise is here!"

'"Tell her to go to the Devil!" shouted Richmond, exasperated at being interrupted.

'"Not till I have seen you, Mr Richmond!" said the Princess sweetly, as she tripped after the maid into the room.'
A. M. W. Stirling, *The Richmond Papers* (1926), p. 256

'[Grasse, 5 April 1891. Princess Louise] was amiable enough but never have I come across a more dangerous woman, to gain her end she would stick at nothing: one would have given her a wide berth in the sixteenth century, happily she is powerless in the nineteenth.'
Life with Queen Victoria: Marie Mallet's Letters from Court 1887–1901 (1968), ed. by Victor Mallet, p. 50

[395]

PATRICK MacDOWELL, RA (1799–1870)

Two of his better-known sculptures are *Girl Going to the Bath* (1841) and *Europa* (1870) for the Albert Memorial.

396 Albumen print by Ernest Edwards, 89 × 70 mm, published in *Portraits of Men of Eminence* (1866), by A. W. Bennett, Vol. 4. *Author's collection*

'. . . MacDowell, sculptor and Irishman, rough and wild-looking, but most intelligent and a thorough gentleman.'
Lady Eastlake, *Journals and Correspondence* (1895), Vol. 1, p. 266

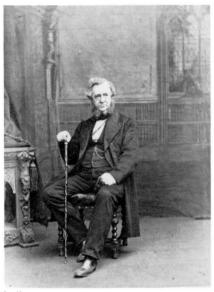

[396]

WILLIAM CALDER MARSHALL, RA (1813–94)

Sculptor, whose works include the group symbolic of 'Agriculture' on the Albert Memorial.

397 Photogravure after J. P. Mayall, 218 × 165 mm, reproduced in *Artists at Home* (1884), facing p. 8. F. G. Stephens, who wrote the text, described Marshall's house as 'large, modern and roomy . . . and where . . . he has resided more than thirty years. The photograph shows Mr Marshall's inner studio, his *sanctum*, which is accessible by a long gallery filled with examples of art.' The hooded figure to the left is a maquette for *The Venerable Bede Translating St John* (1869); the semi-nude girls seated in a group are *The Tali Players* (1873). Behind is a cast of the copper bronze statue of Samuel Crompton (1753–1827), inventor of the spinning-mule. The statue was presented to Bolton in 1862. The statuette beyond the swooning *Psyche* (1889) is *Pygmalion's Mistress*. The draped figure on the shelf is *The Mother of Moses* (1869). To the left is

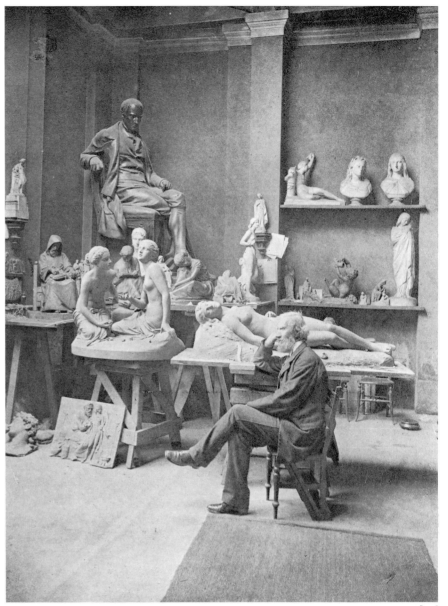

[397]

a cast of a young satyr drinking from a rhyton, entitled *The Last Drop*. This was Marshall's diploma work of 1848. *Author's collection*

'He was rather quiet, and very Scottish and shrewd.'
George Dunlop Leslie, RA, *The Inner Life of the Royal Academy* (1914), p. 171

ALEXANDER MUNRO (1825–71)

After Woolner (q.v.), one of the sculptors most associated with the Pre-Raphaelites. His marvellous marble group *Paolo and Francesca* (Birmingham) was probably based on studies made by Rossetti. Munro at one time shared a studio with his friend Arthur Hughes (q.v.) in Upper Belgrave Place, Pimlico, London.

398 Albumen photograph by an unidentified photographer, 220 × 185 mm, taken in the 1850s in his studio. *Mrs Katharine Macdonald*

'So dark and handsome and poetic and poor.'
Lady (Pauline) Trevelyan in *A Pre-Raphaelite Circle* (1978), by Raleigh Trevelyan, p. 111

'[21 May 1855] Monroe [*sic*] good mannered and tritely talkative.'
The Diary of Ford Madox Brown (1981), ed. by Virginia Surtees, p. 138

'Munro the sculptor, like all sculptors, lives in a nasty wood house, full of clay and water-tubs, so I can't go without catching cold.'
John Ruskin, *Works* (1903–12), ed. by E. T. Cook and A. Wedderburn, Vol. XXXVI, p. 347

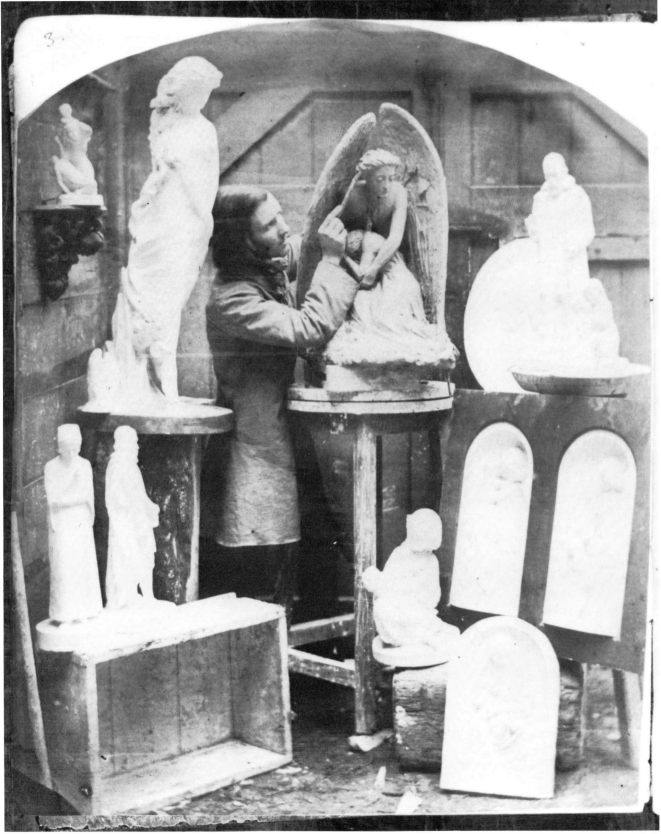

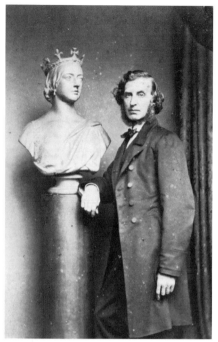

[399]

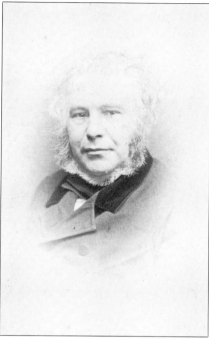

[400]

MATTHEW NOBLE (1818–76)

Sculptor who exhibited one hundred pieces at the Royal Academy, mainly busts. Sculpted many busts and statues of Queen Victoria, one of the most successful being that of 1857.

399 *Carte-de-visite*, albumen print by W. Walker & Sons, London, *c.* 1860. He is standing by his bust of Queen Victoria executed in 1856 and exhibited at the Royal Academy in 1857 (No. 1207). *National Portrait Gallery, London*

'Noble was of exceedingly delicate constitution. The death of a son in a railway accident early in 1876 ruined his health, and he died on 23 June 1876.'
Dictionary of National Biography

EDWARD BOWRING STEPHENS, A R A (1815–82)

Exeter-born sculptor and protégé of E. H. Bailey (q.v.). When he became A R A in 1864, it was believed at the time that he had been elected as a result of his name having been confused with that of Alfred Stevens (q.v.), a sculptor of far greater talent.

400 *Carte-de-visite*, albumen print by John and Charles Watkins, London. *Author's collection*

ALFRED GEORGE STEVENS (1817–75)

Sculptor, painter and draughtsman. He was a highly talented artist in all three departments. Spent eleven years in Rome, being at one time employed by Thorvaldsen.

401 Albumen print by G. C. Eaton, 85 × 76 mm, taken on 9 May 1867. *National Portrait Gallery, London*

'While the photographer [G. C. Eaton] was in the studio Stevens was persuaded, without other preparation, to sit for his portrait, and the result was three or four unconventional impressions of his mature appearance. The best of these [shown here] is unique, and shows the build of the head, and the force of the remarkable features.'
Kenneth Romney Towndrow, *Alfred Stevens* (1939), p. 215

'Stevens's personal appearance was striking. He was below rather than above the middle height. He had a large head, a clean-shaven face for most of his life, expressive and most sensitive features – these epithets applying especially to his mouth – a quick and keenly observant eye, which could, and did, take in at a glance all the details of any room into which he might happen to come, a general look which betokened unusual powers of thought and patience of reflection. He dressed in the style which Englishmen associate with Roman Catholic priests, and by strangers he was often mistaken for one. He was as scrupulously neat and exact in his person as he was the reverse in his mode of life. He was never married, and his domestic arrangements were such as we might expect in a bachelor artist who was so devoted to his art. He ate when he was hungry, and not always then, and went to bed when fatigue drove him there. During his stay in Sheffield he lived with two old maiden ladies, whose precise notions contrasted comically with his own careless habits. He would buy a case of wine and leave it standing in his sitting-room till it was finished, the straw meanwhile finding its way into every corner of the house. He had a strong affection for animals. At one time he used to go about with a small dog in the breast pocket of his coat, and when he was wearied by discussion or tired by stupidity he would bring the little beast out and fall to caressing it with his cheek. He kept peacocks, which used to walk about in his studio. . . .'
Walter Armstrong, *Alfred Stevens: a Biographical Study* (1881), pp. 40–2

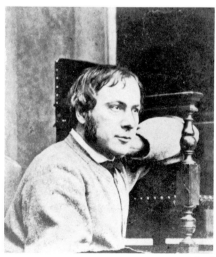

[401]

JOHN MACALLAN SWAN, RA (1847–1910)

Animal painter and sculptor. He is best known for his studies of wild predators: lions, leopards and tigers.

402 Silver bromide print by an unidentified photographer, 215 × 98 mm. *Author's collection*

'Swan's appearance was remarkable. He was tall, dark and burly, with a large head, like a Roman Emperor's.'
Dictionary of National Biography

WILLIAM THEED (1804–91)

After attending the Royal Academy Schools he worked in the studio of E. H. Baily (q.v.). He subsequently studied under Thorvaldsen, Gibson (q.v.) and Wyatt of Rome. He was much patronized by the Queen and Prince Consort. He made busts of Prince Albert and immediately after his death in 1861 Theed was rushed to Windsor to make his death-mask, which led to the sculpting of a posthumous bust, often seen in photographs of the Queen after that date.

403 *Carte-de-visite*, albumen print by L. Caldesi & Co., London. *National Portrait Gallery, London*

SIR HAMO (WILLIAM) THORNYCROFT, RA (1850–1925)

Son of Thomas (q.v.) and Mary (q.v.) Thornycroft. One of his best-known works is *A Sower* (1886). Three other notable statues of his are of General Gordon (1888) and Oliver Cromwell (1899), both in London, and King Alfred (1901) at Winchester.

404 Photogravure after J. P. Mayall, 217 × 166 mm, reproduced in *Artists at Home* (1884), by F. G. Stephens, facing p. 49. On a shelf in the background is a small version of a statue of Lord Beaconsfield (RA, 1882). *Author's collection*

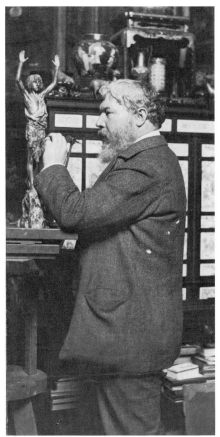

[402]

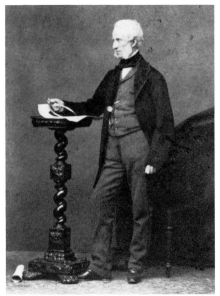

[403]

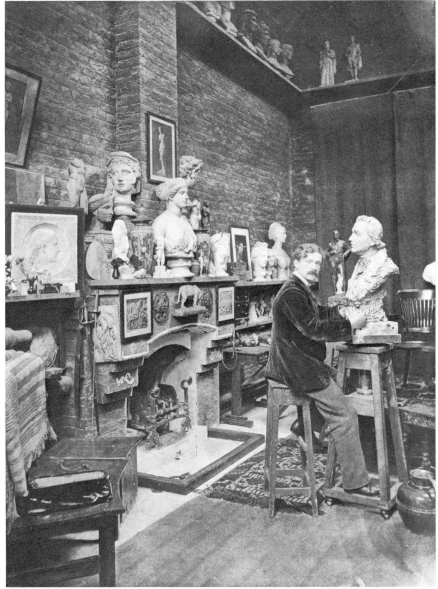

[404]

MARY THORNYCROFT (1814–95)

Sculptress, the daughter of the sculptor John Francis. In 1840 she married another sculptor, Thomas Thornycroft (q.v.). She was much patronized by the royal family. A statue by her of Prince Alfred caused much offence to a tee-totaller who objected strongly to his holding a bunch of grapes.

405 *Carte-de-visite*, albumen print by Maull & Co., London, *c.* 1864. The photographer thought it appropriate to position a bust of Apollo close to the sculptress.
Author's collection

'The sculptress whose handsome, cultured, and highly intelligent features, gentle, yet with latent courage in righteousness. . . .'
F. G. Stephens in the *Magazine of Art* (1895)

THOMAS THORNYCROFT (1815–85)

Studied under John Francis, whose daughter Mary (q.v.) later became his wife. His best-known works were the equestrian statue of Queen Victoria which was shown at the Great Exhibition of 1851, and the great group of Boadicea at the north end of Westminster Bridge in London.

406 Albumen print by Ernest Edwards, 87 × 67 mm, published in *Portraits of Men of Eminence* (1864), by A. W. Bennett, Vol. 2.
Author's collection

[405]

[406]

RICHARD WESTMACOTT, RA (1799–1872)

Of the third generation of sculptors bearing the same name. Specialized in busts, reliefs and monuments.

407 *Carte-de-visite*, albumen print by John and Charles Watkins, London, *c.* 1860.
Author's collection

[407]

— 16 —

ENGRAVERS

It is particularly gratifying to have been able to assemble such a portrait gallery of engravers, the troglodytes of the Victorian art world. For theirs was a dark, lonely world of grindingly long hours, stretching into years of unremitting drudgery, with recognition accorded only grudgingly and with financial rewards often (but by no means always) scarcely commensurate with a small fraction of their daily (and often nightly) toil. Only the need to find work can explain why so many adopted this heart-breaking profession during Queen Victoria's reign.

The nineteenth century was the great age of the reproductive engraving: popular painters painted subject pictures which presupposed subsequent engravings, to be sold in thousands by the enterprising print-publishers, such as Henry Graves, Ernest Gambart, Francis Moon, and the houses of McLean, Grundy and Agnew. A picture and its copyright were often of equal value. Frith's *Derby Day* was sold as a picture and a copyright for £1,500 each. Jacob Bell bought the picture: Gambart the copyright.

This is where the engraver came in. Usually he was apprenticed at an early age, and worked long hours – 7 a.m. to 8 p.m. was not unheard of. When he had learned his skills, he spent the remainder of his working life cutting thousands upon thousands of minute lines on metal plates, taking anything from four years or more to complete single plates. Tragedies abounded: drink, blindness, insanity, suicide, destitution took their toll of many an engraver. Joseph Goodyear died of overwork after completing his first large-scale commission and Joseph Clayton Bentley died similarly. John Havell became insane and John Saddler hanged himself after a lifetime of successful plates after Turner, Millais and Doré. Richard Golding went blind after ten years' work on one plate, which he left

unfinished, and died destitute. G. T. Doo knew about such things only too well when he confided to the photographer John Watkins that 'the photographic artist ought to be gifted with an equable temper and philosophic composure of mind'.

If this were not enough, the question of the status of engravers caused mounting bitterness in their ranks. Throughout the century they were excluded from the first rank of the Royal Academy. Responding to an appeal made in 1812, the Council made known its view that engraving was wholly devoid of 'those intellectual qualities of Invention and Composition, which painting, sculpture and Architecture so eminently possess; its greatest praise consisting in translating with as little loss as possible the beauties of these original Arts of Design'. The first laws of the Royal Academy excluded engraving altogether, at a time when the art of the engraver in England had reached a very high standard. This had prompted Sir Robert Strange, a distinguished line engraver, to remark in 1775 that 'No sooner had the Academicians passed this law . . . than they admitted among them M. Bartolozzi, an engraver and a foreigner. The better to cover this glaring partiality, they pretended to receive him as a painter.' In 1836 nine of the leading engravers signed and submitted a petition to the House of Commons, which ventured

to express a hope that the state of the Art of Engraving will be made a subject of investigation. That, notwithstanding the high estimation in which that Art, as practised in England, is held by surrounding Nations, yet neither the Art itself nor its most distinguished Professors have ever derived, from the Institutions of the Country, that consideration, encouragement or respect which it is presumed so useful a branch of Art may fairly lay claim to; trusting in the wisdom of your Honourable House. . . .

It was only after J. H. Robinson and G. T. Doo had enlisted the support of the Queen and Prince Albert that in 1853 a new class of Academician Engravers was created. The most distinguished of the engravers, Samuel Cousins, was the first to be elected R A in 1855. Doo followed in 1857; Robinson in 1867. Engravers were not granted complete equality, however, until 1928.

It is something of a relief, therefore, to record that there were successful and well-paid engravers. The majority of those included in the pages that follow fall into this category. Perhaps one can detect a trace of strain on the features of some of them, even of the most successful like Lumb Stocks, T. O. Barlow, and perhaps, too, the 'reserved and sedate' Samuel Cousins. Barlow had been engraving for nearly forty years before he was finally elected A R A, and nearly fifty years before becoming an R A. His diploma (ironically engraved by Bartolozzi) is proudly displayed on the walls of his studio in the photograph by Mayall. A certain indomitability must have enabled Barlow and, for that matter, Tom Landseer, Sir Edwin's brother, to maintain a sunny disposition. A singleness of mind and strength of purpose must account for the heroic feat of Samuel Cousins after his encounter with the Duke of Devonshire. The engraver had signed a contract to engrave Edwin Landseer's *Bolton Abbey in the Olden Time*, a picture owned by the Duke, who was so put off by Cousins's brusque manner that he refused to lend the picture. Undaunted and committed in any case by his contract, Cousins journeyed back and forth from Chatsworth to engrave the picture, which hung 8 feet above his head. Undeterred by the remarks of thousands of tourists and excursionists, he produced a masterpiece in mezzotint, which was considered by his contemporaries to have finally signalled the superiority of that medium over line engraving for Landseer's pictures. In spite of a long and highly successful career, at the age of 73 Cousins could only declare that 'hitherto I have only suffered existence. I want to live.' His last years were spent, as were Tom Landseer's, in signing bundles of his old prints. It was photography that inevitably, in the end, killed off the livelihood of most engravers, through the invention of photogravure processes, just as earlier it had dealt the art of miniature painting a near-mortal blow.

THOMAS OLDHAM BARLOW, RA (1824–89)

Mezzotint engraver. An old friend of Millais (q.v.), he engraved a number of his pictures and was the model for the centre figure in his picture *The Ruling Passion* (RA, 1885).

408 Photogravure after J. P. Mayall, 170 × 213 mm, reproduced in *Artists at Home* (1884), by F. G. Stephens, facing p. 86. On the floor to the left is Millais's portrait of Henry Irving, partly obscuring a painting which may be by C. R. Leslie; above, proudly displayed, hangs the (to an engraver) hard-earned Royal Academy diploma; on the easel is a portrait of Cardinal Manning, also by Millais; to the right, above, is Barlow's diploma work, an engraving of Gladstone; below, to the right, is his engraving of Kneller's portrait of Sir Isaac Newton. *Author's collection*

'[11 November 1883] Such a funny little old man. Whatever he is for black-and-white he has no eye for colour, he had got on a brilliant green tie.'
The Journal of Beatrix Potter from 1881 to 1897 (1966), ed. by Leslie Linder, p. 53

SAMUEL COUSINS, RA (1801–87)

One of the most accomplished engravers of the nineteenth century, he reproduced many works after Reynolds, Lawrence and Millais (q.v.).

409 Photogravure after J. P. Mayall, 166 × 220 mm, reproduced in *Artists at Home* (1884), by F. G. Stephens, facing p. 22. Taken in Cousins's sitting-room. The engravings, all by him, are, from left to right: *The Infant Samuel* (1853), after J. Sant; *Marie Antoinette and Louis XVI in the Prison of the Temple* (1861), after E. M. Ward; *A Mother and Child*, after C. R. Leslie; and *Yes!*, after J. E. Millais. *Author's collection*

In a letter, *c.* 1860, to John Watkins, who had taken three photographs of the artist, he wrote: 'The half length and the profile appear to me satisfactory, but the front face very painful and distorted. I therefore request that you will destroy the negative of that one.'
Author's collection

'Mr Cousins possessed a most striking head and an unusual personality. . . . Ugly could never be the adjective applied to such a splendidly strong and intellectual head, but the old man was in reality not a little vain of his personal appearance, although he scoffingly alluded to his head as an "ugly mug". He had been a very handsome man in his youth, and the remembrance of it was still a lingering regret.'
A. M. Reynolds, *The Life and Work of Frank Holl* (1912), pp. 155–6, 157–8

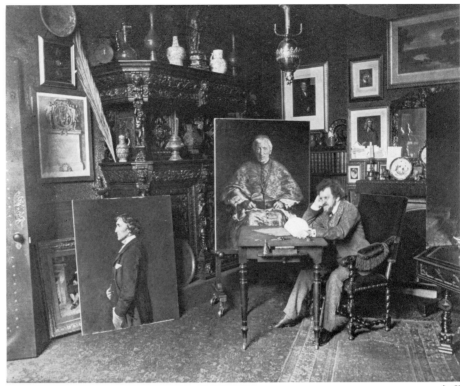

[408]

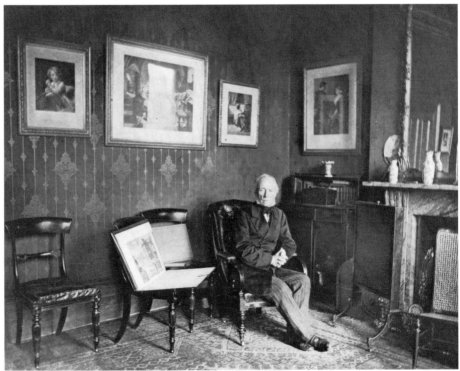

[409]

GEORGE THOMAS DOO, RA (1800–86)

Line and stipple engraver. His first plate was after a painting by Lawrence in 1824. He was appointed Engraver-in-Ordinary to William IV in 1836 and to Queen Victoria in 1842.

410 *Carte-de-visite*, albumen print by John and Charles Watkins, London. In a letter to John Watkins dated 2 January 1856, Doo wrote: 'In addition to other needful qualifications I think I discover that the photographic artist ought to be gifted with an equable temper and philosophic composure of mind.' *Photograph and letter: Author's collection*

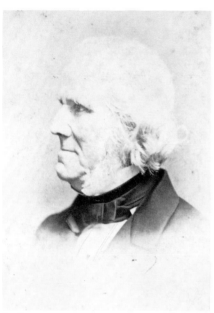

[410]

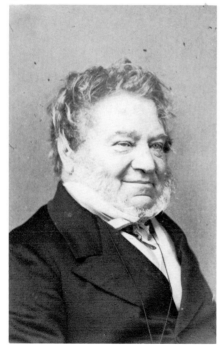

[413]

ROBERT GRAVES, ARA (1798–1873)

Line engraver, son of the London print-seller Robert Graves, and brother of the famous publisher Henry Graves.

411 *Carte-de-visite*, albumen print by John and Charles Watkins, London. A letter from the engraver to John Watkins requesting twenty photographs of himself and ten of Mrs Graves is dated 26 May 1863. *Photograph and letter: Author's collection*

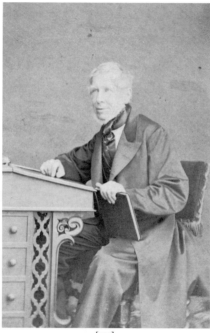

[411]

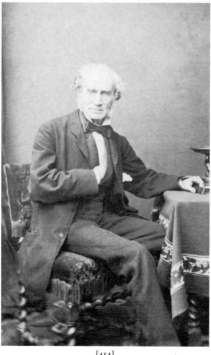

[414]

JOHN LANDSEER (1769–1852)

Line engraver, painter and author. Father of Edwin (q.v.), Charles (q.v.) and Thomas Landseer (q.v.). John and Thomas both engraved Edwin's paintings.

412 Salted paper print by Joseph Cundall, 111 × 78 mm. *Victoria & Albert Museum, London*

'Opinionated, intellectual, voluble, domineering, and embittered, John Landseer must often have been a trial to his family. He was deaf and carried a large ear trumpet, which he waved at people, and he also had a habit of talking to himself. His appearance and behaviour became more eccentric with age, his opinions more blunt and outspoken.'

Richard Ormond, *Sir Edwin Landseer* (1981), pp. 1–2

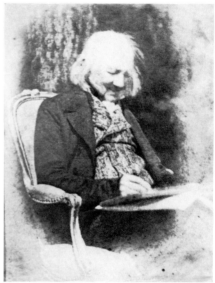

[412]

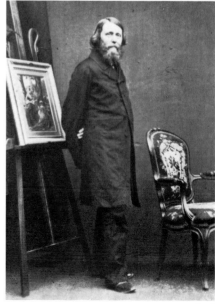

[415]

THOMAS LANDSEER, ARA (1795–1880)

Eldest brother of Edwin Landseer (q.v.). Line engraver, etcher and occasional painter. He and his father John Landseer (q.v.) engraved Edwin's works.

413 *Carte-de-visite*, albumen print by Elliott & Fry, London. *Author's collection*

'His face was always beaming; it was, if anything, wider than it was long, and the very picture of good nature; his figure, too, was almost as broad as he was tall.'
G. A. Storey, *Sketches from Memory* (1899), p. 77

'He was so deaf that he could not modulate his voice at all, and would sometimes whisper the most ordinary remarks, as if they were State secrets, while at other times, notably at the private view of the Royal Academy, he would yell criticisms of the pictures at us which were certainly not meant for the public to hear. Then he would thrust a porcelain slate that he always kept attached to his coat in to our hands, and wait for us to write down a reply to what he had just said. I do not know anything more trying than this mode of communication, and as in those days lip-reading had not been invented, the conversations were usually very one-sided. I wish Mr Tom Landseer could have communicated with us in some other way, for he was a most amusing man, and always made us laugh hilariously, but more from his manner than from anything he said, I fancy.'
Mrs Panton, *Leaves from a Life* (1908), p. 98

RICHARD JAMES LANE, ARA (1800–72)

A line engraver and lithographer, he was also famous for his pencil and chalk sketches, and particularly for his portrait of Princess Victoria, 1829.

414 *Carte-de-visite*, albumen print by Charles Watkins, London, possibly taken in late 1864 or early 1865. A letter to Watkins (addressed as 'Charles') dated 14 December 1864 thanks him for his 'beautiful gift of Photos', a favourite ploy used by *carte* photographers to lure people into their studios.
Photograph and letter: Author's collection

WILLIAM JAMES LINTON (1812–98)

Wood engraver, poet, writer and socialist. Went to America in 1866 where he engaged privately in engraving and printing.

415 *Carte-de-visite*, albumen print by John and Charles Watkins, London, *c.* 1860. *National Portrait Gallery, London*

JOHN PYE (1782–1874)

Line engraver, who executed a large number of works after Turner. He campaigned vigorously to persuade the Royal Academy to accord full academician status to engravers.

416 Albumen print by Ernest Edwards, published in *Portraits of Men of Eminence* (1864), by A. W. Bennett, Vol. 2.
Author's collection

LUMB STOCKS, RA (1812–92)

Reproductive line engraver and one of the best known of the nineteenth century.

417 Photograph by Ralph W. Robinson, 194 × 153 mm, published in *Members and Associates of the Royal Academy of Arts, 1891, photographed in their Studios* (1892). *National Portrait Gallery, London*

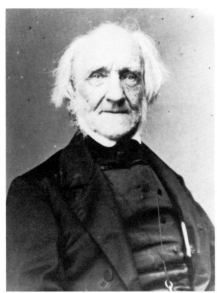

[416]

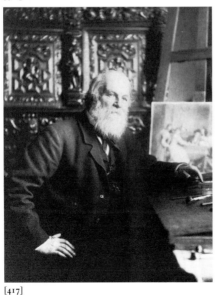

[417]

EDWARD WHYMPER (1840–1911)

Engraver, illustrator and Alpinist. He belonged to a family of wood engravers and contributed many engravings and illustrations to books of the 1860s. Wrote, among others, *Peaks, Passes and Glaciers* (1862) and *Scrambles Among the Alps* (1870). In 1865 he led the first successful attempt to climb the Matterhorn.

418 Uncut proof albumen print, *carte-de-visite* size, by John and Charles Watkins, London. Seen here in Alpine apparel.
Author's collection

'Of course talk fell on Whymper's scaling of famous peaks – both in the Old World and the New – in Switzerland and the Andes. And, of course, he told the story of the tragedy of the Matterhorn.

'The grim, tightly-drawn face, the set lips, the metallic voice, all gave force to the story related in calm tones as if it was of small import and not a notable event in a man's life.

'There was never a semblance of emotion noticeable in him, yet, underneath the dry crust, there was a softness of nature which, speaking from my own experience, showed itself in thoughtful little acts. . . . His humour was sardonic. On this first visit, when called to breakfast and asked if he took porridge, there came an answer, through clouds of tobacco smoke – for Whymper smoked in bed as well as out of it – "Porridge! I would rather leave the house!" And I believe he meant it!'
Edward Clodd, *Memories* (1916), p. 83

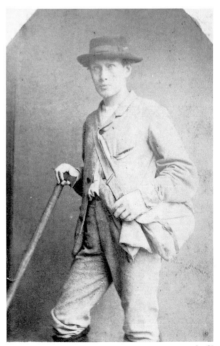

[418]

LITERARY
ASSOCIATES

WITH one solitary but notable exception, the involvement of literature with Victorian art and artists was mainly centred on the Pre-Raphaelite movement. And the mainspring of this world was the painter-poet Dante Gabriel Rossetti. He was social and gregarious, an attractive, amusing, but increasingly tormented genius, whose career was to act as a magnet which drew many of the leading literary figures of the day.

In his immediate circle was Christina, the younger of his two sisters, who together with Elizabeth Barrett Browning (not herself to be absorbed into the Pre-Raphaelite orbit) was one of the most celebrated women poets of the day. Christina Rossetti was the truest Pre-Raphaelite poet of them all. This rather sad, pious woman – once described by Holman Hunt as a 'sepulchral poetess' – was once engaged to James Collinson, an original member of the Brotherhood. Also in Rossetti's immediate circle was his brother William Michael – quiet, unassuming, entirely lacking his brother's charismatic presence yet withal a talented writer, critic and, above all, indefatigable chronicler of the Pre-Raphaelite movement. Another in the painter-poet's periphery was the PRB sculptor-poet Thomas Woolner. Not pre-eminent in either sphere, he nevertheless formed a lifelong friendship with Tennyson, weaving another strand into the fabric of friendships. Two more – another poet-painter, William Bell Scott (again not in the first rank in either capacity) and William Allingham, who had been introduced to the Pre-Raphaelites by Coventry Patmore – swelled the ranks of the literary associates. Bell Scott was a vigorous letter-writer, as was Allingham (whose correspondence was published), and the latter kept a diary, which was also published. He had a small talent and is best remembered for his fairy songs for children. A volume of his poems issued in 1855 was illustrated by Rossetti,

Millais, Hughes and Lizzie Siddal. His *In Fairyland*, illustrated by Richard Doyle, was published in 1870, and is one of the most beautiful illustrated books of the nineteenth century. Bell Scott professed friendship with Rossetti throughout his life, yet when his *Autobiographical Notes* were published posthumously in 1892, they were found to be bitter and resentful towards his former friend, although as source material they are, to us, invaluable.

Photographs of Christina reveal her as we know her to have been – undemonstrative, silent and introvert. Woolner looks solid and robust, more of the sculptor than the poet. Allingham appears dark, Celtic, handsome: his looks complemented those of his wife, the beautiful Helen Allingham, the water-colourist. Bell Scott looks exactly as one would expect – saturnine, broody, Mephistophelian. In his early days he was nicely bearded and moustached and then, through an illness, bewigged, without a hair on his body, as though some unseen agent had taken an anticipatory and unfortunately risible revenge.

In the autumn of 1862 two further literary figures – Swinburne and Meredith – swam into Rossetti's orbit and rapidly settled there, although both were subsequently to go their different ways. Algernon Charles Swinburne had known William Morris and Rossetti at Oxford, but it was in this year that he became a sub-tenant at Rossetti's newly found house at 16 Cheyne Walk. Rossetti found him 'a tempestuous inmate', throwing drunken orgies and prancing round the house naked. Nevertheless, he found time to do much of his finest work there, including *Atalanta in Calydon* and a large part, if not all, of the *Poems and Ballads*. Swinburne has always been closely identified with the Pre-Raphaelite movement: he was to review Rossetti's poems in 1870, and W. M. Rossetti was to defend his

Poems and Ballads, and to collaborate with him on *Notes on the Royal Academy Exhibition* in 1868; together with Morris and Rossetti he was one of the poets attacked as the 'Fleshly School' by Robert Buchanan in 1871. Photographs of Swinburne sometimes suggest but do not always reveal the tiny body. They always show the long thin neck, large head, the stook of hair; but never the colour of it, bright red. When he left Rossetti's house, it is reputed that Madox Brown, used to the ways of inebriated poets, devised a system of attaching labels with his address to Swinburne's coat so he could be deposited at his door for instant rehabilitation. George Meredith, too, was for a few months a sub-tenant at Tudor House at the same time as Swinburne; he wrote *Modern Love* there, as well as a novel, *Emilia in England*.

Alfred Tennyson played an altogether different role in relation to art and artists, and it is an extraordinarily paradoxical one. For, although he numbered several artists amongst his friends – Lear, Woolner, Holman Hunt and G. F. Watts, in particular – he was, like Carlyle, disconcertingly indifferent to art and artists, just as he was to music and musicians, which is all the stranger as his poetry overflowed with music and imagery. Indeed, the senses most appealed to in Tennyson's poetry are those of sight and hearing. He, however, was far more interested in science and scientists. His closest involvement with artists was to result in some of the finest of all Pre-Raphaelite illustrative work: this was the celebrated illustrated edition of his poems, published in 1857 by Moxon. His own interest was that no illustration should deviate by the slightest detail from the text of his poems. 'My dear Hunt,' said Tennyson, when he first saw Hunt's superb illustration of the Lady of Shallot, 'I never said that the young woman's hair was flying all over the shop.' 'No,' said Hunt, 'but you never said it wasn't.' Other illustrations were similarly dismissed.

When the Tennysons moved to Freshwater some twenty-five years later, his wife Emily wrote to Thomas Woolner to find some oil paintings to cover the stains on the wallpaper. They were to be of 'red and flesh colour' with 'bright frames', from a pawnbroker, preferably the 'oldest copies of oldest pictures to be sold for one farthing each barring the discount on ready money'.

But here the irony begins. No poet, alive or dead, with the exception of the newly discovered Keats, inspired so many Pre-Raphaelite paintings as Tennyson – Millais's *Mariana*, Hunt's *Lady of Shallot*, and others, including, later, Waterhouse's *St Cecilia* (based

on lines in *The Palace of Art*). His poetry was the Bible of the Pre-Raphaelites; his clear-cut pictorial imagery exactly suited their aims.

William Morris's involvement was social and commercial yet creative, syphoning off a superabundance of talent and skill to the firm of Morris, Marshall, Faulkner & Co., which specialized in wall-papers, stained glass and the applied arts. It was Morris's friendship at Oxford with the future painter Burne-Jones which altered the course of his life: it had been his intention to take holy orders. Indeed, it was the artistry of Burne-Jones which forged a link between the ideologically nordic temperament of Morris, as expressed in his poetry, and the idealistic Latin strain of Rossetti. The foundation by Morris, in 1890, of the Kelmscott Press gave a new impetus to the creation of medieval and mythological imagery in the illustrative work of Burne-Jones. Morris's wife Janey became, after the death of Lizzie Siddal, Rossetti's muse. Either through lack of vanity or interest Morris was not often photographed, while his socialism would have barred him from many of the albums of the middle and upper classes. Hall Caine owes his place here to his living with Rossetti during the last years of his life, being present at his death and leaving an account of it. Thackeray and Wilkie Collins are treated elsewhere in the book as writers on art. The latter was a lifelong friend of Frith and Holman Hunt.

Mention of these two novelists brings us to another great literary figure, Charles Dickens. He, the one exception to the pattern, had little or no sympathy with the aims of the Pre-Raphaelites. In fact, his only important connections with them were his vitriolic review of Millais's *Christ in the House of His Parents* in *Household Words* and, later, the advice he gave Holman Hunt on how to sell *The Finding of the Saviour in the Temple* to the wily Gambart, for what was considered at the time to be a world-record price. His friendship with artists of the more traditional Schools was prodigious; these included Maclise (after whose death he delivered a funeral oration), Frith, Egg, Clarkson Stanfield, C. R. Leslie, Frank Stone and his son Marcus, Landseer, Leech, Cruikshank, Luke Fildes, Mr and Mrs E. M. Ward, David Roberts and Elmore. He was very fond of water-colours, particularly the work of William Henry Hunt, and he appreciated the early work of Turner. The numerous illustrations to his works testify to his belief in the validity of the pictorial image. Like Tennyson, Dickens was enormously popular with photographers and they with him.

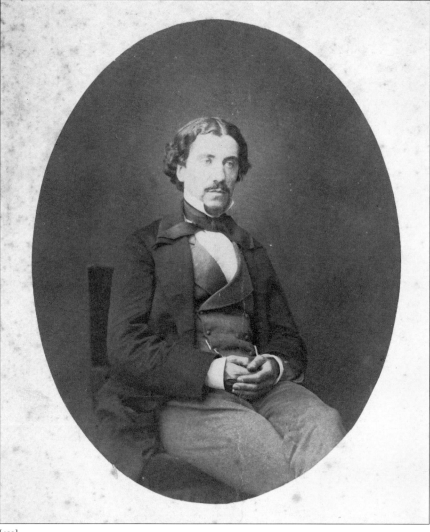

[419]

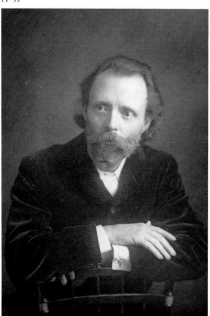

[420]

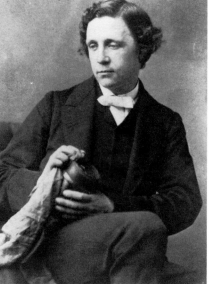

[421]

WILLIAM ALLINGHAM (1824–89)

Irish poet born at Ballyshannon in Donegal. His friendship with many contemporary artists, particularly Rossetti (q.v.), with whom he corresponded, makes his papers an important source for scholars. His wife was Helen Allingham (q.v.), the water-colourist.

419 Albumen print, oval, 166 × 131 mm, *c.* 1855. From the collection of Holman Hunt (q.v.). The two men had known each other from at least 1850. *Author's collection*

'Allingham was a well-built man, hardly up to the middle height, with a thoughtful countenance, fairly regular features, crisp hair, and, under black eyebrows, a pair of very dark blue-grey eyes which I have rarely seen equalled. The "Celtic glamour" was at full in them. One could see him to be an Irishman, but in his speech there was only a faint trace of this. His voice was remarkably pleasing – distinct, low-pitched, deliberate, and in monotone, with a certain seeming air of slightingness or indifference.'
William Michael Rossetti, *Some Reminiscences* (1906), Vol. 1, p. 86

SIR (THOMAS HENRY) HALL CAINE (1853–1931)

Novelist. In our context he is best remembered as a friend and memorialist of D. G. Rossetti (q.v.), with whom he stayed during his last years and death, leaving a valuable account, revised, enlarged and finally included in his autobiography, *My Life* (1908).

420 Cabinet portrait, carbon print by W. & D. Downey, 1892, published in *The Cabinet Portrait Gallery* (1892), 3rd Series. *Author's collection*

LEWIS CARROLL (CHARLES LUTWIDGE DODGSON) (1832–98)

Writer and mathematics lecturer at Christ Church, Oxford. His most famous works are *Alice's Adventures in Wonderland* and *Through the Looking Glass*. His diaries reveal a close association with artists. He was also an accomplished photographer.

421 *Carte-de-visite*, albumen print by Oscar Gustav Rejlander, taken on 28 March 1863. Carroll is polishing a camera lens. *Sotheby's*

'Feb: 8. (Tu.) [1876]. The son of Mr Ward RA [Leslie Ward, better known as "Spy"] called, and wanted to make a picture of me for *Vanity Fair*, an honour from which I begged to be excused; nothing would be more unpleasant for me than to have my face known to strangers.'
Lewis Carroll, *Diaries* (1953), ed. by Roger Lancelyn Green, Vol. 2, p. 350

CHARLES DICKENS (1812–70)

Novelist, journalist and essayist. He numbered many artists among his friends.

422 Silver bromide print by Herbert Watkins, from a negative of 1858, 180 × 152 mm. From the collection of Holman Hunt.
Author's collection

'I should think the first time I saw Charles Dickens myself was when Papa [W. P. Frith, R A] was painting his portrait for John Forster: he was rather florid in his dress, and gave me an impression of gold chain and pin and an enormous tie, and he too, as did so many men then, wore his hair long, with the usual waving lock above his forehead.'
Mrs Panton, *Leaves from a Life* (1908), p. 141

'I think that on the whole my father may be said to have been a real lover of art, but that he undoubtedly had a still greater love of nature, against which he thought that many artists, either from want of reverence for their art, or from want of knowledge, or from a mere whim or affectation, which it was not in his nature to forgive, often very gravely offended.

'That he had the utmost sympathy for all artists was in his lifetime amply proved in many ways, and his earnest desire to help the younger and poorer members of the profession whenever it was in his power to do so is well known, and perhaps still gratefully remembered, by the few who remain to tell a bygone tale.'
Kate Perugini in the *Magazine of Art* (1903)

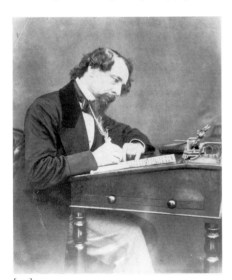

[422]

GEORGE MEREDITH (1828–1909)

He was on terms of friendship with the Pre-Raphaelites, particularly Rossetti (q.v.), whose house in Cheyne Walk he shared briefly, together with Swinburne (q.v.). He wrote *Modern Love* there. The chief Pre-Raphaelite influence on Meredith's work was in the pictorial quality of his description. Meredith is supposed to have been the model for Wallis's *Death of Chatterton* (Tate Gallery): two years later Wallis eloped with Meredith's wife, Thomas Love Peacock's daughter.

423 Photograph by Frederick Hollyer.
Delaware Art Museum, USA

'Mr Meredith had . . . a fine well-chiselled face, more noticeable perhaps for mould of feature, and for the air of observant intellect, than for the expression of indulgent fellow-feeling: an Italian would have called him "bello" rather than "simpatico". It is the face of a man not easily hoodwinked by the shows of the world. My brother was wont to say that Meredith bore a rather marked resemblance to the busts of the Emperor Hadrian; I think he improved upon them.'
William Michael Rossetti, *Some Reminiscences* (1906), Vol. 1, pp. 287–8

CHRISTINA ROSSETTI (1830–94)

Poetess, daughter of Gabriele Rossetti (1764–1853) and Frances Mary Lavinia (1800–86), sister of D. G. Rossetti (q.v.), and W. M. Rossetti (q.v.). Her best-known work is *Goblin Market*. See Plate 214.

'She had a mild religious face, and smooth hair, and very big grey eyes, rather prominent.'
Juliet Soskice, *Chapters From Childhood* (1921), p. 8

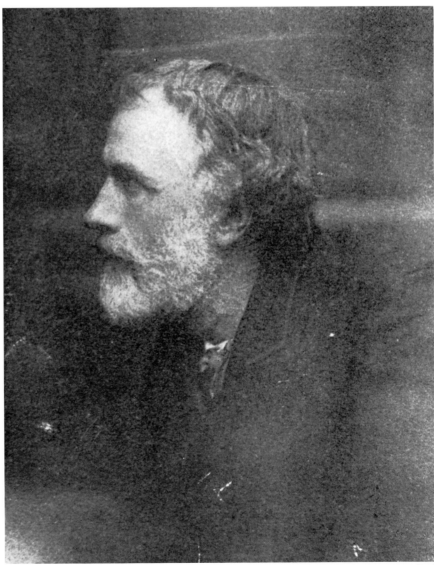

[423]

ALGERNON CHARLES SWINBURNE
(1837–1909)

Poet and close friend of D. G. Rossetti (q.v.), whose house at 16 Cheyne Walk, Chelsea, he shared from 1862 to 1863. He was a friend, too, of Whistler (q.v.) and W. M. Rossetti (q.v.).

424 *Carte-de-visite*, albumen print by the London Stereoscopic & Photographic Company, *c.* 1863. From the collection of Holman Hunt. *Author's collection*

'There was, indeed – I say it with unabated reverence – something absurd, as it were mis-begotten, about Swinburne, which no truthful picture can omit; something that made people turn and laugh at him in the streets, as I once saw some carters do as he went by on Wimble-don Common, with his eccentric dancing, one might even say epileptic, gait, his palms spread open behind him in a tense nervous way. He was certainly an odd, scarcely human, figure.'

Richard Le Gallienne, *The Romantic 90s* (1926), p. 19

TENNYSON, ALFRED LORD (1809–92)

Poet Laureate. Curiously, considering the bright hard imagery of much of his poetry, Tennyson was himself somewhat indifferent to art and artists. However, his own poetry became a major source material for the subject pictures of the Pre-Raphaelites. Perhaps the most celebrated manifestation of this was the Moxon edition of his poems, published in 1857. This contained thirty illustrations by the Pre-Raphaelites.

425 *Carte-de-visite*, albumen print by the London Stereoscopic & Photographic Company, *c.* 1857–9. *Radio Times Hulton Picture Library*

'One of the finest looking men in the world.

A great shock of rough dusty-dark hair; bright-laughing hazel eyes; massive aquiline face, most massive yet most delicate, of sallow brown complexion, almost Indian-looking; clothes cynically loose, free-and-easy; – smokes infinite tobacco. His voice is musical metallic, – fit for loud laughter and piercing wail, and all that may lie between; and specu-lation free and plenteous: I do not meet, in these late decades, such company over a pipe! – We shall see what he will grow to. He is often unwell; very chaotic, – his way is thro' Chaos and the Bottomless and Pathless; not handy for making out many miles upon.'

Letter from Thomas Carlyle to R. W. Emerson in *The Correspondence of Emerson and Tennyson* (1964), ed. by Joseph Slater, Vol. 2, p. 363

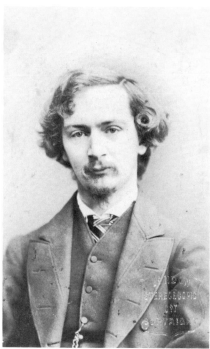

[424]

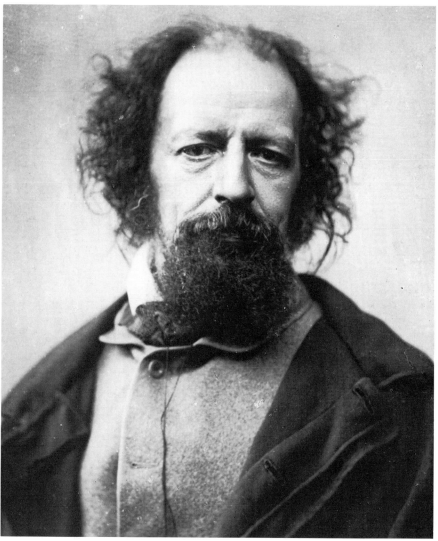

[425]

Robert B. Martineau Charles Collins [John Tenniel]

Edward Lear

G. D. Leslie W M Thackeray Thos. Webster

Henry Moore Thomas Hyde Hills W. P. Frith

Walter Crane Fredk. Lee

W M Rossetti Francis Holl

J. W. Waterhouse William F. Yeames

Henry T. Wells Samuel Palmer Henrietta Ward

J Pettie William Bell Scott

W. S. Dobson Holman Hunt

Oldham Barlow M E Edwin

J E Millais Oliver Madox-Brown Alfred Elmore

D. W. Wynfield E Watkes Thomas Faed W Holman Hunt

Leslie Ward

William Shee Solomon John Everett Millais

Wm Etty James Baker Pyne

Thos Woolner E Gambart

Louise Caroline Alberta James Hinton

F W Burton

L. W. Desanges H Bennett Edward J. Poynter

Matthew Noble Wilkie Collins Mortimer Menpes